DIGITAL ART AND MEANING

ELECTRONIC MEDIATIONS

Katherine Hayles, Mark Poster, and Samuel Weber, Series Editors

(continued on page 292)

DIGITAL ART AND MEANING

Reading Kinetic Poetry, Text Machines, Mapping Art, and Interactive Installations

ROBERTO SIMANOWSKI

Electronic Mediations 35

University of Minnesota Press

Minneapolis

London

Chapter 1 was previously published as "Holopoetry, Biopoetry, and Digital Literatures: Close Reading and Terminological Debates," in *The Aesthetics of Net Literature: Writing, Reading, and Playing in Programmable Media,* edited by Peter Gendolla and Jörgen Schäfer, 43–66 (Bielefeld: Transcript, 2007).

"A Fine View" is reprinted by permission of the poet, David Knoebel.
"Talk, You" from *Dead, Dinner, or Naked* (Chicago: TriQuarterly Books/Northwestern University Press, 1993) is reprinted by permission of the poet, Evan Zimroth.

Published by the University of Minnesota Press
111 Third Avenue South, Suite 290
Minneapolis, MN 55401-2520
http://www.upress.umn.edu

Library of Congress Cataloging-in-Publication Data

Simanowski, Roberto.
Digital art and meaning : reading kinetic poetry, text machines, mapping art, and interactive installations / Roberto Simanowski.
p. cm. — (Electronic mediations ; v. 35)
Includes bibliographical references and index.
ISBN 978-0-8166-6737-6 (hc : alk. paper) — ISBN 978-0-8166-6738-3 (pbk. : alk. paper)
1. Digital art. 2. Interactive art. I. Title. II. Title: Reading kinetic poetry, text machines, mapping art, and interactive installations.
N7433.8.S56 2011
776—dc22 2010033909

Printed in the United States of America on acid-free paper

The University of Minnesota is an equal-opportunity educator and employer.

17 16 15 14 13 12 11 10 9 8 7 6 5 4 3 2 1

CONTENTS

Preface

AGAINST THE EMBRACE

IN 1990, BRITISH ARTIST and self-proclaimed visionary theorist Roy Ascott wrote, in his essay *Is There Love in the Telematic Embrace,* "The past decade has seen the two powerful technologies of computing and telecommunications converge into one field of operations, which has drawn into its embrace other electronic media, including video, sound synthesis, remote sensing, and a variety of cybernetic systems" (2003, 232). Ascott's statement updated his concept of behaviorist art, which he had proposed more than twenty years before at the high time of the search for art forms in which the artist is no longer in complete control of what is happening, or what is presented with or to the audience. In the meantime, this version of participatory or interactive art had successfully allied with technology and transformed itself from an aesthetic (and ideological) concept to a common feature of art within new media. As Ascott explains, the "telematic embrace" implies that "meaning is the product of interaction between the observer and the system, the content of which is in a state of flux, of endless change and transformation" (233). Such a state of flux, Ascott continues, is in opposition to the traditional artwork, which "requires, for its completion, the viewer as, at best, a skilled decoder or interpreter of the artist's 'meaning'" (234). As Ascott adds, the traditional artwork "gives rise to the industry of criticism and exegesis, in which those who 'understand' this or that work of art explain it to those who are too stupid or uneducated to receive its meaning unaided" (234).

As this passage reveals, what is at stake in the embrace that he and others are promoting is not only the work of the artist but also that of the critic. This democratization of the art system seems to want to leave everything to the audience—the production of meaning as well as its analysis. There is clearly a lot of affection for the audience in the telematic embrace.

Although the disempowerment of the artist needs further discussion, any dismissal of the critic simply calls for a rejection. Why should an interactive work not be the subject of criticism and exegesis? Does interaction automatically supply its viewers with education, rendering the assistance of critical and pedagogical professionals dispensable in any attempt to understand the meaning of a work?

Ascott is not really acknowledged as a theoretician in the field of digital aesthetics—which may not come as a surprise, given his obvious opposition to the industry of criticism. However, he nonetheless represents a particular point of view that is manifest in many approaches to digital art, one that is marked by the unconditional embrace of the audience and the resulting rejection of the critic. This book rejects such an embrace and embraces the advances of the critic. It reformulates the questions raised in the title of Ascott's essay and asks whether there is meaning in the telematic embrace. To answer this question, the book addresses three other embraces that occur in the discussion of digital arts: code, body, and presence. I discuss them in turn.

Code is without doubt an indispensable element in every discussion of digital arts because everything happening on the screen or on the scene is first and foremost subject to the grammar and politics of code. In many cases and in many different ways, it is important to understand what has been done and what can be done on the level of code to understand and assess the semantics of a digital artifact. However, a preoccupation with code threatens to divert our attention from the actual meaning of an artifact. It encourages claims such as the notion that everything in digital media is actually literature because everything is represented as alphanumeric code, or that digital spaces represent a strong desire for control over the messiness of bodies and unruliness of the physical world because everything in digital media is coded and computed.[1] Although such claims are not entirely unsubstantiated, they are hardly helpful. If we take, for instance, an interactive installation such as David Rokeby's *Very Nervous System* (1986–1990)—where the physical action of the interactor[2] alters the acoustic information output by the system—we quickly recognize that this closed-circuit installation is not literature; nor does it intend to control the messiness of the body. It is an interactive performance that encourages the interactor to generate a body completely different from the controlled body of everyday life. An abstract embrace of the code with no regard to its materialization on the screen or on site, the formalistic

focus on technologies behind the interface neglects the actual experience of the audience and impedes access to the artwork's aesthetics.

No doubt the body is an important element in any analysis of inter-active installations. Theorists generally have no problem acknowledging that the specificities of the lived body (gender, race, age, weight, health) contribute to the way a painting, text, or performance is perceived. If the audience is physically engaged in the art and the interactor's body be-comes the central focus of the aesthetic experience, the body's importance increases significantly. In such a context, we "think" much more directly through the body and somehow feel the meaning of the work at hand. However, direct bodily sensation and experience must not be our final point of consideration. We must also think the body and reflect, as we will see, even on those experiences that the body does not have during an installation. The body may be our general medium for "having a world," as Maurice Merleau-Ponty (2002, 169) puts it; our mind is the indispens-able means of understanding the mediated world. We must analyze and interpret the body's action in the context of the specific framework that the author provides, and with respect to the implications that this may have for the interactor beyond the actual aesthetic experience. The im-mersed interactor eventually has to emerge from the spontaneous, intu-itive embrace of the given situation and regain reflective distance. Even in an interactive performance, the phenomenal body can finally be treated as a semiotic body—indeed, it must do so in the context of critical reading.

Any shift from phenomenal to semiotic appreciation is obstructed by altered consciousness and participation in dialogue with the work, such as is enthusiastically advocated by many theorists of interactive art. Inter-active art is often conceived as a turn from content to event, from the communication of a message to the production of a space that inaugu-rates dialogue, or from the private symbolic space that traditional art pro-vides to a period of experiential time that asks to be lived through.[3] Yet such an approach often neglects the fact that the inaugurated dialogue embodies a symbolic space on which we may reflect, as does the fact of living through experiential time itself. Meanwhile, the abandonment of reflection is in line with certain statements of aesthetic theory, which object to an overemphasis on content or to the exclusive role of hermeneutics in Western culture, favoring an attention to the materiality of the signifier over any examination of its deeper meaning. Such a move *against interpre-tation,* such a *farewell to interpretation*—to invoke the titles of two relevant essays by Susan Sontag and Hans Ulrich Gumbrecht—can be understood

as a corrective, as opposed to a hermeneutics, that weaves every element of an artifact into a net of meaning, taming the work of art through rationalization, as Sontag (1966) puts it in her essay. However, to embrace an artifact in its phenomenological materiality is not a particularly promising way to develop the discourse of a new object of critical attention such as digital art. Any approach in this context that abstains from interpretation will tend to generate spontaneous, enthusiastic, dismissive, but vague statements about the appearance of a work, or to produce so-called close readings that do not go beyond a detailed description of the material and structure of the piece under examination. Eventually, it is necessary to move from phenomenology to semiotics, from description to interpretation.

Of course, this is not to say that code, body, and presence should not be taken into account in our discussion of digital art. They are fundamental to any understanding of this art, particularly when it is interactive and involves the interactor's body in its formation. However, this book promotes a reading of digital art that is not satisfied with a formalistic appreciation of code or a structural account of the body's actions, let alone a quasi-religious exultation of the moment. This book is driven by the belief that the first purpose that a digital work serves is to produce an act of creative expression; it is not a mere product of technology or chance. The close readings offered up in this book therefore pay close attention to expressive action rather than algorithmic organization. Code matters as much as its materialization in text, sound, visual object, and process matters in the experience of the work by its audience. This book is also driven by the belief that bodily experience within an interactive work is a more or less intentional result of such creative expression and that it thus requires interpretation on the part of the spectator or interactor. Hence, the close or respectively semiotic readings in this book will pay attention to the action of the body without forgetting to discuss the meaning of such action. Finally, this book is driven by the belief that the appreciation and critical discussion of an artifact must exceed attention to its materiality or a meticulous analysis of its structure.

Although the type of reading being promoted here may be seen as in the tradition of New Criticism, it is nonetheless extended beyond the text of a work to include external aspects—for example, the economic conditions of its production, the political implications of the technologies applied (such as the link between GPS and video recording to surveillance), and background information available about or provided by the artist. Because digital media determines the way we conceptualize and

experience our social and cultural life, the final aim in analyzing digital art is to move beyond formalism to a critical reading. However, this should not happen on the ground of a metatheoretical discussion or thematic reading, as was common in the 1990s, when the understanding of the technology (such as hypertext) as the embodiment of contemporary critical theory distracted critical attention for the actual work and led to misinterpretations of the theory applied in favor of establishing a link between this theory and technology. It is important not to reduce any specific example of digital art to the status of typical representative of some aspect of digital media or of some genre of digital art. It is time to pay attention to the specificities of particular works. This does not mean that we should abstain from discussing a specific work as an example of a genre, or try to refrain from understanding a genre itself as a signifying form in contemporary culture. If close reading aims at critical reading, making generalizations and suggestions concerning certain interdependencies between the particular artifact and the broader cultural situation will be inevitable. The crucial questions are where one starts, and how much attention is paid to the work at hand.

The aim of this book is to start close to the actual work before reading it in light of its broader context. As stated above, my agenda proceeds with a threefold rejection of the embrace: the embrace of code as such at the expense of its actual materialization, the embrace of the body's action at the expense of its cognitive reflection, and the embrace of the pure presence of the artwork at the expense of any examination of its semiotic meaning. What this book does embrace, however, is the methodology of close reading while rejecting its more traditional implications. The insistence on close reading is sometimes invoked to recall literary studies to its own native skills and to a requirement to observe the separation of disciplines.[4] The foreclosure of methods and concerns in other disciplines is both unwise and unworkable, given the interdisciplinary nature of the subject of research at hand. I do not limit my scholarly interests to the traditional topics of my discipline—that is to say, literary studies. I nonetheless feel deeply indebted to its typical methodologies and propose to apply them in other fields and disciplines. The legacy that this book hopes to convey to digital media studies is the skill and acumen of close (that is, semiotic) reading. This skill is widely applicable not only to nonliterary texts—as scholars of literary studies point out (Gallop 2007)—but also to other sorts of artifacts and phenomena. Offering skills to students and critical readers rather than offering them knowledge per se teaches them how to produce

their own knowledge. During times when the consumption of information often seems to push critical appreciation to one side, such skills become essential virtues.

Given its subjects and its objectives, this book is indebted to a number of pioneers and scholars in the field of digital literature and arts. First of all, I want to cite N. Katherine Hayles, whose research on digital literature and academic advocacy of the field I appreciate as much as her input as an interlocutor at conferences and in private conversations. One can certainly say that after George P. Landow drew the attention of the academic community to the technology of hypertext, it was Kate Hayles who first practiced close readings and demonstrated how hyperfiction should be treated with the hermeneutic approach typical of literary studies. I am also indebted to Robert Coover, internationally renowned as a writer of fiction, but also well known in the community of digital literature as a tireless advocate of creative writing within digital media. Without Bob's enduring commitment, many significant works would not have been born in the Cave at Brown University, major digital literature events would not have taken place at Brown and around the world, and some central figures in the practice and discourse of digital literature would not have joined the field. I extend thanks as well to Peter Gendolla and Jörgen Schäfer from the research group on Net literature at the University of Siegen in Germany, with whom I am connected through several co-taught seminars, book projects, and conferences we organized. For fruitful conversations at conferences and coffee shops, via e-mail, and over dinner, I thank Jim Andrews, Philippe Bootz, Jean-Pierre Balpe, Noah Wardrip-Fruin, Christopher Funkhouser, Loss Pequeño Glazier, Rita Raley, Alexandra Saemmer, Scott Snibbe, Joseph Tabbi , Camille Utterback, and, of course, Laura Borràs Castanyer. For help in many respects, I am also grateful to Peter Burgard, Jeff Chase, Michel Chaouli, Johanna Drucker, Luciana Gattass, Elli Mylonas, and Edrex Fontanilla.

Finally, there are three others who deserve special mention. I am grateful to John Cayley, a brilliant interlocutor, attentive reviewer, valued editor, great companion, and trusted friend. I first met John at the Digital Art and Culture Conference (DAC) 2000 in Bergen, where I gave my first paper on this subject to the English-speaking community, with John as moderator of my panel. We met again at the Electronic Poetry Festival (E-Poetry) in Morgantown, West Virginia, in 2003. We had our first glass of beer without the usual crowd at DAC 2005 in Copenhagen and our first bottle of

wine at the E-Poetry Festival in Paris in 2007. In fall 2007, Bob Coover was instrumental in getting John hired by the Brown University Literary Arts Program as a long-term visiting professor, which allowed us to discuss new books, artworks, and theories whenever we wanted. Thus, the person who introduced my first English-language paper is now helping launch my first English-language book. Thanks to John for all the time he donated to discussions with me. Thanks also for all the thoughts contributed, for knowing how I think, and for always suggesting the correct word or phrase I had been looking for.

I thank Francisco Ricardo, who literally witnessed my first steps into the field of digital arts when we were standing in line at a Harvard University cafeteria on a sunny spring day in 1999, with me holding George P. Landow's *Hyper/Text/Theory* under my arm. What I understood most during the next hour after Francisco asked me about the book: this man doesn't need any caffeine at all to get started. Give him a name, give him a word, give him an idea, and he will jump on it, associate, elaborate, make connections, and provide references, remarks, and footnotes, no matter what the subject is, as long as it belongs to art, philosophy, or new media. I never met a person with a PhD in computer science who was so erudite in the area of modern art and theory. No wonder that after my return to New England four years later we immediately resumed our conversation. This was my weekly dose of intellectual inspiration, dinner talks I wish I'd recorded. Every chapter in this book owes at least one central idea and one essential reference to Francisco.

Finally, I thank Delphine Gabbay, the person with whom I discussed the first draft of my manuscript. It was in Berlin in the summer of 2006, and Delphine had to cope with the most difficult of tasks: my humble attempts to transform my thoughts into decent English. I thank Delphine for her critical questions and productive suggestions and for her sustained patience and insistence, often late into the night in Berlin, Boston, and Buenos Aires. Thanks for all the tangos not danced because of my book, and all the ones danced too.

Introduction
CLOSE READING

WITH THE INCREASING IMPORTANCE of digital media in all areas of social and cultural life, it is necessary to define a conceptual framework for understanding the social changes produced by digital media and to show students and readers how to interact critically with digital media and culture. Conferences and publications increasingly develop the theoretical background and the methods needed in scholarship and education to approach the new topics. At various universities, scholars are discussing the consequences of such developments under the umbrella terms of digital literacy, digital humanities, or "electracy."[1] On the one hand, this body of scholarship is concerned with the effect on the individual and society as a whole of phenomena related to new media, such as identity tourism, online democracy, online nation, online education, digital divide, new illiteracy, digital economics, and Internet addiction, as well as the increasing possibilities of surveillance that new technologies offer. Also implicated are issues of authorship, copyright, distribution, and preservation in and of digital publications. On the other hand, scholars also concentrate on the aesthetic aspects of digital media, investigating new artistic genres emerging from digital media or changes in existing genres brought about by digital media. Because this book is concerned with digital art and the meaning behind it, it aims to contribute to the discussion of the second group. It starts by examining the meaning of digital literacy, by underlining central aspects of a hermeneutic perspective in digital media, and by arguing in favor of the undertaking of interpretation against its low esteem in praxis and theory. The introduction ends with an outline of the content and notions of the chapters following.

Digital Literacy

Digital literacy refers to familiarity with the issues listed above as well as to competence in the use of digital technology. However, it also entails an understanding of the language of digital media: letters, links, colors, shapes, sound, processing, and interaction—and behind all of these, code. With respect to digital media, "reading competence" means understanding the interplay of these elements. This requires us to decode technical effects and understand the meaning behind their interaction.

For scholars of literature, art, or any hermeneutic discipline, two principal strategies exist to analyze digital media. In the spirit of cultural studies, one approach focuses on the social context and consequences relating to how a work of digital art is produced and consumed: technology, authorship, copyright, distribution, and the digital divide, among other issues. Alternatively, and more in the spirit of a semiotic reading, the analysis is more formal and internally driven: attention is drawn to characteristics of digital language and to codes of meaning—of individual artifacts, and the technical effects within them—with the goal of learning how to read a digitally produced sign and how to understand a specific performance within a piece of digital literature. In this strategy, the codes of literature and the codes of technology converge toward a highly interesting nexus of relations, resulting in multiple, layered domains of signification that have rarely been fully explored simultaneously.

In their 2006 book *At the Edge of Art,* Joline Blais and Jon Ippolito distinguish between investigative art (that is, research), which is "typically understood only by subcultures dedicated to its creation and study," and established art (that is, genre), which is "accountable to the art-viewing public." They hold that "if research rewards expansive or associative thinking, genre rewards close reading. Successful research is interesting; successful genre is good" (241). In the last years, publications about digital art forms have made them known beyond an inner circle and have brought them into classrooms and exhibitions. Digital art, and its turn from research into genre, has long been valued as an attractive title for books, and it has its own entry in reference books, as in a Routledge reader on key concepts of cyberculture: "At its most basic, the term 'digital art' refers to the use of digital technology, such as computers, to produce or exhibit art forms, whether written, visual, aural—or, as is increasingly the case, in multimedial hybrid forms" (Bell et al. 2004, 59). To advance the field, it is important to move from highly generalized perspectives on new media

art and literature into detailed and specific readings that can account, in media-specific ways, for the practices, effects, and interpretations of important works.[2]

There are three reasons why it is still not easy to find assessments of aesthetic value in relation to concrete examples of digital arts. First is the preference for terminological and theoretical debate over close reading. This predisposition may originate in the fact that a highly generalized theoretical discussion enclosing well-known authors, texts, and perspectives entails less risk than undertaking close reading. A theory is a theory, and one may subscribe to it or not. In contrast, the interpretation of a concrete work may either be convincing or simply absurd. The real challenge and adventure of close reading is to undertake it without the safety net of prior assessment by other readers or more theoretically constrained readers. Second is a lack of faith in the significance of the subject. With regard to digital literature, and especially hyperfiction, Jan van Looy and Jan Baetens (2003) explain the lack of close reading by the absence of interesting works that would justify such critical attention. But such an explanation does not hold if we consider other genres of digital art that have generated fascinating and highly successful works.

Third may be a lack of faith in close reading itself. Such a position derives in part from the fact that the attention to aesthetics has often seemed to elevate the aesthetic connoisseur to an elite position above the less cultivated masses, to use terms associated with Bourdieu's (1987) notions of distinction and symbolic capital.[3] When in the 1980s New Criticism was challenged by New Historicism, this was a much-needed correction of the ahistoricism and disregard for political and social issues in the New Critics' readings as well as those inscribed within the canonized subjects to which their readings adhered. However, the attempt to understand literature in its cultural and political contexts need not imply any neglect of the aesthetic dimension of a cultural artifact. As Andreas Huyssen puts it, "In light of the fact that an aesthetic dimension shapes not just the high arts but also the products of consumer culture in terms of design, advertising, and the mobilization of affect and desire, it is retrograde to claim in left populist fashion that any concern with aesthetic form is inherently elitist" (2007, 201). As for the allegation of elitism: the postmodern hybridization of high and low culture does not abolish the distinction between readings that are high or low in terms of detail or sophistication. It would be entirely self-destructive and self-contradictory for academics to refuse to invest symbolic capital or to enable their students and readers

to produce such capital by carrying out refined analyses of a Madonna song or a blockbuster movie. The same conditions apply for digital art, which engages many aspects and features of pop culture.[4] The issue is not so much whether one looks at examples of high or low art, but whether one subjects these examples to critical readings that produce the results of allowing readers to consider the work in a more interesting, even enlightening, way.

In this book, I take up this challenge and perform close readings in the spirit and practice of hermeneutics and semiotics. I thus follow the agenda of the conference *Reading Digital Literature* I organized at Brown University in 2007 and the handbook I coedited in 2009, *Reading Moving Letters: Digital Literature in Research and Teaching,* in which scholars from different national academic environments articulate their conceptual approach to the study and teaching of digital literature and provide examples of close reading of a specific work of digital literature. Hence, the book presented here is different from the introductions to digital literacy or electracy cited above, as well as from the various existing surveys of digital arts.[5] It is also different from a book such as Matthew Kirschenbaum's 2008 *Mechanisms: New Media and the Forensic Imagination,* which reconnects the ideology of digital media to close reading by focusing on the forensic and formal materiality of artifacts in electronic environments.[6] In contrast to Kirschenbaum's close examination of the technological (forensic) "reality" behind the appearance of an artifact—which is first of all concerned with the storage, transformation, and application of software and can be seen in the tradition of bibliographical scrutiny—this book focuses on the screenic or auditory surfaces of the work, and on the readers' interactions with the work and with other readers. It is concerned with the technological aspects only as much as they clearly affect the appearance and meaning of the artwork.

Here, I carry out in-depth analyses of various examples from different genres of digital or new media art, including digital literature, interactive installation, mapping art, and information sculpture. I investigate the deeper meaning of words that not only form an image on the screen, but also react to the viewer's behavior; of nonsensical texts randomly generated by a computer program; of letters that rain down a screen onto a projection of the visitor's body; of words coming off the wall toward the reader in a virtual environment; of images being destroyed by the viewer's gaze; of silhouette movies recorded from the viewer's shadow on the screen; of text machines generating nonsense sentences out of a Kafka story; of a

light show above the center of Mexico City designed by Internet visitors from all over the world; of the transformation of statistics into visual art; of the presentation of text snippets from the Internet as an audiovisual sculpture.

The case studies of digital art that I offer in this book are presented as close readings, as a careful examination of the conceptual, artistic, and artisanal considerations via theoretical discussion that uses the philosophy of art and art history. I aim to achieve a deeper understanding of each particular example and the genre it represents, such as digital literature, concrete poetry, text machines, interactive installation, and mapping art. The discussion is focused on the specific pieces to be investigated rather than on a theory to be demonstrated or a method to be applied. Nonetheless, in the course of this endeavor, it will become clear to what extent current interpretive methods are useful in understanding digital art and to what extent new interpretative skills need to be developed.

Although the aim of this book is to critically discuss the genres of digital arts and to provide critical readings of several works, it does not intend to make explicit statements concerning the artistic value of the works discussed. The question of artistic value requires a general and systematic discussion of what art is or should be and can be answered in very different and contradictory ways. Finding one of the right ways is not my aim. Although I do not systematically engage in the discussion of what constitutes art—or, rather, good art—I do on occasion take a position on the different points of view and offer aesthetic judgments regarding specific works. However, in general, I prefer to demonstrate conceptual potentialities of the various works and leave it to the readers to judge their value by themselves. In a related manner, I do not limit my attention to works that show enough substance to render them worthy of more than passing interest; I also include analyses of works that may not appear to be particularly interesting, but that are nevertheless notable for historical reasons or because they permit understanding of the practice of digital art, its temptations, and its pitfalls.

Digital Hermeneutics

One could argue that traditional criteria cannot be applied in discussing new media artifacts and that digital arts require a completely new methodological approach. However, a theoretical discussion of digital arts is best grounded in a combination of new and old criteria. Genre theory, for

example, is still a valid analytical tool, along with well-established con-cepts such as story, plot, and character, which apply in computer games, interactive drama, and hyperfiction. Other concepts—allegory, isotopy, rhyme—as deployed in classical rhetoric need to be adapted to describe the stylistic devices of digital literature and art. For example, if in conven-tional literature allegory is understood as a narrative representation of ideas and principles by characters and events, in digital literature, this rep-resentation may be provided by the animation of words. Similarly, in the context of digital literature, the notion of rhyme may be extended beyond the repetition of identical or similar sounds in words to the repetition of identical or similar animation as a new way of creating paradigmatic rela-tionships between the elements of a kinetic text.

With the link—the primary characteristic of hypertext—as a new tool to arrange text segments, one must also develop an understanding of the semantics of the link and its contribution to the overall meaning of the text. But even here, the discussion may benefit from criteria established in traditional aesthetic discourse. If, for instance, poet-programmer Loss Pequeño Glazier claims that "writing an 'href' is writing" (2002, 103), one wonders how an HREF coding element ought to be treated in relation to the literary qualities of the generated text. In natural language, the differ-ence between marked and unmarked text language is based on the com-parison with the common, natural use of the language; undermining established rules and habits, be it vocabulary or syntax, makes a differ-ence and may constitute "the literary." By analogy to natural language (but in a certain way also to music or painting), the less ordinary, less expected link would most represent the literary. Such approach to literary texts naturally disqualifies linking between identical or similar words or provid-ing an explanation of the word linked, which in nonfictive HREF writing is commonly used and is entirely in accordance with the principles of usability. Against the general grammatical rules of hypermedia discourse, the incongruous, seemingly irrelevant link is likely to be considered inap-propriate rather than being identified as a poetic element: our sense of the literary collides and contrasts with media literacy. Another stylistic aspect of HREF writing is the number and prominence of links that connect a text segment—lexia or node—within the net of a hypertext. A node hardly linked and therefore hardly present functions like the narrative trope of dramatic irony, containing a message not accessible to every reader. Be-cause this message is not hidden in sophisticated allusions, intertextual references, or complicated reasoning but simply in the labyrinth that a

hyperfiction represents, the narrative trope is no longer based on readers' education and sophistication but on their persistence or luck in clicking through the nodes of a hypertext. The readers' deeper understanding is an effect of their contact with text on the surface of its mere appearance, which is itself an ironic take on the concept of irony.[7]

The same attention needs to be paid to the digital image, the visual symbolism of which is every bit as important to its deeper meaning as the specific effect the code or user interaction has on the surface. Moreover, if an interactive installation applies textual or visual metaphors and symbols that are established in contemporary culture—such as the shadow in *Deep Walls* (2003) and the light show in *Vectorial Elevation* (1999/2000)—one ought also to investigate how their connotations influence the meaning of the work. Because the trademark of such an installation is interaction, it is necessary to physically enter the interaction with the result of a complex interplay of physiological and psychological functions during the receptive process. This does not, as some scholars would have us believe, invalidate the Cartesian paradigm that focuses on cognition and neglects sensual aspects in experiencing reality. New media theory is right to stress the central role of the users' physical engagement in interactive art, in contrast to the mere cognitive engagement in perceiving a painting, sculpture, or text. However, besides the physical engagement, it is still possible, even crucial, to approach the work from a hermeneutic perspective. It is mandatory not only to understand the operational rules of the piece or the "grammar of interaction"—that is, the modus of interaction the artist made possible within the interactive environment—but also to reflect on its specific symbolic (Fujihata 2001). The physical interaction should not overwrite the cognitive interaction with the work but rather become part of it.

The hermeneutic to be developed is one of the hidden text in a literal and metaphorical sense. The text is literally hidden as code behind the interface.[8] "The Code Is Not the Text (Unless It Is the Text)" reads the title of a 2004 essay by John Cayley, meaning that code is only text insofar as it appears as text but not if it generates text and its behavior.[9] Cayley applies a narrower concept of text to point out the essential differences between writing code and writing literature. The use of the broader concepts of text and writing that have come into use in the discourse of semiotic code is text even when it is not the text on the screen. This hidden text can affect the text that is seen: it can substitute words with others, create different links between words, or turn the text from an object to an event through animation and temporalization. This impact demands that we

read not only the words, but also what happens to them. If we use the broader semiotic concept of text, the same is true for the substitution, linking, and "eventilization" (Hayles 2006, 182) of visual objects or sculptures and for the grammar of interaction. The text metaphorically hidden in these manifestations is the text between the "lines," the connotation of a linguistic, visual, sonic, or performative element. The hermeneutic to be developed is located at the intersection between formal analysis and interpretation. One has to examine the formal structure of a given artifact—its elements, interface, and grammar of interaction. One also has to discuss what the presented components and factors represent, or rather how they may be perceived by the audience.

The interpretation to be undertaken is located at the intersection between the different semiotic languages applied. Whereas linguistic signs are divisible into distinct units, each meaningful on its own, a visual sign only gains meaning by shaping with other visual segments to a representative whole. However, although visual signs often have established specific meaning—the red color of a dress is connoted as much as the specific place of a person on the canvas—the various actions and interactions triggered by code are by and large unconnoted. Ken Feingold's *JCJ-Junkman* (1995/96), an interactive work programmed so that the interactor is unable to click on a sequence of images and thus trigger certain reactions, can most likely be interpreted as telling us that "we have no way of controlling the flow of datatrash" (Huhtamo 1996, 50). More open to various views is Bill Seaman's interactive video-sound installation *Exchange Fields* (2000), in which interactors have to immobilize a specific part of their body to trigger prerecorded video clips of a dance focusing on that particular body part. The necessary immobilization can be read as a symbolic substitution of the user's body by the projection of a foreign body on the screen, which may be linked to a criticism of the representation of the body in mass media society. The delay with which the program presents the corresponding video clips seems to underline the fact of replacement, although, as Seaman explains, it was actually not intended, which raises another central issue of digital hermeneutics.

In digital art, the demands or constraints of technology may give rise to unintended situations and signals with no connection to the work's significance. A specific feature may actually be a bug the artist was not able to fix, or it may be there for other nonaesthetic reasons.[10] In computer games, for example, the scenery is sometimes submerged in fog. In a movie,

painting, or book, this would be appropriately understood as the expression of a certain atmosphere or mode of perception. This is principally also true in 3-D graphics, where *fog* is a technical term defined as a rendering technique used to simulate atmospheric effects such as haze, fog, and smog by fading object colors to a background color on the basis of distance from the viewer. However, in computer games, fog—that is, allowing the presentation of objects in a blurry way—may also simply serve the function of saving memory capacity to speed up the game. Fog need not be a metaphor; it can also be a technical requirement. Its meaning differs depending on the medium.

The same is true for the design of text in an interactive drama such as *Façade* (2005). Michael Mateas and Andrew Stern, the authors of this piece, describe various ways to reduce the number of variations to be written for different player inputs and game developments:

> Previously, we set the design goal that each beat goal will be written with dialogue variations for each combination of tension level (low or medium) and each player affinity value (neutral, siding-with-Grace, siding-with-Trip), for a total of $2 \times 3 = 6$ variations. However, some of these contexts are similar enough that they can be collapsed together. Specifically, in the case of a beat about Trip suggesting drinks to the player, as authors we could imagine that Trip would act with similar levels of braggadocio if he has affinity with the player, or if the affinity is neutral, while acting differently if Grace has affinity with the player. . . . Each of these simplifications removes a context from the list, reducing the total to four, thereby reducing the burden for Fight-OverFixingDrinks by 33%.[11]

Mateas and Stern are certainly right, although they say "similar" when they actually have Trip using the same dialogue variation in both cases. The difference may be negligible. However, it is a loss of subtlety resulting from an interest in limiting the text variations. Another example is the design of the dialogue sequences:

> As described previously, each beat goal should have dialogue variation used, in case the beat goal was interrupted by a mix-in and needs to be repeated. However, we can eliminate the need for repeat dialogue for a beat goal if we write the beat goal's dialogue to quickly communicate the gist of its meaning in its first few seconds and annotate those first few seconds as *uninterruptible*. That is, if the player speaks during the first few seconds of such a beat goal, Grace and Trip's response is delayed until the beat goal's

gist point is reached—a delay in reaction of a few seconds, which is just barely acceptable for believability. If the gist of the beat goal's meaning is communicated in those few seconds, we can interrupt the beat goal in order to perform a mix-in response to the interruption, and not bother repeating the interrupted beat goal later. This requires writing dialogue such that the minimum amount of content required for the beat's narrative progression to make sense is communicated close to the beginning of the beat goal, with the rest of the dialogue within the beat goal adding richness, color, and additional detail to the basic content.[12]

The personalities of the characters—reacting to the player only after a long delay; giving the gist right away instead of working toward it—are not necessarily a choice of the authors; they are a requirement to keep the interaction plausible despite the technological challenge. As Mateas and Stern (2007) note, "By design, Trip and Grace are *self-absorbed,* allowing them to occasionally believably ignore unrecognized or unhandleable player actions" (207). What in a traditional text would reveal something about the characters in the story in this context instead points to certain characteristics of the underlying technology. A digital hermeneutics has to take into account the possibility of such technological determinism.

In the culture of remix and appropriation, it is also sometimes unclear what constitutes the artwork. In the installation *Text Rain* (1999) by Camille Utterback and Romy Achituv, viewers interact through their silhouettes, with letters falling downward on a screen landing on anything darker than a certain threshold. Does one need to read the poem from which the falling letters are taken before or after engaging with them? To what extent is Kafka's story "Great Wall of China" part of Simon Biggs's text generator *Great Wall of China* (1996), which creates nonsensical sentences out of the Kafka text? Does the knowledge of the story help understand the generator? One can argue that people are able to engage with the falling letters regardless of the poem used: James Joyce's *Ulysses* has its own autonomous life even without allusion to Homer's *Odyssey*. However, I hold that a major part of the meaning of the installation, generator, or novel is lost if its textual reference is neglected.

Whatever one thinks about the role the conventional text used in a digital artwork should play in the interpretation of this work, with contemporary art criticism, it is possible that the artists themselves want to decide the question. The example of *Text Rain,* however, shows that even the artist is sometimes unsure: although Utterback and Achituv stressed

that the choice of the text was not accidental, she abandoned the original text in a later version.

Beyond Interpretation

Before developing and putting into practice this paradigm of digital hermeneutics, we might consider the question of whether critics really should engage with the artwork on a hermeneutic level or feel it their mission to persuade their readers to do so. There have been arguments made in the humanities criticizing the exclusive role of hermeneutics and semiotics in Western culture, and these may be especially pertinent to art in digital media and hence should be briefly recapitulated here.

Such arguments had been brought forward in the wake of the linguistic turn in the 1960s in which every phenomenon—be it a book, performance, commercial, car, or everyday life situation—had been declared a text that can be read to understand its deeper meaning. Such a perspective was based on the postulation that each artifact, and especially the work of art, is itself its own content and that the work of art by definition says something. Susan Sontag, in her 1964 essay "Against Interpretation," described this "overemphasis on the idea of content" as "philistinism of interpretation" that "tames the work of art"—which otherwise would make us anxious—by reducing it to analyzable and understandable content (1966, 5, 8). Writing in the heyday of New Criticism and psychoanalytic and Marxist analyses, Sontag states, "In a culture whose already classical dilemma is the hypertrophy of the intellect at the expense of energy and sensual capability, interpretation is the revenge of the intellect upon art. Even more. It is the revenge of the intellect upon the world. To interpret is to impoverish, to deplete the world—in order to set up a shadow world of 'meanings'" (7).

An example Sontag gives of depletion by interpretation is the tank rumbling down the empty street at night in Ingmar Bergman's 1963 film *The Silence:* "Taken as a brute object, as an immediate sensory equivalent for the mysterious abrupt armored happenings going on inside the hotel, that sequence with the tank is the most striking moment in the film," Sontag states. However, those who reach for a Freudian interpretation and read the tank as a phallic symbol "are only expressing their lack of response to what is there on the screen" (Sontag 1966, 10). As Sontag states, criticism should "show *how it is what is,* even *that it is what it is,* rather than to show *what it means.*" She concludes, "What is important now is to recover our

senses" and ends her essay with the famous provocation: "In place of a hermeneutics we need an erotics of art" (14).

The revolt against interpretation found its own playground in performance art and performance studies where the body of the actor was no longer reduced to a mere carrier of meaning, the semiotic body, but understood in its own materiality, as the phenomenal body. In *The Transformative Power of Performance* (2008), Erika Fischer-Lichte diagnoses a general performative turn in the aesthetics of the early 1960s, the inception of which she dates back to the turn from the nineteenth to the twentieth century.[13] This turn from text to performance shifts the focus from hermeneutics and semiotics to materiality and event. Much as for Sontag, a tank first of all was a tank rather than a phallic symbol; for Fischer-Lichte, the body of the actor or performer presented his or her bodily being in the world and was not (primarily) to be interpreted as a sign for a particular meaning. Hence, performance art was conceptualized in contrast to theater, which was understood as committed to representation, narrativity and meaning rather than presence, event, and the free flow of energy and desire. When Josette Féral notes, in her 1982 essay "Performance and Theatricality: The Subject Demystified," that performance aims to undo competencies that are primarily theatrical, this is also true for the competence of interpretation; the absence of narrativity "leads to a certain frustration on the part of the spectator. . . . For there is nothing to say about performance, nothing to tell yourself, nothing to grasp, project, introject, except for flows, networks and systems" (2003, 215). This "aesthetics of frustration" has been described as replacement of the "solitary authority of the symbolic with the polyphonous circulation of human feeling." The performing body, as phenomenal body, offers "resistance to the symbolic, which attempts to limit the meanings of action and the body, to channel the flows of desire" (Martin 1990, 175–76). These words about the symbolic channeling of the flow of desire remind us of Sontag's words about interpretation as taming the work of art and emphasize the sense that the performative turn is also a turn against interpretation. Moreover, as has been pointed out, it is also an effective response to the postmodern experience, which deconstructs the symbolic and emphasizes play, process, and experience (Kaye 1994). The link between the suspension of interpretation, performativity, and postmodernism has been established not the least by the scholar who first thoroughly described the postmodern condition.

In 1976 in his essay "The Tooth, the Palm" *(La dent, la main)*, Jean-François Lyotard presented his idea of the "energetic theater," in which the gesture of the body is liberated from the duty of signifying; thus the clinched fist no longer represents the pain caused by toothache but stands on its own. Lyotard saw the sensual perception of energy transmitted by an artifact in its entire presence, as pure intensity, without turning it into a sign subject to hermeneutic or semiotic analysis. The "business of an energetic theater," he notes, "is not to make allusion to the aching tooth when a clinched fist is the point, nor the reverse." The tooth and the palm no longer have a relationship of signifier and signified; they "no longer mean anything, they are forces, intensities, present affects" (2003, 30). To relate Lyotard to Sontag, one should notice the fist without the tooth as one should think of the tank without the phallus. In his essays on Barnett Newman, the sublime, and the avant-garde, Lyotard speaks of the sublime fact *that* something happens *(quod)* abstaining from the question *what* it means *(quid),* thus shifting attention from the significance to the presence of objects. This is in line with the shift from content to form, from intellect to the senses, promoted in Sontag's "Against Interpretation."

Shortly after Lyotard's essays appeared, Michel Serres published *Les cinq sens. Philosophie des corps mêlés* (1985), a resolute protest against the linguistic dominion of perception, promoting a nonverbal paradise in which the body is redeemed as an essential part of our relationship to reality. Here again the paradigm of interpretation is left behind in favor of a more sensual perception. Jean-Luc Nancy, in *Corpus* (1992), demands that the mind–body antagonism be overcome, and Georges Didi-Huberman, in *Confronting Images: Questioning the Ends of a Certain History of Art* (2005; French-language version 1990), insists against the "science of iconology" developed by Erwin Panofsky on the unintelligible forms of images resisting rational understanding.[14]

In Germany, literary scholars, philosophers, and media theorists such as Hans Ulrich Gumbrecht, Dieter Mersch, and Martin Seel promote ideas leading in the same direction. In *Production of Presence: What Meaning Cannot Convey* (2004), Gumbrecht reaffirms his interest in the material aspects of an artwork, which dates back to 1988 when he coedited the anthology *Materialities of Communication* (English-language version 1994). The title of his essay in this anthology, "A Farewell to Interpretation," is already allied with Sontag's critique of interpretation. In the same spirit, Gumbrecht states, "We should try to reestablish our contact with the things of the world outside the subject/object paradigm (or in a modified

version of it) and by avoiding interpretation—without even criticizing the highly sophisticated and highly self-reflexive art of interpretation that the humanities have long established" (2004, 56). Gumbrecht sees his position as in line with other condemnations of the paradigm of interpretation, such as Sontag's famous 1964 essay, George Steiner's 1986 *Real Presence,* Jean-Luc Nancy's 1993 *The Birth to Presence,* and Martin Seel's 2005 *Aesthetics of Appearing* (German-language version 2003).[15] His farewell to interpretation endorses a similar shift from the *what* to the *that* that Lyotard promotes in his aesthetics. Gumbrecht distinguishes between a culture of meaning and a culture of presence, attributing the latter with the aspects of sensuality and intensity. In opposition to the attempt of interpreting an artifact—and thus taming it—he advocates a sensual connection to the world. As an example of the tension between presence and meaning, body and mind, Gumbrecht refers to the "convention in Argentinian culture" not to dance to a tango that has lyrics: "The rationality behind this convention seems to be that, within a nonbalanced situation of simultaneity between meaning effects and presence effects, paying attention to the lyrics of a tango would make it very difficult to follow the rhythm of the music with one's body; and such divided attention would probably make it next to impossible that one let go, that one—quite literally—'let fall' one's body into the rhythm of this music" (2004, 108).[16]

The condemnation of hermeneutics and the focus on presence is also a part of Mersch's agenda. In his books *Was sich zeigt: Materialität, Präsenz, Ereignis* (2002a) and *Ereignis und Aura* (2002b), he aims to ground his aesthetics of the performative not on hermeneutics and semiotics but on event and the aura of materiality as an erratic and intractable disturbance to the symbolic (2002a, 19). In the spirit of Lyotard, Mersch praises the auratic experience of the *quod* of appearing: "das 'Daß' (quod) des Erscheinens" (2002b, 9).

Gumbrecht's concept of presence without rationalization may also be understood in relation to the concept of the "mere" or "atmospheric" appearance as described in Seel's *Aesthetic of Appearing*: "If we restrict ourselves completely to something's being sensuously present, it comes to perception in its *mere* appearing. As soon as the phenomenal presence of an object or a situation is grasped as the reflection of a life situation, *atmospheric* appearing comes to the fore in attentiveness" (2005, 90).[17] Insofar as Seel's book evokes attentiveness to how things and events appear momentarily and simultaneously to our senses, it can be seen as within the conceptual turn toward the presence of things and the materiality of

signs. However, Seel distinguishes among various modes of appearing: "Artworks differ in principle from other objects of appearing by virtue of their being *presentations [Darbietungen]*"; they are "constellational presentations" whose meaning is tied to intentional "nonsubstitutable rendering of their material" (95).[18] For their being "formations of an *articulating* appearing" (96), works of art are objects "not solely of *mere* appearing, nor just of *atmospheric* appearing, even though frequently they are *also* both" (95). They cannot be appreciated through exclusive concentration on mere and atmospheric appearing but require "an interpretative perception that allows a *different* appearing to emerge" (35). With this return to interpretation and meaning, Gumbrecht's reference to Seel becomes questionable, especially with respect to a more recent essay in which Seel (2007) defends hermeneutics against its "hasty farewell."

Despite this necessary differentiation, it is justified to speak of a certain trend in the German and international aesthetic discourse toward the concepts of presence, materiality, and event at the expense of interpretation and meaning. Although the scholars listed can be differentiated in their argumentations and references to art history, they all share more or less the common denominator of attentiveness to the appearance, presence, and materiality of artifacts. Gumbrecht (2005) himself suggests such an alliance when he calls the aesthetic put forward in Fischer-Lichte's study *Transformative Power of Performance* the "philosophy of a new aesthetic sensibility" liberated from hermeneutics and semiotics, an "aesthetics for the present time" valid not only in the field of performance but also with respect to poetry or painting (18).[19]

Although digital media are rarely considered in such theories and aesthetics that lead beyond hermeneutics, they seem to support the case perfectly. When Sontag states, "We must learn to *see* more, to *hear* more, to *feel* more" (1966, 14), one cannot help but think of interactive installations that stress the intensity of the personal experience in the moment of immersion. Because their experience is provided not by vision alone— nor even primarily by vision but also by the other bodily senses—they seem to undermine the "eye-minded, rational world view," which is significant for the "empire of the signs," and pave the way to the "empire of the senses," to use the language of David Howes (2005a, 4). Obviously, the historical debates over performance art already related to many important aspects of interactive installation—the shift from art object to art experience, representation to presence, meaning to event, as well as the blurring

of the distinctions between artist and audience, body and mind, art and life. Hence, it is logical that Philip Auslander's 2003 edited collection, *Performance: Critical Concepts in Literary and Cultural Studies,* ends with an article on interactive art from 1997: David Z. Saltz's "The Art of Interaction: Interactivity, Performativity, and Computers."

However, the particular mode of experience that performance provokes is not simply handed over to interactive installation art. Here, the role of the body changes fundamentally: the performer's body is "outsourced" to the audience. Much interactive art engages the entire body, often making the body itself the ground of immersive participation. Thus, the shift from the semiotic to the phenomenal body is not experienced any longer within an aesthetic of *frustration,* to use Féral's wording, but an aesthetic of *play.* The aim of this play is to connect with one's own body, experiencing it in a new way. I will argue that this does not prevent us from—and even should lead toward—reflecting on one's own body as a semiotic body.

But not only works that require the physical interaction of the audience are an important genre for the culture of presence in the digital realm. The same is true for the products of what Lev Manovich calls Generation Flash (2002a). Gumbrecht refers to the "*'special effects'* produced today by the most advanced communication technologies" as possibly "instrumental in reawakening a desire for presence" (2004, xv). Although he does not further explain this notion, it suggests that such effects often do not convey any meaning but only intend to present themselves. Andrew Darley, in his 2000 book *Visual Digital Culture: Surface Play and Spectacle in New Media Genres,* notes the prevalence of technique over content and meaning in contemporary culture and speaks of a "culture of the depthless image," a "fascination with the materiality and mechanics (artifice) of the image itself" (2000, 192, 114). Darley sees a shift from symbolic concerns to intensities of direct sensual stimulation (3), which reminds us of the ideas of Sontag, Lyotard, and Gumbrecht. It is a shift from the image for reflection to the image for consumption (or interaction).

Darley comes to his conclusion by analyzing movies, MTV, and computer games. In chapter 2, I argue that similar observations can be made in the field of digital concrete poetry and what Manovich calls flash aesthetics. An example of the fascination with the image as image is Mark Napier's *P-Soup* (2003), a blank canvas with its own palette bar of color icons each carrying its own pigment, visual pattern, and tone. After clicking on one of the icons, the "canvas" can be altered by the touch of the mouse; successive clicks on the icons apply different shapes and colors to

the surface, producing chords of interlaced visuality and timbre. The result is a hypnotic and captivating ensemble of nonfigurative visuals and minimalistic sonic patterns that lulls the viewer into a trancelike state. The piece represents the fascination with the image as image and the direct sensual stimulation Darley notes in contemporary culture. It seems not to aim at any deeper meaning beyond technical effect and allows the artwork to be enjoyed on the level of visual and acoustic stimulation without the request for interpretation.[20]

With respect to the "pure visual" in avant-garde painting and film—which does not represent any real object or idea but simply presents itself as visual artifact[21]—such effects for effects' sake in digital media can be described as pure code—that is, code that aims at its manifestation on the screen or scene without the intention to convey any meaning or message other than the ability to generate such a manifestation. In contrast to painting or poetry, in digital media, the basic material (code) is always represented by its manifestation on the screen or scene (text, visual object, sound, process, interaction). Each action that has no other message than its own sheer presence (pure effect) therefore still refers to the code by which it is generated. This narcissistic code, only interested in its own manifestation as action, I call *pure code*.

The fact that in digital media everything is coded and computed has also led to the proclamation that digital spaces represent a strong desire for control over the messiness of bodies and unruliness of the physical world.[22] The problem with this approach is its restriction to technology *behind* the interface. The "neo-Cartesians" (Munster 2006, 2) concentrate on only one aspect of the features of the code (its exact calculation) while neglecting the other (its appearance in various forms, its reaction to user input). However, the execution of the code, its materialization as text, sound, image, and action on the screen or scene, results in new kinds of embodied experiences and experiences of one's own body. In such experiences, the code may watch the body and react to its action, as is the case in closed-circuit installations where the physical action of the interactor alters the acoustic information sent from the system, as in David Rokeby's *Very Nervous System* (1986–90). The code may document the body's action, as is the case in Scott Snibbe's *Deep Walls,* where a camera records the viewer's movement in front of the screen and adds the result to the movies shown in the sixteen small rectangles into which the screen is divided. However, in both cases, as in many others, the situation prompts visitors to experiment with their body, staging a certain role for the movie or moving

in an eccentric way to create bizarre sound. Instead of aiming at control over the messiness of bodies, such interactive installations entice their audience to produce a (grotesque) body unlike that of everyday life. They lure their audience into an "energetic connection of the body with, and in, the world" (Ridgeway and Stern 2008, 133) in accord with the promotion of sensuality in the theories mentioned above. Such installations do not at all carry out the control over the messiness of bodies. Do they embody the shift from the culture of meaning to the culture of presence? Do they take the step beyond hermeneutics?

In *Very Nervous System* and *Deep Walls*, visitors first have to find out how the piece functions. They then may move on to the question, "What does it mean?" Because the grammar of interaction has been carefully coded and is rarely the result of chance (as in other "works of presence," such as Jackson Pollock's drip paintings and John Cage's chance projects), one may ask the reason why it was coded this way, which is not to address the specific issues of programming (that is, alternatives to program the same effect in a different, more robust, more elegant way) but the intention behind it. The aim is not just to understand the grammar of interaction but also to interpret it. While Rokeby's work apparently does not suggest any deeper meaning, we will see that these "systems of inexact control," as Rokeby calls them, actually carry a philosophical agenda. Snibbe's work, on the other hand, embeds the physical interaction in a couple of apparent symbols (the shadow taken from the visitors, the erasure of each documentation after sixteen new recordings) and provides a narrative that allows (and requests) interpretation.

However, undertaking an interpretation would undermine the paradigm of presence and suggest a shift from embracing the presented object or situation to analyzing what it represents. It would drain the energy of the material into a semiotic system. It would not only signify a shift from the body to the mind but also from letting go of control. The hermeneutic approach to the world aims at taming the other, alienating, disturbing (as Sontag stated), or channeling the flows of desire (as Martin put it with respect to the performing body). In his 1973 essay "La peinture comme dispositif libidinal," Lyotard notes that the energy encountered in an artifact will make a noble man dance, while a bad *(occidental)* person will start to talk. As Gumbrecht would say, one should dance the tango and not think about the text.

Interactive installations, including *Very Nervous System, Deep Walls,*

and *Text Rain*, provide many occasions to dance, and dancing—embracing reality—could indeed be considered the adequate reaction in postmodern, postideological, and postmetaphysical times. When the notion of universal truth and values has been eroded and global multiculturalism confronts us with different ways of life and points of view, dancing seems better equipped than talking to foster the acceptance of dissent. The culture of presence is, as its proponents occasionally state, a culture of affirmation.[23] It is an affirmation of life, "not an attempt to bring order out of chaos nor to suggest improvements in creation, but simply a way of waking up to the very life we're living," to borrow John Cage's explanation of the purpose behind the purposelessness of chance art (1966, 12). There is a natural attraction between the aesthetics of intensities and chance art that manifests in Lyotard's many references to Cage.[24] There is also a structural similarity between chance art and interactive art, which Rokeby, discussing "Art Context" (1996), has pointed out when considering the diminished role of the artist in the process of creation.[25] Interactive art, one could conclude, and aleatoric text generation share the life-affirming characteristics of chance art. However, three remarks need to be made here.

First, the audience's participation in the composition of the artwork does not automatically imply the author's evasion of conceptualizing the work and providing it with a specific message. The discussion in chapter 4 will show that in interactive art, authors can also take up a dominant position and design the grammar of interaction in a way that serves the message they want to convey. To this extent, interactive art is not necessarily the affirmation of life and reality the way it is, without any objection or idea of how life and reality could be improved.

Second, it is debatable to what extent, in a world of global multiculturalism, dancing is really a better solution than talking. The denial of interpretation does not necessarily undermine the desire for control, and the affirmation of presence does not guarantee the openness to different, oppositional positions. The desire for control that has been seen behind the purpose of interpretation cannot be challenged by avoiding hermeneutics but only through undoing hermeneutics by hermeneutics—that is, through destabilizing every attempt at making sense by another one. Only if one remains within the interpretive enterprise can one experience the relativity, uncertainty, and infinity of signification. In his 1997 book *Beyond Interpretation: The Meaning of Hermeneutics for Philosophy,* Gianni Vattimo speaks of a "nihilistic vocation of hermeneutics"—the title of the

first chapter—and argues that the ethics of hermeneutics, which means to correspond to the epoch of the end of metaphysics, is distinguished "by the dissolution of the principle of reality into the Babel of interpretations" and "indelibly by the dissolution of fundamentalism of every kind" (39). The nihilistic vocation of hermeneutics is to "reveal the world as a conflict of interpretations" with crucial ethical consequences: "Thinking that no longer understands itself as the recognition and acceptance of an objective authoritarian foundation will develop a new sense of responsibility as ready and able, literally, to respond to others whom, insofar as it is not founded on the eternal structure of Being, it knows to be its 'provenance'" (40).[26] Art, with its specific language of ambiguity, is the perfect provider of such experience, as Christoph Menke points out in his 1999 book *The Sovereignty of Art: Aesthetic Negativity in Adorno and Derrida*. For precisely this reason, Menke takes issue with Lyotard's theory of "asemantic effects" and his concept of the artwork as "an epiphany of an unarticulatable meaning" and distances himself from a perspective on art that promotes the embrace of "pure, meaningless materiality": the "discernment of the vacillation of aesthetic signifiers stands in contrast with an unmediated rehabilitation of the material determinations of aesthetic objects, as proclaimed, for instance, in Lyotard's model of an affirmative aesthetics" (153, 270, 45–46). In this light, one is well advised to stick to the paradigm of interpretation when approaching digital art. Digital literacy, as described above, can only be developed within the paradigm of interpretation. The same is true, one may add, for the particular social literacies needed for global multiculturalism. The hermeneutic venture is political, whatever the subject of the work at hand might be.[27]

Finally, there is another reason why one should maintain the practice of interpretation and reflection and postpone the switch from the empire of signs to the empire of the senses. In "Hyperesthesia, or The Sensual Logic of Late Capitalism," Howes (2005b) gives a telling and disturbing account of the sensory stimulations in the contemporary society of consumption. Consumer capitalism engages as many senses as possible to distinguish a product and seduce the consumer. Thus companies odorize their sewing thread with floral fragrance, grocery stores pipe bakery smells into the aisles, and slot machines are scented with chocolate. Sound, scent, and form are used to please the customer with a product or in the act of shopping. The keyword for such sensualization is *experience economy*.[28] The aim is an emotional association with the product. Even though the emphasis on sensations does not need to entail a loss of critical awareness, in light

of such developments, one becomes suspicious with respect to the proposed shift from the empire of signs to the empire of senses. Interactive art is undoubtedly distinct from product marketing and consumption. Both represent two fairly diverse systems in society, but the borders between art and business are blurring in many regards. Both are part of contemporary culture. As much as one should not overrate the importance of art in society, one should not underestimate its role as a field where crucial issues such as consumption, reflection, critical distance, and affirmative embrace are negotiated and practiced.

This short discussion about the role of hermeneutics and the sensual in Western society and academia intends to link digital art to a broader cultural debate. The valid message of Sontag, Lyotard, and Gumbrecht is that one should not resist the physical and aesthetic pleasure of an artwork, thus reducing its energy, vitality, and expressiveness to a particular proposition. However, although art must not be reduced to ideas, one also should not avoid ideas when talking about art. Although attention should be paid to the sensual aspect of objects, it should also be paid to their possible deeper meaning. To understand the tank as phallus is only inadmissible if it fails to tolerate any other reading. In postmodern times, interpretation is no longer about control or truth. It is not about solving the puzzle of meaning that a work of art represents. It is about suggesting, playing with ideas, reflecting, and sharing thoughts and feelings triggered by interaction with the artwork. Hermeneutics can be considered "a metatheory of the play of interpretations" (Vattimo 1997, 9). No single interpretation should be the end of this process, but there should also be no end to interpretation. To be more specific: after finding out how to engage with the letters in *Text Rain,* and after enjoying the interaction with the letters and other visitors, one ought to contemplate for a moment what it means to engage with letters in such a postalphabetic way—by depriving letters of their linguistic value—and whether one should go and read the poem used.

It is obvious that Sontag's railing against interpretation was not meant to stop others, nor herself, from interpreting. Her critique was an objection in a specific time, when critics constrained art to a particular message often combined with a moral stance. It is unlikely that she would repeat her attack on hermeneutics today. In her 1964 essay, she wrote that interpretation is not an absolute value but must itself be evaluated within a historical view of human consciousness: "In some cultural contexts, interpretation is a liberating act. It is a means of revising, of transvaluing,

of escaping the dead past. In other cultural contexts, it is reactionary, impertinent, cowardly, stifling" (1966, 7). One may wonder whether today's society of the spectacle, with its "shift away from prior modes of spectator experience based on symbolic concerns (and 'interpretative models') towards recipients who are seeking intensities of direct sensual stimulation" (Darley 2000, 3), represents a cultural context in which interpretation is again liberating, elucidating, and necessary. I think it is, and hence my approach to the various examples of digital art not only describes what it is and how it works, but also asks what it could mean. In another essay, "On Style," which appeared a year after "Against Interpretation," Sontag declares an artwork is an experience, not a statement: "Art is not only about something; it is something" (1966, 21).[29] Considering the importance of the visitor's (emotional) cooperation with the artwork, Sontag critically states, "One may see what is 'said' but remain unmoved" (22). This notion ought to be completed: One also may be unmoved before one understands what is said. Thus, the interaction with the letters in *Text Rain* is neat but remains intellectually uninspiring until it becomes clear that this interaction paraphrases the poem used. The recording of the user's movement in *Deep Walls* is fun but becomes intellectually stimulating and emotionally affecting once one considers the fact that the archive is erased after sixteen new films. There is a lot one misses about the tango if one never listens to the lyrics.

Reading Digital Arts

Some experts on digital culture and art see digital (or "virtual") art as leading to the humanization of technology. Frank Popper, for instance, underlines the emphasis on interactivity and bodily experience in virtual art, stating that consequently this art "can even play an ethical role in the present development of globalization by stressing human factors more than any other previous art form" (2007, 3).[30] A less enthusiastic perspective may focus on the fact that within digital culture and art technology comes to cannibalize language. Such cannibalization happens as replacement of text through images, sound, and action but also by rendering text in an asemantic way. What exactly that means and what possible reason it has is explored in the first two chapters. Chapter 1 takes up terminological questions related to the role of text and discusses the characteristics of digital literature, the distinction between digital literature and digital art, and the role of the author when the text is produced by a reader, a

machine, or bacteria. The discussion is combined with the case studies of *Text Rain* by Camille Utterback and Romy Achituv, *The Child* (1999) by Alex Gopher and Antoine Bardou-Jacquet, *Genesis* (1999) by Eduardo Kac, and *Screen* (2004) by Noah Wardrip-Fruin. Chapter 2 explores the shifted role of text with respect to concrete poetry in print and digital media. Besides the general aesthetic and philosophical concepts behind the genre of concrete poetry, I discuss the connection between software art, mannerism, postmodernism, Generation Flash, and the aesthetics of the spectacle, and I compare the culture of the depthless image in the digital age to the pure painting of the avant-garde art of the preceding century. The case study of David Small's *Illuminated Manuscript* (2002) reveals the potentially deeper significance behind technical effects seemingly produced for effect's sake.

Digital technology has been described as the embodiment of contemporary critical theory and was praised for its liberation of the reader from the dominance of the author. Chapter 3 takes a closer look at the oft-proclaimed death of the author and argues that this claim was based on misinterpretation of the critical theory referred to, and that the proclaimed reallocation of power from author to reader marks a betrayal of the discourse theory rather than its practical illustration. The radical disempowerment of the author occurs in the case of text generators. The chapter investigates the quality of such machinic authorship and discusses how avant-garde automated text generation really is. The case study of Simon Biggs's text generator *Great Wall of China,* which relies on the words of a Kafka story, demonstrates the importance of the text used as the generator's database for the meaning of the generator. The real authorization of the reader takes place in projects of collaborative writing, which is finally explored with the conclusion that instead of the death of the author, one may rather declare the death of the reader.

For many theorists and practitioners, interactivity is the sine qua non in digital media and the inevitable feature of digital art. It is assumed that the shift from the former passive perception (in the case of painting, music, film, and literature) to active perception (with the audience taking part in the creation of the work) signifies a process of democratization and over-coming of the paradigm of mass culture. Chapter 4 discusses the short-comings in such understanding of interactivity. It ponders what kind of interactivity existed in art before interactive art and whether interactive art has repressed that kind of nonphysical interactivity. Other important questions regarding interactive or participatory art are addressed. How much control do artists retain over the message of their artworks? What

roles do body and mind, distance and immersion, and the grammar of interaction play in this art? Finally, the chapter explores what chances the logocentric Cartesian paradigm has to survive in an interactive environment. The case studies around which these question are raised include *Exchange Fields* (2000) by Bill Seamn, *Der Zerseher* (1992) by Joachim Sauter and Dirk Lüsebrink, *Deep Walls* (2003) by Scott Snibbe, and *Vectorial Elevation* (1999) by Rafael Lozano-Hemmer.

The transformation of data from one form into another is a feature of digital media; for Lev Manovich (2001), transformation is the distinguishing feature of work in digital media. Mapping art that is based on such transformation can therefore be considered a genuine form of digital art. However, databases and mapping are also symbolic forms in contemporary art and culture, reacting to metaphysical disorientation and voiding the grand narratives in postmodern times with a gesture of absolute control over data of all kinds. Chapter 5 examines the connection of mapping to ready-mades, photography, and science. It discusses the role of the artist's personal perspective and creation in this form of expression and considers mapping art as the modern equivalent of naturalism in late nineteenth-century literature. The discussion focuses especially on *Making Visible the Invisible* (2005) by George Legrady et al., *Black and White* (2002) by Mark Napier, and *They Rule* (2001) by Josh On & Futurefarmers.

Chapter 6 focuses on a single work: the real-time, transmedial installation *Listening Post* (2000–2001) by Mark Hansen and Ben Rubin. This artwork transforms incoming streams of text data from chat room conversations into an audiovisual sculpture. The chapter discusses the project's connotation by critics, its relationship to the history of literature, and its symbolic within the history of digital media. Questions raised are how this presentation of Internet data is a reflection of contemporary society and to what extent visitors of *Listening Post* become readers and coauthors of the text snippets. The discussion reveals that this installation changes from linguistic to visual art if the audience walks away from it. These steps in space are also understood as a journey along the history of the human experience of digital media. Given the text's dissolution into sound and images, *Listening Post* is another example of the cannibalization of language, which becomes even more obvious when extending the analysis to Paul DeMarinis's installation *The Messenger* (1998 / 2005), which represents the incoming text in such bizarre output devices as washbasins, skeletons, and electrolytic jars.

The epilogue takes up once more the problem of meaning as raised in

Sontag's essay "Against Interpretation" and in relation to aesthetic theories of presence and event. With reference to Roland Barthes's *Criticism and Truth* (1966) as well as to Friedrich Schleiermacher's concept of hermeneutics, the epilogue endorses a narcissistic erotics of interpretation and considers ironic and multiple-perspective readings as appropriate modalities of criticism. Because digital art is coded art, the question arises as to what extent critics need to be familiar with coding. The general and obvious requirement that they should know the language of their subject is addressed by the question of how the specificities of the code, including anticipated close readings by specialist critics of software itself, might affect close readings produced from a complementary humanities perspective and how an understanding of art based on the paradigm of programming alters the experience of art as such. Finally, the epilogue tackles the issue of digital art and the avant-garde. It examines an example that seems to mock and undermine the classical avant-garde, the Mondrian machine, replacing the artist with the programmer. The epilogue concludes that digital art may be considered avant-garde in both Greenberg's and Bürger's conceptions. The happy end of the traditional cultural opposition is the happy blend of the scientist-cum-artist hybrid.

The examples discussed in this book are quite different in how and to what end they apply digital technology. A piece such as Rafael Lozano-Hemmer's *RE:Positioning Fear* (1997) may also be called tactical media instead of art; *Text Rain,* because it has been integrated in a German children's museum for experimenting with scientific phenomena, may now be looked at as applied technology rather than art; mapping pieces such as *Making Visible the Invisible* by George Legrady et al. and *They Rule* by Josh On & Futurefarmers may, I argue, be more accurately described as interesting examples of data presentation or investigative journalism.

All the works that I discuss in this book are part of an established canon of art discourse. They appear elsewhere as examples in various books on digital, virtual, new media, or Internet art, as objects in art exhibitions, or as the subjects of relevant academic and popular writing. Nonetheless, it is in the nature of the subject that it is difficult to label and categorize the phenomena of digital arts. I do not ignore such questions and tackle them when it seems to promise a better understanding of the philosophical concepts or aesthetic agendas behind these phenomena. However, my agenda is not to clarify all terminological questions, let alone determine whether a given artifact is really art or rather science, and whether it is

then good or bad art, or good or bad science. Nobody can really say what comprises art today, and everybody knows that judgments about the quality of an alleged example of art are hardly objective. Nonetheless, the question is important and interesting, as is the question whether bad science still (or only then) can be good art. But more interesting and important than putting our thumbs up or down is exploring the details, potentials, and problems of the pieces at hand. That is my purpose here. From there, readers may come to their own evaluations.

1 DIGITAL LITERATURE

THERE ARE MANY WAYS to misconceive digital literature. The most popular misconception is that all text appearing in digital media is digital literature. This is as meaningful as saying that a story read on the radio is a radio play. To avoid such misconceptions, it has been asserted that digital literature should be born digital. This stricture does not help much if it is understood as a requirement to create the text on or with a computer: A poem is a poem even if typed onto a keyboard and read on the screen— which of course does not deny the difference between scribbling words on a sheet of paper in moonlight or hammering them out on a noisy typewriter. The Electronic Literature Organization, founded in 1999 "to foster and promote the reading, writing, teaching, and understanding of literature as it develops and persists in a changing digital environment," tries to be more precise by defining electronic literature as "works with important literary aspects that take advantage of the capabilities and contexts provided by the stand-alone or networked computer."[1] This definition does not really solve the problem either; a poem using the distribution facility of e-mail or Weblogs is still a poem. This formulation actually adds a new problem by shifting from "digital environment" to "electronic literature," leaving to one side the troubled waters of "important literary aspects."

Although importance can only be judged with respect to particular instances, concerning the literary in digital literature it can be said, in general, that it must exceed the existing realm of letters if digital literature wishes to be more than just literature in digital media. Such a moving beyond already takes place when the letters move because a moving letter contains an extralinguistic quality and moves from the paradigm of creating a world in the reader's imagination based on a specific combination of letters toward presenting an event to the viewer and reader's eye

directly. Concrete poetry is a precursor to making such a move because the linguistic value of a concrete text is accompanied and supplemented by its visual qualities. Precisely for this reason, digital literature is only digital if it is not only digital. Although it enters the realm of the digital on the operational level, it must leave it on the semiotic one. The former refers to the computer as a technology based on digitization; the latter refers to the nature of literature to be grounded on a combinatory system of digital units such as letters, phonemes, and words. If by definition digital literature—digital as an aspect of technology—has to be more than text, then it must not be limited to the digital nature of text—digital in a semiotic sense.

This definition of digital literature inevitably leads us to a new problem: how to distinguish between digital literature and digital art. Although it has been argued that the difference is based on the materials used—if words outweigh graphic and other elements, then we are dealing with literature—it would be more appropriate to evaluate the difference on the basis of the way these materials are used. There is a trend in interactive installations to incorporate text as an element of the work that is not to be read but to be looked at or played with. Such desemanticization evokes a cannibalistic relationship between the semiotic systems of text on the one hand and of visual, installation, or performance art on the other. However, sometimes these works allow us to regain the linguistic significance of the text in later operations of reading and interpretation. Hence, some works may be digital art and digital literature at the same time, or at least consecutively, if their audiences and readers are indeed interested enough to engage in an adventure that aims to rescue their literary prisoners.

Defining Digital Literature

In 2003, Jan van Looy and Jan Baetens published *Close Reading New Media: Analyzing Electronic Literature*, an anthology that aimed to provide a set of case studies to illustrate and test theories developed in years of terminological and theoretical debates. The editors broke with standard practice by not arguing over whether we should be talking about digital, electronic, interactive, ergodic, hypertext, Net, cyber, or code literature. Instead, they asked how we can read this new literature.

Van Looy and Baetens offer three reasons for the rarity of such hermeneutic endeavors compared with terminological or theoretical works: "First of all there is the basic conviction that critical attention does not matter,

or even that it is not appropriate to works belonging to a medium which has as one of its primary principles the absence of—literally—fixed shapes and—literally—fixed meanings" (2003, 7). The fundamental openness of digital literature seems challenging for many practitioners of literary studies, whose main orientation is determining signs. But such openness does have literary antecedents. Concrete poetry also demanded that literary studies adapt their methodical tools by assigning predicative processes to the nonlinguistic realm. Van Looy and Baetens argue that we have to develop a dialogue with form, and indeed if form consists in elusiveness or variableness, then we must interpret this very characteristic.

"Second," Van Looy and Baetens continue, "there is the idea, which is not entirely false, that hyperfiction is born on the margins of a medium, the computer, which is still considered a number cruncher rather than a literary device" (8). In this case, they are referring to Espen Aarseth: "The emerging new media technologies . . . should be studied for what they can tell us about the principles and evolution of human communication" (8). We might add that this technology should also be looked at regarding the principles of the *aesthetic* communication involved.

Third—and this is the true problem—"we often hear the argument that hyperfiction has not yet produced enough interesting works to justify a turn towards a more literal and literary tackling of the material" (8). The editors correctly object to this argument, quoting Marie-Laure Ryan that even in the case of lack of quality, close analysis is worthwhile because "for the literary scholar, the importance of the electronic movement is twofold: it problematizes familiar notions, and it challenges the limits of language" (8). The present book, too, stresses that even works of mediocre quality—and perhaps precisely these—can shed light on the extent to which digital literature can handle its material in a meaningful and convincing way, and help us understand where potential traps and pitfalls may lie.

Van Looy and Baetens's book itself, however, gives the impression that hyperfiction has not produced sufficiently interesting works. The three contributions to classic hyperfictions—Stephanie Strickland's *True North* (1997), Shelley Jackson's *Patchwork Girl* (1995), and Marjorie Luesebrink's *Califia* (2000)—are followed by analyses of Geoff Ryman's novel *253* (1996) and Raymond Federman's novel *Eating Books* (1996), which were also published as books and do not really qualify as true digital literature. Equally, the last three contributions do not deliver close readings of hyperfictions but deal with a site promoting a film, with the "Narrative of an Interface,"

and with the subject of hypertextual consciousness. To describe the situation more positively: the range of digital literature is vast. The adaptation of a novel from print to the digital medium can be as valid as the Web site for a film playing with interesting text-graphic elements. But does this mean that the transformation from one medium to another creates digital literature? What qualifies an artifact as digital literature? How can it be differentiated from digital art? Questions such as these point to the necessity to talk about terminology and concepts before proceeding to the case studies.

When the Brazilian artist Eduardo Kac discovered holography in the 1980s, he began with some basic questions:

> It is very important to emphasize that not all texts recorded on holographic film are holopoems. It is technically possible, for example, to record a symbolist sonnet on a hologram. Such a sonnet does not become a holopoem simply because it is displayed on holographic film. What defines a holopoem is not the fact that a given text is recorded on holographic film. What matters is the creation of a new syntax, exploring mobility, non-linearity, interactivity, fluidity, discontinuity and dynamic behavior only possible in holographic space-time. (2003, 184)

Kac's aim is to differentiate genuine holopoetry from the variant that only transplants old artifacts into the new medium. Such a differentiation was necessary, he argues, because of the disparity between technical skills and artistic concepts in artists' use of new technologies—a general problem at that time. The holography artist Margaret Beyon, for example, distinguished between the mere use of a technology and its utilization for aesthetic purposes: "The credit for exhibitions arranged by artists of laser beams as purely physical phenomena, for instance, should go to the inventor and manufacturers of the laser, rather than to the 'artist'" (Coyle 1990, 73). In a similar vein, art critic Peter Fuller questions the share of the artist in the creation of holographic objects and holds that the very process of making a hologram does not allow for the admission of a human imaginative or physical expressive element at any point (74). It was in response to this lack of esteem that Kac issued his demand for holopoetry that would emerge from the medium itself and use its technical potential for aesthetic and conceptual purposes. The example shows that the problems surfacing with digital media are hardly new. Although we do not have to discuss the characteristics that holography as technology offers for specific

artistic statements, we do have to talk about the characteristics that digital media bring to specific artistic statements.

I previously identified these specific characteristics as interactivity, intermediality, and performance (Simanowski 2002). *Interactivity* aims at motivating the recipient to co-construct the work. This encompasses several possibilities: (1) reacting to characteristics of the work (programmed interactivity: human–software), which includes first of all (but certainly not exclusively or even primarily) multilinearity in hypertexts requiring readers to make navigational decisions on their own; and (2) reacting to activities of other recipients (network-bound interactivity: human–human via software), which includes cooperative writing projects asking all readers entering a Web site to become authors of a given project. *Intermediality* marks the (conceptual-integrative) connection between the traditional media of expression: language, image, and music. *Performance* (or *processualization*) refers to the programming of an intrinsic performance or of one that is dependent on reception. One could inscribe aspects of the performance into the invisible textual level of the digital work, for example the succession of images, the number of loops, or the background color in simple GIF animation. Another textual level, much more easily accessible, is the HTML source with its executive commands and the JavaScripts that, although not appearing as text, invisibly continue their activity in the background. The prompt can either come from the program or from the recipient. In the latter case, we are again dealing with the aspect of programmed interactivity mentioned above. But in either case, the data presented are altered during the process of reception, which requires the direction of aesthetic attention not only to the predetermined relations of data, but also to the dynamics of their processualization.

There is no need to stress specifically that we see the aforementioned characteristics acting to various degrees in this concrete case, or that we encounter them in a wide variety of combinations. But it should be stressed that I am referring to phenomena of the monitor and not to the underlying arithmetic operations per se. In my view, the mere fact of encoding is not itself a sufficient element because every phenomenon in a computer, even the classic linear text, is necessarily encoded. The mere existence of such a text in a computer does not make it digital literature, any more than the recording of a poem onto holographic material turns it into holopoetry. Encoding only becomes significant insofar as it manifests itself on the monitor as an aesthetic element of expression. If words move on the screen and disappear after a certain user action—as in *Das Epos der Maschine*

by Urs Schreiber (2000)—or if words in the readers' text contributions automatically link to other text contributions with the same words—as in *Assoziations-Blaster* by Alvar Freude and Dragan Espenschied (started in 1999)—then the arithmetic operations of the computer are indeed used to add a specific meaning to the text presented on the screen that could not have been done in the print medium.

The characteristics of digital media given above do not explain why I am operating with the term *digital literature* rather than with one of the competing terms. I do so because the term *digital literature* seems to offer the least occasion for misunderstandings. It does not refer to concrete individual characteristics such as interactivity, networking, or nonsequentiality as do terms such as *interactive literature, Net literature,* or *hypertext,* which are better qualified to describe genres of digital literature.[2] Instead, it designates a certain technology, something the term *electronic* would not guarantee, given the existence of other arguably electronic media such as cinema, radio, or television. The linkage of subject matter and technology implies that the former depends on the latter for reasons of expression and not, for instance, distribution. As explained above, a conventional text written on the computer and presented online does not meet the criterion to require the digital medium for aesthetic reason if it could also be presented in a printed format.

It should also be stressed again that the term *digital* in digital literature relates to the medium of its production and not to the semiotics of its material. Because language consists of discrete signs, one could say that literature is always the result of digital encoding, contrary to images or sounds that are based on nondiscrete signs. This is the basis for linguists' objections to the prevailing expansion of the term *language* to nonlinguistic signs such as images. They are not based on "a combinatory system of digital units, as phonemes are," as Roland Barthes holds in his essay "Rhetoric of the Image" (1991, 21). However, in the case at hand, both concepts of language apply. Because digital literature by definition is different from traditional print literature, it also by definition has to surpass semiotic digitality. This is achieved by connecting to nondiscrete signs such as visual, sonic, and performative elements. The characterization of the term *digital literature* therefore points to the technological and not the semiotic notion of the medium.[3] The result of this characterization is a shift from linguistic hermeneutics to a hermeneutics of intermedial, interactive, and performative signs. It is not just the meaning of a word that is

at stake, but also the meaning of the performance of this word on the monitor that may be triggered by the reader's action.

How helpful is the criterion of the necessity of digital media? As Espen Aarseth reminds us in *Cybertext* (1997), the digital medium is not indispensable for hypertext or combinatorial poetry. Nor do, one may add, the animated texts of the Young-Hae Chang Heavy Industries or David Knoebel's "Click Poetry" really need the digital medium.[4] Both works are set to sound and do not demand any more interactivity than a single mouse click to start the texts' performances on the screen. Such works could in fact run on the movie screen, as did some literary texts turned into movies in the tradition of the text-films the late 1960s, such as Michael Snow's *So Is This* (1982). What about a work like Antoine Bardou-Jacquet's video *The Child* (1999) for Alex Gopher's song "The Child," which not only makes the text dynamic and sonifies it with bespoke audio and a sample by jazz legend Billie Holiday, but also uses text simultaneously as a linguistic and visual sign in the tradition of concrete poetry? Should we grant medial authenticity to such a work?[5]

The Child shows a woman in labor and her partner speeding through Manhattan in a taxi to get to the hospital. This story, in itself unspectacular and told with conservative camera work, visualizes all its characters and objects with respective letters. For example, in the beginning, the skyscrapers of Manhattan are named by vertically readable names; the window through which the viewer is led into one of the apartments is formed by the word WINDOW formed by two lines of letters placed in a square. Inside the apartment, the body of the woman is outlined in the vertical placement of the words "BROWNHAIR/PRETTYFACE/WOMAN/PREGNANT/REDDRESS/SNEAKERS," while the man standing next to her is shown with the words "BLACKHAIR/PLEASANTFACE/BIGGLASSES/HUSBAND/LITTLEMAN/DARKSUIT." They change into "BLACKHAIR/BIGGLASSES/*ANXIOUSFACE*/HUSBAND" after the woman cries out "The baby, it's coming," with "*ANXIOUSFACE*" appearing in luminescent colors and fluttering handwriting. The script is the main textual level in addition to the words of the song and the sparse dialogue of the main actors—the exclamation of the pregnant woman, the anxious "OK" of the husband, the shouting for a taxi, the instructions to the driver, a short dialogue with the police.

The work is interesting not only as an act of visualization, but also for the underlying concept. It digitizes the world in a semiologic way that is reminiscent of Jeffrey Shaw's *Legible City* (1989–91), which allowed interactors to simulate moving through the streets of Manhattan, Amsterdam,

and Karlsruhe on a stationary bicycle in front of the screen, reading the text mapped onto the buildings.[6] *The Child* is different insofar as it does not tell an invisible story behind walls, but rather reduces the visible objects to their momentary meaning for an unspecified narrator. A Cadillac stretch limousine holding up traffic is only a "VERYVERYLONGCADILLAC" if you are trying to reach a maternity ward. Is it beautiful nevertheless? Does one of the three people in the waiting taxi think that this Cadillac is beautiful? What would this mean for the character? If the other cars are just perceived as "CARS," this already seems to fit with the situation described. In such moments, one does not have a sense for aesthetic details. Nevertheless, the taxi driver is a "DREADLOCKS RASTAMAN CABDRIVER." Why is it important to concretize this? And why aren't we told any information about the driver's ethnicity, age, or build? Is it the hair that speaks most in this plot, which involves a chase with the police and a serious accident with what looks like several casualties? Which cultural stereotypes were used here? Had we seen the "DREADLOCKS RASTAMAN CABDRIVER" we might have had the same associations, but probably without realizing it. The designation of this one characteristic already points to the mechanism of typifying. The textualization of visual signs forces us to choose and is unavoidably direct and revealing. The work, by casting everything into language, sheds light on various methods of encoding visual and linguistic languages. It speaks, to use its own metaphor, about the birth of meaning.[7]

The Child seems to be a good example of digital literature: it is characterized by intermediality (the conceptual coexistence of medial elements) and performance (staging the letters like a running film). It is exciting for its metareflexivity in comparing linguistic and visual levels of meaning, and it is attractive for its intriguing tension between avant-garde and conventional aesthetics. The narrative level and the camera work are located in mainstream aesthetics and seem to represent the (necessary) opposite pole to the provocation of the viewers via the highly unusual presentation of the narrated reality. Nevertheless, as a video clip shown in movie theaters, *The Child* does not qualify as genuine digital literature in my use of the term. The use of digital technology alone is hardly sufficient, given that nowadays every cut, every musical arrangement, and every textual formatting is done with computer assistance.

If for no other reason than to have an interesting and illustrative example to work with, it would be expedient to assign *The Child*—as well as the text-films by David Knoebel and Young-Hae Chang Heavy Industries—to

the realm of digital literature. One could counter the objection that these are merely filmed texts by pointing out their media typicality. It is correct that there are also multilinear texts in the print medium as well as dynamized writing in the film medium. But in both cases, these are atypical features in one medium experimentally crossing the borders of another, in which the exception then becomes a medium-specific rule. Only digital technology provides a medial home for multilinearity and dynamization of texts.

Does this mean that we have come closer to solving our terminological and taxonomic problems? By no means. We still have not talked about the term *literature* in digital literature. What is the literary element in this concept?

Crossing Genre Boundaries

In her 2008 book *Electronic Literature: New Horizons for the Literary*, N. Katherine Hayles states that the "demarcation between digital art and electronic literature is shifty at best, often more a matter of the critical traditions from which the works are discussed than anything intrinsic to the works themselves" (12). That the interactive audiovisual broadening of literature would make the term *literature* problematic was already clear to Richard Ziegfeld when, almost twenty years before Hayles, he acquainted his readers with the phenomenon in his essay "Interactive Fiction: A New Literary Genre?" (1989). Ziegfeld therefore directly posed the question, "Is interactive fiction a literary or a visual art form?" His answer underlined that interactive fiction addresses language concerns that readers can contemplate for so long as they wish and invoked proportions: "While interactive fiction offers potent possibilities in the visual realm, it presents a proportion of word in relation to graphic device that sharply distinguishes it from the visual electronic media. Thus, interactive fiction is the first *literary* electronic form" (370).

In 1989 the borderline between literature and other visual forms—film, TV, video, software adventure games—was still clear even in the realm of digital media, which was dominated by words. Soon after tables turned. However, even in 1989, the criterion of quantity was hardly practical because one soon faced the question: How can we measure the primacy of the word? By the space it takes on the monitor or in the memory? By the attention it captivates or the amount of information it transmits in comparison to visual elements? And what does it mean if a word is staged

mainly in its materiality as a typographic sign, and its effect is therefore converted to that of an image, rather than of a linguistic sign? *The Child* already raised these questions, even though, in the tradition of concrete poetry, it aimed at both visual and linguistic functions of the text. In a piece like *Text Rain,* the situation becomes more difficult.

In the interactive installation *Text Rain* (1999) by Camille Utterback and Romy Achituv, viewers stand or move in front of a large monitor in which they see themselves as black-and-white projections and on which letters fall from the top edge.[8] Like rain or snow, the letters appear to land on participants' heads and arms; they respond to their motions and can be lifted and let fall again. The falling letters land on anything darker than a certain threshold, and they fall whenever that obstacle is removed (Figure 1).

Text Rain is more about playing with the text than about narration. Nevertheless, this work is indebted to literature and doubly inspired by it. It picks up from Apollinaire's concrete poem "Il Pleut" (1918), whose lines were distributed in five long verticals slanted across the page like falling

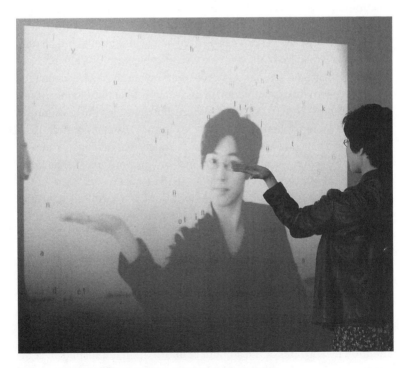

Figure 1. Camille Utterback and Romy Achituv, *Text Rain* (1999).

rain. *Text Rain* uses the poem "Talk, You" from Evan Zimroth's book *Dead, Dinner, or Naked* (1993) so in addition to being a toy, it functions as an object for reading. The authors point out in their description of the piece that participants who accumulate enough letters can sometimes catch an entire word, or even a phrase: "The falling letters are not random, but form lines of a poem about bodies and language. 'Reading' the phrases in the *Text Rain* installation becomes a physical as well as a cerebral endeavor." The falling letters turn into signifiers once they land and can form words. The lines of the poem presented in *Text Rain* make up the following text, which is adapted from Zimroth's poem:

> I like talking with you,
> simply that: *conversing,*
> a turning-with or -around,
> as in your turning around
> to face me suddenly . . .
> At your turning, each part
> of my body turns to verb.
> We are the opposite
> of *tongue-tied,* if there
> were such an antonym;
> We are synonyms
> for limbs' loosening
> of syntax,
> and yet turn to nothing:
> *It's just talk.*

Clearly, *Text Rain* works with the message of the poem by manipulating the way in which it is read: the conversation between two people, wordless and aimless, which lets the movement of the bodies change body parts into words, becomes a playful conversation between the bodies of the viewers and the letters of the installation. There are two ways to read the installation as a translation of the lines "At your turning, each part/of my body turns to verb" or rather to see the poem as a portrayal of the interaction between user and poem. First, the movement of the user's body turns (by accumulating letters along the outstretched arm) the bodies of letters into words, in which case the poem (I) addresses the user (you). Second, the falling letters turn the user's body into words by having the user's action create a specific expression, in which case the user (I) addresses the poem (you). Either way, the text is not just a visual object stripped of

its linguistic meaning but also a signifying system. Utterback stresses that the choice of the text is not accidental,[9] from which we can conclude that the reading process is important for understanding this work.

In my own experiences of and documentary evidence about *Text Rain*, however, the lines can hardly be deciphered even after the viewer has painstakingly collected all the letters. The viewers do not mainly engage in the reading process, but rather test the interface. The fact that the raining letters suddenly form real words contributes to the piece's fascination and encourages the viewers' dialogue with the letters, although it does not allow them to read the entire poem, nor does it elicit the intention to do so. With good reason, then, the description puts "reading" in quotation marks, revealing that even the authors do not expect a real reading from the viewers. The cerebral effort that was announced probably consists more in the "reading" of *Text Rain*—that is, in the interpretation of the physical effort—than in the reading of Zimroth's poem. The work functions primarily on the physical level; the fascinating elements of the installation are the movements that it creates in front of the monitor as viewers interact with the falling letters. Virtually as an inversion, this interaction enacts what the poem describes: letters change the bodies of the viewers while they are moving. The subject of the poem, namely the relationship of body language and verbal language, is also the subject of the interactive installation. But poem and installation have more in common than this.

The poem ends with the lines "turn to nothing:/ *It's just talk.*" This is understood as a celebration of the aimless conversation, which does not turn into a linguistic message as a practical result. Such aimless talk is exactly what users do in their interaction with the letters in the installation. The letters are liberated from their representational function and present themselves as artifacts within a dialogue with the users, independent and innocent: "For the letter, if it is alone, is innocent: the Fall begins when we align letters to make them into words" (Barthes 1991, 119). The letters have left language and turned into a sculpture or perhaps music. Just as Zimroth's poem reflects on the communication of two people going beyond the pettiness of mere concrete information, the installation allows the text to become pure self-sufficient presence. And it is Utterback and Achituv's work with Zimroth's poem that elevates it above the concrete message. The original is longer by seven lines, contains different line breaks, and suggests physical action. It reads as follows:

I like talking with you, simply that:
conversing, a turning-with or -around, as in
your turning around to face me
suddenly, saying *Come,* and I turn
with you, for a sometime
hand under my under-
things, and you telling me
what you would do, where,
on what part of my body
you might talk to me differently.
At your turning,
each part of my body turns to verb.
We are the opposite of
tongue-tied, if there were such an
antonym; we are synonyms
for limbs' loosening of syntax,
and yet turn to nothing:
It's just talk.

In a discussion of *Text Rain,* students deemed the modified version to have stripped the poem of its sensual and sexual innuendo in an act of sanitization. In this sense, the text modification actually seems to suppress the body, which other primary elements of the installation set out to liberate. This makes *Text Rain* appear self-contradictory.[10] However, within the reading offered above, the interference is absolutely justified and clearly shows that Utterback and Achituv were aiming at the relationship between bodily and verbal language, or rather at the playful interaction between letter and body. Needless to say, the decision to use this text in this modified form makes the installation much more interesting than a text like Apollinaire's rain poem or some other text about rain (or snow), which would have presented a better correspondence between title, text, and action but which also would have drowned any deeper meaning in the banality of a double rain metaphor.

Insofar as *Text Rain* does not promote a reading of the text, it functions as digital art rather than as digital literature.[11] An essential difference between literature and visual arts is how meaning is structured, conveyed, and perceived. Whereas in visual arts segments are to be seen and gain meaning insofar as they form a representative whole, literature is based on linguistic

units, discrete signs, which are each meaningful on their own and are to be read literally. In this light, the difference is not necessarily based on the material used but on the material's function: there can be linguistic painting and text without linguistic meaning (sound poetry but also concrete poetry), which then is perceived as art rather than as literature.[12]

Accordingly, I propose using the material's function more than its proportion to distinguish between the two forms. If the text continues to be important as a linguistic phenomenon, then we may speak of digital literature. If the text becomes primarily a visual object of interaction, then we are dealing with digital art. This distinction does not entail defining literature with regard to the letter (from the Latin *littera*) as such, but with regard to the letter's intention of joining with other letters to form meaningful words. The difference is not only based on the way the artist uses the letters, but also on the way the audience perceives them. Thus in *Listening Post,* as I will discuss later, the words and sentences presented in this installation can be carefully read when standing close to the more than 200 screens, or they can be perceived as blinking visual objects embodying the magnitude of online conversation when stepping away to take in the entire sculpture from a distance. In this case, the transition from a linguistic to a visual artwork is the effect of the audience walking away from it. The distinction on the ground of the letters' linguistic value may seem conservative in the light of futurist and Dadaist efforts—for example, Marinetti in his *Parole in libertà* (1932), or shortly thereafter Hugo Ball, Richard Huelsenbeck, and Kurt Schwitters in their sound poetry—to liberate the letter from its meaning in sentences or words. Nonetheless, such a method proves practicable for distinguishing literature from other genres such as painting, sculpture, or music.

But is such distinction necessary? Some scholars working in the area of digital aesthetics, such as Hayles, question the value of categorization and definition, preferring to remain open about the specific characteristics of the new inter- and transmedial phenomena (Hayles 2002, 45). I can only agree with Hayles repeating the plea for more interpretive over terminological work. Of course, the rejection of terminological questions should not come at the cost of any detriment to interpretation. As the discussion of *Text Rain* and *Listening Post* shows, sometimes it is precisely the question of whether a work acts as literature, film, or installation that sharpens the eye for all that work's levels of meaning.

Regarding *Text Rain,* classification remains more elusive and exciting than it might initially appear once we have differentiated the linguistic from

the nonlinguistic functions of the text. *Text Rain* is an example of a work where the text leads a double life and thus may be considered both digital literature and digital art, depending on the role the audience allows the text to play. The communication of interactors with *Text Rain* is one of joyful play with letters rather than a serious attempt to decipher the text to distill the poetic message. *Text Rain* is thus primarily not perceived as a work of literature. However, when audience members are made aware of the poem behind the installation, they may want to read it after interacting with the installation. Such a peek backstage results in demystification because it reveals the words one could hardly decipher before. It also allows us to understand that the inclination to play with the cascading letters, as opposed to deciphering the overall text, is actually appropriate to the poem's message. This is the more subtle message underlying this installation: the extralinguistic layer of meaning cannot be revealed before the linguistic layer has been grasped. To put it another way, only when one knows the message of the poem used in the installation does one understand that the message of the installation is not to look for the message of the poem.[13]

One should not, of course, overestimate the audience's readiness to engage with the text. Even people who are experts in the field of digital aesthetics and who have become familiar with *Text Rain* can fail to initially realize that there is a poem in the falling letters, and even then, many still do not make the effort to access the text and include it in their interpretations. One of my colleagues maintained of *Text Rain* that if reading the poem is a prerequisite to experiencing the piece, then the installation is a failure because it does not offer access to the poem. Another suggested that being able to hear the poem read aloud as one stood in front of the installation would have improved things. This makes a valid point: providing the underlying text in such a way would make *Text Rain* more self-contained and avoid the delay caused by having to look it up after engaging with the installation. On the other hand, there are good reasons to separate the elements of the work in order to separate the steps of its perception. The moment that the underlying poem is identified in the installation's accompanying text, thereby becoming accessible immediately, the repressive power of the text dominates over the interpretation of the installation. Insofar as viewers only read the poem after their encounter with the installation, a belated repression sets in—or, rather, a correction that transfers the completion of the interpretation outside of the representation of the installation, thus providing a useful distance of time and space and the pleasure of suddenly seeing the installation in a different light.

If an installation features text, this text cannot be ignored, even if it remains clandestine within the installation itself. Any serious observer should be expected to take the text into account by familiarizing herself with it and incorporating its meaning in a reading of the overall piece. Yet it is true that James Joyce's *Ulysses* can be understood without knowledge of Homer's *Odyssey*. The story may be equally enjoyable if one does not see Leopold Bloom as Ulysses and Molly Bloom as Penelope and if one does not recognize the vast number of literary allusions. However, only against the background of this essential epic from the origin of Western culture is one able to grasp the connotations opened up by Joyce's novel nearly three millennia later. The text written by Joyce loses complexity without reference to Homer.

Yet as the history of *Text Rain* shows, even the artist may undermine the text's structure. Utterback and Achituv changed the words in a version of *Text Rain* for the Phaeno Museum in Wolfsburg, Germany, where children and adults can experiment with scientific phenomena. They decided not to translate the poem but to customize *Text Rain* for this museum by using German words and phrases such as *Regenbogen* ("rainbow"—a metaphor for luck), *im Regen stehen* ("standing in the rain"—to be forgotten), *Tropfen auf heißem Stein* ("drop on a hot stone"—a drop in the bucket). This German text redundantly refers to the title and at the same time diminishes the complexity the original installation possessed because of its conceptual relationship to the poem. The problem here is not primarily that art ends up in a children's science museum—although this might warrant further discussion—but that it weakens its own principles. However, in the end, this destruction may reveal something about the actual intention of the piece. It may not really have intended the sophisticated utilization of the poem to comment on the grammar of interaction, as assumed in my interpretation above. It may not want its audience to demystify the occasional change of letter rain into words. It may appear to use the poem for some deeper purpose, and yet it turns to nothing. It is all just play.[14]

Playing with Text

In *Screen* (2004) by Noah Wardrip-Fruin and others, the text appears as part of the installation and can be perceived both audibly and visually.[15] This work can be viewed in the Cave, an eight-foot room with two open sides, where the coherent representation of a graphic world can be projected onto the floor and three walls (Figure 2). The viewer wears special goggles:

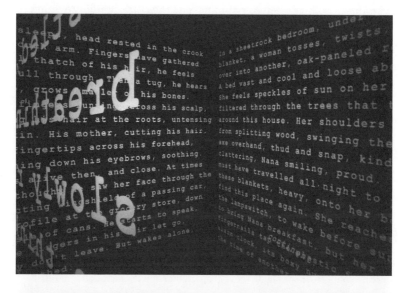

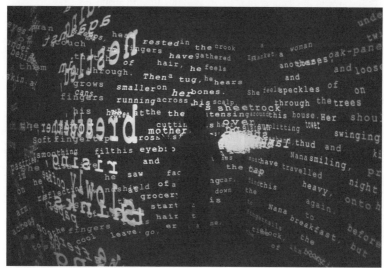

Figure 2. Noah Wardrip-Fruin et al., *Screen* (2004), in the Brown University Cave. Photograph by Josh Carroll.

the projectors display, in flickering succession, a left-eye and right-eye rendering of the graphic world, and the eyepieces of the goggles synchronize with this, feeding the left or right image to the corresponding eye and so enhancing, with stereoscopy, the illusion of immersion in a 3-D world. This also allows users to continue to see and interact with their own bodies, and even use a pointer to position their "hands" within the three-dimensional world. *Screen* begins with a text written by Robert Coover about the loss of memory, simultaneously spoken and displayed as text on one of the walls:

> In a world of illusions, we hold ourselves in place by memories. Though they may be but dreams of a dream, they seem at times more there than the there we daily inhabit, fixed and meaningful texts in the indecipherable flux of the world's words, so vivid at times that we feel we can almost reach out and touch them. But memories have a way of coming apart on us, losing their certainty, and when they start to peel away, we do what we can to push them, bit by bit, back in place, fearful of losing our very selves if we lose the stories of ourselves. But these are only minds that hold them, fragile data, softly banked. Increasingly, they rip apart, blur and tangle with one another, and swarm mockingly about us, threatening us with absence.

The three walls are covered with three texts describing brief episodes of a kind one might always want to remember. The first episode is about a boyfriend or lover who disappeared:

> Light over the sill of an unshaded bedroom window, into a woman's eyes. She turns away, slips half back under sleep. Then a man is curled behind her. Spooned against her. Warming her skin. Holding her in a pocket of him, nestled, protected. Their bodies breathing together, deep, a rhythm slowly rising, moving toward morning. She thinks of coffee and pastries, sharing the paper, sweet crumbs in the bed, afternoon still napping on his shoulder. She uncurls her arm, reaches back to lay her hand across his thigh, to welcome him home, but touches only a ridge of sheet, sun warmed, empty.

The interactor is exposed to all these texts, which are spoken by a female voice and a male voice while the words are displayed on the walls. Eventually, and suddenly, single words peel from the wall, flocking around each other and the interactor, who now has the option to push them back with a pointing device. The system tracks the interactor's hand movements so that she can reach out and strike the loose words she sees in front of her. Struck words return to the place they came from or to a space left open by

another word. They break apart if no space is large enough or if the striking motion is particularly strong. The frequency and speed of the words' peeling from the wall increase during the course of the episode. When too many words are peeled from the wall, the piece ends. All the words that have not been pushed back peel off the wall, swirl around the interactor, and collapse.

Screen first articulates the general subject matter—the loss of memory through the loss of words—by text spoken and written into the Cave environment. This moment forces interactors to listen and read the text without the option to engage with the piece on a physical level. In the case of *Text Rain,* reading the underlying text is optional, but *Screen* makes the reading of the text mandatory. It executes the addressed loss of memory by allowing the words to drop from the storage medium, asking interactors to put them back in their "rightful" place. As Wardrip-Fruin (2004) explains in an interview, "The word-by-word reading of peeling and striking, and the reading of the word flocks, creates new experiences of the same text—and changes the once normal, stable, page-like wall texts into progressively-altered collages." However, the new experience of the text is an experience of playing rather than reading. In the same interview, Wardrip-Fruin reports that a seven-year-old who looked at the scatter of words at the end asked, "Is that my score?" What this young visitor expressed is the probable experience of older visitors as well. Shifting from the role of the listener/reader to the role of the interactor, they also shift from engaging with the words on the linguistic level to taking them as graphical or physical objects to which they must react. Words become balls that have to be returned as fast as possible and as many times as possible. The narrative turns into a game.

Wardrip-Fruin (2007, 230) considers *Screen* an "instrumental text" rather than a game because there is no contest or quantifiable outcome in the piece. However, the idea of a contest is reinforced by the fact that the pace of words peeling from the wall speeds up over the time of the piece and requires faster reactions of the interactor because the piece ends when too many words are off the wall. The contest is to push back words as fast as possible. The quantifiable outcome is the duration of this pushing back before the critical mass of peeled-off words ends the piece. The words presented on the wall afterward are those pushed back by the interactor. They are indeed her score.

According to Wardrip-Fruin, players do not approach *Screen* without attention to its words as words: "Rather, interactors oscillate between reading and playing, with the objects of both coming faster and coming apart,

until both experiences can no longer be sustained and the piece ends" (2007, 231). It is obvious that any ambition to score high will diminish the time spent reading. The more words that are struck and sent back to the walls, the longer the experience—and the less the likelihood the interactor reads the words she engages with. The irony of the interaction *Screen* requires lies in the fact that memory becomes a game in which playing is more important than the perception of the words threatened by loss. Instead of reading the words leaving the wall one last time, the interactor is busy pushing them back. Of course, on the metaphoric level, this pushing back enacts a recovery of memory. However, as a pushing away, it develops its own symbolic power.

The superficial interaction with memory is confirmed at the end of the installation, when readers are invited to play another round. The last words heard are: "If memories define us what defines us when they are gone? An unbearable prospect. We retrieve what we can and try again." This sounds, on the one hand, like an existential moral, but on the other hand, it appears to be in the spirit of an arcade game offering another round of play. It would provoke more of an existential engagement to receive an invitation to read the vanishing words one last time to recall to our memory what soon will have no other place than our memory. We might say about *Screen* what we say of Plato's *Phaidros:* The renewal of what is threatened by forgetting in memory is replaced by the questionable attempt to fixate it in the external medium of the wall.[16] The fact that words break up and return to a site other than their original position suggests that the external memory is unreliable already in the moment of its activation. In this light, the offer to try again makes one wonder whether any attempt to save memory will ever be successful. One may eventually wonder what actually defines memory. Is it what is stored in an external medium or what one carries around in the mind? And how should one regard the pushing back action if one understands the Cave as a symbol for the mind? Is it not rather a pause, a moment of silence and contemplation? These may be exactly the questions the last sentence in *Screen* wants to convey when ironically inviting us to start again.

Noah Wardrip-Fruin (2007) sees *Screen* as a subgenre of "playable media" to which no doubt we could also assign *Text Rain*. What is said in the documentation of *Screen* applies to both: it creates new experiences of text in relation to the reader's body. Yet compared to *Text Rain, Screen* is far more forthright about the relationship within digital literature, of the literary to the physical or digital—that is, to those elements by which the

traditional text is expanded. It clearly allows engagement with the text on the linguistic level before an engagement on the extralinguistic level. One can say the piece demands such engagement by first exposing the inter-actor to four different texts commanding attention to the text precisely in the traditional manner of reading with no option for interactivity. Only after the interactor pays her tribute to the cultural practice of reading is she allowed to engage with the text in the role of a game. In terms of the utilization of text, *Screen* therefore may be considered an ideal case in the attempt at characterizing the quality of literariness within the compass of digital literature. In contrast, *Text Rain* has a different objective. It does not intend to present a linguistic narrative but rather neutralizes the text to an asemantic object whose linguistic value can only be realized in a sep-arated step of perception. It therefore exists rather on the edge of digital literature and digital arts. The same is true for the next example.

Rafael Lozano-Hemmer's *RE:Positioning Fear* (1997) relates historical fears such as those of locusts, the Black Death and Turkish invaders, depicted in a fresco on the facade of the municipal arsenal in Graz, Austria, to con-temporary fears such as global warming, AIDS, terrorism, economic vio-lence, surveillance, genetic tampering, and refugees, which were discussed in real time in an Internet relay chat (IRC) meeting of thirty international artists and theorists (Figure 3). The chat session is projected on the arsenal's courtyard wall, which thus becomes the "book" of fears.[17] The building, as the project site at Rhizome.org notes, "was thus taken over by a deterrito-rialized, decontextual dialog" (Lozano-Hemmer 1997). However, the text was only readable within the projected shadow of the visitors.[18]

The point of this installation seems to be the relation of reading and physical movement that itself can be read as the fear of losing access to the text. People not only have to use their body to access the text; it also requires them to keep angling their heads because the lines were projected vertically. The situation is like painstakingly reading text on a darkened cave wall by holding a candle up to it, although in this case, the cave wall is turned inside out and the shadow has taken over the function of the candle. *RE:Positioning Fear* reverses the evolution of reading (and obtain-ing information) toward more and more convenience (with the advent of electricity, of portable formats), requiring sometimes nothing more than one finger's motion (in the case of electronic books). The modern fears, whose discussion was made possible and collected by modern technology, are read about in an inconvenient way, which may remind us of earlier

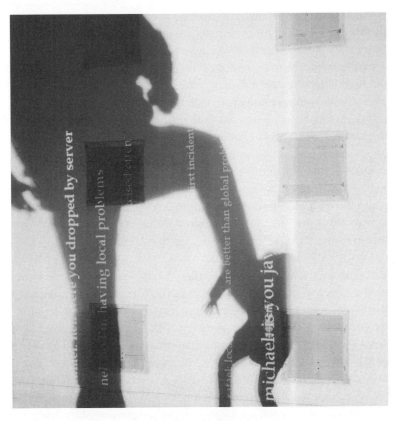

Figure 3. Rafael Lozano-Hemmer, *RE:Positioning Fear* (1997). Photograph by Jörg Mohr.

times. One has to be at the right place at the right time in order to access the text. One cannot just take home the text to read at one's own convenience. The fear experienced—that the reader may have no control over the text—is in fact quite old. What may really be new is another kind of fear.

The relation of reading and physical movement in *RE:Positioning Fear* creates a tension between reading and playing. Did people really read through the text? As video recordings of the piece show, most of the interactors of *RE:Positioning Fear* played with their shadow rather than using it to reveal the hidden text.[19] In contrast to *Text Rain* or *Screen*, in *RE:Positioning Fear*, people do not play with the text, (mis)using it as playable object; rather, they engage with its accessibility. Once the text is accessed, it is at least partly readable. However, the play of the people present at the scene overshadowed the production of text by the people present at the

same time in the virtual space of the IRC. The genuine feature of text—to make its author present at a different place at a different time—is neglected by the interactors' obsession with their own shadow. *RE:Positioning Fear* does not so much address the fear of losing access to the text as it addresses the fear of losing interest in the text. This lack of interest in the objects the interactor is supposed to discover with her own shadow can also be diagnosed in the case of Lozano-Hemmer's *Body Movies* (2001), which I will discuss later in this book. Although both cases show the interactors being self-absorbed, in *RE:Positioning Fear,* the specific nature of the neglected object suggests understanding the piece as a comment on a society of spectacle, where people continue having fun without worrying too much about the fears that others may articulate.

This fear, however, is made by the installation. Projecting the lines vertically requires interactors to angle their heads and does not really promote the idea of reading.[20] This may be due to technical constraints, but surely this sideways projection could have been solved if the readability of the text was to have been the center of attention. One has to assume that, like *Text Rain, RE:Positioning Fear* uses text as a way to engage the interactor with the installation but does not really invite her to read the text carefully. As in *Text Rain,* there is a second step in the process of perception: to go online and read the IRC text. As in the case of *Text Rain,* there is a good chance that this option is disregarded. This may thus be the real fear *RE:Positioning Fear* brings to mind: in interactive installations, text loses its linguistic value and turns into an ornament. Some artists pick up this threat and try to fight it.

By contrast, *Still Standing* (2005), by Bruno Nadeau and Jason Lewis from OBX Labs, Concordia University, insists on immobilization, making the still standing observer a key for accessing the text. *Still Standing* is an installation that, like *Text Rain,* puts the user in front of a big screen and features letters—here at rest on the floor—that react to her movements:

> the installation consists of an amalgam of characters projected on the wall as if they were resting on the floor. when a participant walks in front of the projection, the first reaction of the text is to act as if it was being kicked, pushed by the user's feet. when the participant stops for a short moment, the text is attracted towards his position and moves up, like water soaking his body. the participant can then enjoy a motionless moment and contemplate the textual content that becomes more and more legible. when the user is done and decides to start moving again, the text falls back to the floor and wait for a new interaction.[21]

Rather than sorting through the text using motion, *Still Standing* requires the participant's body (or rather, her silhouette) to be immobilized as a condition for the reading and contemplation of its linguistic content (Figure 4). The text itself was written specifically for the piece, which is, as Lewis makes clear in a private e-mail to me, one of the guiding principles of the work in OBX Labs: "The writing of the text influences the development of the interactivity which, in turn, influences further evolutions of the text" (September 19, 2007). Such integration and mutual association with one conceptual idea are exactly what should be expected whenever two semiotic systems like text and interactive interface are combined. The text naturally comments on the interface:

> five chapters of addiction for my perpetual commotion bring my brain to a
> stop. the inception of sedation is needed for the waves to break and the spin
> to reduce. letters to literal the motionless moment hides for my sight to
> seduce.

The message of *Still Standing*, as Nadeau explained, is evident on both of its semiotic layers. As the artists declare:

> nowadays, designs are created to be decrypted and enjoyed at a glance, re-
> quiring no attention span. the piece evolved as a response to the "collapse
> of the interval." a phenomenon of fast pace culture that rarely allows us a

Figure 4. Bruno Nadeau and Jason E. Lewis, *Still Standing* (2005).

moment to stop and observe. a habit that weakens the fragile approach towards design with dynamic typography.[22]

The symbolism of the silhouette filled up with text may convey the deeper meaning that the Self is composed of the kind of text it perceives.[23] The underlying subject is the cannibalistic relationship between the two semiotic systems of text and visual art or interactive installation, respectively—the consumption of text by replacing it with images, but also by transforming it into image, sound, or action, or depriving it of its linguistic value.[24] The established academic term to discuss the interdependent and competitive relationship between media is *remediation,* which Jay David Bolter and Richard Grusin describe as "the representation of one medium in another" carried out in a spectrum of different ways, "depending on the perceived competition or rivalry between the new media and the old" (1999, 45). A specific form of remediation is the transformation of text into an event depriving the medium text of its aesthetic logic to present a linguistic message. *Text Rain* and *RE:Positioning Fear* are two examples of such transformation in a digital environment. Others include Caleb Larsen's pointilistic image, *Complete Works of W.S.* (2008), which replaces each letter in Shakespeare's work with a small colored square, and Paul DeMarinis's installation, *The Messenger* (1998/2005), which represents each letter of DeMarinis's e-mails by a talking washbasin, dancing skeleton, and a blinking electrolytic jar.[25] Bolter and Grusin point out the common practice of repurposing—"to take a 'property' from one medium and reuse it in another"—in the entertainment industry transforming novels into movies (1999, 45). Although I have to leave it open to what extent the mentioned examples undertake such repurposing or appropriation of text in the spirit of the entertainment industry, it has become clear that there are also works that use new technology to enhance the cultural practice of reading, endangered since the arrival of electronic and digital media. Thus, *Screen* requires its audience to pay attention to the text before it allows it to play with it. *Still Standing* goes even further by commanding the viewer to stand still and concentrate on text, with no reward of final action. New technology turns out to be a kind of Trojan horse containing an old-fashioned paradigm of communication. The letters standing in line inside the user's shadow in *Still Standing* resemble the Greek soldiers lined up within the Trojan horse.

This strategy reminds me of the use of cinema by Guy Debord in the 1950s to protest the transformation of the world into a society of images.

After World War II, image production increasingly occupied the conscious and unconscious processes by means of which the subject sensed, desired, and understood the world. According to Debord, the cinema had become the cathedral of modernity, reducing mankind, previously an autonomous, contemplative subject, to an immobile, isolated, passive viewer, sitting in the dark and fixed in front of the shining screen. In reaction to this voyeuristic fixation, Debord declared war against cinema—not, as *Contre le cinéma* shows, by renouncing film, but by appropriating it and freeing it from the dominance of the spectacle. An example of this iconoclastic reappropriation of film is Debord's *Hurlements en faveur de Sade* (1952), an eighty-minute-long film without pictures and with almost no sound. From time to time, three expressionless voices recite fragmentary sentences taken from law books, modern literature, and newspapers; during these intervals, the screen changes from black to white. With this film, Debord temporally occupied the cinema and interrupted the circulation of false images with the intention to use the suspended film to create critical awareness. It comes as no surprise that the audience was not interested in spending eighty minutes this way in the cinema. The premiere on June 30, 1952, ended in chaos and scandal. The film was stopped after less than ten minutes.[26]

In *Still Standing*, Debord's iconoclasm translates into the critique of bustling activity in front of the screen. Nadeau and Lewis interrupt the business of action and interaction, which not only has become the new religion in art, but also an integrated element of the society of spectacle that Debord described with regard to image production. Part of this trend is the cannibalization of the text and the abandonment of reflective, contemplative reading. Forcing the audience to stand still to read text on the screen of an interactive installation is analogous to having the audience watch an empty screen in the movie theater.

The irony, however, is that *Still Standing* sends an almost empty horse into Troy. It does not, for instance, refresh the text once the interactor has finished reading it. Tracking the eyes should be no problem, nor replacing one text sequence by another. But could *Still Standing* have kept the interactor still standing still after three, ten, or even a hundred text fragments have been presented? Could it have told an entire story this way? Could it capture its audience longer than Debord's film did? It does not dare to try—and for good reason, I think. *Screen* exposes its audience to a much larger text than *Still Standing*, but it can only afford to do so because the

circumstances in which it is perceived do not allow its audience to simply leave. The audience is, as it were, imprisoned in the Cave.

Without such restraints, the prospects of a text's survival in a hostile environment, such as an interactive installation, are limited. By not refreshing the text, by not testing the patience of the audience, this installation actually confirms this view and essentially portrays its own undertaking as futile. To put it another way, the equally weighted proportion between the time the text requires its assembly into a readable form and the time needed to actually read the text allows one to experience this moment of standing still as an action in its own right. By abstaining from requesting a longer period of immobilization and thus requesting a long attention span, *Still Standing* undermines its own agenda and contributes to the fast-paced culture it criticizes. Nadeau and Lewis's work demonstrates that in interactive installations, interpretation is not only needed beyond the text with respect to the experience of the body, but it is also needed beyond this bodily experience if one considers the fact that the text does not refresh, and thus the body's experience of immobilization is not extended. We also have to consider the experiences that the body is not encountering because of the composition of the installation.

The only way for text to endure in this environment is to appear in the paradigm of double coding—or double life—providing action on the surface level of perception and moments of contemplation on the deeper level. This is the case with *Text Rain* and *RE:Positioning Fear.* These works contrive not to open the Trojan horse from inside, but to leave it for the audience to investigate its content. They mean to offer cognitive interaction, with the linguistic dimension of text only beneath, behind, or inside the physical interaction with the visual dimension of text, which suggests a disguising of digital literature as digital art.

Outsourcing Authorship

Finally, when talking about the specifics of digital literature, we also have to ask about the role of the author. The so-called death of the author in hypertext and the collaborative authorship in cowriting projects have often been the subject of discussion, and I will treat them thoroughly elsewhere in this book. Here I will focus on the dismissal of the author from text production via narrative machines and real-life bacteria.

Narrative machines are a contemporary form of experiment in automated writing going back to the Dadaists and Surrealists of the 1920s—

and even further to the poetry permutation in the baroque. They were taken up again later by authors such by William S. Burroughs. The aim of these experiments in aleatoric, nonintentional writing was not dismissing the author as such but surpassing the limits of creativity, overcoming personal perspectives by the intention and meaning of chance, nature, or, in baroque, the divine. Such a goal could be achieved by narcotizing[27] or multiplying the author.[28] Automated writing in the age of actual narrative machines, however, is based on a previous schematization of characters, potential conflicts, and their solutions. It does not really lead to a widening of expressive forms, as can be seen by examining the story generator *Makebelieve* by Hugo Liu and Push Singh (2002), Scott Turner's *Minstrel* (1992), or *Tale-Spin* by James Meehan (1981). In these cases, automatic text production effectively means the expansion of alienation to include the poetic process that in turn produces further alienation in its audience. If the reader is not confronted any longer with the specific self-conception and perspective of an author, what is the point of the reading process? What message can a text still have without a real sender? I do not want to get overly absorbed in this discussion. I will argue later that in the case of Simon Biggs's text machine *Great Wall of China* (1996), the producer of the software (Biggs) and the writer of the original text (Kafka) share the authorship much as in the vertical collaboration between the author of the poem and the author of the installation in *Text Rain*. Here I want to investigate the collaboration between the author of an installation and bacteria used in Eduardo Kac's *Genesis* (1999).

In his writing, Kac not only addresses holopoetry, but he also discusses biopoetry, a form in which not narrative machines but living organisms take over the coauthorship of a text (Figure 5). In a world of clones, chimeras, and transgenetic organisms, Kac states, it is time to consider new directions for poetry in vivo (2003, 184). Kac proposes the use of biotechnology and living organisms as a new realm of verbal creation and lists, among the proposals, "transgenic poetry," which synthesizes DNA according to invented codes to write words using combinations of amino acids. Kac suggests the incorporation of these DNA words into the genome of living organisms, which then pass them on to their offspring, combining with words of other organisms: "Through mutation, natural loss and exchange of DNA material new words and sentences will emerge. Read the transpoem back via DNA sequencing" (184). Kac's example of transgenic poetry is aptly entitled *Genesis*.

Genesis allows bacteria—in cooperation with the visitors of a Web

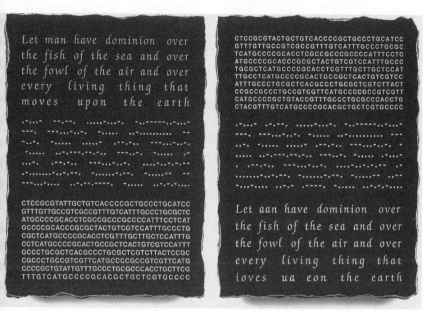

Figure 5. Eduardo Kac, *Genesis* (1999). "Encryption Stones," laser-etched granite (diptych), 20 × 30 inches (50 × 75 cm) each. Collection of Richard Langdale (Columbus, Ohio).

site—to rewrite the following sentence from the Bible: "Let man have dominion over the fish of the sea and over the fowl of the air and over every living thing that moves upon the earth."[29] Kac translated the sentence into Morse code and replaced its signs with the letters of a genetic code: the periods were replaced by C (cytosine), the lines by T (thymine), gaps between words by A (adenine), and spaces between letters by G (guanine). From this results an AGCT chain representing a gene nonexistent in nature. Kac connected it to a fluorescent protein and injected it into *E. coli* bacteria. These bacteria were stored in a petri dish on a counter of an exhibition hall under an ultraviolet light that could be switched on by the visitors to the exhibition or the visitors of the installation's Web site. The light affects the DNA sequence of the bacteria, speeding up mutation. After a certain time, the new genetic code is translated back according to the same pattern. The result of the cooperative writing activity between visitors and bacteria results in only small changes, but those minor alterations already serve to obscure the biblical message of human domination: "Let aan have dominion over the fish of the sea and over the fowl of the air and over every living thing that ioves ua eon the earth."[30]

Kac's message seems easy to comprehend. By acquiring authority over all other living beings, human beings destroy the scriptural foundation that originally authorized them to do so. The judgment passed by the rewriting of the sentence reminds us of the confusion of human languages inflicted by God on humanity as a reaction to their building the tower of Babel, another famous symbol of human hubris. But the hidden message of the project concerns a conflict between aesthetic experience and individual responsibility because the mouse clicks that speed up the mutation of the bacteria also cause a fascinating play of colors. (The bacteria glow in cyan and yellow under the ultraviolet light.) Viewers' curiosity about and aesthetic pleasure at this play of colors may suppress the question of the actual results of the activity.

The future body in the present constellation is not written with a specific goal in mind, but rather blindly, so that it hardly corresponds to the logic of any intelligent design in creation. Because the interventions of bacteria and interactors are conceptually empty, one cannot even say that the word is becoming flesh. Instead, it is the subconscious that is becoming flesh—that is, the temptation to indiscriminately satisfy our own curiosity and demands for aesthetic pleasure. The point is that flesh again becomes word, as the biological participants randomly rewrite the original sentence. The human dominance originally promised in the citation from the Bible is revoked as a direct result of humans exercising that dominance.

The phenomenon of perpetrators becoming victims is part of the public's aesthetic experience of the work. Jessica Wyman (2003) writes: "What surprises is the degree of trauma into which we are psychically thrown by the creation of this gene and the action (sometimes read as violence) that we do to it as viewers by the activation of an ultraviolet light which speeds its mutation." Steve Tomasula stresses the associative connection with the object of one's own activity: "Standing in the box formed by the walls of *Genesis*, it's easy for viewers to reverse the scale and think of themselves in the position of the bacteria with ultraviolet light streaming down (possibly through a hole in the ozone layer?)." Kac's *Genesis*, Tomasula holds, invites us to contemplate consequences of interfering with evolution: in it we see "an icon for our new-found ability to rewrite ourselves—instantly, and in ways whose ramifications might not become apparent for generations" (2003, 255).

Genesis does not only ask questions about authorship. It is itself an artifact of authorship. Beyond that it plays with the ambiguity of whether it is poetry, as suggested by Kac's terminology, or an installation. Where

should we draw the line between the two? One spontaneous answer might lead us back to the linguistic aspect: If the words produced by the bacteria in their singularity were meaningful, the result of their work could possibly be called poetry. In *Genesis,* the words generated by the bacteria are in themselves meaningless. However, this is also true for aleatoric poetry. Moreover, one can also identify meaning in the words generated by the bacteria in the very fact that they become semantically fragile, the halfway coherent words functioning like an exclamation or even a cry for help by a degenerate author. Thus, from the perspective of the linguistic function of text, *Genesis* can still be considered digital literature.

However we decide the question of literature versus installation, it has become clear that the phenomenon of digital aesthetics is full of borderline cases. Answers vary according to what role the text plays in each individual, concrete example. Thus categories ought to be applied sparingly and provisionally. We may also reconsider the return of our taxonomic diligence and perhaps decide to shift our attention to more useful undertakings. The situation in traditional literary studies is troubled by a number of taxonomic doubts and scandals. It should not come as a surprise that we have to face even bigger dilemmas in an area where a main characteristic is intermediality.

2 KINETIC CONCRETE POETRY

RELATIONS BETWEEN DIGITAL MEDIA and text so far have been ambivalent and in many respects disappointing. At first, computers and the Internet served as a petri dish for text. Although it was unpleasant to read text on the screen rather than on a page, it was encouraging to find that after the constant dimming of the Gutenberg Galaxy relative to modern media such as cinema and television the world's newest medium operated with and displayed text. We now know that this was not the beginning of a lasting friendship but simply a function of immature technologies. As soon as hardware and software had sufficiently advanced, images entered the realm of the digital and increasingly occupied the screen in animated, distracting, and annoying modes. Hypertext, "the word's revenge on TV," became hypermedia, a threat to any work of lettered art (Joyce 1995, 47). As we have seen, Twitter is no exception from this rule.

In the previous chapter, I explored the chances of text's survival in a potentially hostile environment such as an interactive installation. The situation is similar with linguistic phenomena on screen, which can be considered the successors of concrete poetry in print and may be called kinetic digital poetry. Similar to the poetics of playable text in interactive installations, kinetic concrete poetry remediates the poem in a manner more in line with the mainstream aesthetics of film and club culture than with either the Gutenberg Galaxy of text or the elitism of conceptual art generating intermedial artefacts, such as those of Joseph Kossuth, Lawrence Weiner, and Jenny Holzer. It seems that the competition and rivalry between old and new media have been answered in the spirit of the entertainment industry. Whereas in classical concrete poetry the visual effect was played out to add meaning to the linguistic dimension of the text, in contemporary kinetic concrete poetry the representational function of the word has been dismissed in favor of the technical effects.

David Small's installation *The Illuminated Manuscript* (2002), a commissioned project for Documenta 11 in Kassel, Germany, is an example of this undermining of the linguistic value of text in digital media. This work features an oversize, seemingly empty book (Figure 6).[1] When viewers move their hands over one of its 26 pages, sensors around the book trigger a projector to beam down text from above according to what page has been opened and according to the movement of the hand over each page. The text runs from one side to the other and overwrites itself like a palimpsest, or it circles around a transparent 3-D tube. As Small states, "The piece explored new types of reading in tune with human perceptual abilities."[2] Such exploration is in line with many other experiments with the visual appearance of text in digital media as well as in print media. It brings up a tradition that goes back to ancient and medieval times. In this chapter, I set out to discuss the historical and contemporary context of Small's piece as well as the aesthetic and philosophical concepts behind such experiments with the appearance of text. Small's piece seems a perfect fit with postmodern mannerism and the aesthetics of the spectacle—the earmarks of contemporary culture. It also seems to be a good example of the aesthetics of "pure code," which allows us to simply enjoy the materialization of the code without engaging with it on a semiotic level. While the analogy of "pure code" to the "pure visual" and "pure poetry" will require discussion of this effect-aesthetics in the context of the avant-garde, the reading of Small's piece in this chapter will, in the end, reveal a deeper meaning behind its seemingly self-absorbed technical gadgetry.

Concrete Poetry in Print

The title of Small's piece is in itself suggestive because it succinctly describes what is happening: "Writing with Light." However, the title not only refers to a technologically innovative method of text presentation, but it also points back to the past. Illuminated manuscripts are the brilliantly embellished books created in the Middle Ages. These texts—mostly copies of the Bible or religious hagiographic works—were laboriously hand copied and illustrated by monks in a scriptorium. The monks spoke the words aloud as they were copied, like a prayer or a form of meditation. The technique of illumination—elaborately conceived initial letters, ornamental borders, and ornate illustrations, often gilded in gold and silver—sought to illuminate the text in the sense of revealing its inner qualities. Illumination was an act of religious devotion, intended to release the light of

Figure 6. David Small, *The Illuminated Manuscript* (2002).

truth of the text from within. Illumination and ornament were in this sense not just illustration or art; they bolstered the message and authority of the text. Text and decoration were thus united in the truth of God's word.

William Blake revived the genre of the illuminated manuscript at the end of the eighteenth century as a vehicle for the revolution of the imagination. His *Illuminated Books* were pitted against the capitalist mode of mass production and presented a fusion of the visual and the literary into a form intended to cleanse the relationship of the senses to the imagination. This fusion is a constant, although rarely recognized, aspect of the history of books and writing. From antiquity onward, there have been texts that accrued additional meaning through their presentation. For example, in so-called labyrinth poems, the text line winds its way over the paper like the path through a maze, adding to the message of the text itself. In figurative poems, the text follows a given shape—in a religious context, often a cross, or in the baroque, secular figures such as a goblet, as was the case with a wedding poem for a couple from Bremen in 1637. Such poems can be considered early versions of interactive writing because they call for action by the reader, who must turn either paper or head to read the text. In the case of the wedding poem, the self-reflexive joke was that in doing so, the reader may have felt dizzy, as if she herself had just drunk a goblet full of wine.

The philosophy behind this playing with form, this shift toward the visual quality of text, is a desire to free the word from its pure representational, designational function. Whereas in literature the physicality of language—such as its visual aspect—is normally neglected and even considered detrimental to the authority of the text (that is, the relation between signifier and signified), here the graphic arrangement of words on the printed page augments meaning. Words not only represent an object; they present it on the visual level. The goblet is seen before the reading process even commences.

Attention to the visual materiality of language increased in the 1910s and 1920s when futurists such as Filippo Tommaso Marinetti and Dadaists such as Tristan Tzara or Kurt Schwitters engaged in typographic experimentation, with the rise in the exploration of form beginning with Stéphane Mallarmé, who once condemned the tedious patterns of verbal presentation in newspapers and conventional books. Stéphane Mallarmé's *A Throw of the Dice,* first published in 1914, along with works by the Dadaists, take up Ferdinand de Saussure's division of the sign into two independent elements

linked only by chance: the signifier and the signified. Dada attempted to undercut a linguistics in which an absent signified might be construed to exist independent of its relation to a material signifier. The same is true of the work of poets such as Velimir Khlebnikov and Ilia Zdanevich, who gave theoretical treatment to the materiality of typographic character.[3]

Such experiments on the physical level of language were dismissed by surrealism, which only experimented with language on the level of mental representation. The earlier approaches were resumed in the 1950s and 1960s in the form of concrete poetry, a worldwide postwar movement in the art of poetry with leading figures such as Franz Mon, Eugen Gomringer, Reinhard Döhl, Ernst Jandl, Gerhard Rühm, Konrad Balder Schäuffelen, and Daniel Spoerri—to name only a few from German-speaking countries—and Augusto de Campos, Emmett Williams, and Jiří Kolář, to name three from other nations. The unifying element of these authors' poetry is that one cannot read it aloud; it has to be seen, as the title of one of Franz Mon's essays indicates: "Poesie der Fläche" (Poetry in Space; Mon 1994).[4]

A famous example of this more recent period of concrete poetry can be found in Williams's 1967 anthology of the genre: a work by Döhl, in which an apple is shaped by instances of the word *apple* surrounding the word *worm*. Another example is Gomringer's work *Schweigen* (Silence) from 1954, where the word *schweigen,* in five horizontal and three vertical lines, surrounds an empty, silent space. This gap in the center is the message of Gomringer's piece. The words are there to form the gap, driving home the point that, strictly speaking, silence can only be articulated by the absence of any words. The message resides, rather than linguistically between the lines, literally between the words. However, the piece does not dismiss the representational function of the word in favor of its visual value. Certainly the message is to be seen. But it can only be revealed if audiences previously read the surrounding words.[5]

Concrete poetry deals with the relation between the visible form and the intellectual substance of words. It is concrete in its vividness, in contrast to the abstraction of a term. It is visual not because it uses images, but because it adds the optical gesture of the word to its semantic meaning: as completion, expansion, or negation. The intermedial aspect is not a change of the medium or material but a change of perception, a change from the semiotic system of reading typical of literature to the semiotic system of viewing typical of visual art.[6] Whereas concrete poetry stands for the visualization of language, visual poetry applies images—for example, the image-text collages by Klaus Peter Dencker and Johannes Jansen.

A later version of visual poetry is *Leuchtstoffpoesie* ("luminous poetry") by Günter Brus, which combines prose and poems (his own and those of other writers) with drawings and which Brus, in the late 1970s, still called "illuminierte Manuskripte" in reference to William Blake's *Illuminated Books.*[7]

So after this brief historical survey, what is the deeper sense behind Small's *Illuminated Manuscript*? Is the installation intended to help release the truth of a text from within, like its medieval predecessors? I will postpone answering until after I have introduced the further development of concrete and visual poetry in the digital realm.

Concrete Poetry in Digital Media

The English translation of Franz Mon's *Poesie der Fläche*—"poetry in space"—already evokes Jay David Bolter's 1991 book *Writing Space.* Although unaware of Mon's essay, Bolter does not fail to establish a connection between digital media and concrete poetry: "Concrete poetry too belongs in the computer; indeed, the computer makes possible truly kinetic poetry, a poetry in which letters and words can dance across the screen before the reader's eyes" (145). Although Bolter here goes beyond the trope of space and evokes that of time, the main subject of his book remains as hypertext. Because of its nonlinearity, writing in hypertext is "both a visual and a verbal representation"—not writing of a place, as Bolter adds, "but rather a writing *with* places, spatially realized topics" (25). As such, however, taken as a form of concrete poetry, hypertext does not go beyond the traditional modes of expression already familiar from print media. By contrast, a piece such as Small's installation represents the dancing letters Bolter imagined and shows that in the digital realm, concrete poetry gains two additional means of expression. In addition to the linguistic and graphic qualities of words, time and interaction also provide elements of expression; words can appear, move, and disappear, and they can do all this in response to audience input.

An early example of the use of time in concrete poetry is *First Screening* (1984) by bpNichols, a suite of a dozen kinetic poems programmed in the Apple BASIC programming language on an Apple IIe computer.[8] Other examples include the work of Augusto de Campos and Ana María Uribe, both proceeding from concrete poetry in print to its kinetic version in digital media. Although the original version of de Campos's *poema-bomba* (1983–97) in the static realm of print captures the concretization of an exploding poem in a specific, silent moment, the digital version is more than

a mere still; it depicts an explosion in time as motion and sound.[9] De Campos sees digital media as a new playground for concrete poetry: "Practice has shown that the anticipations of concrete poetry find in the computer a naturally adequate vehicle for its new verbal propositions" (1999, 169).

In this spirit, Uribe proceeded from *Typoems,* as she calls her concrete poetry pieces in print, to *Anipoems,* her name for animated pieces of concrete poetry, which combine elegant minimalism with a refreshing sense of humor.[10] A link to the concrete poetry of the 1960s is also represented by Johannes Auer's 1997 digital adaptation *worm applepie for doehl,* in which the word *worm* eventually eats the apple made of instances of the word *apple.*[11] A further reference is Miekal And's *After Emmett* (1998), a poem of 53 pages, or rather screens, each consisting of a three-by-three grid of letters and punctuation marks such as "Eys Voy Age," "Eye Sea Eye" or "Sum Hot Day." Each character continuously cycles through a sequence of five to eight different typefaces, which creates an image of twitching, convulse hyperactive letters. The poem is a homage to Emmett Williams's *The Voy Age,* a 1975 piece composed of 100-word squares that diminish in size as the work proceeds until the grid is so small that it appears to be a period.

In David Knoebel's 2000 *A Fine View*—part of his collection "Words in Space"—we initially encounter a cloud of indistinguishable white over a black background, which then reveals itself as lines ascending one by one, slowly at first; then the speed and the space between the lines increase, as well as the size of the lines, until, after the last line, a big gray rectangle comes to take up the frame.[12] *A Fine View* features the following text:

> The view is fine from where
> the roofers take their break
> and offer coffee talk
> of sports and Bill, who lost
> his footing on the dew
> slick plywood.
> One flicks his cigarette.
> The others watch it smoke
> in downward arc between
> two beams, the shatter sparks
> against the basement slab.

The text starts out as a thin column ascending gently like the smoke of the cigarette it mentions; then the widening and acceleration evoke a fall to the ground. The evolving movement of the lines gives the viewer the

impression of falling; at the end, the word *basement* almost seems to crash into the viewer's face, like the gray rectangular slab, blending the fall of Bill, the fall of the cigarette, and the fall of the reader. This presentation of the text is a more performance-heavy and novel realization of the same impulse that yields a poem about an apple, shaped like an apple. The spatial and temporal presentation of the poem mirrors the written content and complements it by giving the reader a viewpoint which is a part of the reported fall of Bill. Needless to say, despite being in Bill's shoes, the viewer never feels as though she is in any real danger. However, this kind of remote immersion also mirrors the experience the other roofers may have. Exposed to the risk of a fatal fall every day, but needing to carry on with their lives and their jobs, they have no choice but to think of themselves as readers who remember their observation of a terrible accident at a distance, as if it could never happen to them. Thus, in addition to getting a taste of the experience of falling to one's death, the reader of *A Fine View* is put in the surviving roofers' shoes, and vice versa: they themselves take on the role of reader.

Although this kind of kinetic concrete poetry is reminiscent of the text movies and television poetry of the late 1960s and early 1970s—for example, *So Is This* by Michael Snow (1982)—the interaction between a piece and its perceiver goes beyond the cinematic.[13] *Das Epos der Maschine* (The Epic of the Machine), by Urs Schreiber, the winner of a Net literature competition sponsored by the French–German TV channel *Arte* in 2000,[14] depicts technology as a kind of dubious God trying to control us. It also allows the interactors to feel the pressure exercised by technology because they have to follow certain hidden patterns before gaining access to other parts of the text. One remarkable effect is that the words that call technology into question are themselves formed into a question mark. The visual realization—the fact that the words move a bit across the screen—distinguishes them from the word *Wahrheit* ("truth"), which remains immobile. When interactors click on this word, the other words disappear behind it, suggesting that doubt has been suppressed behind an unshakeable truth, or that truth has swallowed up what called it into question. However, the removal of the critical words is short term: as soon as interactors move the mouse (and with it automatically the word *Wahrheit*), they all reappear. They adhere to the word truth, follow it wherever it goes, and can be eaten up again and again, but never erased. Once a question has arisen, the message would seem to be, it can never be gotten rid of—it will be

encountered again and again, provided there is movement in the discourse. The interaction suggests that the openness of discourse rests in our own hands.

The interactive audiovisual rollover poem *Yatoo* (2001), by Austrian artists Ursula Hentschläger and Zelko Wiener, starts without any text (Figure 7, *top*).[15] A red, glowing orb appears in the middle of the dark screen. A group of dots swirl in to make a complicated geometric weave in the center of the orb. Then the weave teases apart, shaping into a large, solid star. As the reader moves the mouse over the star, it falls apart again into a clutter of fragments that alter their shape with every new mouse contact. The fragments each utter a word in a female or a male voice that appear to be similarly fragmented. The interactor strives to return to the solidity and coherence of the initial star and will realize that the fragments may restore the original shape if rolled over several times. She will eventually discover that if she touches one side of the corners of the star in sequence, whole sentences can be heard, and the star's constituents modify themselves constantly in kaleidoscope movements (Figure 7, *center*). Failing to do so, however, will produce verbal nonsense and visual disorder (Figure 7, *bottom*). The sentences are admittedly simple—"You are the only one," for example, which also explains the initials of the title— and certainly do not represent a pinnacle of English-language poetry. However, this is partly due to the poetics of constraint within which the poem is founded: each line can only consist of five words, one for each corner within the star. The piece becomes interesting in the realm of interaction, which adds a constraint of perception to the poetics of formal constraint. To understand the given text, one has to navigate the star in a certain sequence. The requirement to pay careful attention while moving the mouse over the star appears to comment on the overall romantic message of the poem. Relationships require people to understand and take into account their underlying setting; otherwise, communication is impossible. The poetics of constraint and the constraints of perception are nonlinguistic elements of the message, a subtext of the spoken words, which cannot be overlooked during our interaction with the piece.

All the examples of kinetic concrete poetry discussed above share the requirement of a common medium: they all are presented on a computer screen. Another grouping of kinetic concrete poetry is found in installations such as *Text Rain* (1999) and *Still Standing* (2005) that combine a linguistic, textual dimension and its mode of presentation with the bodily

Figure 7. Ursula Hentschläger and Zelko Wiener, *Yatoo* (2001). Copyright Ursula Hentschläger and Zelko Wiener, 2001. The poem initially begins without text (*top*). Whole sentences can be made to appear (*center*). Verbal nonsense and visual disorder will appear if the interactor does not learn how to control the installation (*bottom*).

movement of the interactor. As far as medial environments are concerned, there is a third grouping of kinetic concrete poetry: that found in the Cave. An example from this group already discussed in the previous chapter is *Screen* (2004) by Noah Wardrip-Fruin, which executes the loss of memory addressed in a text by having words peel of the wall and requiring interactors to put them back in their place. Another example is *Lens* (2004–) by John Cayley, which plays with different layers of text interlaced in a mise-en-abyme (Figure 8).[16] The visitor to the Cave is first presented with a layer of text (white letters on dark ground), among it the word *lens* with small (dark) text on the surface of its letters. Moving closer to the word *lens* gives the impression this smaller text exists behind the letters in an entirely different space to which *lens* is a window or lens. The reader can eventually step through the word *lens* or one of its letters into this other realm of text (black letters on white ground)—to find again the word *lens* with smaller text on its surface.[17] As in any mise-en-abyme, the journey through the layers of text by stepping through the lens is infinitely recursive.[18] In contrast to other media, however, in this case, it is up to the reader or viewer to terminate her journey. The symbolic of this form of mise-en-abyme is twofold. First, text becomes the surface for or window to another text. Second, all text becomes the surface/window for/to another text. The first aspect may signify that the perception and understanding of one text yields to another, deeper layer of text which then will lead to an even deeper level of understanding. A less optimistic reading understands a constant deferral related to Derrida's concept of *différance* as endless deferral and difference without the happy ending of an arrival at a destination (or an origin). In this reading, the symbol of the lens takes on a different meaning. Rather than promising access to the truth, it obscures this access through endless deferral and resembles a trapdoor to the abyss of skepticism characteristic of the philosophy of *différance*. Instead of promising the exit from the cave—as Plato imagines in his allegory in book 6 of *The Republic,* anticipating the Enlightenment—it underlines, in the sense of postmodern enlightenment, its inescapability.

While *Lens,* with its symbolic inevitably, triggers a philosophical reflection, the concept and title of *Arteroids* (2001–4) by Jim Andrews seems to point rather to the context of computer games. *Arteroids* is a literary computer game, a first-person shooter that allows us to shoot down words.[19] The weapon is the word *poetry,* and its targets are words slowly crawling over the screen; the attacker, also the word *poetry* (in a different color) aims at collision. Whereas *Yatoo* requires the interactors' navigational discipline

Figure 8. John Cayley, *Lens* (2004–), screen shot based on electronic installation, Brown University, Center for Computation and Visualization, Cave installation environment. Image courtesy of the artist.

to receive a meaningful text, *Arteroids* requires navigational skills to decipher entire sentences. The more skillfully one plays, the more words appear, until one is able to construct sentences: "The battle of poetry against itself and the forces of dullness." The attempt to decipher these words (sometimes rotated by 180 degrees) absorbs the attention one needs to fight attackers: reading is threatening your life, as on any battlefield. The meaning of this poetic shoot-'em-up game is the undermining and redefinition of the rhetoric of such games which is already referenced by the title's allusion to the classic 1979 arcade game *Asteroids*, in which asteroids and flying saucers are to be shot with rockets from a spaceship. The appropriation and resemanticization of the shooting game can be understood in terms of the situationist's détournement, but also as a practice of what poetry is supposed to do: attack clichés and expectations. The fact that all the words hit will burst, making characteristic game sounds, into their component letters and rearrange themselves on the screen reenacts the breaking of asteroids into smaller asteroids in the

original game (although in *Arteroids* those smaller pieces do not present a new level of threat). The transformation from readable words into mere visual objects also allows a symbolic reading: the killing of the text is read as a shift from the culture of meaning to a culture of presence. The question of meaning and presence is picked up by Andrews himself, who considers *Arteroids* to be a shift "between text as readable literary object that gets its primary meaning from the meaning of the words to text as meaning via sound, motion, and destructive intent" (2002). *Arteroids* raises the question of tension between reading and physical action that we have already encountered with respect to *Text Rain, RE:Positioning Fear* (1997), and *Still Standing.* As concerns *Arteroids,* the difference lies in the speed: "When you play the game, you can play it at low velocity and read the texts and at low velocity it's a kind of vispo [visual poetry] (dis)play device, whereas if you turn the velocity up, it turns into a challenging, slightly competitive computer game" (Andrews 2002). Speed alters the genre of the piece and its relationship to meaning.

The questions Andrews explores with *Arteroids* can be applied to all forms of kinetic concrete poetry: "What are the possible roles of language in dynamic multimedia work for the Web? Can poetry go here and live?" Andrews leaves the answer to the audience: "Well, judge for yourself." In the context at hand, his question gives reason to discuss the poetics of kinetic concrete poetry. We are well advised to recommence this discussion in relation to concrete poetry in print.

Neo-Baroque and Generation Flash

Because of its focus on form, concrete poetry could be accused of being incapable of having an impact on the reader's consciousness, and hence useless for political interventions.[20] Such a judgment would seem to be inappropriate with respect to clearly political messages in examples such as Claus Bremer's *immer schön in der reihe bleiben* ("keep in line"), which intends to undermine obedience, or Ivan Steiger's *Nein* ("no"), which builds the word NEIN out of many JA ("yes") words.[21] Apart from such direct political examples, the argument has been made that focusing on the text's materiality implies reflection on the use of language and increases our sensitivity toward, and ability to discover and reject, all attempts at instrumentalizing language. Subverting the conventions of representation also opposes the established social order (Drucker 1994). The isolation of words from the usual setting of language, as Gisela Dischner (1978) argues, allows

the natural way of speaking suddenly to appear in a different light—as questionable, less straightforwardly comprehensible. From this perspective, the deconstructive play with the symbolic orders of language—and representation—involves questioning and undermining social patterns. As Chris Bezzel (1978) notes, a revolutionary poet is not somebody who writes appealing sentences about revolution, but somebody who revolutionizes poetry with poetic means.

This focus on form rather than content reminds us of Adorno's dictum that it is not the content but the form that makes an artwork socially significant. Nonetheless, it can be said that however revolutionary concrete poetry may be, this revolution occurs as a playful event, as "a kind of game," as Williams states (1967, vi). There is a danger that the sensual pleasure is not combined with the pleasure of reflection, that the linguistic play remains harmless. The focus on form reminds us of the hypertrophy of artistic means and the atrophy of content in the baroque and mannerism, which are marked by exploiting effects, audience amazement, and emphasis on entertainment.[22]

With respect not to concrete poetry but to film and other forms of entertainment, the shift from content to form in contemporary culture has been widely described as neo-baroque.[23] Important in this diagnosis is the perception of a trend in the direction toward the spectacle. Angela Ndalianis sees contemporary entertainment media dominated by neo-baroque logic because it shares a "baroque delight in spectacle and sensory experiences" (2004, 5). Thus, in contrast to the classic Hollywood film, which "entails a visual and auditory style that remains at the service of narrative unity," in the new Hollywood, for instance, "existing reality is devalued in favor of an effects space that postpones narrative and instead invokes the experience of transcendence or heightened emotions" (158). The prioritization of spectacle over narration also informs the ideas of Andrew Darley, who discovers "a shift away from prior modes of spectator experience based on symbolic concerns (and 'interpretative models') towards recipients who are seeking intensities of direct sensual stimulation" (2000, 3). The "prevalence of technique and image over content and meaning," manifest in computer-designed movies such as *Star Wars* (1977), *Total Recall* (1990), or *Terminator 2: Judgment Day* (1991), signifies a "culture of the depthless image," an "aesthetics of the sensual," which puts the audience "in pursuit of the ornamental and the decorative . . . , the amazing and the breathtaking" (192, 193, 169). The link between digital media and the baroque is also made by Anna Munster, who maintains

that both the baroque and digital space "engage the viewer visually, seductively and affectively" (2006, 6) and sees a revival of the baroque *Wunderkammer* in the wonders and curiosities of virtual reality. As early as 1998, Sean Cubitt compared the rendition of space as spectacle in baroque ceilings and immersive VR systems: "As in the decay of the baroque, we find ourselves addicted to the shocking for its own sake, the montage of affects" (1998, 77). Cubitt also notes a change of the nature of the spectacle due to the loss of divine reference: "Without it, church and state alike lost the right to provide narrative coherence to the processes of spectacle, and the spectacle took on a life of its own for subjects uncertainly placed between God and throne" (77). Although it is important to note that in baroque, the divine and the metaphysical dimensions do not disappear, nor does narration, it is certainly appropriate to state that the baroque (and more so mannerism) is dominated by the sense of fragility of world and the prevalence of the spectacle, and it is inspiring to make the link between this historic moment and the present time.

Darley and Ndalianis, Munster and Cubitt come to their conclusions from the analysis of movies, MTV, computer games, and VR environments. However, the attention to formal aspects, the transformation of the reader or interpreter into a sensualist, which Darley notes in respect of electronic media (2000, 169), can also be identified in other fields of digital media. When Michael Joyce declared hypertext "the word's revenge on TV" (1995, 47), he also pointed out the general feeling that the MOO (a text-based online virtual reality system) is a mistake of technological history, an interregnum in the immanent hegemony of the postalphabetic image, and "soon the image will either rob us of the power—or relieve us of the burden—of language" (2000, 42). Shortly thereafter, Bolter spoke of the "breakout of the visual" in the digital world, observing that in multimedia, the relationship between word and image is becoming as unstable as it is in the popular press (and TV, I might add), where images are no longer subordinate to the word and "we are no longer certain that words deserve the cultural authority they have been given" (1996, 258, 262). In 1999, Robert Coover, a leading advocate of hyperfiction, declared the passing of its golden age. The constant threat of hypermedia, he wrote, is "to suck the substance out of a work of lettered art, reduce it to surface spectacle."[24] One element of this aesthetics of the spectacle is the postalphabetic text, as Matthew Kirschenbaum (1999) calls David Carson's design style that "refashions information as an aesthetic event." Carson represents the shift from the reader to the sensualist even before the takeoff of

digital media in design and typography between the mid-1980s and the mid-1990s. The replacement of the reader starts by means of letters. In addition to the displacement of text by other media, there is its transformation into a visual object deprived of its linguistic and literary value and function. As we have seen, this transformation is characteristic of interactive installations. It is, as will be shown, typical of examples of kinetic concrete poetry as well.

Ndalianis suggests that the domination of contemporary entertainment media by neo-baroque logic is the result of technological, industrial, and economic transformations (2004, 5). The impact of economics and technology on aesthetics is definitely an important factor, and as far as digital media is concerned, one certainly has to take into account the fact that software, with its libraries of effects and its facilitation of the production of new effects, supports and encourages the use of effects for effects' sake. However, it is also important to note that Peter Greenaway, a 1980s filmmaker whose work has been compared most often with the baroque and mannerism, explains the irony and lack of a fixed narrative position in his films by claiming there are no positions one can still take, no certainties, no facts (Kilb 2002, 235). This statement represents not only the metaphysical disorientation characteristic of the baroque but also the position of skepticism and metaphysical void typical for our postmodern times. Greenaway, who also has been considered *the* postmodern filmmaker, prompts us to ask, what impact will philosophy and politics have on aesthetics?

Reference to postmodernism opens many cans of worms—not only with respect to its charge of being a neoliberal lifestyle philosophy that has ruined critical theory, but also in terms of its origin, tradition, duration, and theoretical contradictions.[25] Thus, it has been fiercely debated whether postmodernism constitutes a break with modernism or is rather to be seen as a radical continuation of its tendencies. When Michel Foucault, in "What Is Enlightenment?," suggests to "envisage modernity rather as an attitude than as a period of history," meaning by attitude "a mode of relating to contemporary reality . . . a way of thinking and feeling" (1987, 164), he opens up a way to understand postmodern thinking as rooted in what has been described as the beginning of modernity: the Enlightenment. When Foucault rejects the "intellectual blackmail of being for or against the Enlightenment" (169)—that is, to "accept the Enlightenment and remain within the tradition of its rationalism" or to "criticize the Enlightenment and then try to escape from its principles of rationality" (167)—he allows us to

speak of a "postmodern enlightenment" even though, or rather for the very reason that, this enlightenment does not share the Enlightenment's belief in grand narratives such as the destiny of history, the universality of values, and the binding power of truth. Although this is not the place for a thorough discussion of the complexities of postmodernism and its interpretations, I will state—and it is surely safe to do so—that postmodern philosophy is characterized by an antifoundational bias and a skepticism of any kind of claim to knowledge of the truth. This skepticism is an effect of the epistemological crisis postmodern philosophy entails, described most prominently in Jean-François Lyotard's *The Postmodern Condition: A Report on Knowledge* (1984).

This skepticism translates into "a knowingness that dissolves commitment into irony" (Pegrum 2000, 106), an irony that incites a hip and fanciful attitude that takes nothing seriously.[26] In pop culture, postmodern skepticism generates song lyrics such as, "Now write down some lines tomorrow they are wrong" in Maxim Rad's "It's Now It's New" (1979) or, from "A Sense of Belonging" (1984) by Television Personalities, "Once there was confidence / Now there is fear. . . . Once there was reason / For our optimism / Now we are drowning / In a sea of cynicism." Talking Heads, in their 1985 song "Road to Nowhere," present this cynicism as humor: "We're on a road to nowhere / Come on inside." Four years earlier, Italian philosopher Gianni Vattimo (1981) declared it to be the new agenda of his discipline: no longer would philosophy show people where they are on the road in life; rather, it would describe how to live with the condition of being on the road to nowhere. A cynical reaction to the postmodern condition in the academic world is the replacement of communism by consumerism as the new ideology of social utopia, as, for example, by German media researcher Norbert Bolz, who celebrates the substitution of consumerism for ideology as "pragmatic cosmopolitism" and a sign of global society's immunity against the virus of religious fanaticism (2002, 14).

The aesthetic significance of the postmodern experience is the loss of the author as social critic.[27] While modernism supported "the age of manifestos" (Danto 1997, 34), contemporary art is marked by conceptual disorientation. The trans-avant-garde, which was first described in Achille Bonito Oliva's 1980 book *La transavanguardia italiana*, no longer seeks to generate or propagate social utopia. The end—Vattimo says the *Verwindung*—of metaphysics results in the "Death or Decline of Art," to quote the title of one of Vattimo's essays (1988, 60).[28] If there are no more emphatic messages, a logical reaction is to shift focus to ornament, decoration,

and rhetoric refinement. Art has lost a belief in depth—"it doesn't believe there is any depth in life, and wouldn't be able to endure the pressure of its depth if it believed life had any," as Donald Kuspit explains with respect to the "postmodern nihilism" in Andy Warhol's work (2004, 152). The loss of depth is also deplored by representatives of critical theory. As Frederic Jameson notes, in a postmodern society, the beautiful is compromised as decoration "without any claim to truth or to a special relationship with the Absolute" (1998, 84). As he observes in his foreword to the English edition of Lyotard's *The Postmodern Condition*, the philosophical speculations brought forward here had significant consequences in the field of aesthetics (1984, vii).

Lyotard himself, in his writing on aesthetics, following the description of the erosion of grand narratives in *The Postmodern Condition*, focused on the event and intensity of the moment at the expense of message and signification, as in his study on Kant, *Lessons on the Analytic of the Sublime*, as well as in his essays on the sublime and the avant-garde. In his "Answering the Question: What Is Postmodernism" (included as an appendix in *The Postmodern Condition*), he calls "modern the art which devotes its 'little technical expertise' (son 'petit technique'), as Diderot used to say, to present the fact that the unpresentable exists" evoking an "aesthetic of sublime painting" (1984, 78). The rationale behind Lyotard's focus on the event is his notion that the language games supporting what we call knowledge consists of discourse and figure—that is, the general structure through which a narrative gives meaning and the specific event of narration. While the modern emphasizes the former, the postmodern favors the latter as interruption of the control-seeking discourse, the contingent incident in a presumed universality. "This orientation," Marvin Carlson concludes, "shifts attention from general intellectual or cultural structure to individual events, and from the determination of a general truth or general operating strategy to an interest in 'performativity'—activity that allows the operation of improvisatory experimentation based on the perceived needs and felt desires of the unique situation" (1996, 138). This shift, I shall argue, also paves the way for the return of decoration and mannerism.

Hal Foster formulates his critique on the prevalence of excessive decoration in postmodern aesthetics in his incisive book *Design and Crime* (2002), borrowing from the Austrian architect Adolf Loos (1970), who confronted the aesthetic hybridity of art nouveau in his 1910 essay "Ornament and Crime," in which he argued that the evolution of culture is synonymous

with the removal of ornament from utilitarian objects. Foster likewise condemns the "penetration of design in everyday life" and sees in Frank Gehry's 1997 Guggenheim Museum in Bilboa an example of the aesthetic of the spectacle: "Rather than 'forums of civic engagement,' his cultural centers appear as sites of spectacular spectatorship, of touristic awe" (2002, xiii, 41). Foster's reference to Guy Debord's legendary 1967 essay "The Society of the Spectacle" can also be found in Jameson when he describes our postmodern time as the "society of the spectacle" (1998, 87). The return of the ornament is part of postmodernism's overcoming of the modern aesthetics of functionality and consolidates the aesthetics of the spectacle.[29] With its focus on decoration, formal experiments, and the spectacular, postmodern aesthetics reenacts what is known not only from the baroque but from all forms of mannerism. Postmodernism may, as Umberto Eco suggests, just be the "modern name for mannerism as metahistorical category" (1994, 530).

Coming back to our question concerning the poetics of kinetic concrete poetry, we note that kinetic concrete poetry differs from its predecessor in the 1950s and 1960s not only with respect to the medium used, but also with respect to the role it is playing as art in society. The revolutionary pathos of the 1950s and 1960s can hardly be found today, when literature and art have abandoned a position of political commitment and are no longer really considered a means to intervene in the symbolic practice of contemporary society. Art has become more a place for formal experiments without the political significance of formal play with the symbolic orders of language—and representation—that it had, or was supposed to have had, in classical concrete poetry. Coming back to Andrews's question about the possible role of language in dynamic multimedia works, we have to expect that such social circumstances in this medial environment yield, as Darley concludes in his exploration of *Visual Digital Culture*, a prevalence of technique and image over content and meaning: "a curiosity or fascination with the materiality and mechanics (artifice) of the image itself" (2000, 114). While earlier artists may have criticized the society of the spectacle, a new generation of artists do not care much about such critique. Rather, they engage in the mannerist or neo-baroque delight of spectacle and sensory experiences. Borrowing from Lyotard's description of modern art and Foster's comment on Gehry, we may say that these artists devote their technical expertise to a presentation of the spectacular, which perhaps should not be called sublime but nevertheless aims to evoke the audience's awe.

In "Generation Flash," Lev Manovich (2002a) announces the software artist as successor to the media artist, who during the 1960s supplanted the romantic artist. The software artist overcomes the "second hand" art of the media artist and produces once more "from scratch." As Manovich points out, the subject matter of the media artist is not reality itself, but the representation of reality by media, which provides artistic permission to use the content of commercial media—to, for instance, rephotograph a newspaper photograph or reedit a segment of a TV show. In Manovich's words, the media artist is "a parasite who lives at the expense of the commercial media—the result of collective craftsmanship of highly skilled people." In reaction to thirty years of media art, the software artist is "tired of being always secondary, always reacting to what already exists." As the romantic artist did before her, the software artist "marks his/her mark on the world by writing the original code." The focus on coding original work increases the importance of craftsmanship and is accompanied by a diminishing role for critique. Generation Flash "does not waste its energy on media critique. Instead of bashing the commercial media environment, it creates its own: Web sites, mixes, software tools, furniture, clones, digital video, Flash/Shockwave animations and interactives."

Manovich is right to state that Flash aesthetics exemplify the cultural sensibility of a new generation. This aesthetic is not unique or limited to Flash software but to the concept behind this and other programs (Shockwave, DHTML, QuickTime), which indeed can be best characterized by the word *flashy. Flash* may be the modern word for mannerism or baroque. Such comparison runs counter to Manovich's (2002a) notion that Generation Flash "re-uses the language of modernist abstraction and design—lines and geometric shapes, mathematically generated curves and outlined color fields—to get away from figuration in general, and cinematographic language of commercial media in particular," to get away from, as Manovich puts it at the beginning of his essay, the "baroque assault of commercial media." It is debatable how representative Manovich's report about the earmarks of Flash aesthetics is and to what extent the software artist of the Generation Flash indeed and deliberately "uses neo-minimalism as a pill to cure us from post-modernism." However, the difference between the pompous realism of commercial media and the minimalist, abstract compositions of digital media must not obscure the shared obsession with sensory experiences, curiosities, and artifice, as well as the fascination with materiality itself. When Alan Liu notes that in contemporary culture "libidinal investment in technology converts with unprecedented ease into

the pure eroticism of *technique,*"he also points out that the "hedonism of pure technique" is "not just fun but fun expressed elegantly in design technique" (2004, 236). Programmers observe a certain discipline that explains why their "design worship" (236) does not automatically result in baroque opulence but also in minimalism. Yet this kind of cooling the eroticism of technique does not revoke the noted ascendancy of technique and virtuosity (that is, programming skills) and fascination (of coded effects) over content and meaning characteristic of baroque and mannerism as well as the neo-baroque aesthetic in contemporary culture.

The obsession with sensory experiences and attraction to the curious is proven by many contributions to the exhibition of 122 software artists for which Manovich's 2002 essay on Generation Flash was originally written.[30] Those works provide a fascinating mixture of sound and animation, wit and beauty, which, however, do not aim to convey a specific message beyond the joy of the creation itself and the celebration of the technical effect as such.[31] A typical example of the Generation Flash aesthetic is also Mark Napier's *P-Soup* (2003), which I discussed in the introduction. The "pure visual" in this work is reminiscent of the "pure visual" in avantgarde painting and film and can be seen as "pure code"—that is, code that does not generate objects to represent reality or ideas but to present itself. Pure code is selfish and narcissistic. It does not serve to convey any meaning or message; it is only interested in its own presence manifested as/represented by text, visual object, sound, process, or interaction.

Pure code may be considered the equivalent of "pure technology," which the Critical Art Ensemble, in their essay "The Technology of Uselessness," defines as technology that "serves no practical purpose for anyone or anything" but is "existing in and of itself" (1996, 77). Liu, who in his study *The Laws of Cool,* identifies cool as "information designed to resist information" and "use of information to abuse information" (2004, 179, 186), borrows the concept of pure technology from the Critical Art Ensemble when discussing the entertaining rather than utilitarian status of cool Web sites. According to Liu, the allure of "information cool" lies in the "technology of uselessness" (177, 186). This analogy is based on the neglect of utility in both, pure technology as well as information cool, that nevertheless has different reasons and intentions. The Critical Art Ensemble conceptualizes pure technology as an end of technological progress alternative to both the utopian as well as the apocalyptic narrative of technological and social evolution and understands it as the continuation of the conspicuous consumption of previous leisure classes as analyzed by Thorstein

Veblen (1996, 76, 79–80). Information cool can be seen as the update of useless technology, carrying on the need for excess—"that is, the need to have so much that it is beyond human use" (81)—by the consumption of useless or rather abused, i.e. uselessly rendered, information.[32] I hold that Liu's analogy between pure technology and information cool can be expanded to pure code to the extent that in Flash aesthetics the "code of uselessness" noted by the Critical Art Ensemble for pure technology (1996, 90) has been turned into useless code, i.e. pure code, that, to borrow the words of the Critical Art Ensemble, serves no other purpose than to exist in and of itself. To restate the reference to the pure visual made above, we may even say: The *l'art pour l'art* of digital art is code for code's sake.

Such analogy is also suggested by Liu's description of cool as "awareness of the information interface": "Cool is the code (in almost a literal sense, as we have seen) for awareness of the information interface—as if at the moment of cool we stared not *through* 'windows' toward the content of information but *at* the gorgeousness of stained-glass windows themselves" (2004, 183). In a footnote following this quote, Liu refers to the concept of "immediacy" and "hypermediacy" as developed in Jay David Bolter and Richard Grusin's *Remediation* (1999) and quotes from the book: "What characterizes modern art is an insistence that the viewer keep coming back to the surface or, in extreme cases, an attempt to hold the viewer at the surface indefinitely" (Liu 2004, 457n7; Bolter and Grusin 1999, 41). Such hypermediacic holding on the surface, such prevalence of the form by which content is presented over the content presented, is what characterizes pure code. It is a playful use of code beyond the use of the specific result of coding. Liu marks cool as "a 'way of looking' at the world of information that exceeds the utilitarian sense of either presenting or receiving information" (2004, 184). I will illustrate in chapter 5 how useful information is rendered uselessly in Mapping Art. In the chapter at hand, however, I focus on the question to what extent kinetic concrete poetry and the poetics of Flash result in works exceeding the utilitarian sense of meaning by offering artifacts for the sake and pleasure of their sheer presence.

My notion of pure code requires three clarifications. First, despite the anthropomorphization of the code that I am undertaking, it should be clear that it is the software artist who is celebrating the technical effect as such without the intention of producing deeper meaning. Second, it should also be clear that the software artist is not necessarily a serious programmer but may base her work on the effort of those who created the application program (Flash, Shockwave, DHTML) and therefore actually may

testify to their achievements rather than flexing her own technical muscles. Third, the code for code's sake that I am describing differs from the code for code's sake that is not so much interested in the effects representing the code but in presenting sophistication and virtuosity in coding by coding an effect under restrained circumstances such as, for instance, writing the shortest code possible for the solution of all sudokus.[33] This exploration of play in programming can be compared with the aesthetics of constraint such as palindrome, lipogram, pangram, tautogram, and homosyntaxism known from the experiments of the Oulipo. While this type of code for code's sake aims at the amusement of programmers (similar to the mathematical entertainment that Raymond Queneau claims in his 1965 manifesto *Litterature Potentielle* for the Oulipo), the code I am discussing does not direct its acrobatic ambitions toward programmers but intends to impress the nonspecialist.

The notion of pure code also calls for two additional remarks. If the artist does not intend to convey any meaning or message, she does not, of course, target conceptual thinking in respect of symbolic issues but rather matters of coding itself. Success and recognition is gained at the level of design and technical execution rather than on the level of thinking. This consideration complies with Clement Greenberg's assumption that the close concern with the nature of the medium, and hence with "technique," becomes an "artisanal" concern (1971, 46). In the paradigm of pure code, which is only concerned with its own materiality, fame is based on craftsmanship. How does the audience react to this situation? One has to assume that there is an implicit agreement between the author of pure code and her audience. If the author does not intend to convey any message but just wants to celebrate the potential of code, the audience is not required to engage with somebody else's point of view and can simply enjoy the code's emergence on the level of (visual, acoustic, performative) stimulation. The delight is on either side; the narcissism works both ways.

Generally, the academic approach to such narcissism is condemnation. The obsession with the technology of coding can be seen as another step in what Marshall McLuhan, in the chapter of *Understanding Media* entitled "The Gadget Lover: Narcissus as Narcosis," describes as man's infatuation with the devices he has created. With regard to the audience, the technology inculcates a disposition to surrender. The delight of sensual stimulation without symbolic concerns could be seen as kitsch in the sense

of giving up the specific distance between the "I" and the object in favor of a feeling of fusion and surrender (shall we say embrace?) to the object.[34] However, such labeling carries connotations that are not applicable in the case at hand and implies a pejorative statement to which we should not so easily acquiesce. In contrast to the effects of kitsch in literature, painting, or music, the focus on technical effects in digital media does not necessarily lead to the presentation of highly charged imagery, language, or sound, which normally yield an unreflective, emotional reaction. Pure code is not characterized by the oversimplified signification of an aesthetic means— on the contrary, it explores and helps establish the aesthetic means of digital media—but by the use of aesthetic means without the intention of signification. Rather than comparing it with kitsch, pure code should be associated with the avant-garde, which is also suggested by the terminology used: *pure visual* or *pure poetry* is normally discussed as avant-garde.

Such a link is also proposed by Darley (2000), who understands the growth of spectacle and the fascination with image as image within mass entertainment as a function of increasing attention to formal aspects, which prompts him to ask whether the popular films he discusses (including *Terminator 2: Judgment Day* [1991], *The Mask* [1994], *Independence Day* [1996], and *Starship Troopers* [1997]) share something in common with avant-garde films that also downplay or even oppose narrative. Darley's connection can be supported by reference to the cinema of attraction and its aesthetic of amazement represented, for example, by Sergei Eisenstein and Georges Méliès.[35] Ndalianis, in her discussion of neo-baroque aesthetics in contemporary entertainment, also sees this connection but points out that in contrast with the cinema of attraction, the contemporary cinema of effects is the product of a radically different industry (2004, 287n26). Such an explanation does not help us much with respect to the neo-baroque aesthetics of the sensual, the amazing, and the depthless in digital media, which is, except for the computer games industry, mostly based on independent individual production. Darley, who also adheres to a distinction between the avant-garde and the entertainment industry, offers a decidedly functional perspective by seeing the differences in the ways the excessive is foregrounded in avant-garde film and entertainment cinema: "For if it is the materiality of film (grain, focus, movement etc.) that is concentrated upon in the one, in the other, it is spectacle—the image— itself enabled by techniques such as computer image synthesis which, paradoxically, attempt precisely the opposite, that is, the dissembling or covering up of those features foregrounded in the former" (2000, 114).

Ornament and spectacle, one may conclude, obviate the need for inter-pretation, while the focus on materiality in formal aesthetic experiments inclines to make us aware of the material. For the audience, the aesthetic difference often translates into two completely distinct experiences. While the spectacle in mass culture provides distraction and pleasure, formal experiment in the avant-garde tests the patience of its audience. For exam-ple, Nam June Paik's *Zen for Film* (1964–65) confronts the audience with forty minutes of undeveloped film, and in Stan Brakhage's *Persian Series 13–18* (2001), undeveloped film is manipulated by hand. The difference becomes clear if we compare the digital morphing in James Cameron's movie *Terminator II* (1991) and in Michael Snow's film *Corpus Calossum* (2002). In Cameron's work, the technical effect makes the story more dra-matic and thrilling; in Snow's work, it is repeated over and over for the duration of a full-length movie without being embedded into a story, re-sulting in growing alienation and irritation in the audience.

It is obvious that Darley—and Ndalianis as well—wants to maintain a difference between the similar. He holds that the aesthetics of the formal and the special effect in the avant-garde makes us aware of and reflective concerning materiality, whereas in mass media it promotes spectacle. With the contrast of reflection versus distraction, the traditional opposi-tion of high and low art is reestablished. Darley nonetheless questions the valuation of this opposition, wondering whether ornamentation, style, spectacle, and giddiness are really aesthetically inferior or just different from the established values of literary, classical modern art (2000, 6). Such notions repeat the reclamation of pleasure in popular art that has appeared since the 1960s and has famously been endorsed by Susan Sontag in her "Notes on 'Camp'" of 1964. However, camp's appreciation of kitsch because of its extravagance and excessive decoration requires a sophistication— Sontag calls it "a good taste of bad taste" (1966, 291)—that resembles the old elite coterie of artists and viewers whose philistine sincerity and intel-lectual narrowness, as Sontag puts it, camp aims to undermine. Darley's intention in contrast—but in line with the postmodern opposition to the traditional distinction between highbrow and lowbrow art—is to justify an aesthetic without depth as "another kind of aesthetic—misunderstood and undervalued as such" (2000, 6). He therefore claims to approach the "'poetics' of surface play and sensation" openly and without any reserva-tions due to cultural pessimism (193).

Darley's intentions accord with that of Sontag's essay "Against Inter-pretation," in which she questions the quest for depth and describes the

"overemphasis on the idea of content" as "philistinism" (1966, 5). In the introduction, I discussed this essay in the context of aesthetic theories that point beyond interpretation and hermeneutics toward the sensual and the intensity of the moment. Such theories all more or less promote a shift from the paradigm (or culture, as Hans Ulrich Gumbrecht says) of meaning to the paradigm of presence. As an ideal genre representing such a paradigm shift, I proposed interactive installations, which stress the intensity of the personal experience in the moment of immersion, as well as what has just been described as Flash aesthetics. The keyword again is the neglect of hermeneutic distance and the playful and/or enthralled embrace of what is presented. Last, I want to discuss two examples of kinetic concrete poetry which willingly and unintentionally represent the aesthetics of the Generation Flash before I return to Small's *Illuminated Manuscript.*

Technical Effects and Deeper Meaning

A good example of nonfigurative software art is *Untitled* (2000) by Squid Soup, a group of designers, artists, and musicians that formed in 1997 who create commercial products such as online games, Web toys, and multi-user environments; they also experiment with the spatial materialization of sound (Figure 9).[36] *Untitled* is an audiovisual environment completely

Figure 9. *Untitled,* copyright Squid Soup (2000). Commissioned by The Remedi Project, http://www.squidsoup.org.

constructed of letters, between which the interactor is able to navigate and, in addition to psychedelic sound in the background, trigger small audio files with mouse clicks. Together with the sound, moving letters appear and slowly vanish into the room. Neither these letters nor the letters of the text walls combine to indicate linguistic meanings. The same applies to the words mumbled by a group of male voices as part of the audioscape. These words are created in a cutup-like technique.[37] *Untitled* is, as Squid Soup explains at the online gallery the Remedi Project, an exploration of synergy between audio and visuals. The result is postalphabetic, asemantic text, a fascinating, somehow hypnotic experience that makes absolutely no claim to semantic meaning. As Squid Soup explains in an e-mail from September 3, 2001, they consider their work successful if the audience is fascinated by the piece and gets "a feeling of being somewhere." *Untitled* is an example of art beyond hermeneutics aimed merely at the embrace of the present moment.

An example that almost paradigmatically embodies the development of concrete poetry from a meaning-driven aesthetics to the aesthetics of the sensual and technical is *Enigma n* by Canadian artist Jim Andrews. *Enigma n* was first developed in 1998 in DHTML as an anagrammatic play with the letters in the word *meaning.*[38] In print, one might perhaps concretize the shift of meaning by ordering the letters in horizontal and vertical lines reading in one direction as *meaning,* and in the other as *enigma n.* This setting reveals the anagrammatic surplus of the letter *n.* However, in Andrews's digital version from 1998, the letters, which at first appear as the word *meaning,* in contrast to the title *enigma n,* can be "prodded" and "stirred" by the interactor and take, when stopped, different positions on the screen each time, thereby giving meaning even to the letter *n* as the sign for a variable number. Andrews calls *Enigma n* "a philosophical poetry toy for poets and philosophers from the age of 4 up." This description stresses the artwork's playful character, which goes far beyond the play of concrete poetry in print not only because of the aspect of interaction, but also because of the possible alteration of size, color, and speed of the letters.

In 2002, Andrews published an audiovisual version with increased sensual effects. In *Enigma n^2,* the letters of the word *meaning* are not shown in changing positions. Instead, the word is spoken and manipulated by software.[39] As Andrews explains in a private e-mail from November 25, 2001, "The sound itself starts out with the word 'meaning' backwards and then there are two normal repetitions of the word 'meaning.' The program randomly selects a starting point in the sound and a random end

point (after the start point). And it selects a random number of times between 1 and 6 to repeat the playing of that segment"—with the option for the user to set the start point by clicking on the waveform. Andrews is certainly right in seeing *Enigma n^2* as continuation of *Enigma n* in that it is concerned with the enigma of meaning. Indeed, hearing these endless, interrupted, randomly looped attempts to articulate the word *meaning* supports this characterization. However, whereas *Enigma n* requires contemplating the deconstruction one sees on the screen, *Enigma n^2* allows users just to dip into the hypnotic atmosphere of sound mixes and visual effects. As Andrew notes in his e-mail, he considers *Enigma n^2* a kind of strange generative/interactive sound poetry/music: "I have my stereo hooked up to my computer, so my computer speakers are my stereo's speakers. I play it sometimes (fairly loudly) for a few minutes to hear if I can figure out more about that sort of music." The result is a work that, similar to *Untitled,* lulls us into a hypnotic, trancelike state. The original philosophical effort of the anagrammatic play in *Enigma n* has been replaced by the intensity of the sensual. Concrete poetry has turned into music.[40]

Considering Small's *Illuminated Manuscript,* we may not speak of a shift from concrete poetry into music but perhaps into a performance of attraction, with the same result of rendering the text unintelligible. The circumstances in which the piece was installed hardly provided an appropriate environment for a comprehensive reading. The embellished book in a dark room attracted many visitors, gathering around this virtual campfire, curious to know how the display of text worked. Reading was difficult because in order to decipher the text, interactors had to stop moving their fingers and wait until the letters had settled down. It is easy to imagine how hopeless these attempts proved because any would-be reader was surrounded by other people eager to test out the installation. However, this does not alter the fact that the book did feature text. This text draws attention to a third meaning of the title besides its technical and religious aspects, a meaning that does not stand for a technology of presentation but of thought. Illumination evokes Enlightenment, and indeed, the assembled texts are all dedicated to a typical Enlightenment topic. Small's book begins with Franklin D. Roosevelt's Four Freedoms speech to the U.S. Congress on January 6, 1941—freedom of speech, freedom of religion, freedom from fear, and freedom from want—and explores on the subsequent pages a collection of writing on the subject of freedom. Among the writings are the American Declaration of Human Rights, Martin Luther King's Letter

from a Birmingham Jail, and George W. Bush's Address to a Joint Session of Congress and the American People on September 20, 2001. What are we to think of this collection of texts? And what are we to think about the way such significant, important texts are presented?

To understand the scope of Small's attack on the intelligibility of the text, we may focus on the last text in his collection. In this text, President Bush speaks to the American people about attacks on their freedom and assures them that justice will be brought to terrorists. As Bush points out, "These terrorists kill not merely to end lives, but to disrupt and end a way of life," and he promises that "whether we bring our enemies to justice, or bring justice to our enemies, justice will be done." One can argue that such promises embody a way of life that is not the actual target of the terrorists. It signifies a strong belief in what is right and what is wrong, a belief typical particularly of conservative, static societies such as a fundamentally Islamic one. In the Western world, such belief has been undermined not only since postmodernism or Nietzsche's philosophy beyond good and evil, but starting (and this is the point of Foucault's essay "What Is Enlightenment?") with the Enlightenment, which requires disbelief in any authority and promotes the use of one's own reason instead. The result was that the use of reason eventually led to the disbelief of all authority and reason, including one's own, and led to a knowingness that dissolves commitment into irony. The postmodern "anything goes" is the popular and extreme reaction to—and simplification of—the constant discussion and inevitable deconstruction of any standard and regulation, resulting in acceptance of adultery, legalization of homosexuality and abortion, acceptance of medically assisted suicide, and so on. It is not only consumerism that signifies the way of life the terrorists of September 11, 2001, wanted to disrupt—and signifies the threat to dogmatic traditionalism—but also relativistic secularism, with its deconstruction of traditional concepts and values.

There is obviously a strong commitment and a lack of irony in Bush's speech. Nobody would expect things to be otherwise in such a situation. However, not everybody anticipated the biblical rhetoric of justice Bush established with concepts such as "crusade," "axis of evil," "you are either with us or against us in the fight against terror," and the apocalyptic declaration of the "moment of truth."[41] Apart from the truth that there were no weapons of mass destruction in Iraq, the (religious) fundamentalism that Bush represents is not far from the fundamentalism of the terrorists. It is well known that many politicians and religious leaders in the Western

world refused war as a just means. This already shows how difficult the issue of justice actually is, let alone the discussion about the possible role the Western world plays in the creation of the hatred behind the terrorist acts.[42]

From a philosophical perspective—or, rather, on the grounds of post-modern philosophy and the ethics of difference—the idea of universal value and truth has been challenged, and with it universal concepts of justice. Postmodern pluralism can hardly be aligned with the regulative idea of judgment. As a consequence, Lyotard declares that there cannot be a "sensus communis" and that we make "judgements about the just and the unjust without the least criterion" (Lyotard and Thébaud 1985, 14). While Lyotard here is speaking about judgment as such, be it in the field of beauty, truth, politics, or ethics,[43] Derrida, for a similar reason, questions the possibility of justice in his book on law and the "mystical foundation" of authority. Like Lyotard, who refers to a notion of Blaise Pascal's that "what is just is that which has been judged as just and on which everyone agrees" (Lyotard and Thébaud 1985, 81), Derrida refers to Pascal's *Pensée*, which in turn refers to Montaigne, who states that laws are not just as such, but only because they are laws. Pascal confirms that on the ground of reason nothing is just per se but everything is in flux (Derrida 1994, 29). Derrida takes up this notion of the early Enlightenment about the mystical foundation of the laws' authority and asks what we are left with after its deconstruction. A condition for any justice, he notes, is to address oneself to the other in the language of the other. Because this is not feasible, justice is eventually an experience of the impossible. Derrida concludes that one cannot objectivize justice; one cannot say "this is just" and even less "I am just" without having already betrayed justice (26). A demand for justice, he continues, whose structure is not the experience of an aporia has no chance to be what it intends to be: a just, appropriate call for justice (38).

Lyotard's and Derrida's takes on justice represent a thinking absolute in opposition to the position taken by Bush's politics and his Address to a Joint Session of Congress and the American People. While for Bush the world is divided into good and evil, friend and enemy, "with us" or "against us," from a postmodern ethics of difference, one's own position is to be regarded with skepticism and the position of the other is to be considered equally justified; freedom must include the freedom of the dissident. Such perspective is of course itself a very Western perspective not at all shared by people content with the mystical foundation of judicial and moral

authority—who, needless to say, are also an essential part of the Western world. It is this postmodern position at which the terrorist attacks aim first of all, because they share the belief in eternal values, while the postmodern rather believes that "absolute truth abolishes a habitable planet."

The line quoted above is borrowed from Brus and brings us back to Small. We find this sentence in a work from Brus's *Leuchtstoffpoesie* mentioned above as successor of Blake's illuminated books (1999). If not before, now the illuminated manuscript has given up the gesture of revelation once characteristic of this genre. Although the act of illumination already went beyond religious devotion with secular texts illuminated since the thirteenth century, and although the illuminated books by Blake and John Ruskin in the eighteenth and nineteenth centuries mainly had a social value as a protest against anonymous, mechanized capitalist processes of production, the aim of the illuminated book was never to mock its own content. With Brus, the poetics of revelation of the *illuminated* text has not only turned into *luminous* text, as he calls his work (*Leuchtstoffpoesie*), but it also questions the concept of absolute truth, which the illuminated text once served to release through its very illumination and ornament. With such downgrading of illumination from revelation to lighting and skepticism, Enlightenment has, so to speak, moved on to postmodernism.

Brus's statement about the invalidation of truth is trapped in the same contradiction that postmodern philosophy has been accused of: it suggests being true. Small's *Illuminated Manuscript* finds a much more subtle and convincing way to carry out the same maneuver of deconstruction by situating its message in the nonlinguistic dimension of technical effects. It neither reveals the inner qualities of the installed texts nor makes a statement about their validity. It just invites the audience to play disrespectfully with a number of important writings on the subject of freedom instead of allowing, let alone inciting, an engaged reading of such basic texts of Western culture. The authority of the texts—be it sacred or acquired through personal experiences—is destabilized by the way they are presented: in a postalphabetic, unintelligible mode. With this grammar of interaction, Small of course does convey a statement about the text, and to that extent, his piece uses the method of the original illuminated manuscript, although in a reverse manner: it uses the way the text is presented not to underline its authority but to undermine it.

This treatment of the text reminds us of the devaluation of the text's linguistic functioning in *Text Rain,* discussed in chapter 1. Similar to *Text*

Rain, and similar to traditional concrete poetry, the meaning of *Illuminated Manuscript* is based on both the linguistic value of the text and the specific mode of its presentation. Only if the reader knows the content of the text that is treated so disrespectfully will she understand the implicit message of the piece, which, in this case, is of course much more political than was the "message" of *Text Rain.* As with *Text Rain*—and *RE:Positioning Fear*—the text lives a double life as linguistic artifact and as object for playful interaction. As in those cases, only once the audience has researched and read the text (online or elsewhere) does Small's installation become complete.

Small's *Illuminated Manuscript* proves that kinetic concrete poetry may play with formal effects in a mannerist or neo-baroque way but still can provide meaning beyond the spectacular. The concern with formal play does not need to end in effects for effects' sake or in what I called pure code. There is room behind design and surface spectacle for deeper meaning. *Illuminated Manuscript* combines the concept of software art (to create from scratch while being concerned with the materiality of the code) with the concept of media art (to reuse content while being concerned with representation). Small's piece is another example of the paradigm of double coding noted with respect to *Text Rain* and *RE:Positioning Fear.* It provides joyful action on the surface level of perception, but it also provides moments of contemplation on the deeper level if the text undermined and mocked by the mode of presentation is accessed and understood in acts of reading beyond any physical interaction with the work. We may localize the former within the "culture of presence" and the latter within the "culture of meaning." As we will see in the next chapter, such double citizenship also occurs in other variations of asemantic text.

3 TEXT MACHINES

AT THE END OF THE 1980S, when people started to write about digital literature, they took their keywords and perspectives from the philosophers of the time, who intensively discussed death: the death of truth, the death of grand narratives, the death of identity, and the death of the author. Hypertext seemed to fit perfectly into this way of thinking. It was considered as democratizing and antiauthoritarian as those theories, for, with its system of links, it "[did] not permit a tyrannical, univocal voice" (Landow 1997, 36). As it turned out, the reference to poststructuralist and postmodern thought was based on misinterpretation. The death proclaimed in those theories was different from the kind of death announced by hypertext theorists; in fact, the latter was a renunciation of the former.

However, there was another demise of the author, one that poststructuralists and postmodernists rarely thought about: the replacement of the author by the text generator. Strangely enough, in this case, theoreticians in the field of digital literature argue for the life of the author, stating that she survives in the output of the machine because she has configured its databases and algorithms. All the nonsensical text generated by the computer is related to the way it has been programmed. Does such downplaying of the role of the computer in favor of human agency reveal an unconscious technophobia in the midst of our much-vaunted technophilia? The author is dead, long live the author?

Although some examples of literary text generators allow us to establish authorial intent in the text, the question remains how to construe the meaning of a text generated by an "author" for whom meaning has no meaning. If we refuse to anthropomorphize the computer, we are left with three options: (1) dismissing any meaning in texts without authorial intent regardless of its quality, (2) admitting meaning in texts regardless of their

authorship, and (3) seeing meaning in chance. While the first leads us to the old-fashioned theories declaring that the meaning of the text is identical with the intention of the author, the second resonates with deconstruction's search for meaning beyond the author's intention, and the third evokes a technologically enhanced oracle or pantheism. Although the religiously inclined path feels bizarre, it probably does less harm to literature than the technological ambition to generate text that seems to have a human author, but instead is generated automatically.

If the goal is to have the machine generate non-nonsense text, this necessarily requires formalization and simplification. Thus, an impetus with its roots in the classical avant-garde, in warfare against traditional aesthetic expectations, now leans toward conventionality. The internal problem of this genre of digital literature is its poetics of technology, which replaces a language juggler with a crafter of code. Because absurdity, weirdness, and illogicality are the default modes of text generators, mastery is only proven by overcoming such characteristics. Any idiosyncratic style— which might be read in conventionally generated literature as an attempt to be avant-garde—is perceived as a failure of the program. The less particular the language of the generated text, the more it demonstrates its excellence of coding. Because for the programmer the artwork is not the text but the text machine, its textual output is doomed to tend toward mainstream aesthetics.

The situation changes once the literary text machine is interactive and engages the reader as writer, as in the interactive drama *Façade* (2005) by Michael Mateas and Andrew Stern. Now it is up to the interactor to play the part of a rebel and test whether the program is advanced enough to keep the dialogue conventional. The situation is also different if the database is, for example, a story by a well-known author, such as Kafka. As Simon Biggs's *Great Wall of China* (1996) demonstrates, the generated nonsense receives its meaning from the meaning of the hacked text. The ghost in the machine in this case is an author from the past.

Although hypertext does not really empower the reader, her authorization obviously takes place in projects of collaborative writing. However, the reader's transformation into an author does not bring back the kind of author poststructuralist and postmodern theorists declared dead or departed. In fact, this brings about the death of the reader because coauthors do not listen to what other readers have written, and readers who drop by accidentally will not enjoy the text much if they fail to get involved in the project.

Computer-Generated Text

In 1990, Roy Ascott, one of the early and influential visionaries of digital art, stated in his essay "Is There Love in the Telematic Embrace?" that computer-mediated communication networking "makes explicit in its technology and protocols what is implicit in all aesthetic experiences, where that experience is seen as being as much creative in the act of their viewer's perception as it is in the artist's production" (2003, 233). In the context of this statement, Ascott refers to Roland Barthes's "From Work to Text" (1971) and to Derrida when he speaks of "electronic difference," reiterating a connection that also has been made by other theoreticians of digital art. George P. Landow referred to this connection in the title of his book *Hypertext: The Convergence of Contemporary Critical Theory and Technology*, explaining, "Contemporary theory proposes and hypertext disposes; or, to be less theologically aphoristic, hypertext embodies many of the ideas and attitudes proposed by Barthes, Derrida, Foucault, and others" (1997, 91). The alternatively navigable hypertext seemed to be the bringing into focused realization of principles that had otherwise seemed abstract and difficult. Hypertext was considered "a vindication of postmodern literary theory" (Bolter 1992, 24). However, this association was based on simplification and misinterpretation.

When Roland Barthes and Michel Foucault were proposing the author's death or dismissal, they meant the ownership of text in terms of creativity and originality, not in terms of composition. In his 1968 essay "The Death of the Author," Barthes declared "it is language which speaks, not the author" (1977, 143). Foucault, in his 1969 essay "Qu'est-ce qu'un auteur?," argued in a similar vein that the author is not the producer or owner of her text. Jay David Bolter's notion, that "the text is not simply an expression of the author's emotions, for the reader helps to make the text," seems to confirm this idea (1991, 153). Just as the author is determined by the discourses to which she is subject, so her reader is determined by his discourses and will consequently read the text in his own way. However, when Bolter relates this perspective on text to the technology of electronic writing, he conceptualizes the reader as "the author's adversary, seeking to make the text over in a direction that the author did not anticipate"—not, therefore, because of his own discourse history, but because of the option he may exercise to navigate the hypertext according to his own desires (154). In the same vein, Landow declares with reference to the linking in electronic text the "reallocation of power from author to reader" (1999, 156).

The author's loss of sovereignty over her text is mitigated by the loss of control over the text's combinatorics; the issues of ownership and power are reconnected to interpersonal opposition, which Foucault dismissed in favor of more complex structures. Hypertext theorists did not support discourse theory but rather betrayed it.

The "authorization" of the reader carried out by this shift of power was part of a general rhetoric of liberation of the audience, which can also be found—and reveals its historic tradition—in the discourse of interactivity and the degradation of the artist as heralded by John Cage and Roy Ascott in the 1960s. This valuation of the audience—and devaluation of the artist— is supported by the theory of interpretation promoted by Wolfgang Iser and Stanley Fish in the 1960s, giving the reader a much larger role in the author–text–reader triad. Both were seen as having anticipated hypertext—"When Wolfgang Iser and Stanley Fish argue that the reader constitutes the text in the act of reading they are describing hypertext" (Bolter 1992, 24)—while in fact, by giving the reader more power in establishing the meaning of a text, they did not claim her influence in shaping the physical body of the text, as did the debate on hypertext.

However, even if Barthes's and Foucault's notion of the death or disappearance of the author is misunderstood, the author writing a hypertext is not dead or powerless; nor does the reader who configures the text bear the same relation to writing as the author. It is the author who sets up the hyperlinks from which the reader can choose. It is the author, not the reader, who usually has access to the files that define the online content and thus controls the text after it has been published. In addition, one can argue that the hyperlinks allow the author to control the reader's associations: while in traditional text the reader encountering an abstract or ambiguous word uses her own concepts of that word based on her experience, in hypertext, the reader will usually follow the link if one is provided, to see what content the author relates to that word. Hence one can even say the author's annotations overwrite the reader's connotations (Matussek 1998).

Apart from hypertext, there is another genre of digital literature that addresses authorship and suggests the death of the author. In text machines and story generators, the text is automatically created by a computer program. Although in the discussion of hypertext today the role of the author is understood in a way that is much more complex than was the case in the early 1990s, with respect to computer-generated text, the question of authorship still requires a thorough critical exploration. Ironically, in

contrast to the author's hasty discharge in the early hypertext debate, the trope of the death or disempowerment of the author is now not at all played out in the way one would have expected. Rather than considering the author as being replaced by software, a number of theorists and practitioners regard the author as present in the software.

Automated text generation may be the oldest form of digital literature. As early as 1952, Christopher Strachey invented a program he named the Love Letter Generator, which automatically produced love letters on the basis of predefined words and patterns. One result reads as follows:

> Honey Dear
> My sympathetic affection beautifully attracts your affectionate enthusiasm.
> You are my loving adoration: my breathless adoration. My fellow
> feeling breathlessly hopes for your dear eagerness. My lovesick adoration
> cherishes your avid ardour.
> Yours wistfully
> M.U.C. (Strachey 1954, 26)

As is to be expected, the text sounds awkward and does not seem at all equipped to serve the usual aims of a love letter. Strachey appears to hand over authorship to a machine that cannot live up to the assignment. One may remember Roald Dahl's 1948 short story, "The Great Automatic Grammatizator," in which an engineer realized that the automatic computing engine he built can be used for more than counting numbers. His machine soon allowed him to dominate the field of fiction publishing, so presumably it would have written better letters than Strachey's. While "The Great Automatic Grammatizator" is fiction, the Love Letter Generator is real. Outside the fictional world, the replacement of person by machine generates text that may be syntactically correct but semantically nonsense or odd. However, the case at hand may be more complex. There are good reasons to see the actual intention of Strachey's Love Letter Generator as the deconstruction of the standard love letter in society, rather than the creation of generic love letters. Like his colleague Turing, Strachey experienced homophobia in postwar society. It is probable that with his Love Letter Generator, he parodied the familiar, sanctioned, conventional way to express love. The actual meaning of the Love Letter Generator would thus be the deconstruction of love letters. In this light, Strachey has not handed over authorship to the machine but authored a program that communicates his feelings.

However, although there are text generators deliberately uttering non-sense and intentionally undermining the notion of meaning—the deeper meaning behind such deconstruction of meaning will be discussed with respect to Simon Biggs's Kafka adaptation below—most of the literary text generators programmed since Strachey do not have an ironic or critical intention. Rather, they aim to create intelligible text that can stand on its own or support the writer's process of creation by offering plots and phrases. An example is Scott Turner's Minstrel (1992), which creates story fragments by "imaginary recall," a three-part transform–recall–adapt method (TRAM) that resolves a newly encountered problematic situation by recalling related problems from its memory, adapting them and apply-ing an invented solution. A product of this text generation is the story "The Vengeful Princess":

> Once upon a time there was a Lady of the Court named Jennifer. Jennifer loved a knight named Grunfeld. Grunfeld loved Jennifer.
>
> Jennifer wanted revenge on a lady of the court named Darlene because she had the berries which she picked in the woods and Jennifer wanted to have the berries. Jennifer wanted to scare Darlene. Jennifer wanted a dragon to move towards Darlene so that Darlene believed it would eat her. Jennifer wanted to appear to be a dragon so that a dragon would move towards Dar-lene. Jennifer drank a magic potion. Jennifer transformed into a dragon. A dragon moved towards Darlene. A dragon was near Darlene.
>
> Grunfeld wanted to impress the king. Grunfeld wanted to move towards the woods so that he could fight a dragon. Grunfeld moved towards the woods. Grunfeld was near the woods. Grunfeld fought a dragon. The dragon died. The dragon was Jennifer. Jennifer wanted to live. Jennifer tried to drink a magic potion but failed. Grunfeld was filled with grief.
>
> Jennifer was buried in the woods. Grunfeld became a hermit.[1]

As is typical of text generated in this way, the story is coherent but told in a strange, flat, uninspired manner. Because the text-generating machine has no understanding of the text it creates, it does not apply any stylistic variations between the different parts of the story. Interesting and emotional aspects, such as the dragon's actual identity or Grunfeld's despair after he realizes he has slain his love, are rendered in the same tone as the more banal parts of the story. There are no syntactical varia-tions, and the relationship between story time and time of narration does not vary depending on the content. The computer's rhetoric is a rhetoric of indifference.

The computer's rhetoric is also deeply rooted in a schematic dissolution of complexity that is in line with the principles of structuralism, the most prevalent theory of the 1960s and 1970s.[2] This is even more the case if the text is generated within the top-down paradigm, as is the case for Minstrel. This paradigm is based on preorganized knowledge of possible conflict solutions: The approach to a given conflict situation is the reduction of a complex process into its essential elements and rules. Thus for the story generator Makebelieve (2002) by Hugo Liu and Push Singh, for instance, the authors selected a subset of 9,000 sentences from the Open Mind Common Sense (OMCS) knowledge base. These sentences are semi-structured as a result of their use of sentence templates in their acquisition (Liu and Singh 2002).[3] Liu and Singh normalize the English sentences into a consistent form, for which they chose "crude trans-frames, each with a before (cause) and after (effect) event, further decomposed into verb-object form with the help of a constituent structure parser." The automated text generation then applies "fuzzy, creativity-driven inference" to the 9,000 sentences. It parses the sentence entered by the user into verb–object form and matches it, as an initial event, to the cause slot of some transframe in the repository. This leads to an effect phrase that yields a further cause phrase. In this way, the program creates a plot of five to twenty lines that reads like the following:

> John became very lazy at work. John lost his job. John decided to get drunk.
> He started to commit crimes. John went to prison. He experienced bruises.
> John cried. He looked at himself differently.

As Liu and Singh state, this plot of course needs to be filled with life and flesh by a real author. However, one wonders whether this text generator will lead to genuine stories the author would not have thought of without the help of the machine. Can this program really help a writer develop intriguing plots, let alone meaningful characters?

In contrast, RACTER (from French *raconteur*), a program in compiled BASIC written by William Chamberlain and Thomas Etter in 1983, delivers entire stories. This text generator for prose and poetry fills in its structures by searching through a database of 2,400 words that are categorized by identifiers that allow matching adjectives and nouns and provide the right context for nouns and pronouns.[4] The sentences are grammatically correct, and the program's adaptation and reuse of phrases previously applied gives the story a certain continuity. However, the word choice is random and the text appears all in all senseless, as the following excerpt

from the RACTER book *The Policeman's Beard Is Half-Constructed* (1984) shows:

> "War," chanted Benton, "war strangely is happiness to Diane." He was expectant but he speedily started to cry again. "Assault also is her happiness." Coldly they began to enrage and revile each other during the time that they hungrily swallowed their chicken. Suddenly Lisa sang of her desire for Diane. She crooned quickly. Her singing was inciting to Benton. He wished to assassinate her yet he sang, "Lisa, chant your valuable and interesting awareness." Lisa speedily replied. She desired possessing her own consciousness. "Benton," she spoke, "you cry that war and assault are a joy to Diane, but your consciousness is a tragedy as is your infatuation. My spirit cleverly recognizes the critical dreams of Benton. That is my pleasure."
>
> Benton saw Lisa, then began to revile her. He yodeled that Lisa possessed an infatuation for Diane, that her spirit was nervous, that she could thoughtfully murder her and she would determinedly know nothing. Lisa briskly spoke that Benton possessed a contract, an affair, and a story of that affair would give happiness to Diane. They chanted sloppily for months. At all events I quickly will stop chanting now.

Jack Barley McGraw (1995), who quotes this example, is certainly right to consider RACTER's prose "disturbingly superficial" and to underline that its acceptance relies on the audience's ability to construct "conceptual justification (seemingly out of thin air) for vaguely related strings of words." This need to read meaning out of hints that there might be meaning has been appropriately described as the author's becoming a parasite of the reader (Lem 1983, 265). However, readers may—especially if they know about the real authorship of the text—stop trying to "glean meaning that is not really there from empty prose," as McGraw puts it, but rather just be amused by the Dadaist nonsense that the text presents.

The situation changes when literary text generators create poetry instead of prose. The tradition of permutational poetry can be traced back at least to the Ars Combinatorica in the baroque, when authors required the reader to choose from alternative words offered at the end of a line, thus providing countless alternative readings.[5] Other milestones are Tristan Tzara's famous manifesto, "How to Write a Dada Poem" (1920), which suggests the composition of a poem by cutting out words from a newspaper and putting them together in random order, as well as Raymond Queneau's recombination of each line of ten sonnets in *Cent mille milliards de poèmes*

(1961).[6] While computer-generated prose can hardly be taken seriously by its audience, computer poems receive much more appreciation. The "stochastic" poems by Theo Lutz made with the legendary Z 22 computer (named after his developer, Konrad Zuse) in 1959 were given approval when published in the journal for young adults *Ja und Nein* at the end of 1960. Lutz used sixteen substantives and adjectives from Kafka's novel *The Castle* (1926) and combined them observing the syntactical paradigm numeral–substantive–"is"–adjective to come up with text like this:

A Castle is free and every farmer is distant.
Every stranger is distant. A day is late.
Every house is dark. An eye is deep.
Not every guest is furious. Every day is old.[7]

The example shows redundancy and discursive leaps but also—for instance, the last sentence—interesting semantic connections. Even more amusing are the poems by RACTER, little stories with a certain narrative coherence and a Dadaist delight in weird semantic juxtapositions. One of theses stories starts, for example, with the foreshadowing utterance, "Bill sings to Sarah. Sarah sings to Bill. Perhaps they will do dangerous things together." After adding that Sarah and Bill may eat lamb or stroke each other and chant of their difficulties and happiness, it concludes, somewhat reflexively: "They have love but they also have typewriters. That is interesting." While in the case of RACTER people soon found out that the text could not have been generated solely by the program,[8] in other cases, the positive reaction to computer poetry was given under the assumption the text was generated solely by a human author. When Ferdinand Schmatz and Franz Joseph Czernin published their collection of poems *Die Reise. In achtzig Gedichten um die Welt* with the prestigious publisher Residenz in 1987, they received much praise—until they revealed the computer as real source of their seemingly avant-garde poems (Gendolla 2000).[9] The success of their deception should not come as any surprise. Much more than prose, poetry lives on strange metaphors and the violation of linguistic norms and common ways of expression. The more the text alienates, one could argue, the better it conveys the alienation that the lyrical subject feels and wants to communicate. For this reason, the idiosyncratic style characteristic of computer poems stands a good chance of being received as avant-garde.

Concerning the hoax of RACTER, Espen Aarseth concludes that rather than the traditional author-poet, it deconstructs "the idea of the poet-computer as a randomly driven autonomous compiler of pseudopoetry"

(1997, 133). Although this notion addresses the technical insufficiency of text generators, with the last word, it also points to the philosophical problem of the matter. Aarseth continues by saying that RACTER's poems deserve its readers' interest precisely for the reason that they are not exclusively written by a program. Because *The Policeman's Beard Is Half-Constructed* only poses as the product of a machine while in fact being the result of human activity, it is not pseudopoetry. Chamberlain's manipulation of the outcome is an evaluation process that refurnishes the text with the human factor.

Meaning of Chance

Aarseth's question, "How can art be evaluated if we don't know its genesis?" (1997, 134), is rendered more precisely by Katherine Hayles, who asks, "What are we doing when we exercise our human ingenuity to come up with meaningful interpretations of poetic lines generated by a machine for which meaning has no meaning?"[10] There are at least four possible answers to this question: (1) one dismisses any meaning in texts without authorial intent regardless of its quality; (2) one admits meaning in texts regardless of their authorship; (3) one sees meaning in chance; and (4) one establishes authorial intent in the text.

In their 1982 essay "Against Theory," Steven Knapp and Walter Benn Michaels ask what we ought to think if, on a sand dune, we came across the fragment of a poem written by waves.[11] To complicate the matter, they choose as their example Wordsworth's intriguing poem, "A Slumber Did My Spirit Seal" (1798). For Knapp and Michaels, the answer is clear: If there is no author, then the marks seen on the sand "merely *resemble* words" while actually being the meaningless result of an accidental movement of waves: "It isn't poetry because it isn't language." To deprive the words of an author is to convert them into "accidental likenesses of language" (16). This indispensable relation of meaning to author intent reminds us of Eric Donald Hirsch's claim, for example in his 1976 study *The Aims of Interpretation,* that the text's meaning is identical with the author's intent whose reconstruction is therefore the proper object of interpretation.

A position that reverses Hirsch's playing of the author's meaning against the reader's meaning is taken by deconstruction maintaining that the text carries meaning beyond or independent of an author's intention. While deconstruction shifts the locus of meaning from the author to the text, constructivist theory goes even further, holding that the meaning of a text

is not in the text itself but is created through interaction with the reader, and that reading is actually an autobiographical art in which the reader constructs meaning trapped in her own self-referential cognitive system.[12] One might wonder whether, in light of the notion that interpretation takes place on the individual level between the reader and the text, the author is still needed at all. If there is no text without the reader, as the maxim of reader-response theory goes, does the text need an author as long as it has a reader? Does one need to recognize a human being, with a concept of meaning, behind the utterances? Wouldn't this indicate recourse to a kind of Benjaminic aura or even genius aesthetics, which avant-garde and (post)modern practices discarded long ago? Why would the assurance of an author's presence in the text be relevant if we do not intend to explore her individual and societal contexts, so we can recapitulate her intention and hence the meaning of the text, as Hirsch demands? A thought experiment may help to put the essential difference between a human author and a machine into perspective. What if we find a great line of poetry in the text of a rather mediocre poet who just experimented with words and came up, in the midst of many bad lines, with this one very good one? Would it develop the same weight without the context and authorship that this line has for us? Could this line speak to us more than it does to its author? Could it have more (not just different) meaning for us than for the one who randomly uttered it? If the answer is yes, we may proceed to the next level: What if this line is uttered by a poetry machine?

A position that does not need a human being behind the evocations the language may create for the reader is based on an aesthetics of chance. In this paradigm, any utterance is valid, even without an author—or, rather, precisely because of the lack of human authorship. The philosophy of chance art is, as John Cage, one of its most prominent advocates, states, the abdication of human control and the "affirmation of life" the way it is: "not an attempt to bring order out of chaos nor to suggest improvements in creation, but simply a way of waking up to the very life we're living, which is so excellent once one gets one's mind and one's desire out of its way and lets it act of its own accord" (1966, 12). Life, expressing itself in chance, has now been centered in the algorithms of a machine. Embracing chance now means first of all embracing the machine. The machine is the sublime, not in the technological sense, as has been described in David Nye's *American Technological Sublime* (1994), but in the sense Jean-François Lyotard discusses in "The Sublime and the Avant-Garde" (1989a). The sublime is that it happens at all—that the machine utters a line that

could be meaningful to us if we were to accept the machine as a meaningful source of meaning. The line of text that "happens" is both more and less representational than, for example, Barnett Newman's sublime abstract paintings. It is more representational because it is not abstract; it is less representational because it does not represent a human intention. One may say that the seemingly representational line in fact only (re)presents its own occurrence. It is pure code.[13]

Such a perspective, however, invalidates the message of the line as uttered by the computer and actually falls into category 1 (dismissing any meaning in texts without authorial intent) rather than category 3 (seeing meaning in chance) in relation to the four possible answers to computer-generated text cited above. In the trope of chance art, the utterance of a machine—as the placeholder of life—can be attributed to the same existential authority characteristic of the Greek oracle or the Chinese *I Ching*. In this light, the aleatoric combination of words reveals, in a kind of technologically enhanced pantheism, a deeper spiritual truth. If the machine had a consciousness, one could consider it the subconscious of the machine, analogous with the subconscious revealed to the surrealist in a throw of the dice.

A position that opposes such mechanic pantheism or the concept of chance and wants to hold on to human control insists that the intention of a human author survives in the outcome of the machine because the human author configured the database and algorithms for the text generation. Thus Christopher Thompson Funkhouser, for example, maintains, "If a program's database itself is not randomly prepared—that is, if the author has a purpose, theme, etc.—then presumably intentionality is infused" (2008). Similarly, Jean-Pierre Balpe (1997) held a decade earlier that the text generator does not dismiss the author but only carries out the virtualities of text programmed by the author. This common position seems to advocate computer-generated text by negating its actual point: it downplays the role of the computer in favor of the human author. Such claim reminds us of Tzara's notion that the poem generated from randomly recombining the words of a newspaper article will be like the agent of this action. One may as well state that the chess games we are playing resemble the person who invented chess. Regardless of the irony, the claim of human agency in computer-generated text is valid; and as a matter of fact, playing chess, we certainly resemble the person who created this game more than the person who created the card game bridge. We have to discuss

how human author and computer cooperate in the generation of the text, and who at the end owns its meaning.

It seems to be plausible that the author's agency in the phase of prepro-cessing[14] somehow translates into an intentional outcome. How exactly would this work? The matter is easy if discussed at the level of genre. The author's purpose in undermining the processes of signification and rep-resentation surely translates into the result of randomly generated text. However, this does not mean that the author is present in the specific text produced. The question is whether her intention can be conveyed by her choice of a specific database and algorithm. This claim has been gener-ally made but has hardly been demonstrated. Ralf Bülow does speak about it regarding a concrete example, although only in passing, when he holds that the choice of nouns from Kafka's novel *The Castle* makes the texts Theo Lutz generates with Z 22 "dreary" (2007, 153). Although one can argue that lines from the examples given above, such as "Every stranger is distant" or "Every day is old," do appear cheerless, one wonders to what extent this really depends on the vocabulary used and how it relates to lighter utter-ances, such as "No village is late" or "A castle is free."

An example that will help to make the point is Pedro Barbosa's *Cityman Story* (1980), described in Funkhouser's exploration of *Prehistoric Digital Poetry* (2007). The original poem describes the humdrum life of a thirty-five-year-old white-collar employee who takes the bus every morning, gets in the office to catalog index cards, recatalogs them after lunch, drinks two beers before returning home where he kisses his wife, says hello to the children, eats a steak with the television on in the background, lies down, fornicates, and finally falls asleep. Barbosa, who heard this uniden-tified poem on the radio, deconstructed its form by running it through his text generator. The result presents a "thirty-five beer man" who every morning gets in the index cards and classifies the years, lunches the office, reclassifies the years afterward, drinks two wives before returning home where he kisses a steak, says hello to the television, and eats the children with his wife in the background. The outcome is predictably absurd and humorous, and portrays wild deviations from the mundane occurrences found in the original. Applying the chance procedures of a text generator to this poem inevitably subverts the status quo of his subject. It spices up the boring life of the city man by turning the depressing poem into sea-soned surrealist lines. The form of the computer-generated text responds to the chosen content of the database. The result seems to declare that

there is no other chance than accepting the chance. Barbosa could hardly predict the lines produced by the text generator. However, he did foresee that they would subvert the original. If this was his intent, it certainly is preserved in the outcome of the machine. Although the content of the outcome is owned by the machine, the meaning belongs to the human behind it, who doubtless could also have easily rearranged the original poem himself. We will discuss another example of the preservation of the author's presence in the outcome of the text generator later. First, I want to explore further ways to mark the author's presence in her computer-generated text.

The presence of the programmer in the text is easier to demonstrate if the text is not presented in its way as it leaves the machine. To a certain extent, the programmer always leaves an imprint on the generated text by deciding what parts of the endless production should be presented, where it should start and stop, which line breaks it should have, and which orthographical and grammatical modifications it needs. A more serious modification happens when the content of the text is modified, as we assume in the case of Chamberlain's RACTER book. This postprocessing operation often takes place without being declared, or it is recommended and encouraged by the programmer. Thus, for Michael Lebowitz, a computer science professor who researches and promotes artificial intelligence and automated text generation, the machine is not supposed to replace the author but to assist her; it supports creativity by offering plot possibilities with which the author can work.[15]

As for the example of Makebelieve, one may doubt that the plot offered by the program is a good starting point for a serious writer. In fact, one wonders how the formalization of the process of narration on the level of database and algorithm translates into the output of the text generator. When authors of text generators welcome the reduction of complexity,[16] one wonders whether this reduces the intricacy of life to simple solutions derived from mainstream culture. Such apprehension is reconfirmed when authors of text generators reveal soap operas as their inspiration and formulaic romance and mystery as aspiration of their work.[17] The necessary formalization and simplification may jeopardize what distinguishes important literature—ambiguity and violation of formulas with respect to language, concepts, and values—and offer instead the straightforward good-or-evil schema of the fairy tale. The question remains whether such issues can be fixed during postprocessing.[18]

One could argue that text generators are of sufficient interest if they manage to produce convincing texts on the level of soaps, formulaic romance, and mystery. After all, such literature comprises the bulk of texts required by contemporary society—and it was no different at the time of the reading revolution in the late eighteenth century. We must not, one could argue, demand text generators to be highbrow art or avant-garde. They may just be part of the entertainment industry, as it is in the case of Dahl's "The Great Automatic Grammatizator." However, we should keep in mind that automatic or aleatoric writing did not proceed with the objective of contributing to mainstream culture, but of opposing it. This is obvious with respect to Tzara's instructions for a Dada poem, or regarding the surrealists' premechanical practice of écriture automatique. While Dada went against the neoclassic aesthetics of its contemporaries, the surrealists pursued the truth of the subconscious. However, both questioned common modes of aesthetic expression and undermined the established culture. The projects of mechanical writing within digital media can certainly be seen in the tradition of those experiments; Funkhouser speaks of "cybernetic Dadaism" and points out that some text generators acknowledge the relation in their title—for example, *MERZ poems* (1992) from Rudolph Valentine and Doug Rogers (Funkhouser 2007, 33). The cybernetic successors of Dadaism have been considered the new avant-garde, as, for example, Italo Calvino (1987) in his 1967 essay, "Cibernetica e fantasmi," and the German Stuttgarter Gruppe, which have produced stochastic texts since the end of the 1950s. The aim of such "progressive aesthetics," as Max Bense and Reinhard Döhl (1964) from the Stuttgarter Gruppe qualify computer-generated text, was seen as advancement of literature and condemnation of the entertainment industry. As Richard Bailey notes in the introduction to his anthology *Computer Poems* (1973), "Computer poetry is warfare carried out by other means, a warfare against conventionality and language that has become automatized" (quoted by Funkhouser 2007, 79).

As far as computer poetry is concerned, there really is warfare against convention. I discussed above why computer poetry has nonetheless received appreciation. The violation of expectations happens within a genre that leads us to expect such violation. This is why Calvino considers the text machine as "an entirely lyrical instrument, serving a typical human need: the production of disorder" (1987, 13). The situation is different with prose. Here, where a convincing and interesting development of the characters and the line of narration is expected, an idiosyncratic style has

less chance to be taken as avant-garde. Here textual anarchy is perceived as lack of structure and concept—or, from the perspective of programming, as deficient programming. The challenge for the author of a story generator lies first of all at the level of programming, a challenge that is also expressed in the manifesto of the Stuttgarter Gruppe.

The computational generation of text has not only been considered as progressive aesthetics, but also *Poietike techne.* The poet-visionary (*Dichter-Seher*), the juggler of content and mood (*Inhalts- und Stimmungsjongleur*), was discharged and replaced by the craftsman (*Handwerker*), who sets up and sustains the processing of the material (Bense and Döhl 1964). The success of the craftsman (that is, programmer) is not measured on the basis of a new poetic sound but on a convincing imitation of a poet. It is not important that the text has a specific style. In fact, it is important that it does not. Any strange language or behavior could be understood as a failure of the programmer. What Samuel Beckett can afford to do, the machine cannot.

An example is *Façade* (2005), by Michael Mateas and Andrew Stern, a text generator that reacts to the text input of the user, who thus influences how the marriage crisis of her longtime "friends" Grace and Trip, the two cartoon characters on the screen, develops (Figure 10). This interactive drama is quite sophisticated, with an artificial intelligence controlling Grace and Trip's personality and behavior (including emotive facial expressions, spoken voice, and full-body animation) and choosing the next story "beat" on the basis of the past and present interaction. It avoids the "I don't understand" response all too common in text-adventure interactive fiction by "generic deflections and recovery global mix-ins for responding to overly confusing or inappropriate input from the player" (Mateas and Stern 2007, 192).[19] As the passages quoted in the introduction demonstrate, Mateas and Stern simplified the utterances of Grace and Trip by reusing certain phrases in similar, but not identical, situations. To have the interactor react to the utterances of Grace and Trip rather than have the program react to the utterances of the interactor, Mateas and Stern also made sure that the gist of a dialogue's meaning is always communicated in its first few seconds, during which any interruptions from the interactor are blocked. The purpose is a dialogue as smooth and natural as possible. *Smooth* in this case does not mean boring or without incident, but as plausible and logical as possible in its development. It is no surprise that the program manages such dialogue only to a certain extent. When the user answers Trip's

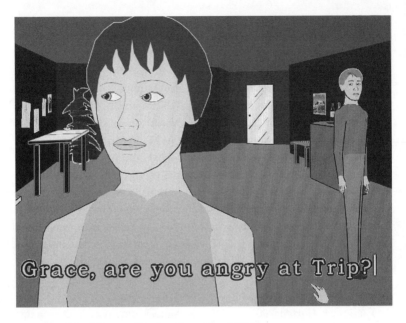

Figure 10. Michael Mateas and Andrew Stern, *Façade* (2005).

question about a drink with "Martini works for me," and Grace responds: "Don't let's talk about work!" the AI obviously misunderstood the meaning of the word. Another example of miscommunication is when the interactor says, "You can be a painter, Grace," and Trip responds, "N-n-no, no I don't want to make art. Please." There is more strange behavior, as the following dialogue between Trip, Grace, and the interactor, Will, shows:

> TRIP: See, I don't think you really want to be an artist. This is all just—
> (interrupted)
> WILL: How did you two meet?
> GRACE: How?
> GRACE: Oh my God . . . you think I'm lying!
> GRACE: Uhh . . .
> WILL: How did Trip propose to you?
> TRIP: Why?
> GRACE: Uhh . . .
> GRACE: Uhh, you . . . uhh . . . does anyone . . .[20]

The neglect of Will's actual utterance may evoke a passage by Beckett. However, this is not the intention of Mateas and Stern. It results from the

failure of the program to appropriately understand and process all utterances. What looks avant-garde is actually an accident. The ideal of Mateas and Stern is not the absurd theater of Beckett, but the relatively conventional theater of Edward Albee, whose 1962 drama *Who's Afraid of Virginia Woolf?* inspired *Façade* (see Harger 2006). Therefore, one could say that *Façade,* and interactive drama in general, is camp with a twist. Camp is appealing because it fails to achieve its original goal; its seriousness is undermined by extravagance and kitsch. Interactive drama is appealing in such moments as the one above, when the AI fails to maintain a serious dialogue. While "camp is art that proposes itself seriously, but cannot be taken altogether seriously because it is 'too much'" (Sontag 1966, 284), interactive drama appears avant-garde because it is not advanced enough to be conservative.

The situation is more complicated. What if Mateas and Stern want to generate absurd theater? It would be difficult to demonstrate. While in a Beckett play the absurd dialogue is backed up by the authority of its author, in an interactive drama the absurd dialogue is perceived as the flaw of the machine, which needs to be fixed. Even if the programmer decides to permit her program to generate nonsense, it would still signify a lack of programming. Because absurdity is the default nature of text generators, the author or programmer—or craftsman, as the manifesto of the Stuttgarter Gruppe says—can prove her craftsmanship only by making the generator produce text as conventional as possible. Calvino pointed to this issue in "Cibernetica e fantasmi," where he asks what the style of a literary automaton would be. He suggests that the automaton's true vocation would be classicism: "The test of a poetic-electronic machine would be its ability to produce traditional works, poems with closed metrical forms, novels that follow the rules" (1987, 13).

In this light, one should neither be surprised nor disappointed that the aim of most authors is to program a text generator whose outcome fits smoothly into mainstream literature. Calvino may be right in stating, "The true literature machine will be one that itself feels the need to produce disorder, as a reaction against its preceding production of order: a machine that will produce avant-garde work to free its circuits when they are choked by too long a production of classicism" (1987, 13). However, if Calvino foresees such a literature machine "unsatisfied with its own traditionalism . . . turning its own codes completely upside down" (13), he has overlooked the fact that the author of such a machine can prove herself as an

artist only if she proves herself as a craftsman. After all, her artwork, we must not forget, is not the text but the text machine.

Understanding Nonsense

Reading a computer-generated text, we are normally aware of the fact that it is not exclusively concerned with literature but also concerned with engineering. We give credit to the text not for being a great text, but for being what it is, for where it comes from. We actually do not read the text, but the machine. The text is the means to evaluate the quality of the program. For that reason, it is inappropriate to accuse text generators of a lack of human interest, of reversing emancipation, of undermining social responsibility by leaving communication in a coma, as Josef Ernst does in his 1992 essay "Computer Poetry: An Act of Disinterested Communication." However, the question remains: How do we respond if we do encounter a great line in the text? Does the line matter to us, knowing that it doesn't matter to the machine? Do we need the authority—the aura—of human feeling, thinking, suffering, and life experience behind a great line for it to touch us? This brings us back to Wordsworth's poem, written by waves on a sand dune. Knapp and Michaels (1982) underline the natural attempt of the reader to anthropomorphize the sea, searching for a human soul in the water that could sign the text on the sand, make it authentic, make it language. Stating the presence of the programmer's intent in the generated text is a similar practice. We seem to need an author.

This may be the real message of this genre. Rather than leaving communication in a coma, computer poetry leads it into aporia. We are unsure what to do with an affecting utterance that is not attributable to a human. Take the famous ending of Rainer Maria Rilke's 1908 sonnet "Archaischer Torso Apollos": "There is not one spot/Which cannot see you. You must change your life." Generations of students read these lines as a thrilling experience. What would be its power coming from waves? Who would look at me if it was uttered by a text processor? Wouldn't it feel like counterfeit money, which we'd like to use but know to be worthless? The actual subject of this genre of text is the search for the person on the other side who can give us a reason to listen, if not to change our life. Who would at least be able to understand us if we shared our understanding of the text with her? This may in fact be the real issue here: We do not really need the author's assurance of the aura of the utterance; we only need her as the potential addressee of our own reading. "Look what I have done with your

text!," we want to say proudly, excited what the answer would be: "How do you like what I found out?" But the other is not there. The machine does not listen. We are authors without a reader. This is what makes these texts so tragic even when they are amusing.[21]

The question of how to respond finds an easy answer if there are no great or intelligible lines. In such cases, one can connect to the text on the base of its aural qualities. Instead of language, one can understand it as music, which does not need a human signature, for we are used to enjoying all kinds of sound without human authorship. Perceiving the text as the presentation of its sonic materiality rather than as representation of an object or idea is in line with the culture of presence discussed in the introduction and chapter 2. Sound poetry also reminds us of the bruitistic or optophonetic poems of Hugo Ball, Raoul Hausmann, Kurt Schwitters, and other Dadaists, who generated nonsense texts as a critique of the contemporary forms of representation. To the extent that these texts questioned contemporary culture, they were of course also meaningful. But rather than announcing meaning in the refusal of meaning and thus making meaning inescapable, I want to explore how the nonsensical outcome of a text generator can be meaningful in a meaningful way if we consider the specific database used.

Simon Biggs's project *Great Wall of China* (1996) uses the words of the English translation of Franz Kafka's story "Beim Bau der Chinesischen Mauer" (1917) as a database to create new text. On mouse-over, contact letters appearing on the project's Web page change until the contact is broken. Then a sentence is offered, such as this: "These communes hopelessly scrutinize these gradually pure realities or must rapidly quote any mightily taken couch." The sentence has been formed "on the fly," as Biggs (1996) writes in his introduction, "through object oriented and behavioral programming techniques, based on pattern recognition, redundancy algorithms and Chomskian Formal Grammars." In this way, correct syntactical formation is ensured: article, subject, adverb, verb—everything shows up in the right form and order. However, although correct, the sentence makes no sense. *Great Wall of China* seems to invite us into the realm of nonsense, as creation without myth and logos, which cannot be abused by pensiveness *(Tiefsinn),* as Dieter Baake puts it in his notes on the phenomenology and theory of nonsense (1995, 376). However, following the traces Biggs lays out with the choice of his database, one encounters myth and logos and deeper meaning.

Found unfinished in Kafka's estate, his story was chosen—given its extraordinary quality—as the title of a posthumous anthology of his stories. That it was also important to Kafka is suggested by the fact that he used the legend of the imperial messenger from this text for his story *Ein Landarzt* (A Country Doctor). The legend speaks of a messenger who sets out to convey the dying emperor's last words, addressed to every single person in his realm. Because the way is long and full of obstacles, the messenger is on the road for ages. Indeed, his undertaking is hopeless, for nobody is able to work his way through the center of the empire toward the frontiers. But "you"—as the narrator apparently addresses the reader—are sitting at your window looking forward to the message. Although the messenger is still on his way, the message about him has already arrived. While it is certain that there is a text, it remains unknown as to what it concerns.

Kafka's story reads like a parable of the process of reading as such: the text is already there, but without our hermeneutic efforts, it will not tell us much. Without interpretation, it is as if the text is still on its way. Nevertheless, in Kafka's story, the message about the coming of the messenger—whose name in Greek mythology is Hermes—has already arrived. If one does not want to assume a second, much faster messenger, there is only an anthropological explanation: the message about the messenger does not arrive from the future but from the past. It is the ever-present longing for meaning, for the holy word, be it that of God or the emperor.

The question of sense is already discussed in the story's first part, which focuses on the construction of the wall itself. The wall, one is told, provides the foundation for a new Tower of Babel. Once the former has been finished, the latter will be built. The symbolic significance of this biblical tower is well known. Defiant men united in the presumptuous project of building a tower that could reach the sky. God thwarted this and any further attempt with polyvocality, causing hopeless confusion. Ever since, people have been trying to understand each other and to come to agreement. Because language is the house of everybody's being—as Martin Heidegger, Johann Gottfried Herder, Johann Gottlieb Fichte, and many others have pointed out—people fail to settle their differences; even individuals within one nation are unsuccessful because each has her "individual language," as Herder's and Fichte's contemporary Jean Paul stated as early as 1780 (1974, 115). Unity can only be achieved if everybody lives in the same house, which requires a long, high wall.[22]

The implicit subject of the discussion of understanding is always the possibility of a universal language—that is, values, perspectives, ways of

communication. The linguistic turn addressed the tower as such; deconstruction undermines it even further. While Ferdinand de Saussure questioned the substantiality of the relationship between signifier and signified and considered it arbitrary that, for example, the animal *dog* is signified by the word *dog* and not by, say, *hand* or *chair*, he however argues that in the end, every signified finds its own signifier. Derrida, for whom Saussure's position means to adhere to a "transcendental signified" (2004, 19), goes even further, questioning the substantiality of the separation between signifier and signified and assuming a constant shift between both.[23] Derrida's concept of *différance* (referring to the double sense of the Latin *differre*, "postponing" and "differentiating") concludes endless deferral and difference without the happy ending of an arrival at a destination. Signification is an ongoing process. Because it never ends, one can never reach the truth. Because truth never arrives, neither does the messenger.

This perspective on Kafka's story provides the means for uncovering the deeper meaning of Biggs's text machine. The incomprehensibility of the text, which uses language material from Kafka's story, is a meaningful illustration of the nonappearance of Hermes in the story. The fact that Hermes's arrival is postponed again and again is not rendered by the difference of signification changing from one statement into another, as is the case in reality, when each new reading of the same text generates a new textual meaning as a result of altered circumstances. Although the created text in Biggs's piece changes, it remains incomprehensible for the reader from the beginning. This may be because providing sense is much more difficult for the machine than providing correct syntactical formation. However, the constraint also contributes to the meaning of the work. The fact that there is no process of signification in the first run and no message offered to which the reader could turn draws the attention even more to this aspect of signification. One understands the act of change without having to understand its starting point and result.

Biggs's *Great Wall of China* talks about storytelling without telling a new story. It is the translation of a text into immediate perceptibility within a visible performance on the surface of the screen. It presents the uninterpretability of this text and thus repeats the experience of almost all texts by Kafka. The judgment is, as in Kafka's 1912 story "The Judgment," that meaning does not occur. Whereas the reader of "The Judgment" is affected by the sentence of revocation of all sense and so finds herself in the shoes of the sentenced Georg Bendemann of the story, the interactor of *Great Wall of China* is waiting in front of the screen for a meaning that is similar

to that addressed to the person in Kafka's text who is waiting at the window for the message. The linguistic burden of *Great Wall of China* is the fact that the linguistic material does not make any sense. Biggs's text machine uses the linguistic function of words only to underline the absence of any linguistic meaning. However, without the hermeneutic effort of reading Kafka's text, this aspect would not be present. It is the same mode of double reception—of the machine's performance and of the underlying text—discussed with respect to *Text Rain* (1999), *Screen* (2004), and *Illuminated Manuscript* (2002) in chapters 1 and 2. It carries with it the same transmedial quality and additional obligation for the reader. As far as the death of the author is concerned, it has become clear that the automated text in *Great Wall of China* is not without author, but actually has two. Biggs's authorship is superimposed on Kafka's authorship, as is the machine on the original text. The choice of the database indeed translates into the generated text and makes the programmer, who brings Kafka with him, present in it.

Biggs's *Great Wall of China* is not the only example of the combining of a text machine with words from a canonized work of art. In 1996, Ken Feingold, in his installation *Orpheus,* presented a puppet head that from time to time speaks a syntactically correct but meaningless declarative statement, such as, "Time goes slower sideways." The statements derive from the English translation of sentences from Jean Cocteau's 1950 film *Orphée.* In the film, these sentences come from the radio arranged by Death in order to hypnotize Orpheus and lure him into the underworld. Feingold uses the original text as a grammatical matrix, to which he added words of his own. He explains: "The computer program randomly pulls words from this matrix each time through the loop of the overall piece" (Huhtamo 1996, 54). In this way, the original syntax is fixed, but the poetry is "real-time" and variable. Thus the sentence above results from the film's sentence: "Silence goes faster backwards."

The difference between Feingold's and Biggs's application of a text machine is that the sentences from the film *Orphée* already present a kind of nonsense following the aesthetics of surrealism and its concept of automated text production. Rather than illustrating the message of the original text—as Biggs does with Kafka—Feingold reiterates what Cocteau did: his installation addresses the power of poetry or art, like Cocteau's film paraphrased—in an ironic twist—this question from the ancient myth where Orpheus's art overcomes Death. Feingold's *Orpheus* thus becomes

a many-layered comment on the role of poetry, music, and art, which can only be realized if the cultural reference is understood. The additional layer in Feingold's installation points to the perceived authority of a text machine's message mentioned above; if a nonsense sentence produced by a human being—or by Death, for that matter—is able to hypnotize Cocteau's Orpheus, why shouldn't one produced by a machine be able to impress a contemporary human?

Readers and Writers

Although the author is not dead, it is perhaps more appropriate to announce the death of the reader. This slogan can be understood in many ways. With respect to text machines, it has been noted that one does not read nonsense, and that if the text is meaningful, one reads the machine rather than the text. One circumstance applies if the audience of Biggs's *Great Wall of China* or of Utterback and Achituv's *Text Rain* neglects the request to become a reader of the contained text. With respect to the click gesture in digital media and the contemporary fast-paced culture that the authors of *Still Standing* (2005) try to counter, one could state the reader's transformation into a restless traveler through the world of text. With respect to the visualization of the Web and the focus on nonlinguistic values of text in kinetic concrete poetry and interactive installations, one can announce the reader's transformation into a viewer. With respect to computer games (especially first-person shooters) where the story lures the player into the action but is itself of no real interest, one can declare the demise of the narrative. What I would like to discuss next is the reader's transformation into an author. This does not refer to the claim that the navigational decisions of the reader in hypertext turn her into a (co)author. It refers to collaborative writings, where readers are invited to contribute their writings.

Collaborative writing is one of the main types of digital literature, which relied on the arrival and existence of the Internet. There are many ways to engage in this sort of collaboration. Regarding the relation of contributions to each other, this has to be distinguished among linear story, tree fiction, and the assemblage of independent text segments. Regarding intermediality, although there are still some projects consisting only of text, most apply images, sound, and even video. Other variations between collaborative writing projects can be observed in the openness to the public, and the role the project leader and the program play in the configuration

of the project. I want to discuss three examples from Germany, which handle authorship, readership, and cooperation in completely different ways.

As any regular dictionary states, *to collaborate* means either "to work together, especially in a joint intellectual effort" or "to cooperate treasonably, as with an enemy occupying one's country." When talking about collaborative writing, we are used to the first sense. In literature, people with whom we collaborate are anything but enemies. One of the pioneers of German collaborative writing projects shows that collaborators also can be perceived as enemies occupying one's country of text.

Managed by Claudia Klinger, *Beim Bäcker* (In the Bakery; 1996–2000) started when Carola Heine wrote about a woman who encounters three preschool girls in a bakery. The girls want to buy lollipops but are short a quarter.[24] The woman is touched by the girls, gives them the quarter, suddenly wishes for a baby, feels the need for a man, and develops a sexual fantasy focusing on a worker in the background having coffee. Instead of talking to this man, the woman buys herself a lollipop and leaves the bakery. Thus the author leaves the text, leaving it to the next author to carry the story forward.

What ensues is a fight for and with words. After the first author has introduced the female protagonist, another writer, a man, fills in some gaps; he turns the character in a direction the first author does not agree with at all, adding a construction worker outside the bakery who describes the woman inside in a derogatory way. Now the first author tries to rescue her figure and to overwrite the personality the male author attached to her. However, she cannot just erase the former contribution; she has to take into account what has been said so far. This situation makes her both angry and inventive. She calls the construction worker names, and she has him staring at the woman in the bakery whom the male author had just ruined while her character walks away. It is interesting to see how she uses the information in the other author's contribution to achieve a different result, and how she implies some common prejudices about the male sex in order to get at her opponent. Here the collaboration is perceived as occupation of the text.

It gets even more interesting when other readers turn into authors and jump in. Soon one finds all kinds of characters, not so much within the text as among the authors. There is the clumsy one, who does not really know how to pull it off. There is the obsessive one, who tends to find sexual connotations in everything. There is the inhibited one, who does not

know how to deal with this. There is the politically correct one, who brings up racism and argues for solidarity. There is the social one, who complains about the mess and calls for more cooperation. And there is the genius, who easily brings all the threads together again.

In the end, one has to realize that a new author hardly takes into account the unfinished business of the authors before. It is as if nobody wants to allow her predecessor to occupy her story time by acknowledging its legacy. If the previous authors set up a meeting between two characters, or if they close a contribution with an unexplained incident, then the incident will not be resolved and the characters will not meet if those who opened this track do not bring it to completion. Thus it turns out that many collaborative writing projects are actually playgrounds for self-centered people, except for a few who suffer from collective solipsism and nevertheless desire cooperation.

With respect to *Beim Bäcker,* one can conclude that the pleasure of a collaborative writing project is not so much the story itself as what the text reveals about its authors. There is a text beyond the text in which the authors are the characters. Part of this text is, for example, the fact that Caroline Heine, the first author, runs a women's emancipation Web site that at the time bore the slogan, "If she is too strong, you are too weak." The second author, on the other hand, runs a "Man-Site," "where a man still can be a man," as the welcome page read eight years ago.[25] It should not be surprising that both start to fight and abuse the other as an "incorrigible macho" or as "frustrated aggressive women." The real story of this project is the dynamic between the authors; the real interest lies in the social aesthetics behind the text.

Whereas *Beim Bäcker* is a project where several authors write one linear story step by step, the next example assembles independent texts. *23:40* (11:40 P.M.) was initiated by Guido Grigat in October 1997.[26] This work's backbone is the 1,440 minutes of a day. Every minute of a theoretical day is to be filled with a text that should somehow apply to this moment in time, either describing something that happened in this minute or describing something remembered in just this minute. The text can only be as long as can be read within a minute. The project is programmed in such a way that, after sixty seconds, the current text automatically gives way to the next. Every text has its minute, and every minute has its time.

This setup marries features of written with oral communication. If spoken language frees knowledge of an event from time and place, written

language frees us from having to be present at the time and place this event is reported. However, *23:40* ties to a certain time again: the reporter appears during his minute, and if one is late, one will miss the story. A consequence of this setting is, for instance, that a description of a sunrise can only be read in the morning or, for whatever reason, only at 10 P.M. Another consequence is exemplified in the following: at 9:18 A.M., a contributing author describes downloading and reading her e-mails (it is one of the most common sorts of texts in this work to merely describe what the author happens to be doing). She then encounters the message that her best friend has died. The next minute consists only of one sentence, signified as a postscript: "Real life sucks." The point behind this phrase is that this is all one gets to read in minute 9:19; one has to wait almost sixty seconds for the next text. The author has her readers observe a minute of silence for her dead friend.

It is the setting rather than the text that is intriguing here. The attraction of this project lies in its program. One may even say that the program is the author, in the sense that John Cage is the author of his piano piece *4'33"*. As Cage silently sits at the piano in front of the audience, the empty "minute-page" is silent in front of the reader. The only text it offers is a request for collaboration ("Unfortunately 23:40 cannot remember anything in this moment. Could you please help it?"). The empty minute explicitly calls on the reader to fill it with a written contribution, and Cage's silence implicitly calls the audience to fill it with noise. Who is the author, Cage or the audience, the writer or the empty minute? Consequently, the reader may contribute text and fill up the minute; she nevertheless will not be acknowledged as the author because *23:40* does not show the names of its contributors. Where one normally looks for the author's name, all one sees displayed is the number of the current minute. The only name one finds in this project is, on the first page, the name of Grigat, the program's author.

Other interesting aspects include the development toward a predetermined end. The project offers its readers exactly 1,440 opportunities to become an author and to put in their two cents. The number of free pages decreases with each new contribution, and prime time—between 8 P.M. and 10 P.M. —is largely occupied. Surprisingly, ten years after the start of the project, only two thirds of these opportunities are taken, although a second phase started in October 2006 containing 170 contributions one year later (and 21 in March 2009). However, one may imagine the day when only ten minutes are left, offering only ten opportunities to still become

part of this project. And nobody knows which minutes these are! The end of *23:40* may be its actual heyday. It will turn into a special form of performance, all about having access to those last spots rather than the actual text placed in the other spots. But even now, it becomes clear that the attraction of *23:40*—and this holds for many other collaborative writing projects as well—lies in its concept more than in the contributed texts.[27]

The third example offers absolute freedom to the reader as author. Whereas in the former examples the project leader herself includes each new contribution to the project, in Assoziations-Blaster, initiated by Alvar Freude and Dragan Espenschied in 1999, the program does, and it is therefore the only entity that definitely knows all the segments in the text pool.[28] The program also creates the links, which here are called associations. The links are established between texts that have keywords in common. If, for example, one sentence reads, "to be or not to be," and another sentence starts, "she has been in the city," there will be a link between them because of the word *be,* provided this word is on the list of keywords, to which each reader who has already contributed at least three times can add a new word. In order to create ever-new associations, the link from sentence A is not directly addressed to sentence B, but to a program that knows about all texts entailing the word *be.* The link now will randomly be created each time one clicks on the underlined *be* in one of those texts. The *be* in sentence A may link to sentence B; however, if one goes back and clicks *be* in sentence A again, one may get sentence C or D or G.

As one can imagine, the resulting associations are not always very meaningful, if words like *be* or *I* are on the list and if the linking is based only on morphological similarities. This type of association therefore differs from the concept of wit, where different words are linked together to show what different things actually have in common or where different associations of one word are activated to create an amusing situation of misunderstanding. In Assoziations-Blaster, similar words are linked together with almost no relation between the texts linked.

However, one should not take this project too seriously. It only pretends to be looking for truth by revealing how everything is linked, as Freude and Espenschied declare in their project statement. In reality, it ridicules the notion of truth in random, mechanical, and intentionally silly associations; it actually already signals the parody with its title, which signifies "to explode" as well as "to overdrive," "to frustrate," and "to destroy associations." What really matters in this project is to blast open the connections

of texts and their writers—and in this respect, this project is indeed one of the most successful projects, offering almost 900,000 German entries (43,600 English entries) with 69,000 keywords as of March 2009.

What really matters is the association of all contributors. Most of them visit the Web site by accident and send in their text because the project promises to incorporate and present the text immediately. Other contributors develop a special dynamic within the project. For example, they invent absolute nonsense words—*Mettwurst-Bettwäsche* ("sausage bed-clothes")—that, by deliberate use in other contributions, qualify to enter the list of linkable keywords. An internal game is also the "6wortAssoziationskunstwerks" ("six-word-association artworks"), which aims to build a sentence with the title keyword of one of the project's text segments plus five linking words from within this text. Authors receive extra points if the title keyword takes a central position in the sentences and if all the linking words appear in their original order. Such acrobatic text games remind us of the poetics of constraint familiar from the Oulipo. The results may be meaningless for those who happen to find it on the Web, but not for the contributors who evaluate each other's contributions and communicate their success to each other in the project's discussion group.

These examples represent three very different kinds of collaborative writing. In *Beim Bäcker,* collaboration takes place between various contributors and finally fails because of their inability to work together. In *23:40,* the author collaborates with the program: it instructs the reader to become an author, it occupies the author's name, and it creates, together with the author, the deeper meaning of the text. The Assoziations-Blaster shows collaboration almost solely at the program level. The program sets the links and develops the structure of the whole independently from the authors. The shift from contributions connected to a given text in *Beim Bäcker* to a program connecting the contributed texts in Assoziations-Blaster can be considered a response to the genuine problem inherent to collaborative writing. It is a response that separates the text from its readers.

If in collaborative writing and interactive stories the reader becomes the writer, the question then becomes whether quality will be compromised by interactivity. Marie-Laure Ryan (2000) has a convincing answer to this concern: "A plot that would not be very interesting for a pure spectator may become fascinating—just as playing a tennis game not worthy of televising may be a richly rewarding experience for the player." We are, Ryan points out, certainly not as critical of the scenarios that we generate

as we are of the plots of classically staged drama. This perspective supports the conclusion that collaborative writing is more about the process of collaboration than it is about the outcome. This also means that someone not in the game might not enjoy the story. To someone who accidentally stops by and starts to read, the text itself does not say all that much. She has to become a writer herself; she has to join the authors, including their discussion group, to understand what is going on and to enjoy the project. One has to read this implicit text to enjoy the other, official text. Quality of text, in the way critics are used to approach this issue, does not matter anymore. One may say that the text as such does not matter anymore. What matters is the event of which the text and the reader are a part. Favoring the event at the expense of reading is, as the next chapter demonstrates, even more of an issue for interactive installations.

4 INTERACTIVE INSTALLATIONS

ONCE UPON A TIME, visual art was simple: it originated with an artist's conception and craft, which the viewer acknowledged and then strove to understand while standing before the object. When paintings turned abstract, when found objects were glued to the canvas, and when urinals were brought into the museum, art changed. But it still observed the classic triad of artist, viewer, and art object: one viewed a static object on which an artist had bestowed meaning. A further change took place with the introduction of interactive art, which insisted that the viewer become some part of the work of art and participate in its creation. Such notions are fraught with simplifications, which are already exposed by my fairy-tale opening. As will be discussed below, it was never a simple matter of the artist endowing an artifact with meaning, which the spectator then discovered in careful analysis. Long before the advent of interactive art, the meaning of an artwork was also created as a dialogue between the work and its audience. In the case of interactive art, however, the work itself is created within such dialogue, which complicates the issue of meaning tremendously.

The unfinished work is linked to the unfinished body. Rather than presenting a message to be deciphered, theoreticians and practitioners of interactive art create spaces and moments that inaugurate a dialogue. This dialogue is mostly thought of as a physical dialogue and often as a dialogue not (only) with other interactors but (also) with oneself. Interactive art is conceptualized as a place to encounter one's own body, to connect to it in a way that is independent of the strictures and inner dialogues inculcated and developed over the years. In a sense, in interactive installations the body of the performer—made explicit in its social relations through performance art—is outsourced to the audience looking for its implicit body, with political and semiotic consequences.

Performance art, and especially performance art by women, has highlighted the fact that the body is an object of desire, a commodity to be consumed. It has often played with the expectations of conventional theatrical spectatorship. After video art allowed the spectator to resume her position as observer from within the darkness of interiority, interactive installations disturbed this setting and required the audience to move onto the stage and to become physically involved in the artwork. Turning the spectator into an actor rearranged the schematics of exhibitionism and voyeurism, redirecting the question of identification away from the exhibited foreign body and toward the interactor's own body. The interactor may initially perceive this body as foreign to itself as it unfolds and recovers from restraint and suppression. However, the experience of interaction sets out to overwrite and undo the social construction of the body. The interactor's uncertainty is a function of the extent to which her body is subjugated and her relative degree of awareness. Although interactive installation art cannot guarantee that every spectator follows the call, inevitably, if indirectly, it puts those who stand to one side into the spotlight: They are recognized as people who do not join in, who watch in detachment. Interactive installation art is the perfect deconstruction of the voyeur.

However, such perspective is grounded in a conception of the body that presupposes that the discovery of the implicit body is a natural goal. Such a conception of the body is itself the result of social construction, more likely to be found in the discourse of body-focused performance theory than meaning-focused literary studies.[1] From a different, more skeptical, more critical point of view, one can also argue that interactive installation art represents a further step in the ongoing visual exploitation of the body: It implicitly discloses the inhibited body in its social and cultural inferiority, failing to step into the limelight of public attention in the age of surveillance cameras, Facebook, YouTube, and other technologies that expose the individual to a new form of the public. Any offense to the body and its wearer is unlikely to be intended by the artists, and this is far from being the only way to look at the situation. Rather than try to argue which perspective is more accurate, this chapter is going to focus on the other consequence that the outsourcing of the performing body entails.

While performance art is considered a shift from the semiotic to the phenomenal body, interactive art is considered a shift from facts to events, from offering a message to inaugurating a dialogue. In both cases, the shift is understood and described as a shift away from meaning. This seems to be appropriate, especially with respect to interactive artwork, which, by

definition, is unfinished and is realized only as a function of audience inter-action. However, such a viewpoint is sometimes based on a misconception of what constitutes a (un)finished work, and it fails to distinguish between central and marginal elements of an interactive installation. The activity of the interactors is often framed by a carefully designed system of sym-bolically articulated options. If one closely reads the grammar of interac-tion and the symbolic articulation used in an interactive installation, one often realizes that the actual behavior of the interactors is constrained, does not contribute greatly to the overall meaning of the work, or both.

In addition to the audience's invitation to (physical) self-discovery dur-ing its encounter with an interactive work, reading the structures of such work will be the objective of this chapter. Although it focuses on specific works rather than on a systematic examination of the philosophy and his-toric context of interactive installation art, this chapter will nonetheless also discuss the importance of distance from and emergence in the art-work, and the risk that physical engagement results in cognitive passivity. The credo of this chapter is that the body privileged by interactive instal-lation art shall not be prevented from interpretation but shall become a favored, interpretable subject of this art.

Turn to Interactivity

The elevation of the audience took place hand in hand with the degrada-tion of the artist, which was hailed not just by theorists but also by the artists themselves. For example, John Cage, in 1966, declared the artist no more extraordinary than the audience and demanded that the artist be cast down from the pedestal (2002, 93). The same year, Roy Ascott stated, "In the past the artist played to win and so set the conditions that he always dominated the play. The spectator was positioned to lose, in the sense that his moves were predetermined and he could form no strategy of his own" (2003, 111). Ascott promoted behaviorist art, whose necessary con-dition is "that the spectator is involved and that the artwork in some way *behaves*" (129). The shift was also conceived as one from passive specta-tor to active user or interactor. One can, Ascott writes, no longer be at the window looking in on a scene composed by another, but is instead "invited to enter the doorway into a world where interaction is all" (226).

Behaviorist art or "responsive environments" (Krueger 2002) have their predecessors and contemporary colleagues in modern art genres such as performance and happenings.[2] Another source is chance art. As David

Rokeby (1996), a prominent representative of interactive art, points out, the structure of interactive artworks can be similar to those used by Cage in his chance compositions: "The primary difference is that the chance element is replaced by a complex, indeterminate yet sentient element, the spectator." While both chance art and interactive art diminish the role of the artist in the process of creation, the latter also enables, in exchange, a more powerful role for the audience. Instead of mirroring nature's manner of operation, as chance art does, the interactive artist, Rokeby continues, holds up a mirror to the spectator. This mirror not only reflects the interactor within the interactive system, but it also allows the interactor to experience herself in a new way, reflecting who she is. Interactive art is an opportunity for self-discovery; it is an invitation to explore one's own body in the process of interaction.

However, interactive art also holds a mirror up to the interactors as a group by producing space-times of interhuman experiences. Nicolas Bourriaud speaks of "spaces where we can elaborate alternative forms of sociability, critical models and moments of constructed conviviality" (2002, 44). Such spaces and moments are important as alternatives to the ideology of mass communications but also to various utopias of the New Man and the calls for a better world to be found in futurist manifestos. Utopia, Bourriaud holds, is now experienced as a day-to-day subjectivity, in the real time of concrete experiments; "the role of artwork is no longer to form imaginary and utopian realities, but to actually be ways of living and models of action within the existing real, whatever the scale chosen by the artist" (13), and "the artwork now looks like a *social interstice* in which these experiences and these new 'life possibilities' prove to be possible. Inventing new relations with our neighbours seems to be a matter of much greater urgency than 'making tomorrow sing.' That is all, but it is still a lot" (44). This perspective, especially given this final sentence, sounds like an answer to the loss of grand narratives in postmodern times. Art, which learned to abstain from providing ideological orientation and metaphysical consolation, becomes modest and pragmatic. It still wants to make a difference, but now on the spot and among neighbors. In this regard, Bourriaud claims that relational art represents the heritage of the avant-gardes while rejecting their dogmatism and teleology: It is an art that does attempt "not to tell (like theater), but rather to provoke" relationships between subjects, as Josette Féral stated for performance art in 1982 (2003, 215). Similar connections and expectations can be found with other theorists. Dieter Mersch, for example, sees performance- and interaction-based

installation art in relation to the aesthetics of the event in classical avant-garde and underlines that this kind of art turns the audience from recipients into participants who interact with each other. The aesthetics of *response*, Mersch, playing with words, concludes, implies an ethics of *responsibility* (2002, 20). Erika Fischer-Lichte describes the performative turn—which she sees as symptomatic of the early 1960s—as a turn from the artwork to the event, in which not only the artist but also the audience is involved (2008, 22).

Convincing examples for such claims may be *Text Rain* (1999), where participants work together in order to collect enough letters so they can read an entire line, and *RE:Positioning Fear* (1997), where participants may not team up to gain access to the hidden text on the wall but nonetheless to interact with their shadows, as discussed in chapter 1. Another example, from chapter 2, is *Illuminated Manuscript* (2002), which calls on interactors to coordinate their actions in order to make the text legible. However, as described in chapter 2, we have also seen cases—*Screen* (2004) and *Still Standing* (2005)—where the participant only interacts with the program and is not required to respond to other participants or to create mutual responsibility. We may note here that although not all interactive artworks directly contribute to the invention of "new relations with our neighbours," as Bourriaud (2002, 44) claims, most of them do invite interactors to self-discovery. We will see that this self-discovery directly or ultimately can still have an effect on the interactor's neighbor.

Rokeby's *Very Nervous System* (1986–90) provides a space in which the movements of the interactor's body (recorded by a video camera and processed by computers) create sound that is fed back into the space and thus affects the movement of the interactor.[3] As Nicole Ridgeway and Nathaniel Stern put it, "Rokeby turns the body into an improvisational jazz instrument" (2008, 123). Likewise, Camille Utterback's *Untitled 5* (2004) uses body-tracking software and creates abstract paintings according to the interactor's movement through space, turning her body into "a painterly tool for an ever-changing visual feedback system" (129).[4] The status of the body as instrument and tool enhances its role in the process of perception—in opposition to the suppression of the body in Christian religion and in the perception of art since the eighteenth century.[5] Although traditional Western art—painting, literature, theater, sculpture—served the eye as locus of perception, in interactive art, the interface is no longer exclusively focused on vision but engages the entire body and turns it into

a privileged site for experience. The boundaries between body and world dissolve in favor of an affective contact. Interactive art restores the intrinsic link of affect and the body: one is "seeing with the body," as Hansen titles an essay on the digital, reactive image (2001), and one is "seeing through the hand," as he entitles a subchapter of his book *Bodies in Code: Interface with Digital Media* (2006).

If interactive art is so much grounded in the body, it insists that we revisit the concepts of ocularcentrism and disembodiment whose traces in Western culture go back not only to Descartes' "Cogito ergo sum" but at least as far as Plato's *Nominalism*. Although initially digital technology contributed to the notion of disembodiment—the keywords here are *artificial intelligence, cyberspace,* and *neo-Cartesian*[6]—it later fostered the return of the body through an engagement with physical immersion and interactivity. It is generally conceded, for example, that electronic digitality "invests in bodily affectivity" and that virtual reality engenders "nonrepresentational experience" (Ridgeway and Stern 2008, 119). This return of the body points us in the direction of theories on the correlation of body and mind in Western intellectual history, suggesting, as in Maurice Merleau-Ponty's *Phenomenology of Perception*, that "the body is our general medium for having a world" (2002, 169).[7] Although it is apt and imperative to underline the central role the body is playing in our being bodily in the world, N. Katherine Hayles is correct in her response to Mark B. Hansen that the body only sees in the ways that the technology involved allows (2008, 108). By analogy, one is inclined to say that the "world" we are "having" through the body can only be understood in the detailed manner allowed by our mind-set.

When considering interactive installation art, however, it is common to promote the body over reflection on the ground of the body's return as the privileged site for experience.[8] Granted such a turn, it would be appropriate to point out that the interactive environment encourages the body to find itself. As Brian Massumi notes, "In motion, a body is in an immediate, unfolding relation to its own nonpresent potential to vary" (2002, 4). Interactive installations are a playground for cognition, or rather the site for potential implicit experiences that the body might accomplish. Ridgeway and Stern therefore argue that "interaction is incipient action, in which an implicit body emerges alongside an unfinished art work," and interaction "inaugurates rather than enacts a priori script" (2008, 117).[9] We will explore below to what extent interactive installations really invite their interactors to search for the implicit, nonpresent body. First we shall

discuss to what extent interactive installations have a prior script that is enacted by its audience. The best way to start is to ask: What kind of interactivity was there in art before interactive art? Does interactive art still contain that kind of interactivity?

Rokeby (1996) quotes the Japanese journalist and curator Itsuo Sakane, who points out that "all arts can be called interactive in a deep sense if we consider viewing and interpreting a work of art as a kind of participation."[10] In this context, Rokeby reminds us of Marcel Duchamp's famous declaration that the gaze—that is, the spectator—makes the painting. The notion of the productive recipient has become popular at least since the 1970s and is supported by many theorists, especially in the fields of reader-response theory, cultural studies, and constructivism. According to such readers, the subject constructs and decodes an object in a way that she can maintain her own conceptions and thinking.[11] From this viewpoint, the perception of art (and reality in general) is always an interactive dialogue between the audience and the author—or rather, the audience and the text, painting, or sculpture. Japanese artist Masaki Fujihata describes the perception of traditional art accordingly as interaction between the different codes that the spectator has read in an artwork (2001, 316). In terms of art history, this cognitive interaction precedes the physical interaction encountered in interactive art.

Concerning our question about the relationship of cognitive and physical interaction, one has to ask whether the latter can be accompanied or followed by the former—that is, whether the interactor can attempt to understand—decode—the work with which she is or has been interacting. When Ascott described his concept of behaviorist art, he underlined the point that this art, and modern art in general, is no longer concerned with facts or objects but with events; initiating an event replaces the transmission of a "clearly defined message" (2003, 110).[12] The shift from the field of objects to the field of events and behavior includes a change from providing a specific message to providing a specific space for interaction. In behaviorist art, the artist's concern is "to affirm that dialogue is possible—that is the content and the message of art now; and that is why, seen from the deterministic point of view, art may seem devoid of content and the artist to have nothing to say" (112). More recent reflections on interactive art repeat the notion that this kind of art creates space for the openness inaugurating dialogue (Bourriaud 2002, 166). In all these cases, interactive art is conceptualized as an experience. The audience is expected

to engage with the generated event or situation. Meaning can be produced within this moment of interaction but is not to be found as something already created by the artist.[13]

The shift from a specific message to an event reminds us of the move from a culture of meaning to a culture of presence, as discussed in the introduction. Interactive art, with its physical action and immersion of the audience, seems to be the perfect fit for theories and aesthetics that question the urge of interpretation and promote a focus on the intensity of the present moment and on the materiality of the signifiers rather than their meaning. The farewell to interpretation is echoed in a corresponding modification of Descartes' famous motto, "Cogito ergo sum." The catch-phrases of interactive or participatory art reads, "Creamus, ergo sumus" ("I experience, therefore I am"; Heibach 1999).

With respect to the role of hermeneutics in the realm of interactive art, I noted in the introduction that the audience's participation in the composition of the artwork does not automatically imply that the author has evaded the work's conceptualization or failed to provide it with a specific message. The situation, created in behaviorist or relational art, may allow a dialogue between interactors and provide them with a space-time of interhuman experiences. This very situation can nevertheless already carry its own message and open a dialogue between the artist and interactor(s), namely by way of the specific grammar of interaction used by the artist. As Fujihata defines it, the grammar of interaction is the way the interface is set up and the specific modes of interaction possible within the inter-active environment. Any given grammar of interaction is a necessary and important restriction of that interaction. It is necessary in order to specify the relation between the system and the interactor. It is important, Fuji-hata continues, because it reveals the artist's viewpoint, "his vision, his thought and the communication he wishes to make" (2001, 317). In this light, the specific interaction that interactive art allows and requires itself represents a message and a call for understanding and decoding.

However, there are cases where the interactors use the grammar of inter-action in a way the author did not have in mind, thus appropriating the generated space-time of interhuman experiences according to their own desires. In *Body Movies* (2001), by Rafael Lozano-Hemmer, for example, the audience is supposed to make visible the photo portraits taken on the streets of Rotterdam, which are projected onto the wall of the Pathé Cin-ema building at the Schouwburgplein Square in Rotterdam (Figure 11). These portraits only appear inside the projected shadows of the interactors,

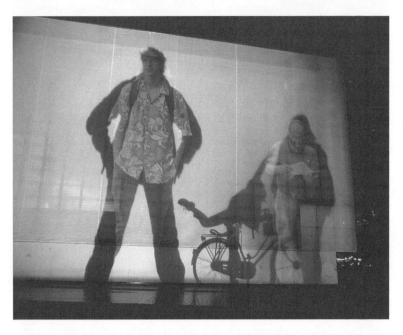

Figure 11. Rafael Lozano-Hemmer, *Body Movies* (2001). Photograph by Antimodular Research.

which can measure from two to twenty-five meters high, depending on how far people are from the light sources placed on the floor of the square. The essential element of the grammar of interaction is to give presence to those who are absent. In media ontological terms, one could say that the images exist only if they exist *to* somebody; that is, the image is physically created in the process of perception rather than production. The interactor's shadow also manifests a split between self and other. The interactor is symbolically deprived of her shadow, or rather of her self, because by functioning as a means of projection, her shadow represents another person. One can see an analogy with tattoos in that the body is being used as a canvas. Here, however, the image is revealed not on the skin but on the shadow, and is ephemeral. In addition, the person has no choice as to what is displayed on her body. *Body Movies* thus carries out an emblematic occupation: the body of those present is overwritten by absent others.

Lozano-Hemmer's intent that interactors embody a portrait by align-ing scale and position of their shadow was only partly transmitted into practice. Because the actual embodiment "is dull and boring," as Graham

Coulter-Smith (2006, 275) puts it, interactors showed more interest in playing with their own shadows than in engaging the portraits. While the disclosure of the portraits occurred in "deathly silence," the creative infringement of the grammar of interaction—that is, a gigantic shadow woman stomping a tiny shadow man to the ground—was "followed by peals of laughter" (275). Lozano-Hemmer's surprise about the audience's reaction demonstrates that the artist expects interactors to act in a specific way, as opposed to just providing the interactive environment for self-discovery.[14] The interactors' misuse of the apparatus signifies a resistance to the artist's expectation, a rejection of the prescribed inscription and threatening deprivation, or simply of the dullness and boredom of the original grammar of interaction—and a creative, playful occupation of the work. Coulter-Smith wonders "whether Lozano-Hemmer possesses the proverbial gift of genius because even when he fails he produces something quite extraordinary" (275). Given the title of this work, one may also wonder whether the artist in fact (unconsciously) wanted his audience to act exactly in this way because whereas the display of the hidden portraits generates stills, the shadow games can indeed be seen as producing little body movies.[15]

One conclusion of the discussion above is that an example of interactive art can—and should—be perceived as both event and object. The event is object insofar as it is a deliberately composed structure of different signifiers (the falling letters and the real poem behind them in *Text Rain*) and possible actions (collecting the letters with the option to elevate but not to rearrange them) building up to a specific meaning. This notion seems plausible for works such as *Still Standing*, whose grammar of interaction (and title!) clearly points to a particular interaction: standing still. Similarly, in *Screen*, the action expected from the interactor is obvious. Even if the user refuses to perform the expected action by not standing still, by not pushing back the dropping words, it would only be in response to the grammar of interaction and would reinforce the message behind it. However, in cases where the interactors' actions are much less restricted or predesigned, it seems to be impossible to read the interactive setting as an object with a certain meaning. Two examples are Rokeby's *Very Nervous System* and Utterback's *Untitled 5*, both of which give interactors complete freedom in how to engage with the work. Both do not allow interactors to completely understand the grammar of interaction such that they could deliberately use their body as an instrument or tool.[16]

However, if the grammar of interaction is obscure, it does not necessarily

have to be without meaning. Behind the very fact of its indistinctness can be a philosophical and pedagogical agenda, as Rokeby's *Very Nervous System* proves. Rokeby deplores the general fetishization of control and considers it dangerous "if we weed out of our lives those things that are uncertain, unpredictable and ambiguous." This is why he likes to create "systems of inexact control" (Rokeby 2003). The computer, Rokeby states, sets up the illusion and fantasy of total control, which is not a useful paradigm for real-world encounters. Rokeby's system tangibly reflects the interactors' input but does not allow them to gain complete control. It is a learning experience intended not least to improve our relationships with our neighbors, as Rokeby suggests: "The fact that my neighbour does not always reply the same way when I say 'hello' does not mean that this is a disempowering experience."

It is helpful to illustrate the different approaches to an interactive artwork with a particular example. Picking a work that has been reviewed by an art critic and that reveals how little attention even experts pay to the possible meanings of the symbolic structure of a work and its grammar of interaction will help to show us what is at stake for the treatment of interactive art. In Bill Seaman's interactive video-sound installation *Exchange Fields* (2000), the viewer can interact with thirteen furniture-like objects, each designed and labeled in relationship to a particular part of the body, and trigger certain dance sequences on one of the three video screens in front of the objects (Figure 12).[17] If, for example, the interactor puts her arm into the appropriate box and does not move it, after a while she will trigger the projection of a dance sequence, choreographed and danced by Regina van Berkel, focusing on the arm. If the interactor puts her leg in the appropriate box, a moving leg will appear on the screen. The installation is able to project four overlapping dance sequences, thus allowing four viewers to interact with four furniture sculptures at the same time. In addition to the video sequences, which are almost the only source of light in the gallery, one hears meditative sound playing in the background, blending with the chanting of Seaman's lyrical texts reflecting on human–machine interrelations. The grammar of interaction is easily understood; the hypnotic composition of visuals, sound, and material environment provides the audience with an intense experience. However, there are at least three different ways to engage with this work.

A reaction that might be termed *atmospheric perception* will be based on the fascination by the hypnotic composition of visuals, sound, and

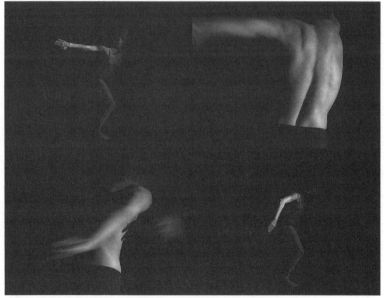

Figure 12. *Exchange Fields* (2000). Drawing for arm sculpture (*top*). Video still for arm object (*bottom*). Copyright 2000 Bill Seaman and Regina van Berkel, drawing by Seaman, rendering by Casino Container, detail from the installation Exchange Fields.

material environment in this *Gesamtkunstwerk:* the clever space design, the striking dance scenes, Seaman's meditative chanting about the human–machine relationship. Others will be less impressed. They have seen similar settings and heard similar lyrical refashioning of philosophical language and will be more interested in testing the interface. They will enjoy tricking the system by putting their hand in the box assigned to the foot and their chest onto the spot for the back. This form of rebellious interaction is supported by Tilman Baumgärtel, a pioneer among the German critics of digital art, who considers Seaman's work to be a manipulation of the audience because its grammar of interaction requires the interactors to constrain their body parts in order to see a ballerina on the screen. *Exchange Field,* Baumgärtel (2000) concludes, degrades its audience to "interactive guinea pigs," and he calls the observed attempt of interactors to crash the system the "revenge of art lovers." Such revenge is unfair to the implicit pact between the artist and the audience in interactive art: the acceptance of the proffered interface, regardless of its practical limits and flaws. Such revenge is also unwise because it entraps the so-called art lovers, as well as the art critic, within an ignorance regarding the work's possible meaning, rather than opening out to a creative engagement with the work. Both consequences may reinforce each other insofar as the search for technical flaws reflects a focus on craft that may (although it does not have to) reveal a lack of interest in any conceptual aspects of the work.

A third approach—beyond both naive enthusiasm and "been there–done that" boredom—will consider the specific grammar of interaction and wonder what the artist wishes to communicate. Analysis will reveal that one must immobilize one's limbs to make the corresponding limb of another person appear and move on the screen. One will also note that this other limb disappears as soon as the interactor moves again. One possible way to understand this grammar of interaction is the notion that the reality of the interactor's body is traded for the projection of a foreign body on the screen that appears in dramatic lighting and camera moves, and is imbued with eroticism. The corporeal (thick, fleshy, old, washed-out) body is exchanged for the ideal body. In a double reverse of the Pygmalion myth, the viewer is converted into the sculpture and brings her object of desire alive if she ceases to move. It is easy to imagine that the reception of the work and the interaction with it would change if the immobilization of the interactor's body triggered the appearance not of a young, idealized body but an old, exhausted one. The interpretation will also suppose that the screen in *Exchange Fields* represents more than the

screen of the installation—namely television, movie screens, and advertising billboards, which confront people every day with beautiful bodies and hence inform their personal body ideal. This information overwrites our native conception of the body and thus, in a way, results in what Seaman's work requires its audience to do. What is more or less consciously our day-to-day experience is literally reenacted within the artwork. *Exchange Fields* urges us to discover this ongoing substitution and to reflect on our complicity with it.

The aesthetics of *Exchange Fields* could also be discussed with respect to recent developments in neuroscience offering a scientific explanation for the intuitive understanding of how others feel and the empathetic response to an artwork and engagement in aesthetic experiences. The theory of mirror neurons states that a type of brain cell is activated both by performing an action and by watching the same action performed by others. The discovery of mirroring mechanisms and embodied simulation no doubt has tremendous implications, not only for the empathetic responses to images and works of visual art (Freedberg and Gallese 2008), but also for interactive installations and immersive environments, where the audience, motivated by mirror neurons, is able to react directly to what it sees. In this context, one may consider *Exchange Fields* as a play with the mirror drive deliberately, and in contrast to the common logic of interactive installations, avoiding any visual signs of the possible emphatic response through the required immobilization of the interactor.

In this context, we should also note that although the discovery of mirror neurons challenges the primacy of cognition in responses to art, it does not necessarily question the role of cognition in the discussion of art. Aesthetic experiences based on noncognitive operations can still be interpreted—and should, in order to move the reflection of an art work beyond sheer description. If David Freedberg and Vittorio Gallese state, "historical, cultural and other contextual factors do not preclude the importance of considering the neural processes that arise in the empathetic understanding of visual artworks" (2008, 198), one may add that the reversed perspective is also true: The audience's noncognitive response to an artwork does not preclude considering the importance of historical, cultural, and other contextual factors to the artist's aesthetic decisions and the critic's discursive approach.

For the immediate argument, it is not important how convincing the suggested understanding of Seaman's work may be, or how many other ways

to read it can be found. What is crucial is the implied recurrence of the Cartesian focus on cognitive activity. This recurrence does not dismiss the role of the body in interactive art, as is usually the case within the Cartesian paradigm. However, it claims that physical interaction within the responsive environment should not exclude the reflection of the experience. One may argue that in some cases, the discussion of a work does not require a live experience of the work and that one can also talk about the grammar of interaction by observing others physically engaging with the work or even only seeing a documentary or reading a description of it. Yet even if a work such as *Still Standing* can be understood without experiencing it, one will not understand it with the body if one does not actually stand still in front of the screen to read the text. Without really experiencing those minutes of immobilization—in *Still Standing* as well as in *Exchange Fields*—one cannot feel the meaning of the grammar of interaction. The physical experience is imprinted in the body, with lasting consequences. An hour of the continuous, direct feedback in Rokeby's *Very Nervous System*, for example, strongly reinforces a sense of connection with the surrounding environment. The body remembers having been an "instrument" and wants to play again. "Walking down the street afterwards," Rokeby reports, "I feel connected to all things. The sound of a passing car splashing through a puddle seems to be directly related to my movements. I feel implicated in every action around me. On the other hand, if I put on a CD, I quickly feel cheated that the music does not change with my actions" (1997, 30).

To be sure, the experience of an interactive environment and one's own (re)action within it does not necessarily lead to a reflection of the body's experience within the interactive environment. In many cases, the audience only tests the grammar of interaction, assuming it has understood what the work means once it has understood how it functions. To use Ascott's terminology to contradict his own statement above (2003, 110), it may be said that interactive art can be perceived as both event and fact. It provides a space for experiences, but also a message to be understood. The fact that an interactive artwork needs its audience's participation to be completed does not mean that it merely receives its meaning from this participation. On the contrary, by generating a specific grammar of interaction, the artist infuses her work with meaning and obtains a certain control over the message that the artwork offers. This becomes clear with respect to Rokeby, who declares, in line with declarations by Ascott, Bourriaud, and many others, "I'm an interactive artist. I construct experiences,"

but also announces a deeper meaning behind the experience of inexact control he intends to construct: "If culture, in the context of interactive media, becomes something we 'do,' it's the interface that defines how we do it and how the 'doing' feels" (1997, 28). According to Rokeby, interfaces are content; using the term *interface* for what Fujihata calls the *grammar of interaction*: the specific mode of interaction made possible by the artist. There is no reason not to make this content the subject of interpretation.

A condition for such an endeavor is, as in any hermeneutic task, to undertake a close reading, paying attention to all details of the work and discussing the results. In what follows, I want to illustrate what a close reading of the grammar of interaction and the discussion of the symbolic involved can mean with respect to various examples from different genres of interactive art that have different degrees of interaction. We will then resume the general discussion of the role of interpretation in interactive art.

Understanding the Grammar of Interaction

JCJ-Junkman is an interactive work by Ken Feingold from 1995. Here a puppet head, which Feingold had used previously in *Jimmy Charlie Jimmy* (1992), appears on the screen surrounded by a whirling storm of ever-changing images that appear and disappear. If one manages to click on one of the images, the puppet speaks a piece of arbitrary language, such as "Hasta la vista, baby," "Put it down," "May you go and dig this," "Message," "Kambiariota," "Das wär's." There is no beginning and no end in this game of chasing the links, no other levels, no score. "It is 'interactivity' reduced to a zero-degree, as thousands of narrative fragments displace each other, fueled by a raw desire to get something," says Feingold. "The emotion produced is that any choice will do."[18] Erkki Huhtamo identifies in this situation of pseudochoices an obligation to rethink our relationship to the medium. For him, the meaning of the work is the loss of control over the flow of data trash that we have already internalized: "The junkmen we have become do not collect the garbage to sort it or recycle it in the ecological sense of the word. Although we may think otherwise, we merely reiterate the cycle of junk that connects our minds with the media reality" (1996, 48).

Another work from the early days of digital media, not online but in a museum, is *Der Zerseher* (literally, "dis-viewer," also known as *Iconoclast*) by Joachim Sauter and Dirk Lüsebrink (1992). In this installation, the viewers deconstruct a painting by looking at it. The painting—*Boy with a*

Child-Drawing in His Hand (ca. 1525) by Giovan Francesco Caroto—is a framed rear projection onto canvas behind which, invisible to the viewer, an eye tracker is installed (camera, PC, video-tracking software). The camera sends the information about the viewer's eye movement to the computer, which locates the center of the iris and the point where an infrared light reflects from the viewer's eye. With the resulting data, it can precisely identify the part of the painting the viewer is looking at. This part of the painting is consequently distorted. The observer who encounters this work in a museum environment, not expecting a painting to dissolve under her gaze, realizes that the more she looks at the painting to discover its meaning, the more she destroys the object of her analysis. Because this comes as a surprise, it may contribute to confusion, but it will certainly also reinforce a reflection concerning the difference between this kind of experience of a painting and the more traditional way. It is part of the irony of the work that the painting can be restored only by disinterest in it. If more than thirty seconds elapse without the picture being viewed, it reverts to its original condition.

This installation fundamentally changes the perception of a visual object. As the artists state, "In the past an old master might leave an impression in the mind of the passive onlooker—now the onlooker can leave an impression on the old master."[19] This explanation is in line with the early 1990s debate in which the manual choice of links (in the case of hypertext) or clicking buttons was described as an active involvement and ranked higher than the intellectual involvement of pure perception, which was seen as a mode of passivity. *Der Zerseher* seems to contribute to this simplifying juxtaposition. It promotes one of the most important qualities of the computer, namely interaction, as Sauter (2001) proclaims in an interview.

Although it is the eye on which the interaction of *Der Zerseher* is based, it has been taken as an example of the shift from an aesthetics of vision to an aesthetics of touch, where the eye is taken as an extension of the hand in this particular context (de Kerckhove 1993). Such a metaphoric understanding of the eye is perhaps justified with reference to Saint Thomas Aquinas's understanding of the eye as subtle version of the sense of touch (de Kerckhove 1993). However, it may also lead to a neglect of the intricate relationship between an active and passive mode of perception and the double role that the eyes play in the configuration of this work. A closer look reveals that *Der Zerseher* deconstructs the painting presented, as well as claims made concerning the passive and active onlooker.

Given Duchamp's earlier statement that the spectator makes the pic-ture, or Jean-Luc Godard's famous saying, "It takes two to make an image," one can argue that deviewing does not require the technology applied in *Der Zerseher* but—in a less literal and more conceptual way—takes place all the time when looking at a picture. "Making the picture" in this case means to see in it what one brings to it. The viewer is never the passive onlooker that Sauter and Lüsebrink suggest, but rather a person with cer-tain ideas and ways of seeing the world. The viewer carries all the pictures she ever has seen with her when stepping in front of a new picture. She activates all the concepts she has developed about children and child-hood when looking at a painting of (and by) a child. It is the problematic effect of knowledge as overwriting or distorting the perceived painting that inclines Georges Didi-Huberman to suggest a more passive mode of per-ception, the alternative of "not-grasping the image, of letting oneself be grasped by it instead: thus of *letting go one's knowledge about it*" (2005, 16). Knowledge and concepts govern our perception of reality, not only of painting or art. "We see what we know and what we are" would be a collo-quial way to express the fact that perception is an autobiographical act.[20]

If one agrees that the spectator constructs the picture she sees and therefore deconstructs the picture the artist saw while painting, one un-derstands that *Der Zerseher* only renders literal what is a general phenom-enon of perception. One could even argue that this interactive installation allows the onlooker less in way of opportunity to make an impression on the old master's painting than would be the case in a painting that does not physically react to the viewer. Because each area of the painting fades away under the viewer's gaze, there is limited time for her to look ideas into the painting. The painting seems to escape its appropriation by the viewer. The installation prevents the painting from being de-viewed on the semantic level by de-viewing it on the physical level. It is a shift of deconstruction from the viewer's mind to the canvas's surface.

So far, my argument does not take into account the painting itself. One wonders why Sauter and Lüsebrink have chosen this particular painting for their installation. Is there a deeper correlation between the painting and the installation similar to that between the poem and the work in *Text Rain*? The artists note: "This painting shows the first documented child-drawing in art history—an adequate metaphor for the state of computer-art at the early 1990s."[21] This explanation affirms the importance of the painting's content for the installation's message. Equally important, however, seems to be the fact that the painting duplicates the action of the installation:

looking at a painting. The mutuality of this feature helps indicate a difference. The boy in this painting does not de-view the drawing in his hand in the physical way. Does he do it in the semantic sense? One doubts this for two reasons: The drawing is assumed to be his own creation, which explains why the boy looks up while presenting the painting rather than looking at it—and, more importantly, the boy represents an innocence that makes him unlikely to be a source of de-viewing.

It is understood that a child has developed less in the way of cognitive concepts to guide his perceptions. A child is expected to be more open to reality than an adult, to carry less baggage of other pictures and ideas when stepping in front of a painting. The boy in Caroto's painting may indeed be the passive onlooker in whose mind the painter leaves a strong impression. He represents the innocence that the adult viewer no longer possesses. *Der Zerseher* is the symbolic destruction of such innocence and thus becomes symptomatic for the history of art and of media. The boy in Caroto's painting not only represents innocence in an ontogenetic way, but also in a phylogenetic way. Living at a time when images were exceptional in everyday life and may have had a huge impact when encountered in public spaces, this boy also represents the childhood of visual culture. The time of this painting is the time before or just around the birth of the history of art—which places the figurative under the "tyranny of the *legible*" and was effective in terms of "dissolving or suppressing a universe of questions the better to advance, optimistic to the point of tyranny, a battalion of answers" (Didi-Huberman 2005, 8, 6). The child in the painting embodies a certain suggestion of the innocence of mankind in its dialogue with paintings.

By contrast, people today—at least in the Western world—are adult when it comes to the undertaking of looking at paintings and images. We are trained in the reading of paintings, and we are familiar with different modes and forms. Not only impressionism, which caused scandals once, but even the most abstract representation seems usual to us. Painting has more and more moved to the edges of representation, reflecting not only its own materiality as in formalist painting but also its environment beyond the canvas: the tools, the frame, the gallery. Examples are the use of living objects as brushes, such as reeds or naked women in Yves Klein's *Cosmogonies* and *Anthropométries* in the early 1960s, the use of houseflies as paint in Damien Hirst's *Armageddon* (2002), and Daniel Buren's *Within and Beyond the Frame* (1973), with its moving beyond the gallery space.

The actual content of a painting can often be found in the way of its production and in the way of its presentation, in dialogue with its location. *Der*

Zerseher moves one more step in this direction by making the audience an active physical element of the painting. It is one more step away from what is represented on the canvas within its frame toward a metareflection. This is also, as it was the case with Yves Klein's anthropomorphic brushes, a step toward the spectacular. The de-viewing of an inexperienced child from the early sixteenth century seems to be an appropriate symbol for the expression of such a situation of excess and lost paradise. One imagines the artists behind this installation smiling, as proud of their clever production as the child is of his drawing. In this light—the light of art history and visual culture—*Der Zerseher* provides, as it de-views a painting, a clear view of contemporary painting and of viewing itself.

A year after Sauter and Lüsebrink's *Der Zerseher*, two other Germans, Monika Fleischmann and Wolfgang Strauss, released the installation *Rigid Waves* (1993), which also plays with the connection of the viewer to the image (Figure 13). In this case, the image is a picture of the viewer herself taken by a hidden camera. The connection between viewer and image is not established via eyes but via body movement: the closer the viewer approaches, the more unrealistic the image becomes. The visitor meets himself as an image in the image: "He himself is the interface he is acting with" (Fleischmann and Strauss 1995). This grammar of interaction reminds us of Bruce Nauman's *Live-Taped Video Corridor* (1970) and seems to be its digital cover version: as in *Corridor*, with the visitor's recording, in *Rigid Waves*, "the visitor cannot pin down his digital twin."[22]

Regarding the goal of her work, Fleischmann states that in opposition to the theory of the disappearing body, she wants to "recover the senses of the body and to observe the dynamic gesture of different gender and culture in interactive media" (Wilson 2002, 734). Indeed, in contrast to *Der Zerseher*, the interaction in *Rigid Waves* is not based on eye movement but body movement. In *Der Zerseher*, the interactor can direct her eyes intentionally and thus deliberately de-view certain parts of the image, which gives her much more control over the interaction than is the case in Feingold's *JCJ-Junkman*. However, the interaction is still—and in contrast to *JCJ-Junkman*—bound to the Cartesian paradigm. The movement of the eyes of the de-viewer mirrors the movement of the eyes of a reader or—more in line with my interpretation of the viewer as the painting's maker—of a writer. Because on its conceptual level *Der Zerseher* is not about body but mind, it does not require any further action of the body.[23]

In *Rigid Waves*, however, it is the movement of the visitor that changes the image. Does this mean her body is more involved? Not really. The

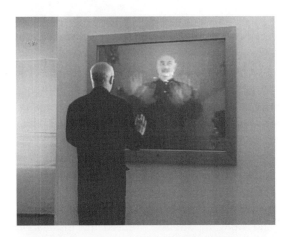

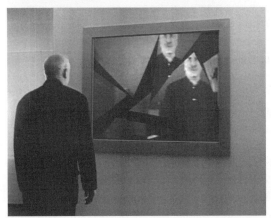

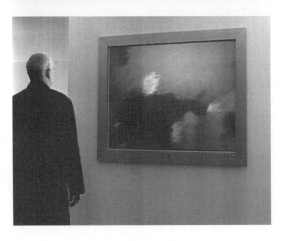

Figure 13. Monika
Fleischmann and
Wolfgang Strauss,
Rigid Waves (1993),
image distorted, burst,
and frozen.

participant's action is fairly limited and does not extend further than the action of walking, which is hardly a new experience for the interactor. It would certainly be wrong to say the interactor plays her body like an instrument and, by doing so, learns anything new about it. The body is only the means to trigger a cognitive process, as is the case with Nauman's *Corridor*. Thus, *Rigid Waves* does not require any creativity on the user's part. However, it does generate the experience that the body is connected with the surrounding environment and may—similar to what Rokeby feels about the persisting consequences of *Very Nervous System*—make one wonder why one's image in the glass door of a store does not distort when approaching it.

The interactor in *Rigid Wave* could also move in an unusual way and hence experiment with her body as with an instrument. It would be similar to a spectator dancing in front of a painting: the work itself does not require, encourage, or inspire such movement. The conceptual difference becomes clear with respect to *Deep Walls* (2003), by Scott Snibbe. This work's interface or grammar of interaction stimulates movements that differ from those within the usual experience of the body in daily life (Figure 14).

The installation consists of a camera and a rectangular screen divided into sixteen smaller rectangular screens. The camera records the projected

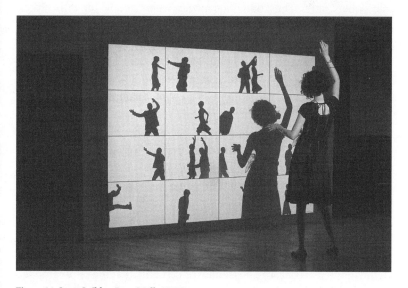

Figure 14. Scott Snibbe, *Deep Walls* (2003).

shadow of the viewers who move in front of the screen, and each of the small screens plays one of those recordings over and over until a new recording replaces the oldest. The work is set up such that the viewer is not aware that she is recorded; she only realizes that her oversized shadow is projected onto the big rectangle, not knowing that when she leaves, her action materializes as a looping silhouette in one of the small screens. Given the inexplicitness of the grammar of interaction, in many cases what is recorded is an attempt to construe the grammar of interaction. However, this installation yields much more in terms of its symbolic significance.

Deep Walls has a vital cinematic aspect. It creates, as Snibbe notes, "a projected cabinet of cinematic memories."[24] However, not on the aesthetic level but at the level of interaction, one may also consider *Deep Walls* to be a bulletin board where people communicate with each other. This possibility presents itself particularly when the work is exhibited outside the gallery context, in an environment frequented by the same people again and again.[25] Here, interactors can leave visual messages—a funny or irritating shadow play, for example—for their friends and colleagues, who will search the screen for a familiar silhouette and respond with their own little movie. But even though users do not have specific addressees in mind, the movies generated suggest that users understand this interactive installation as an arena where they can stage filmic messages for subsequent users. Thus, one finds movies where people (or, rather, their silhouettes[26]) obviously talk to the audience, or where two people get involved in an argument and finally turn violent. *Deep Walls* not only requires its audience to act—in front of other people or unobserved[27]—but it also inspires them to act in terms of both a past and a future: The silhouette recordings that are already looping inspire the current viewers, who then create their own. However, those new viewers not only embody inspiration from and appreciation for the existing movies, but also their future erasure. The moment of recording clearly exists in relation to a past and a future—a future that will become a past.

In a sense, any recording is always about the past. With respect to photography, Roland Barthes states that every image represents a *here-now*, which has become a *there-then* (1991, 33; 1984, §33). Once, the photographed subject was really in front of the camera; the photograph is proof of its existence at that historic moment.[28] However, it is also a testimony to the moment's past. The possibility or certainty that the photographed subject no longer exists at the moment the photograph is perceived causes,

as Barthes put it, the melancholia of photography; the message of the medium of photography is "the return of the dead" (1984, §33, §4).

Barthes (1991) also notes that historically, photography began as an art of people: their identity, their social status, their body per se. According to mythology, this is also true for painting, whose origin goes back to a maid of ancient Corinth, Dibutade, who traced the shadow of her lover onto a wall in order to remember him during his absence. In that sense, painting actually began as photography because the subject represented really had been present and his image was a truthful copy of the original, which is something that the shadow Dibutade traced and the shadows in *Deep Walls* have in common. Apart from this, they relate to each other like a romantic and a postmodern perspective on life, because the old setting comes to a simple, happy end (one maid, one lover, one room, and one shadow, which lasts forever), while *Deep Walls* reveals how remembering turns into forgetting: every new silhouette recorded makes one old silhouette disappear.

Thus, Barthes's thoughts about photography and death become even more powerful for *Deep Walls*. New visitors provide their shadows with an audience, which may in turn be inspired by those shadows—observation confirms that many interactors mimic the actions they were watching on the screens as they perform for the camera. But this audience—inspired, witnessing—is also a competitor for public visibility and eventually replaces previous shadows. This seems to be the major characteristic of *Deep Wall*'s grammar of interaction: the interactor has a chance to have a moment recorded, only to see it ultimately vanish. It would not have been difficult to store and make available all the recordings online (as Lozano-Hemmer, for example, does in his 1999 work *Vectorial Elevation*, discussed below). However, Snibbe did not want to design *Deep Wall* this way and hence suggests reading *Deep Walls* as a work about time passing, about death, and about the decay of our traces. The actions of the former generations—represented in movies of silhouettes—are inspiring to the next and may survive in their actions, although the record of it may finally get lost. That this loss happens as a function of joyful, pleasurable play makes the work even more melancholic, or rather it suggests seeing the inevitable decay with the necessary distance while at the same time urging us to seize the moment.

This moment is about a kind of courage. As mentioned above, being recorded in front of the screen while watched by other people requires overcoming one's self-consciousness. Interactive art such as *Deep Walls*

and *Text Rain* requires the participants to step into the center of attention. As many authors of interactive installations know, children are very likely to do so, but adults often shy away from such a requirement. This may seem strange, as Rafael Lozano-Hemmer holds, "considering that we live in the age of reality TV and the society of spectacle" (2001, 242). Scott Snibbe has obviously had better experiences. With his work, he hopes to help people escape from their sense of themselves, "to just lose themselves in the experience of the piece," and states contentedly that it always seems to work effortlessly.[29] One reason may be that the interfaces of his works clearly articulate what is required from the audience. At the same time, they put the interactor at ease because there is no obvious right or wrong way to perform. In the case of *Deep Walls*, for example, the interactor already seems to do a great job just by lifting an arm because as long as she interacts with the work, her silhouette is bigger than all the other shadows, and overshadows some of them. It is only after she steps away from the screen and her shadow is, in its smaller, recorded version, integrated into the collection of videos that she may wish to have done something more extraordinary. However, now she can watch her own silhouette from behind, together with other people who may not recognize the silhouette's identity.

The integration of the shadow as new animation into the work arranges the interactor within a broader context, distanced from who one was in focus just a moment before. This is reminiscent of the short life of most appearances of a person or topic in contemporary media.[30] Moreover, the contextualization easily translates, symbolically, as filing and archiving, which actually gives the work its name. Snibbe refers to the architect Christopher Alexander, whose admonition to architects is to build the walls of homes thick, so that cabinets, drawers, and windows can perforate the interior space and provide areas for storage. In the spirit of Alexander, Scott states, *Deep Walls* gradually "remembers the contents of its environment upon its surface."[31]

The idea of a wall as an archive of its historical environment is surely close to anyone who, standing before an old building, has wondered what it (or one particular stone, to make our thought more dramatic) has witnessed and would tell us if it could. Sometimes walls do speak by means of the signs history has left on them: color, letters, plants, bullet holes, graffiti. In *Deep Walls*, the wall/screen certainly echoes the content of its environment, and it does so longer than a mirror would. Nonetheless, all in all, the symbolic meaning of this work is not preservation but erasure.

Strictly speaking, the symbolic meaning *is* preservation in addressing its erasure: Addressing recording and erasure, the work triggers reflections about transcription and preservation. However, this reflection may have its source in the participants' bodies to the extent that they do or do not transcribe the shadow play of their predecessors and so preserve it for their successors in their own shadow play. The metaphorical meaning of the shadow or silhouette becomes that of a trace, which survives, for a while at least, even after the shadow's owner and the shadow are both gone.

Quite different from Snibbe's work is the way Edward Tannenbaum uses a similar technique to project the interactor's silhouette onto the wall. His installation *Recollections 4.5* (2005) invites the interactor to move in front of a large video projection screen (Figure 15). Her image is recorded and assigned a color by a computer with special image-processing capabilities. The result is immediately projected onto the screen, where images build up and create a painting based on the movement; the rotation of the colors generates an animation in real time.[32] Tannenbaum notes that even the most inhibited people seem to rise to the occasion and create beautiful images. His trick is the computer's promise to turn—with time

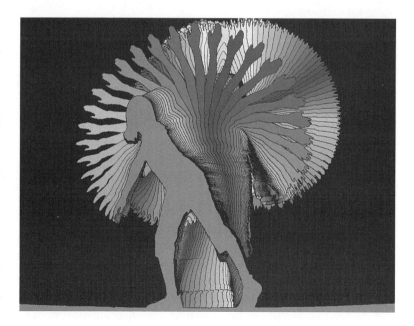

Figure 15. Screen image from Edward Tannenbaum, *Recollections 4.5* (2005).

delay and coloration—any unobtrusive motion into fascinating effects. This assurance may also encourage interactors to perform more daring movements. Compared to Snibbe's *Deep Walls*, Tannebaum's *Recollections 4.5* appears as the baroque playfulness of Catholicism contrasted with the sincere, respectable work of Protestantism.[33] The result of this playful experience is similar to what Rokeby reports about *Very Nervous System:* Walking down the street afterward, one may imagine the body movement of passersby, but with delay and coloration. In contrast to *Deep Walls*, however, *Recollections 4.5* takes the burden of coming up with something interesting away from the interactor. Nor does it confront the interactor with specific symbolic implications. By contrast, *Deep Walls, Der Zerseher,* and *Rigid Waves* all provide symbolically loaded grammars of interaction: deleting the recorded, viewing as destroying, and destroying the self in approaching it. In *Recollections 4.5*, the focus of perception is the real-time action rather than any interpretation. Beauty, so to speak, trumps meaning; being beautiful may be considered the goal of symbolic practice in this case, or the becoming present of a moment of intensity, making no claim to interpretation.[34]

Public Art as Deprivation

Vectorial Elevation (1999) is probably Lozano-Hemmer's best-known telerobotic installation. It is the fourth in his Relational Architecture series, which aims to produce large-scale interactive events transforming emblematic buildings through new technological interfaces, bestowing on them "alien memory" (Lozano-Hemmer 2000b, 55).[35] In contrast to virtual architecture, which is based on simulation, relational architecture is based on dissimulation: it transforms the master narratives of a specific building by adding and subtracting audiovisual elements. Lozano-Hemmer states the critical intention behind it: "I want to design anti-monuments" (2002, 155). Such a transformation is not necessarily a rebellious act, as was situationism with its concept of *détournement,* a subversive turnabout or hijacking of the meaning of an object, space, image, or concept. It can be officially legitimized, like Christo's and Jeanne-Claude's *Wrapped Reichstag* (1995)—an example of narrative transformation without digital technology—or even commissioned, as was the case with *Vectorial Elevation,* the result of an invitation by the Mexican National Council for Culture and the Arts to develop a relational architecture project in the context of Mexico City's millennium celebrations.

One of the requirements of the commission was the location: the Plaza el Zócalo, the third largest public square in the world, and a site critical to the country's past and present. Lozano-Hemmer installed eighteen xenon 7,000-watt projectors around this plaza, set up on the rooftops of various buildings, with light beams that could be seen over a ten-mile distance, and connected them to another popular site: the Internet. On a publicly accessible Web site, anyone on the Internet could experience a visualization of the Zócalo and design the light sculptures that were displayed in the night sky above it between December 26, 1999, and January 7, 2000.[36] With hundreds of thousands of visits from eighty-nine countries and all the regions of Mexico, the project was truly a collective public art project and a huge success, resulting in various awards (Golden Nica of Prix Ars Electronica 2000, Honorary Mention at SFMOMA Webby Awards 2001 in San Francisco, Excellence Prize of CG Arts Media Art Festival in Tokyo, Trophée des Lumières 2003 in Lyon), a replication of the project at other cities (Vitoria-Gasteiz in 2002, Lyon in 2003, Dublin in 2004), and a book publication in 2000. Having a book with collected essays on a single work of digital art is a rare and fortunate circumstance: it introduces the artist's own perspective and gives us insight on how scholars and curators perceived the work.

Obvious topics to address in the case at hand are the history of spectral architecture, the history of the Zócalo, the archeology of both searchlights and human–computer interaction, as well as the relation between public spheres and network interfaces. The book's contributions show that the Zócalo has a rich symbolic significance as a gathering place for black-market street merchants, vendors, tourists, the unemployed and underemployed, hunger strikers, protesters, and political campaigners, as well as providing framing sites of governmental and religious power represented by the Metropolitan Cathedral, the National Palace, and the Supreme Court of Justice. In addition, the reader is reminded of the plaza's foundations, the ruins of the Aztec temple over which the Spanish conquerors constructed their city center to signify the victory of the Christian colonizers. Contributors note that *Vectorial Elevation* ends the "monolithic and hierarchical tradition" of public light shows.[37] It is also pointed out that *Vectorial Elevation* symbolizes Mexico's interrelationship with the world by repeating a gesture of inclusivity toward the world while placing Mexico on the world stage.[38]

While most criticism contextualizes aspects of *Vectorial Elevation* as a way of better understanding its symbolic significance and meanings, only

Erik Davis offers an interpretation of the project that considers *Vectorial Elevation* as spectacle, one that "refused to provide any representations, narratives, 'local color,' or cues for how spectators (or participants) should feel" (2000, 245). Despite his assertion of the lack of any narratives and the reduction to special effects—"the piece stripped that rhetoric [of the millennial spectacle] down to its essential component: light" (246)—Davis implicitly delivers a narrative of the work when he notes, "The piece gracefully deflated expectations in any cathartic moment by presenting a nonlinear flow of abstract patterns whose origin—public inputs from the Internet—undercut any sense that the millennium would reveal some new center of authority, value, or narrative" (246).

In a way, longing for the decentralization of authority and values came to an end on September 11, 2001, when the promotion of Western culture was reacted to in the demolition of one of this culture's most symbolic sites. However, in a sense, *Vectorial Elevation* itself represents such promotion because it recasts the Zócalo without "local color," to use Davis's terminology. Erkki Huhtamo also points in this direction by underlining the discrepancy between the street-level and the Net-level experience of *Vectorial Elevation*: "There was no way of talking back, the spaces remained segregated" (2000, 111). The hierarchical tradition suspended over the Net survives on the street: "Public light shows are a continuation of age-old spectacles, firmly connected with hierarchical structures, collective spectatorship and mass rituals. In spite of all heroic and thoughtful efforts, some of these aspects managed to sneak into the street level experience of *Vectorial Elevation*" (112).

What Huhtamo carefully formulates as an imperfection in *Vectorial Elevation* actually signals its failure, measured against the artist's own stated intention to avoid any discriminating representation of Mexican identity. In his concept notes, Lozano-Hemmer speaks of the "temptation to select from and summarize the country's presumed historical milestones in order to represent Mexico's identity" and warns that such a historicist approach that purports to be exhaustive "in fact misconstrues the pluralistic reality of Mexico's heterogeneous and *mestizo* culture" and inevitably signals what is excluded rather than what has been chosen to be displayed (2000a, 29).[39] For these reasons, Lozano-Hemmer opted to eschew a didactic, historicist, or monologic approach, instead offering an artistic vehicle through which people could have a direct impact on the urban landscape: "People from all over the country and the World will take part in a telepresence event that emphasizes action, interdependence and feedback."[40] Lozano-Hemmer

points out the two million of Mexico's Internet users and the large number of free public-access terminals around the country that allowed more people access to the work, as if expecting critics to raise the issue of the digital divide.[41] However, access to the Internet—and to the design of the show above the Zócalo—is not only dependent on free terminals. It requires digital literacy, which cannot be expected of many of Mexico City's inhabitants or the Zócalo's daily occupants. It is particularly the underprivileged who have limited or no access to new media (or any media) and thus are inevitably underrepresented in this work of interactive art. They may not even have understood the scope of the work. According to Mónica Mayer, on the night of the project's inauguration, people in the Zócalo "didn't seem to know exactly why the moving lights were there; but they were enjoying them" (2000, 235). One may wonder how they felt learning that technically literate people in Japan, Italy, and the United States— other than technically literate people in Mexico—were designing the light show. Even though they had no hand in its design, they could enjoy the beauty of the show in the night sky. However, a postcolonial reading must not neglect the deep symbolic significance of this dispossession, this taking away of local privilege by means of global technologies. Such a reading has to object to any hasty celebration of *Vectorial Elevation* as an emancipatory deconstruction of power, as found, for example, in Coulter-Smith's review: "If Zocalo square can be understood as a site of tension between the power of the state and that of its citizenry, then for duration of his installation Lozano-Hemmer hands the spectacular power of square over to the public" (2006, 270).

Lozano-Hemmer concedes the "power gradient" in *Vectorial Elevation* and reports that he received a good deal of criticism concerning the fact that people on site were not involved in the process of creative action, instead experiencing the work in the mode of contemplation (2002, 154). He also provides the keywords for a postcolonial reading, noting that the sky above the Zócalo was the only place that allowed for perfect visibility; he claimed, "The sky has not been precoded with political, architectural or social markings, unlike all other sites around the Zócalo, including the floor under which lie Aztec ruins" (2000a, 31). When Fernández speaks of *Vectorial Elevation* as the "roof" to the Zócalo and reminds us of the tradition of conquerors building the symbols of their power over those of the conquered (2000, 144), one may see the dark side of this light show: the symbolic conquest of Internet users around the world, a modern recurrence of the invasion and occupation of indigenous societies. Those who

inhabit the Zócalo are symbolically deprived of it by outsiders who are more technologically advanced and remotely control the plaza via the project's Web site. If the sky above the Zócalo has not been precoded before, after *Vectorial Elevation*, it carried the marks of remote control and the connotations of technological colonization.

Taking over a local space from a remote location is in fact the central point of *Vectorial Elevation*. It does not matter whether this remote location is in Mexico, Mexico City, or even around the Zócalo. What matters is that it does not have to be at any particular site. The democratization of light in the public space exceeds this public space and offers a say even to participants who have no real connection to the location. This mirrors the paradigm of globalization. Like food and clothing chains spreading out into local areas and changing the local culture according to the taste and standards of the chains' origin, *Vectorial Elevation* overwrites regional specificities with global light. The project symbolizes the overwriting of local space with global signs, and to this extent, it is undoubtedly suitable to herald the new millennium. It may be an antimonument undermining the power of the elite, but it also establishes the power of a new elite: the digerati.

In digital media, globalization translates as remote control, which is an essential feature of the Internet and has inspired its own genre of art. Two other examples of this genre, which Lozano-Hemmer reports as inspiration for *Vectorial Elevation*, are Masaki Fujihata's *Light on the Net* (1996), which enables the turning on and off of individual light bulbs in the lobby of the Tokyo Gifu Softopia Centers, and Ken Goldberg's *Dislocation of Intimacy* (1998), which also allows switching on and off the light via a Web site in an off-line installation (Lozano-Hemmer 2000a, 41). This remote control genre inevitably entails an ethics, as becomes clear in Eduardo Kac's interactive installation *Genesis* (1998), discussed in chapter 1. The moral question resulting from the fantasy of remote control is the question of individual responsibility in such cases where an action does not establish a responsible and manifest agent. *Vectorial Elevation* does not prompt this question with the didactic obtrusiveness of *Genesis*. Rather, it seems to avoid it. Nonetheless, it cannot deny the genre-specific issues. In fact, it highlights these same issues because of its postcolonial connotations.

The perspective we argue here becomes clearer if *Vectorial Elevation* is compared with another installation that also hijacks the emblematic significance of the Zócalo in Mexico City to endow it, to use Lozano-Hemmer's words, with "alien memory" (2000b, 55). On the morning of May 6, 2005,

American photographer Spencer Tunick assembled 18,000 nude participants at the Zócalo to photograph their bodies covering the square.[42] This project was part of a series of performances in which Tunick covers and fills various public places and buildings with naked human bodies. Although both Lozano-Hemmer and Tunick change the emblematic significance of the Zócalo with their projects, in Tunick's case, it is not the indiscernible virtual body but the real, naked body that takes over the space. This takeover is twice justified. The participants conquer the place with their presence by literally covering it with their skin, thus signifying an intimacy with the site that Web site visitors cannot develop at all in the case of *Vectorial Elevation*. However, real presence on the ground was also characteristic of the Spanish conquistadors. The second, more important justification is the fact that these 18,000 people are mostly Mexicans and residents of Mexico City. These 18,000 people are, potentially, 18,000 constituents representing a modern, free-thinking minority of the Catholic, macho Mexico. By getting out onto the street and lying down in the plaza, they vote for a liberal understanding of the body and sexuality. As Tunick states, "I think all eyes are looking south from the United States to Mexico City to see how a country can be free and treat the naked body as art. Not as pornography or as a crime, but with happiness and caring."[43] Rather than colonization, this takeover may be characterized as revolution, albeit an exported revolution, given that the idea comes from an American and is carried out by Mexicans.

Immersion and Distance

Works such as *Exchange Fields* and *Deep Walls*, as well as *Text Rain*, aim to engage participants in bodily actions, which may be unfamiliar or unknown in daily life. Be it an interaction with falling letters *(Text Rain)*, the use of one's own body to reveal the dance of another body *(Exchange Fields)*, or the invitation to create one's own shadow play *(Deep Walls)*, in all these cases, participants are encouraged to experience their own bodies in a new way. These three examples of interactive installation support a shift from the Cartesian paradigm to direct bodily sensation and experience, and a shift in audience role from a visitor in front of the work to an interactor within the work. I already discussed the invitation to self-discovery and direct bodily experience in such installations. We must now take up some of the questions I introduced earlier and address them in a more general context. Does Hansen's "seeing" body, does the shift

from vision to touch that de Kerckhove proclaims for the aesthetics of new technologies, make us blind, that is, displace any theoretical concerns?[44] Does the "energetic connection of the body with, and in, the world" (Ridgeway and Stern 2008, 133) cut off the head—that is, the mind—from this connection?

Oliver Grau (2003), in his book on the history and presence of virtual art, discusses the issue of immersion and distance with respect to virtual reality, one which absorbs and immerses the user in a 360-degree virtual environment. The immersion in VR is seen as complete, in contrast to other media such as painting, panorama, diorama, cinema, or television, which are not able to keep the appearance of the medium itself (the frame, the screen, the TV) out of the users' sight and hence beneath their level of awareness. In VR, however, the medium becomes invisible. In light of such a totalization that extinguishes the artwork as an autonomously perceived aesthetic object, Grau (2003, 339) wonders whether there is still any place for distanced, critical reflection. As he stresses, aesthetic distance allows us to attain an overall viewpoint from which to understand the organization, structure, and function of the artwork and so achieve a critical appraisal, one that includes searching for hypotheses, identifications, and associations: "Notwithstanding the longing for 'transcending boundaries' and 'abandoning the self,' the human subject is constituted in the act of distancing; this is an integral part of the civilizational process" (202). Grau argues, like Adorno, that distance is the primary condition for getting close to the meaning of a work and quotes the German philosopher Hartmut Böhme: "All happiness is immersion in flesh and cancels the history of the subject. All consciousness is emancipation from the flesh to which nature subjects us" (202). These references reveal how clearly Grau argues from and within the Cartesian paradigm of logocentrism, stressing the head as the locus of perception and cognition as the aim of the aesthetic experience. Do heightened emotional awareness and body experience necessarily have to be the counterpoints of critical distance?

Grau (2003) points to the role of the interface as the determinant of the dimension of interaction and immersion. Although the goal in VR research is the intuitive, "invisible" interface that explains itself—or, rather, does not require any explanation—Grau points out the manipulative influence of the suggestive potential of virtuality. He questions the "ideology of a 'natural interface'" and concludes, "Against the backdrop of virtual reality's illusionism, which targets all the senses for illusion, the dissolution of the interface is a political issue" (203). Artists who are concerned with

media reflection therefore stress the interface and design it as the site for deliberate decisions, as Grau then demonstrates through the work of Knowbotic Research. In such cases, immersion is countered by reflection; the audience is playing a double role, alternating between both positions.

Such alteration can also be witnessed occurring over a longer span of time. One can think of the double position of the audience as playing and watching, or as being inside and being outside. Immersed in the work one may—and should—surrender to the intensity of the moment and the experience of bodily sensation. Afterward, one may nonetheless move onto a reflection of this experience and its circumstances. It is questionable whether the spatial criteria of this double position—internal, external— are inevitably bound by temporal criteria—the moment of experience, the afterward of reflection. With respect to VR art—such as *Screen*—it may indeed be crucial that the external audience has previously been an internal audience. With respect to interactive installations—such as *Text Rain, Exchange Fields,* or *Deep Walls*—one may also be able to reflect on the work entirely from the position of the visitor without an experience of personal (inter)action. It could be argued that the direct immersion in the interaction in examples such as *Deep Walls* or *Text Rain* is not mandatory in order to understand their grammar of interaction and to discuss their deeper meaning. One can think about the concept of the work without experiencing it.[45]

Such a disembodied relationship with the work resumes the Cartesian focus on visual perception and cognitive activity. It entails receiving the interactive installation as an object—or, as Fujihata puts it, in the way of a "painting" (2001, 318). I do not intend to play the Cartesian paradigm against the desire for bodily liberation in interactive installations. It is clear that even if an interactive installation can be understood without experiencing it, the point of this kind of art is to experience the aesthetic situation with and from the body. The discussion above has shown how the physical experience is imprinted in the body, with lasting consequences. An important element of interactive art is to feel the meaning of the grammar of interaction.

However, I do want to underline the importance of the Cartesian paradigm, even in interactive art, and not only with respect to interactive installations that use text and thus do not exclusively focus on body play and sensual experience but participate in the cognitive action of reading. Even installations without text require "reading" in terms of thinking about the body's action. This requirement is evident in an example such

as Maurice Benayoun's 1997 Cave environment *World Skin,* a computer-simulated three-dimensional landscape of war in which the interactor literally takes pictures—that is, what she photographs is replaced by a black silhouette and printed out as a trophy from this special photo safari into the land of war, which phrase serves as the subtitle of the work (Benayoun 1997).[46] The grammar of interaction of this work has unmistakably political connotations, although its message remains ambiguous. Benayoun's (1997) own statement points in many directions: "Taking pictures expropriates the intimacy of the pain while, at the same time, bearing witness to it. . . . The viewer/tourist contributes to an amplification of the tragic dimension of the drama. Without him, this world is forsaken, left to its pain. He jostles this pain awake, exposes it. Through the media, war becomes a public stage." However the interactor reads the erasing/taking of pictures in this work, it is obvious that the artist expects her to reflect on her actions.

In other works, the grammar of interaction is less direct. Nevertheless, the bodily experience is itself a sign, which the author has carefully outfitted with meaning. As has been seen with respect to Rokeby's *Very Nervous System,* the transmitted experience of inexact control bears a philosophical message and a pedagogical agenda. In the case of Chris Salter's *TGarden* (2000–2001), an interactive environment quite similar to *Very Nervous System,* the goal is "social listening"—as opposed to the solipsistic listening to music alone at home or using earphones—and the "physical presence of encountering other people, of seeing what other people do, of looking at how other people perform" (Salter 2004).[47] One might argue that *Very Nervous System* and *TGarden* are able to transmit their message solely on the sensual level of bodily experience and thus do not support a Cartesian paradigm or the demand for distance and reflection. However, Salter (2004) himself opts for the double position of the audience as playing and watching, as being internal and external, overwhelmed and critical when he combines two very different aesthetic concepts:

> The poles in the 20th century are Artaud and Brecht: Brecht representing the critical in the sense of that the stage or the environment is a place of social display and of being critical of the social mechanisms, and Artaud with his position of the one being subsumed or being overwhelmed by an experience. And, I find that oscillation or that play between the two interesting. So, I would say that the ability to be immersed and then to step outside of the immersion is one of the aims of my work.

It is this combination of immersion and distance, bodily experience and cognitive reflection, that is important for critical interactive art. The privileged body in interactive installation art must not outplay the activity of the mind but rather become its favored subject. In the discourse of the aesthetics of presence and of the performative (Fischer-Lichte 2008; Gumbrecht 2004; Mersch 2002), the replacement of the paradigm "culture as text" by the paradigm "culture as performance" has been celebrated and has shifted attention to the intensity of the event rather than its meaning. In contrast, one should treat performance as text—that is, reading the grammar of interaction, trying to understand its meaning.

One precondition, however, may be that the grammar of interaction must have its own meaning. As seen above, some theorists claim that interactive art—or behaviorist, responsive, relational art, as Ascott, Krueger, and Bourriaud call it—is no longer concerned with facts but events (Ascott 2003, 110). Instead of providing a specific message, such art provides a specific space for interaction; "inter-human experiences" and "alternative forms of sociability," a space-time that inaugurates dialogue (Bourriaud 2002, 44). The discussion in this chapter has shown that authors of interactive art—be it as open and seemingly unstructured, as in Rokeby's *Very Nervous Systems*—do provide facts, symbols, and particular grammars of interaction that carry certain meanings and require the work of interpretation. Even Lozano-Hemmer's playful and effect-focused work is loaded with meaningful allusions: the metaphor of the shadow, the symbolic significance of searchlights, the simultaneity of spatial identities.[48] Absolute openness hardly exists and would in fact be rather problematic. The concept of such dialogic openness without the artist's underlying references or predesigned messages has been questioned especially with reference to Bourriaud's concept of *Relational Aesthetics* (2002). It may or may not come as a surprise that this critique has been voiced not by conservative but by left intellectuals. Thus, Hal Foster maintains that politics are sometimes ascribed to such art on the basis of a shaky analogy between open work and inclusive society, "as if a desultory form might evoke a democratic community, or a nonhierarchical installation predict an egalitarian world" (2006, 193). In contrast, Forster insists on art that still takes a stand and does this in a concrete register, bringing together the aesthetic, the cognitive, and the critical. Foster's conclusion does seem conservative, or at least anti-avant-garde, and reminds us of Adorno's aesthetics: "Formlessness in society might be a condition to contest rather than to celebrate in art—a condition to make over into form for the purpose of reflection and

resistance (as some modernist painters attempted to do)" (194). Foster notes that the artists and theorists in question frequently cite, without justification, the situationists, who valued precise interventions and rigorous organization above all things.

One may argue that the situationists' objection against the society of spectacle is undermined or even reversed by spectacular actions without a clear agenda. Lozano-Hemmer is certainly right to point out that in contrast to Jean Michel Jarre's pompous and exclusive Millennium Concert at the pyramids of Egypt, *Vectorial Elevation* was much more open in terms of attendance as well as direction (2002, 156). However, the fact that in contrast to Jarre's work, Lozano-Hemmer's light show was designed by thousands of participants does not circumvent the problems that we considered regarding the excluded local Mexican population. The fact that despite its conceptual flaws *Vectorial Elevation* is considered a huge success may be explained by the impressive and persuasive power of its special effects and the overvaluation of participation as such.

Lozano-Hemmer, whose work often evolves from existing and exciting special effects—big shadows, powerful light beams, intriguing surveillance technology (as in *Under Scan* of 2005)—declares he has no problem admitting that his work is "effectist" because "through participation, special effects become something that's more dialogical, something that's more of an exchange" (2002, 156). This opinion suggests that special effects are justified or redeemed by collaboration. One wonders, however, whether it doesn't just turn the audience into collaborationists in the society of spectacle. The seduction of powerful technology must not be underestimated. Eighteen 7,000-watt projectors make a strong impression and argument. Operated by people all over the world, they even convince critics.[49] To be sure, the visual outcome and the technological background of this work are impressive. Nonetheless, as has been argued, the work fails to live up to its own objective and reveals central conceptual contradictions. If one pays attention to the implicit connotations of the work and takes into account the artist's own original intention, one is less impressed by *Vectorial Elevation*. If one were to use less balanced language, one may even consider it bad art in disguise.

The justification of special effect or spectacle lies in conceptualization rather than participation, or as Foster would say, in the stand that the artist takes when she uses the effect in a particular form. The completely open interactive installation, the pure event—assuming it exists at all—will be in collaboration with the culture of spectacle rather than striking a blow

against it. There is a "cult of interactivity" (Huhtamo 1999, 109) not only in contemporary culture, but also academic writing, preventing more than a few from seeing the less positive aspect and effects of this concept. Let aside the practice of interactive shopping, the cultural logic of interactivity and participation may—despite its apparent and praised merits, and comparable to the cultural logic of computation as David Golumbia describes it—merely be an updated tool ensuring the "existing structures of power" (2009, 4) rather than a means of emancipation. As Adorno, and in a similar way Debord as well, would have pointed out, interactivity is cultural industry in camouflage. We leave this notion for a later study—which will also have to include the culture (and cult) of participation in new media social networks and multiuser communication forms—and further elaborate the issue of form and artistic quality. In the next chapter, we turn to another native genre of digital media: mapping art.

5 MAPPING ART

MAPPING ART IS THE ART IN WHICH the computer celebrates itself because this art is made manifest on the basis of the computer's most significant feature: once digitized, once represented to the machine, all phenomena lose their bodies and live as numerical code that can easily be materialized in different forms. In this sense, the computer is a relative to money, the classical machine of intermedial translation between different objects on grounds of their abstract numerical value. The fact that this technology makes this kind of art so easy makes it easier for us to be suspicious of this art. Is it really more than the random application of available tools? Is it more than an appealing visualization of data? When do statistics turn into art? What could be the message of such art? The fact that mapping art focuses on a notion of evidence seems to signify a return of the message, which is no longer left to the dialogue between interactors, displaced by technical effects, or undermined as such by computer-generated nonsense. But an accurate representation of reality should not be mistaken for a message; in fact, it may be a clever way to say nothing at great length.

There are several interesting aspects of the aesthetics of mapping art to be taken into account: its elevation of found objects (data) into art by their transformation and relocation reminds us of ready-made, although in this case, there is an emphasis on beautification. Mapping art's accurate reproduction of reality resembles photography, although in the case of real-time mapping, the *here-now* does not turn into a *there-then* but makes a claim to represent what is happening at the moment of perception. Above all else, the most important issue for our discussions is the relationship between content and form. Although Lev Manovich (2002b) considers their lack of integration to be the "basic problem of the whole mapping paradigm," the opposite is the case. The 1:1 translation of content into new form leads to a radicalized naturalism in which the voice of

the artist is not heard underlying the data. Instead, the data themselves speak. This problem has been raised by Albert Camus (1956) and Theodor W. Adorno (1984) with regard to the history of naturalism, and it now needs to be addressed in the present context. Because the mapping of politically charged data is sometimes enthusiastically praised as contribution to a new form of art engaged by digital media, it is helpful to remember Adorno's assertion that art that makes a claim of social relevance by making direct political statements frequently does little else than reveal a lack of talent. We also do well to discuss his declaration that the social content of art articulates itself in formal structures.

Against this background, overtly formalistic mapping pieces such as Mark Napier's *Black and White* (2002) deserve a more thorough analysis in light not only of Adorno's somewhat aged theory, but also that of Alan Liu's *The Laws of Cool: Knowledge Work and the Culture of Information*, according to which "cool is information designed to resist information" (2004, 179). Although it may be claimed that mapping art does not portray the individual's experience in a data society, one can also see this genre of art—or at least its neonaturalistic, quasi-enlightening version—as the perfect symbolic form of postmodern times. It represents a shift from the expression of ideas to the administration of information, one that helps us to respond to postmodernism's denial of grand narrative and the demoralizing void of metaphysical prospects with a gesture of absolute control.

However, such a conclusion would align with an aesthetics of autonomy as represented by Adorno and Camus. A different perspective involving a defense of naturalistic mapping as art would consider it as an expression of affirmation or of apathy or of protest. Granted its removal of the artist's voice, naturalistic mapping can be read as a branch of chance art. Or granted its indifference toward the data mapped, it demonstrates the affective inexpressiveness that Liu cites as a law of cool. Or given its rejection of the middle-class aesthetics of meaningful expression, it finds itself in the tradition of the avant-garde's violation of artistic conventions. In the end, there are several ways to be symbolic. In contrast to the art of mapping, mapping art can be mapped in various ways, and sometimes, as we know, this can also be true of maps.

Database and Mapping in Contemporary Art

One result of the very nature of digital media is that all data utilize the same numerical code and thus are stored in the same physical form. Christiane

Paul notes that "information itself to a large extent seems to have lost its body, becoming an abstract 'quality' that can make a fluid transition between different states of materiality" (2003, 174). Another significant aspect of information in digital media is its storage in a database. A database is generally defined as "a collection of data stored on a computer storage medium, such as a disk, that can be used for more than one purpose" (Downing, Covington, and Covington 2000, 118). Use for more than one purpose includes the possibility of rearranging data and presenting them in new contexts. For this reason, Manovich sees a natural enmity between database and narrative: "Competing for the same territory of human culture, each claims an exclusive right to make meaning out of the world" (2001, 225). While the way a narrative makes meaning out of the world is to "create a cause-and-effect trajectory of seemingly unordered items (events)," the database "represents the world as a list of items, and it refuses to order this list" (225). With reference to Erwin Panofsky's analysis of linear perspective as a "symbolic form," Manovich calls databases "a new symbolic form of a computer age . . . a new way to structure our experience of ourselves and of the world." He sees a correlation between the modern history of Western civilization and its current culture of remixing, stating, "After the death of God (Nietzsche), the end of grand Narratives of Enlightenment (Lyotard) and the arrival of the Web (Tim Berners-Lee) the world appears to us as an endless and unstructured collection of images, texts, and other data records, it is only appropriate that we will be moved to model it as a database" (219). Manovich adds, "But it is also appropriate that we would want to develop poetics, aesthetics, and ethics of this database" (219). I consider this appeal and discuss the aesthetics of mapping art, a genre essentially based on the disembodiment of information in databases.

The mapping of a data set and its visualization is a widely used method to illustrate and organize scientific and statistical data, be it in medicine, biology, geography, or economics. Manovich (2002b) defines mapping as transformation of one set of data into another form—"grayscale image into 3D surface, a sound wave into an image"—and considers visualization "a particular subset of mapping in which a data set is mapped into an image." In the last few years, visualization has become a more generic term that covers the sensory presentation of data and processing, including sonification and interactive techniques (Wright 2008). Over the course of the 1990s, mapping—or data visualization—spread from the sciences into engineering, marketing, and policy making, and then into art. It is

applied in architecture and fashion[1] and can be found in almost all genres of art.[2] The artistic use of mapping transcends the mere utilitarian purpose of illustration and orientation; it aims to defamiliarize data or grant data expression through the way it is mapped. This is the guiding assumption for the subsequent discussion, which follows the definition of art as something that, according to Adorno (1984), questions assumptions and preconceptions or, according to Arthur Danto (2000), indicates *aboutness*.[3]

The data used in mapping art are mostly invisible or neglected and are mostly gathered from everyday life, be it a public library, Internet traffic, the stock market, or online communication. One example is *Making Visible the Invisible* (2005) by George Legrady and his collaborators, an installation of large LCD screens behind the information desk of Seattle's public library, visualizing statistical analyses of the circulation of books and media.[4] In this work, one form of visualization (entitled "Vital Statistics") is simply two increasing numbers indicating what has circulated during the last hour and since the morning (Figure 16, *top*). A second form of visualization is "Dot Matrix Rain" (Figure 16, *bottom*), in which, on the screens subdivided according to the Dewey classification system, titles of checked-out items pop up at their Dewey location, with books in yellow, DVDs in green,

Figure 16. George Legrady et al., *Making Visible the Invisible* (2005). Copyright George Legrady. "Vital Statistics" (*top*), "Dot Matrix Rain" (*bottom*).

and other media in blue. By the end of the animation, the bars (there are 100 bars vertically placed to represent the divisions of each Dewey category from 0 to 99) are color-coded to provide an overview as to which Dewey categories received the most circulation. In the "Floating Titles" form, checked-out items are condensed into a linear representation based on time. The titles enter the screens from the far right and slowly move toward the left until the whole hour's set of items has passed by. Items checked out at the same time will be close to each other; gaps in the movement represent a lack of activity.

Another example of mapping art is *Black and White* by Mark Napier (2002), which reads the 0s and 1s on the CNN server and visually translates them into black-and-white patterns moving horizontally and vertically over the screen (Figure 17).[5] A third example is *Ping Body* by Stelarc (1996), in which the time lag of data going to and from a server is measured and transformed into voltage, which then is directed to Stelarc's muscles, triggering their contraction and action on stage.[6]

These three examples are quite different and may each represent its own subgenre of mapping art.[7] *Making Visible the Invisible* reveals information to make people aware of certain aspects of the systems they live in. It is focused not as much on the visual pleasure of the transformation as on the disclosure of data; the way the data appear does not encourage visitors to search for a deeper meaning or personally connect to the piece. One also may call it a sociological study or data architecture. Besides the

Figure 17. Mark Napier, *Black and White* (2002).

title, the description on Legrady's Web site clearly announces this intention: "From a cultural perspective, the result may be a good indicator of what the community of patrons considers interesting information at any specific time. Visualizing the statistical information of the titles and their categories therefore provides a real-time living picture of what the community is thinking" (Legrady 2005). The work provides real-time data and does not express in any way the author's opinions or conclusions about the subject. To use a label employed in Mitchell Whitelaw's essay on data art, the practice of *Making Visible the Invisible* is "indexical," for it "it aims to somehow present us with the data 'itself'" (2008). The question to be discussed below: Does the revealed, no longer invisible data yield any information in the context of art?

Black and White applies spy software to scrutinize the CNN server but does not really offer any new perspective on how the Internet, global communication, or CNN work. It simply sensualizes the data retrieved into an abstract visual object and thus seems to be a mere formalistic play with information, a "non-cognitive 'visualisation'" that gives up the significance of the source data, to borrow from Richard Wright's article on data visualization (2008, 84). Finally, *Ping Body* connects certain effects of digital technology directly to the body and thus raises questions about control and sovereignty. It can be argued that in the case at hand, this effect is not the natural result of the use of technology but the intended effect of Stelarc's construction. Because he sets up the data's effect on his body, he ironically proves human superiority over technology in the moment of the human's humiliation by technology. On the other hand, it is a fact that technology, always first invented by humans, eventually develops on its own and creates an environment that dominates and shapes human interests. The Internet itself is a preeminent example of this fact. Given his writings, it is questionable, though, whether Stelarc means to convey this message and warning. *Ping Body* may rather be looked at as a way to act out Stelarc's obsession with the cyborgization of the human body.[8] In any case, in contrast to the other two types of mapping art here, the data mapping is clearly part of a broader concept or philosophy and serves a specific agenda.

What all three examples have in common is the use of data accessible online and their transfer into another form. It is important to note that the structure of the data itself is not touched but is transposed into another form; the data are not restructured and presented as a new, alternative story. The different length of ping data is reflected in the different

intensity of voltage; the amount of 0s and 1s is accurately, although inde-cipherably, presented; the ranking of books checked out in relation to the Dewey Decimal Classification is mirrored in the density of titles appear-ing on screen within their respective Dewey classifications. An example of remixed and restructured data would be Legrady's *Pockets Full of Mem-ories* (2001), in which audience members scan and describe objects in their pockets.[9] This information is stored in a database and organized by an algorithm that positions objects of similar descriptions—the criteria on the touch screen questionnaire include old/new, soft/hard, personal/nonpersonal, natural/synthetic—near each other in a two-dimensional map projected in the gallery space. The order of this map emerges from the users' contributions and changes as long as new objects are added. Unlike *Making Visible the Invisible*, it thus comes close to the idea of data mining to reveal "secret" relationships between data by applying certain algorithms.

In contrast to such a remixing work, in most examples of mapping art, it is not the content's structure that is altered but its form. Any "narrative" the data offers is preserved. This preservation lies in the nature of map-ping, which is defined as correspondence of elements of a given set with elements of a second set. This preservation, as will be argued later, is also the actual poetic problem of mapping art. In its propensity for recruiting its contents for uses not originally intended, mapping art's aesthetic imper-atives mirror those of another art practice: the ready-made. Consequently, we might first consider how mapping art relates to this form of art.

Beautification, Photography, Content, and Form

Mapping art can be seen in the tradition of ready-made aesthetics be-cause it uses found objects. As with the classical ready-made,[10] what ele-vates the trivial object to art is the new environment, within which it is transformed. While the classical ready-made was transferred into a differ-ent space (from everyday life environment to art gallery), the object of mapping art is transferred—or rather copied—into a different medium (data to visual artifacts). In addition, unlike Duchamp's ready-made, which was intended to sabotage this new environment (that is, the art system), mapping art often carries out a beautification of the ready-made. Although people also emphasized the beauty of the urinal displayed in the sacred realm of a museum, this beautification was, as Duchamp remarked, not his intention, and in fact sabotaged his sabotage. (On the other hand,

however, Duchamp encouraged such a reception of the urinal by commissioning a beautiful picture from Alfred Stieglitz.) One may want to distinguish between aestheticization, which is an abstract operation changing the essence of something (recognizing the actual beauty of the urinal), and beautification, which is a sensory operation changing the appearance of something (transforming boring statistics into appealing visual objects).

One effect of this beautification, it has been argued, is usability. In the chapter "Meaningful Beauty: Data Mapping as Anti-Sublime," Manovich (2002b) speaks of data visualization as a transfer of "invisible and 'messy' phenomena . . . into ordered and harmonious geometric figures." Asking why he often finds himself emotionally moved by these projects, he assumes that it is because of their promise to render phenomena that are beyond the scale of human senses into something that is within our reach, something visible and tangible. Manovich comes to a surprising conclusion: "This promise makes data mapping into the exact opposite of the Romantic art concerned with the sublime. In contrast, data visualisation art is concerned with the anti-sublime."

Manovich's reference of mapping to the sublime is fruitful and problematic, and it certainly requires more elaboration. One aspect to be taken into account is the distinction between mapping as art and nonart. Warren Sack (2004) considers only nonart mapping to be antisublime, an "attempt to create 'user friendly' interfaces to huge amounts of data." With regard to mapping as art, Sack quotes John Simon's *Every Icon* (1998)[11] as an example of what Kant describes as the mathematical sublime: the immeasurable number of Milky Way systems, the experience of infinity.[12] Lisa Jevbratt expresses her disagreement with Manovich, insinuating, in a somewhat free understanding of Kant, a "mobilizing effect the sublime has on our organizing abilities" (2004, 6).[13] One may in this context also consider the technological sublime, which consists of man-made phenomena such as the railroad, the steamboat, the airplane, and great bridges and dams, and their displacement of the sublime of mighty nature in the late nineteenth century. With respect to this type of the sublime, it can be held that the technical mastery and command over data in mapping induce exactly the kind of awe that is the signature of the sublime.[14]

However one sees the relationship between mapping and the sublime, Manovich is certainly right to note a beautification of data in this process. Although a database is not messy but is instead a structured entity that conforms to formal organizational criteria, mapping does turn ostensibly unexciting data[15] into an interesting and intriguing visual artifact. This

beautification contributes to the general aestheticization one encounters since the "pictorial turn" (Mitchell 1992) at the end of the twentieth century and reminds us of photography, which also gives everything captured a special aesthetic value. In addition, the paradigm of mapping art resembles photography insofar as it is an indexical reproduction of reality, a reproduction that in both cases is shaped by the decision what part of the reality to include with what perspective and how to contextualize its presentation. The key differences between mapping and photography are that the former is a dynamic medium (such as film) and does not (in contrast to film) establish a presence representing the past. The *here-now* does not turn into the *there-then* or *having been there*, as in photography and film; the signified is—in most of the examples, which achieve data directly from the Net—present in the very moment of its presentation.[16]

In the case of mapping art, the "photographer's" specific perspective is manifest in the data she is using and in the way she transforms and presents them. The comment of the artist lies in the form she generates. It could be argued that all art is about finding the appropriate form for a specific content, and we might then conclude that art as such is mapping: the image is a form of artistic thinking; the metaphor, story, character is a way to embody data given by reality. Such a broad understanding of mapping would magnify the scope of this concept but not necessarily provide a better understanding of the subject at hand. The notion of shaping content, expressing meaning by an appropriate form, is subject to Susan Sontag's critique of such an assumption, as I noted in the introduction. Nevertheless it may be well to pick up the old question of unity of content and form and explore what in this regard can be said about mapping art, which seems to be all about finding a specific form for a given content. Manovich himself brings up this question claiming that the "basic problem of the whole mapping paradigm" is the lack of oneness of content and form:

> Since usually there are endless ways to map one data set onto another, the particular mapping chosen by the artist often is not motivated, and as a result the work feels arbitrary. We are always told that in good art "form and content form a single whole" and that "content motivates form." Maybe in a "good" work of data art the mapping used must somehow relate to the content and context of data—although I am not sure how this would work in general. (2002b)

Manovich's premise is not without problems because it is based on a grand narrative itself. The expectation that the qualities of the form unmistakably correspond to the qualities and connotations of a represented theme implies, as Meyer Shapiro notes, a "kind of generalized onomatopoeia" and may even, as Shapiro goes on to suggest, "rest on an ideal of perception which may be compared with a mystic's experience of the oneness of the world or of God" (1994, 41, 48). But the claim of oneness of form and content is also problematic in at least three other respects: (1) the concept of content and form does not clarify what it is that establishes content and form;[17] (2) one may appreciate the unity of content and form without knowing the meaning of the content (45); and (3) the conventions of form independent of the subject but due to a specific genre or to the style of the time may inform the way a specific content is represented (42, 47). With regard to mapping art, however, there is a paradoxical answer to the issue at hand. If one sees as the content of mapping art the database itself, which is to be understood as a collection of data that can easily be remixed, the specific way to represent such quality of constant reordering seems to be a formless re-formation. The seemingly purely motivated way to map a specific set of data is motivated by the subject itself. In this perspective, the lack of unity of content and form actually establishes this unity.

Besides such dialectic turns, one can argue that in pieces such as *They Rule* (2001) by Josh On & Futurefarmers—which creates maps of the interlocking directories of the most influential American corporations—the content motivates the form (Figure 18).[18] The individuals are visualized by icons of businessmen, some of them fatter than others, indicating those who sit on the boards of several corporations. The connections between businessmen and corporations are represented by thick gray lines imitating the stereotypical aesthetic of the corporate workplace. If in the content–form discourse colliding and broken shapes are considered the adequate form for a violent action and horizontal shapes the adequate form for a scene of rest (Shapiro 1994, 41), a net of icons, which aesthetically renders the aesthetic of the subject matter, can certainly be seen as the adequate form to display a network of rulers. Thus *They Rule* presents the wholeness Manovich is missing in mapping art. This is also true for works such as Roy Want's *Internet Stock Fountain* (1999) at Xerox PARC, whose rate of water flow indicates whether Xerox shares are up or down, or Koert van Mensvoort's *Datafountain* (2007), whose three fountains display the currency rates of the yen, euro, and dollar. Both works transform the strength

Figure 18. Josh On & Futurefarmers, *They Rule* (2001, 2004). From TheyRule.net.

(value) of the stock into the strength of the water jet in the simplest way of converting content into form.

However, this 1:1 translation, this obvious oneness of content and form, may be a much more basic, serious problem than the alleged lack of it. This kind of "imitative naturalism"[19] and transmedial replication does not really present an appropriate, significant form or image for the content given; it just mirrors the form and image found. We will come back to *They Rule* after discussing the historic predecessors of its aesthetics.

Mapping as Naturalism

It is clear by now that part of my argument traces an ongoing concern with a special kind of description—the most precise possible—and the attendant subjugation of the observer's subjective position. These two qualities, central to the anatomy of mapping art as a descriptive, objectivizing paradigm, are not historically unique. These imperatives also lie at the center of other, earlier lines of effort, most notably naturalism. This movement, especially in German and French literature, which reached its height between 1870 and 1890 in the works of Émile Zola and Arno Holz, among others, aimed to provide reliable accounts of reality by describing

it as precisely as possible and ruling out the author's subjectivity as much as possible. This movement reflected the growing popularity of natural and social sciences in the second part of the nineteenth century and the goal of basing aesthetics on such paradigms. It was grounded on empiricism and its basic premise was the belief in the contemporary theory of social determinism—that is, the notion that one's heredity and surroundings decide one's character. The naturalistic writer was considered to undertake an experiment similar to a chemist's, having characters from a specific milieu and therefore with a specific disposition react to each other with a logical, predictable result independently of the author's own idea.[20]

This concept of writing as a kind of mathematics was attacked by the naturalists' contemporaries as well as by later writers and theorists for its exclusion of the author's personal perspective (Camus 1956; Adorno 1984, 151; Bürger 1979, 37). Camus considered the style of naturalism in literature the expression of nihilism precisely for its apotheosis of reality that does not impose any transformation or correction on reality. The artist claims, Camus notes for the poetic principle of naturalism, to give the world unity by withdrawing from it all privileged perspectives including the perspective of the artist herself. In this sense, Camus holds, the artist "renounces the first requirement of artistic creation" (1956, 268). He continues, "Whatever may be the chosen point of view of an artist, one principle remains common to all creation: stylization, which supposes the simultaneous existence of reality and of the mind that gives reality its form. Through style, the creative effort reconstructs the world, and always with the same slight distortion that is the mark of both art and protest" (271).

It is evident that pure naturalism is impossible. It would require of the writer the ability to reproduce the elements of reality without making any kind of selection, which is unattainable because one would need hundreds of pages to cover all elements of just one short situation.[21] However, with mapping art, the absolute exclusion of the subject from the organization and presentation of the content—though not from its transformation—is feasible. Mapping preserves the structure of data in an exact way and mirrors it in a new form. A good example is *Making Visible the Invisible*, which claims—as naturalism did—to provide a reliable account of its subject matter: the reading habits of the community mapped. It is logically consistent that in light of this goal, the form of mapping has changed during the production phase of the piece from a poetic, metaphoric, and arcane visualization to an informative, statistically precise visualization. In its earlier version, Legrady, for example, planned to visualize the data

as an untitled row of vertical lines—the Dewey system without marking (Figure 19, *top*)—and as a net of dots with changing brightness, which would have reminded us of the starry sky or of a radar image, with books as airplanes and topics as geographical space. Another idea was a "Flow" format that generated, from the checkout activities, an abstract, animated image (symbolizing the Dewey system) that did not reveal any information but produced a mesmerizing impact on the viewer (Figure 19, *bottom*).

Legrady explains the shift in design as prompted by the challenge to arrive at the ideal balance between information and poetics. If the project understands as its prior goal to make visible what the community of patrons is interested in, it needs to be as specific as possible and has to provide the titles of the checked-out media. The price is to abstain from any poetic, but perhaps also obscuring, transformations. Legrady (2005) justifies this price with the value of the data itself: "In the end, the most fascinating element is the cultural narrative and associative resonances that emerges out of the stream of data itself, so it's best to let it speak for itself." Such submission to the pure data follows the guidelines for how to design information graphics—"let the data speak for itself," declares an early handbook (Tufte 1997, 45)—and is very much in the spirit of naturalism.[22]

It is remarkable that Legrady uses the terms *information* and *data* interchangeably, now calling "stream of data" what was formerly "statistical information." This lack of distinction is significant for what is at stake in this chapter. If we understand, as Whitelaw (2008) requests, information as "the result of processing, manipulating and organizing data in a way that adds to the knowledge of the person receiving it," we must ask how informative the data are revealed in Legrady's work. To the extent that they had been unknown to the audience, it will perceive them as a "difference that makes a difference," to apply Gregory Bateson's well-known definition of information (1973, 428). Invisible data made visible are information by default. However, it is important to note that in the case at hand, the "difference" derives from giving the audience access to the data, rather than from processing or manipulating them. *Making Visible the Invisible* does make visible invisible data—thus providing information—but it does not make anything visible within these data that would make a difference to what they seem to say themselves. Whitelaw, referring to the same interview with Legrady cited above, defines data art as that which "aims to somehow present us with the data 'itself'"; it is indexical. Given the requested

Figure 19. George Legrady et al., *Making Visible the Invisible* (2005). Copyright George Legrady. "Dewey Dots" (*top*). "Flow" (*bottom*).

distinction between data and information, he consequently calls data art that which "resist, or defers, information" (2008). By the same token, White-law considers data art that finds a metaphor for the nature of the data used to "generate meaning and information" even if the data themselves are rendered useless. A case in point is Alex Dragulescu's *Spam Architecture* series (2006), which "performs a poetic transubstantiation on spam" by turning it into "jittery, origami structures" evoking the violent nature of spam (Whitelaw 2008). Thus, information in the context of data art is conceptualized as meaning added by the artist through a specific processing of data, which can be linked to Camus's concept of "stylization" as "creative effort [that] reconstructs the world" (1956, 271). As Whitelaw's example shows, one location of such information generating data art is abstract artifacts. This is important for our subsequent discussion and requires returning to Camus and Adorno again.[23]

The opposite of naturalism is formalism, which focuses on the organization of forms rather than on the content given in reality. An example here is Napier's *Black and White*, with its obvious rejection of any compelling relation between content and form. It should be mentioned that Camus considered formalism to be as nihilistic as absolute realism for the same lack of a specific perspective offered by the artist. While naturalism[24] escapes into pure reality, formalism purely escapes reality. It appears plausible to compare naturalism and formalism on the account of their abdication of a symbolic description of reality—Peter Bürger (1979, 31) reaffirms such a comparison—but Camus's premise is problematic. Formalism is not necessarily art for art's sake, nor does it automatically void a message by the artist, as can also be seen in Adorno's aesthetic theory holding that "what makes art works socially significant is content that articulates itself in formal structures" (1984, 327). Adorno explains his position with respect to Kafka and comes to a conclusion that is equally important when discussing mapping art:

> Kafka, is a good example here. Nowhere in his work did he address monopoly capitalism directly. Yet by zeroing in on the dregs of the administered world, he laid bare the inhumanity of a repressive social totality, and he did so more powerfully and uncompromisingly than if he had written novels about corruption in multinational corporations. . . . While his work foreswore any attempt at transcending myth, it lays bare the universal blindness, which is society. The exposure is brought about by Kafka's language. In his narrative the bizarre is as normal as it is in social reality. Artistic products that are nothing but regurgitations of what is happening socially, flattering themselves that this kind of metabolism with second nature passes for a genuine process of copying such products, are smitten with silence. (1984, 327)

Adorno questions not only the aesthetic creativity of mimetic naturalism—he accuses, quite undifferentiated and unfair, the underdog poetry of Arno Holz of being aesthetically unsophisticated (1984, 352)—but also its social relevance. Ethos is not enough, Adorno states, when defending formalism against Georg Lukács and disapproving an "aesthetics that puts a premium on material and nothing else" ("stoffgläubige Sozialästhetik") neglecting any figuration ("Gestaltung") (327). Adorno's advocacy of aesthetics of autonomy is well known, as is his criticism of Lukács demanding partisanship and Jean-Paul Sartre calling for politically engaged art.[25] As much as Adorno expects art to question society and to refrain from any affirmation of the status quo, he also dismisses art that claims social

relevance by making direct political statements. For him, "commitment is frequently no more than lack of talent or of adaptation, in any event a weakening of subjective strength" (356).

In this perspective, a piece such as *Black and White* must—like Dragulescu's *Spam Architecture*—not be dismissed too quickly as a pure formalistic play without any deeper meaning. It deserves a more thorough analysis. One approach to a more complex understanding of the nature of this formalistic play is provided by the deployment of the concept of cool as developed in Liu's *Laws of Cool* (2004). According to Liu, cool is "not so much a quality of information as a view or stance toward information, expressed from within information itself. It is a 'way of looking' at the world of information that exceeds the utilitarian sense of either presenting or receiving information" (184). Cool is an ethos of information that is against information; it is the uselessness of useful information and the use of information to abuse information (185): "Cool is the aporia of information . . . cool is *information designed to resist information* . . . cool is the paradoxical 'gesture' by which an ethos of the unknown struggles to arise in the midst of knowledge work" (179). Such abusive play with information is exactly what *Black and White* (and also *The Source* [2004] by Greyworld[26]) seems to carry out. In this case, the artist's particular perspective or vision, as claimed by Camus and Adorno, is what Liu defines as the laws of cool in the culture of information: to parody, misapply, and defamiliarize the notion of efficient information (2004, 186). However, there is another way to look at *Black and White*.

Taking into account the details of Napier's piece, it should make one suspicious that such a highly politically charged software as Carnivore[27] is applied to an equally politically charged news outlet like CNN, only to generate a "meaningless" formalistic play. Such contrast demands interpretation and allows us to respond beyond the laws of cool. The formalistic play gives up the significance of the source data, but not the significance of the data source. The limited utilization of the spy software's power may be understood as a repudiation of the temptation (or illusion) of using the system's means against it. The downgraded visual, the avoidance of color, and the title could be seen as a comment on the binary (black and white) way news programs reduce complex real-life events to simple reports. Napier's piece, one can argue, appears to take the opposite perspective compared to *They Rule*, which does demonstrate the desire to turn the weapons of the data-society elite back on themselves and therefore is

considered by Bruce Wands and many others to be an excellent example of political activism (Wands 2006, 169; Blais and Ippolito 2006, 140). Interesting in this context is the use of the same spy software, Carnivore, in Jonah Brucker-Cohen's *Police State* (2003), which grabs incoming packets of information from the local network, checks them against keywords related to domestic U.S. terrorism, and, if a word is found, assigns a police code to twenty little police cars.[28] The cars then simultaneously start to drive in a certain pattern while sirens sound, and a police officer's voice relays the message over loudspeakers. As Brucker-Cohen states, he intends a "reversal of the control of information appropriated by police by using the same information to control them" so that "the police become puppets of their own surveillance,"[29] which certainly sounds less cool than the deutilization of data in *Police State* would actually be.

Black and White and *They Rule* recall the opposition between Adorno and Lukács, who were seeing political engagement in art on either the level of content (Lukács) or the level of form (Adorno) and thus favored either critically and educationally committed but stylistically conservative prose (Lukács) or disturbing formalistic experiments with no clear messages on the level of content (Adorno). *They Rule* certainly shows a social engagement by the topic picked, which is also true for naturalists, who made the underclass the subject of their writing. At the same time, this kind of mapping lacks formal aspects of artistic creation, which is, according to its critics, also true for naturalism. It is remarkable and significant that the jury statement on the award-winning contribution of Ars Electronica 2002 in the section Net Vision/Net Excellence praises *They Rule* particularly for the easy usability of the piece, the focus on "eye-opening facts," and the abdication of excessive dramatization of the data in a sensationalist manner.[30]

In contrast, *Black and White* can be seen in the tradition of formalism, which does not necessarily mean the lack of a specific message or comment by the artist on the subject matter. Napier's withdrawal into pure formalism may be as strong a statement as Samuel Beckett's escape into nonsense dialogue. What Adorno concludes in his review of Beckett's play *Endgame* (1957) seems to be applicable to Napier's *Black and White*: "If it [art] is to live on, it must elevate social criticisms to the level of form, deemphasizing social content accordingly" (1984, 354). As much as Beckett's antirealism addresses human alienation on a formal level, Napier's rejection of any counterculture romanticism addresses disillusion on the formal level. *Black and White* may be pessimistic; however, using Camus's criteria, it is not nihilistic, whereas *They Rule* is.[31]

Camus emphasizes the importance of stylization in the creative process. Critics and even advocates and practitioners of naturalism have similarly made clear that the essence of literature is not to copy the language of everyday life; they have suggested that such radical copying would only reveal the lack of poetic competence. In addition, they have pointed out that even in naturalism, the author needs to decide what details should be covered and how they should be composed, and thus develops presence in the text as an organizing authority. As Zola (1885) himself holds, this presence differentiates naturalism from photography. Finally, German theorist of naturalism Julius Hart (1889, 1890) stresses that the precise observation in naturalism must not become an end in itself, as in science, but can only deliver the material to work with.

As much as writings of naturalism are not without the presence of stylization by the author, mapping art still is the result of an artistic process, including the choice of which data are to be mapped and the decision of how to visualize them.[32] The specific form of visualization is an artistic decision. Because the data themselves are ready-made, they are the actual place from which the artistic value can be measured. In light of the discussion above, it can be said that this value does not so much depend on the accuracy with which mapped data are presented, but on the symbolic depth of the way they are presented. In contrast to other forms of communication, such as a report, sociological study, or an academic or scientific analysis, art is a form of communication that is supposed to question a given picture of reality (including our Self). Art is supposed to be about more than providing access to specific information. It is the reflection of and comment on the information it provides through the personal perspective or vision of the artist, or, as Camus puts it, through the specific stylization of the information. To quote a representative not of literary but of visual art, Paul Klee maintains, in the same spirit, that art should not repeat the visible and obvious but reveal the invisible. To be sure, Klee does not speak about making visible the invisible, but about the presentation of the individually experienced objective data (the "geheim Erschaute") (1949, 49).

In the context at hand, this agenda is best accomplished by way of a visualization that somehow defamiliarizes the data mapped. I conclude that a visualization that most seems to provide the oneness of content and form appears to be least able to provide a specific perspective by the artist. Examples such as *They Rule, Making Visible the Invisible,* and *Internet Stock Fountain* simply repeat the form attached to the given content

and thus are not very convincing from an aesthetic point of view. This does not change if they reveal interesting information, as is the case with *They Rule* and to a lesser extent with *Making Visible the Invisible.* Content does not make up for aesthetic deficits. As we have seen in the case of *Black and White*—and as Whitelaw convincingly argues with respect to Dragulescu's *Spam Architecture*—an apparently absolutely arbitrary visualization can offer a specific perspective by the artist in a highly symbolic and complex way. The same is true for *Ping Body,* in which the artist chose exactly the form of visualization he needed to convey his own perspective on reality. Can the first subgenre of mapping art, focusing more on the disclosure of data, present those data in a similar poetic way, or would this inevitably obscure the underlying data?

An example of a poetic disclosure of data is Golan Levin's *The Secret Lives of Numbers* (2002), which presents a graph of every number from zero to one million, showing the popularity of each number according to statistics gathered from a Google search (Figure 20).[33] Similar to *Making Visible the Invisible,* this work offers precise information about the data mapped and obtains with the graphic visualization of the numbers' rank a clear oneness of content and form. Nevertheless, the aesthetics of *The Secret Lives of Numbers* is poetic rather than naturalistic (or positivistic). The artist undertakes in a way an anthropomorphization of numbers and suggests that we see the ranking of numbers according not to their natural

Figure 20. Golan Levin et al., *The Secret Lives of Numbers* (2002).

ordering system but rather their "fame." The artist teaches us to see the world (of numbers) in a different way and is present in his work not through a specific form of visualization but by the content chosen. The choice itself represents a poetic relationship to the world and is reminiscent of the humor applied in German realism.[34]

A similar form of "poetic statistic" may, after all, be found in *Making Visible the Invisible.* Visualization form IV, "KeyWord Map Attack," collects main words from the checked-out titles and adds keywords associated with the titles to the list (Figure 21). The words—those that have nine or more hits and are present in at least two Dewey subcategories—are then "thrown on stage" one at a time, with white lines showing their Dewey connections. The result is a mix of words that triggers a reflection about the places they take in the Dewey system, words that somehow hang loosely in the air because the white lines—thin and overlapping—are not really traceable. Here exactness has been sacrificed for a poetic image. The artist has eventually overcome the statistician.

While Levin's *The Secret Lives of Numbers* is a convincing example of poetic statistic, Graham Harwood's *Lungs: Slave Labour* (2005) clearly steps away from revealing precise information towards generating a striking image. *Lungs* computes—depending on age, sex, and height—the vital lung capacity of 4,500 slave laborers in an ex-munitions factory in Karlsruhe, Germany, during World War II and emits a breath of air for each worker through a speaker system.[35] Harwood describes *Lungs* as a "software poem memorial" that bridges the gap between the perception of data and social experience: "The aim is to take computer records of local events or

Figure 21. George Legrady et al., *Making Visible the Invisible* (2005). "KeyWord Map Attack." Copyright George Legrady.

communities that have been reduced or demeaned to the status of information and to allow the people to reexperience and/or recover their own value."[36] Although Harwood speaks of the audience experiencing and recovering the data's own value, it is in fact he who allows the experience and insinuates the value by providing an image as strong as the "last breath of air."[37] The way he visualizes the data is not as precise as in the case of *They Rule* or *Making Visible the Invisible*. However, it is precisely because of the metaphoric, noncognitive visualization that Harwood counters the diminution of the record of a local event to the mere "status of information" and has his audience experiencing them in a specific stylization. This stylization represents his personal view of the past event and makes a different difference than the pure information about it. The breath of air takes on the form of a sigh with which the victims virtually express their concealed, forgotten existence.

Harwood does not let data speak for themselves but extracts the actual message from them. His agenda becomes clear when he proposes to apply this form of mapping to any database of a social atrocity and to present the outcome in the area of the atrocity. Harwood suggests computing the sound of the 8,000 Bosnian Muslim men killed by Bosnian Serb forces, which results in 3.65 liters of air per person, 29,200 liters altogether, and pushing them through a speaker system "in the wave form of a scream."[38]

Thematically similar to *Lungs* is Caleb Larsen's mapping installation *Monument (if it Bleeds, it Leads)* (2006), which continuously scans, via Google News, the headlines of 4,500 English-language news sources around the world, looking for people who have been reported killed.[39] For each death, a ceiling-mounted mechanism drops a small yellow ball (a BB) into the room. During the course of the installation, BBs will accumulate on the floor, eventually covering it, with errant BBs traveling throughout the building. The contrast between the yellow balls rolling around and the puddle of blood they represent could not be bigger. While the BBs, used for combat games, normally symbolize the imitation of killing, here, in the context of art, they signify real killings. The subtitle puts it in dry, unmistakable words: *if it Bleeds, it Leads*. Larsen's decision not to release the BBs from a gun, as it is used in combat games, but from a transparent box containing 100,000 BBs, is certainly wise. This way, he avoids overdoing the reference, and by showing all the balls not yet dropped, he further emphasizes the severity of the situation.

The dichotomy between the playfulness of the material and the sobering reality of the subject matter is, as Larsen states, clearly the intention

of the work. This tension is combined with a confusing ethical situation because the viewer's natural inclination is to expect and desire activity from a kinetic sculpture: "The viewer finds himself secretly and selfishly waiting for someone to be killed only so that he can watch a little yellow ball bounce around on the floor."[40] Even the artist himself is entangled in this dilemma because his natural inclination is to verify the technical sophistication of his work. However, the implication of such desire compels him rather to wish his artwork does not happen. *Monument* challenges the technical narcissism that McLuhan describes as a human characteristic (1964, 51–56) and that is so prominent in digital art, especially the genre of mapping art.

The tension between the playful ball and its deadly message aims right at the heart of contemporary media society and the society of the spectacle, where news about catastrophes, riots, wars, and killings are a kind of entertaining element in our everyday life. The drop of the BBs is charged to an extent that one must wish the artwork would not reveal itself in action. At the same time, it is not possible to approach this work in the spirit of the culture of presence discussed in the introduction because the focus on pure materiality, the delinking of the dropping BBs from their meaning, would reenact the killing on the level of perception. Of course, the wish that nothing would happen does not prevent the next BB from falling. This experience is the message one has to bear: that (to reverse Lyotard's notion of the sublime in postmodern art) something happens, and not nothing. The audience may feel innocent; however, it cannot be sure.

Monument not only undermines the sensory pleasure for its resemanticization (or détournement) of the BBs. It also challenges the cognitive pleasure that may occur because of the clever, compelling rendition of such a grim subject. The audience knows that the artist's aim is to unsettle the audience by creating the tension described. The more the audience considers this undertaking successful, the more it will appreciate the artist's job. This equation creates the paradoxical situation that sensory discomfort turns into cognitive pleasure. In turn, by becoming aware of this condition, one feels guilty for acquiring pleasure from the aestheticization of the horrible. Thus, this example of art finally elevates the tension between the playfulness of the material and its sobering meaning onto the higher level of aesthetic experience: as tension between the sobering reality and its artistic representation. The specific stylization of the information in *Monument* goes way beyond the mere presentation of data.

It carries a symbolic depth that clearly makes the artist—his personal perspective, objection, and vision—visible in the piece.

The effect of *Monument* and *Lungs*—as well as of *The Secret Lives of Numbers, Ping Body,* and *Black and White,* as well as similar noncognitive visualizations—rests in the distance to the naturalistic paradigm of mapping. It is, as Wright concludes, about data visualization, "its ability to put cognitive and affective modes of perception into creative tension with data structures and with each other, and to articulate the gap between the processing of data, social life and sensory experience that will allow visualization to reach its full potential, both as a scientific and as an artistic technique" (2008, 86).

Mapping Postmodernism

As much as naturalism intended a convergence of art with science, so does mapping art—regarding its naturalistic subgenre—more than a century later. Both phenomena point to an art that oppresses the artist's subjectivity in favor of a trustworthy account of reality. Naturalism developed from the zeitgeist of the last decades of the nineteenth century, which was characterized by the advances of science and positivism. Does mapping art come out of a zeitgeist as well?

Manovich (2002b) rightly points out that modern art—despite its role of "data-epistemology" with which it enters "in completion with science and mass media to explain to us the patterns behind all the data surrounding"—always plays a more unique role than science and mass media by showing us other realities embedded in our own. Manovich implicitly endorses an aesthetics represented by Adorno and Camus and concludes that the real challenge of data art is not to map abstract and impersonal data into something meaningful and beautiful—as economists, graphic designers, and scientists do—but to "represent the subjective experience of a person living in a data society." However, according to Manovich, "the data mapping new media projects" miss portraying "our new 'data-subjectivity,'" our "being 'immersed in data.'"

The question Manovich raises is crucial for the discussion of our concept of art. It needs more discussion and ultimately calls for a similar, paradoxical answer as his earlier question regarding the unity of content and form. In this case, I argued that the seemingly purely motivated way to map a specific set of data is motivated by the subject itself—remixable data—and hence represents the lacking oneness of content and form. I

also argued that a 1:1 translation from content into form is nothing to do with a search for form as representation of the author's voice. I am now going to argue that mapping art's failure to offer such voice actually represents the experience of a person—the zeitgeist—in contemporary culture that Manovich misses in mapping art.

As seen in chapter 2, contemporary society has been described as a "society of the spectacle" (Jameson 1998, 87) and a "culture of the depthless image" (Darley 2000, 192), one where images overwrite and replace ideas, and one marked by the loss of truth and visions—or, as Manovich puts it with reference to Lyotard, by "the end of grand Narratives of Enlightenment" (2001, 219). I concluded that the postmodern condition brings with it a felt metaphysical disorientation, one logical consequence of which is the artists' refusal to provide explanations or utopian prospects of reality and their explicit focus on form rather than content. As Andrew Darley describes it in his exploration of *Visual Digital Culture*, the diagnosed shift from content to form often translates as a "prevalence of technique and image over content and meaning" or a "fascination with the materiality and mechanics (artifice) of the image itself" (2000, 114).

In such a situation, mapping seems to be the perfect symbolic form of our time, not primarily for its relation to the database paradigm of "endless and unstructured collection" of data records (Manovich 2001, 219), but for its modus to "turn the data over to us to explore" (Whitelaw 2008). Mapping does not really alter the structure (or narrative) of the database, instead rendering it in a different form.[41] It can be seen as the symbolic form of our time precisely for that reason. The exact visualization of ready-made data represents a shift from the expression of ideas to the administration of information, which at the end is another version of the shift from content to form, with the common denominator of the prevalence of technique over the creation of message.[42]

Given the wide spectrum of data mapped and the sophisticated ways of mapping, one may consider mapping art an aspiration to absolute control, which fills the void left by metaphysical prospects with a gesture of containment in a rather bureaucratic way. At first sight, the assumption of control as escape seems incorrect for works such as *They Rule* and *Making Visible the Invisible*, disclosing hidden information about reality and society with the intention of delivering a truthful picture of reality. They seem to be driven by a clear agenda, which places them in the tradition of Enlightenment, rationalism, and realism. They do not seem to

have any connections to disillusioned postmodernist art. However, a closer look reveals that such works lack a specific perspective or vision by the artist, and rather than giving meaning to reality, they simply mirror reality. With their rhetoric of mimesis, they avoid any explanation of reality that would go beyond the listing of facts and may be based in the artist's subjectivity. They emphasize "openness and intuition, rather than the extraction of value or meaning" (Whitelaw 2008).

This position is in line with the loss of truth and vision in postmodernism. In contrast, and by the same token, a formalistic piece such as *Black and White* turns out to have more personal perspective than it seems. Although it does not disclose hidden information in a meaningful way, it provides a specific message by the author, which is also true for a mapping piece like Stelarc's *Ping Body*. Thus we have the mere administration of data versus mapping that also expresses an idea, naturalistic mapping versus metaphorical mapping. The accurate disclosure of data may be seen as a neonaturalism or quasi-Enlightenment; its hidden purpose could simply be an attempt to respond to the postmodern denial of grand narrative. It seems to be a loquacious way of saying nothing.

Those focused on (political) content over aesthetic considerations inherent in works such as *They Rule* may have difficulties accepting such an approach to mapping art, which is very much grounded in the aesthetics of autonomy and argues with Adorno and Camus instead of Lukács and Sartre. However, as I see it, the political content may only be, to use Marshall McLuhan's phrase from the appropriately titled "The Medium Is the Message," the "juicy piece of meat carried by the burglar to distract the watchdog of the mind" (1964, 32). Perhaps the actual message of this kind of mapping art is the lack of a privileged artist perspective and the renouncement of artistic creation. This lack has been considered a plus, holding that—by abstaining from providing "well-formed messages" and "directing us instead towards data" to explore them ourselves—data art opens spaces for "the distributed reconstruction of information" (Whitelaw 2008). I am skeptical regarding such optimistic reading that, reminiscent of the hypertext discourse of a decade ago, implicitly turns the absence of a genuine idea or artistic statement into the audience's liberation from the author's predominance. I concede, however, that there are at least two ways to defend naturalistic mapping from an aesthetic point of view as art.

Naturalistic mapping can be seen within the perspective of chance art and in the tradition of questioning art. The lack of the artist's perspective

in naturalistic mapping recalls the degradation of the artist in chance art advocated, for example, by John Cage and others in the 1950s and 1960s. Almost at the same time as Camus criticizes the absence of the artist in the artwork, Cage defines purposelessness as the highest purpose in the creation of art. For him, the purposeless play is abdication of human control and affirmation of life as the way it is. Cage's concept, which is inspired by Zen Buddhism,[43] can be applied to the subject at hand insofar as naturalistic mapping art also undermines the agency of the artist in art and lets reality "act of its own accord," or, as Legrady (2005) puts it, the stream of data "speak for itself." In this light, the artist's withdrawal from "stylization, which supposes the simultaneous existence of reality and of the mind that gives reality its form" (Camus 1956, 271), is itself to be considered a form of stylization. Through style, Camus states, the artist reconstructs the world with a slight distortion that is the mark of art as well as protest. Although Camus declares art not presenting the artists' perspective to be nihilistic, against the background of Cage's statement, such art rather has to be called optimistic or affirmative.

Chance art is decidedly the refusal of protest. It has, as discussed in the introduction, a natural affinity to Jean-François Lyotard's aesthetics of intensities and Hans Ulrich Gumbrecht's culture of presence, which both subscribe to a position of affirmation of life.[44] The affinity between naturalistic mapping and chance art prompts the question: What underlying affinity exists between such mapping and the affirmative position of the culture of presence? It is certainly ironic to see politically committed works such as *They Rule* in line with the affirmative aesthetics advocated by Cage, Lyotard, Gumbrecht, and others. Nonetheless, with its pure focus on data, with its embrace of the data as such, *They Rule*—and naturalistic mapping in general—seems to replicate the embrace of reality the way it is: in a subtle way, unconsciously and unwillingly, not in the dimension of content but of form, which, in Adorno's (as well as McLuhan's) perspective, *is* the content.

A different reading of naturalistic mapping that may correspond better with its authors' intentions is to understand the pure embrace of data not as affirmation but as apathy or protest. The presentation of information without information—that is, without any specific perspective of the artist—could be understood in the context of Liu's laws of cool, but in a different manner as compared with the discussion above: not as aporia but apatheia. Although the precise presentation of data in naturalistic mapping does not render information useless, in contrast to *Black and White*,

for example, it may represent the apathy and emotional inexpressiveness that Liu lists as an attribute of cool (2004, 234). Cool Web sites, Liu states, allow us to enjoy the "feel of precision." To repeat the quote discussed in chapter 2: "The libidinal investment in technology converts with unprecedented ease into the pure eroticism of *technique*" (236). Such feelings of precision, such feelings for the technical, are the driving forces behind examples of naturalistic mapping such as *Making Visible the Invisible* or, despite its political content, *They Rule*. When Liu notes that "cool is feeling muted by the technical" (236), this also translates into mapping as representation through the withdrawal of all personal sentiment and opinion from its presentation of reality. To put it another way, mapping becomes emotionally expressive when it shows a commitment beyond the precise, dry rendering of data, when it uses the mapped data to express the artist's perspective. The accurate rendition of statistics for the circulation of books and media in a public library certainly does not provide us with any such personal stance, but resists or parodies information in the disguise of information and ought to be called, as Whitelaw (2008) suggests, "[data] art against information." Hence, it may deserve even more Liu's label of cool than *Black and White*, which is, in comparison, much too eager and meaningful—or uncool—in rendering its information useless.

Within the context not of information culture but of art history, such refusal to furnish data with a personal perspective can be understood as protest: as an aesthetic protest precisely against the aesthetics that Adorno and Camus stand for. To reject this aesthetics, which is in fact a middle-class aesthetics, art must turn into antiart, as was the case with Dada, which undermined the art system by completely neglecting its aesthetic conventions. The strategies used in Dada and mapping are surely different and in fact antithetic. While Dada creates nonsense, naturalistic mapping offers meaningful information. The common denominator, however, is to abstain from producing meaning through a "chosen point of view of an artist," as Camus puts it, which in both cases violates the conventions of art and challenges the common definition of art. Both Dada and naturalism—the historic prototype of mapping—rejected the remnants of the neoclassic aesthetics in their time. Today, in an age characterized by the aestheticization of everyday life and by an aesthetic of the spectacle, the strategy of Dada to shock with nonsense and sensation no longer works. The social and cultural system has integrated the spectacle into its collection of cultural forms and stripped it of its shock value. In such a situation, the target

for an aesthetic attack is not only the remnants of neoclassic aesthetics, but also the aesthetics of the spectacle.

Against this background, the preservation of pure information could be considered an act of resistance. The poetics behind naturalistic mapping, one could argue, is to inject information into the economy of attention, to preserve and promote the nonaesthetic world—"making things public," to borrow the title of a 2005 anthology on object-oriented democracy edited by Bruno Latour and Peter Weibel. Naturalistic mapping could be understood as a poetics that reverses the focus on form in art for art's sake to a focus on information for information's sake. The aesthetic formlessness of information is the stylistic principle of this poetics.[45] However, this is only one part of the story. The other part is the fact that this antiart or nonart claims to be art. Naturalistic mapping, one could argue, is art precisely for the reason that it is not recognizable as art. However, it is art only insofar as it claims to be art. Only insofar its authors consider their work a contribution to art is it one, for only if it enters the realm of art can it deconstruct art.

This may look like a win–win situation. The point has been made that sometimes the release of a certain program alone produces a new generation of artists.[46] However, sometimes the author's entering into the art world has to be initiated from the outside, if, for instance, he understands his work in the context of programming, data engineering, or artificial intelligence—that is, the field in which the technology had been developed—rather than in the context of art. It then needs an external impulse to convert the scientist into an artist. An example is Sack, who, as a computer science student at MIT, presented his *Conversation Map* in artificial intelligence journals and at anthropology conferences and "wasn't really thinking about it as an art project" (Blais and Ippolito 2006, 160). Only after people from the art world showed interest in his work did he start to consider it art and begin writing essays on cultural and aesthetic issues, which finally made him change from being the director of a social technology group to being a member of a film and digital media department.[47]

The discussion in this chapter has shown various ways to look at mapping art. There are certainly more ways than could be discussed here. The aim was to explore different approaches to the subject, not to conclude with one "correct" point of view. The goal was to sharpen the understanding of mapping art and to make visible the invisible, or at least not very obvious, links between mapping art and other phenomena in art history

and in contemporary society. How we judge mapping art, and especially its naturalistic version, depends, after all and first of all, on the general assumptions we share about art. This is a highly controversial subject that cannot be taken up in this book. Instead of engaging in a general debate on principles, we may in the end rather have a closer look at a particular work and explore its status as art. It is a work that uses the technique of mapping and has been described as a mirror of reality, although it is more than that, and in a sense combines the poetics of *They Rule* with the poetics of *Black and White*.

6 REAL-TIME WEB SCULPTURE

PRODUCING A COLLAGE OF TEXT taken from real-life communication is now a common praxis in experimental literature and has been advocated as one of the essential features of, for example, a Dada poem. If these ready-made texts are presented on screens, one may still consider such collage as experimental literature. If they are taken from the Internet and are sufficiently extensive so as to form a message, one might consider these collage pieces as documentation of online conversation and thus a mirror of society. Such a mirror would be somewhat distorting, given that the text snippets are taken out of context and presented in a partial, and partially unreadable, manner. Moreover, when a piece is described as captivating, hypnotic, and sublime, this will not be due to the content of the text; it is a function of its appearance. This is where we have to look for the actual meaning of Mark Hansen and Ben Rubin's *Listening Post* (2000–2001).

As has been discussed in the previous chapter on mapping art, not everything mapped and transformed necessarily translates into art. As a rule of thumb, we may say that a focus on the accuracy of data visualization does not impart the status of art. The data presented in *Listening Post* are as accurate as those presented in *We feel fine* (started in 2005) by Jonathan Harris and Sepandar Kamvar, which is another project assembling utterances from the Internet. However, the differences begin to be significant when we consider the number of screens. A total of 231 screens arranged as a grid in a darkened room versus one screen on a computer gives a different impression of the scale of virtual communication. Moreover, the theatrical setup—a shaded room with chairs in front of the curtain of screens—suggests that the text has dissolved into a sonic and visual environment. Close to the screens, people may read the actual text and imagine its context. If they step back to take everything in, the text becomes

a visual and sonic emblem of the virtual communication, in all its vast-ness. *Listening Post* lives the double life as (experimental, documentary) literature and as a (real-time, ready-made) sculpture or installation with its own aesthetic effects. It is up to the audience members to choose—according to their position in the room vis-à-vis the installation's displays—the life they prefer.

From this point of view—a position that most of the piece's reviewers do not advance—one may venture further in revealing a deeper meaning. Our critical pathway passes by another installation that desemanticizes text mined from the Internet—Paul DeMarinis's *The Messenger* (1998/2005)—and leads us back to issues discussed in the first chapter: "consuming" the text by depriving it of its linguistic value. Although DeMarinis is deter-mined to underline the inherently democratic character of the Internet, as critics, we also have to take into account an interest-based online dis-tinction between Internet information as the Daily Me or the Daily We. This undermines a shared culture of discourse essential for a democratic society. Moreover, the transmutation of text from meaningful utterance to sensational event—as undertaken in DeMarinis's *Messenger*—must be seen as another threat to a culture of democratic discourse. *Listening Post* features both inclinations, the separation within communication and the invalidation of its linguistic meaning, and combines them in an implicit political utopia. The different, diverse, often conflicting statements one is confronted with when reading the texts fuse and unite once the utterances are no longer distinctly recognizable. The meaningless murmur symbol-izes the end of ideology and the neutralization of all dissent. It is a happy ending insofar as it makes people begin to see what they have in com-mon: the search for answers. That the answers themselves—different and potentially divisive—are neglected in favor of an intensive moment of their conjoined murmuring signals a shift from the hermeneutic paradigm to the paradigm of erotics, as discussed in the introduction. As always, how-ever, the embrace requires that its participants forego distance.

Collage and Collaboration in Literature

Imagine a text compiled out of chunks of online conversation, presented as an endless flow of words written by people whose names remain un-known and who have no idea that their texts are assembled in such a way. This text group would have no clear structure and no specific author. It would be a collage of texts taken from real life. Would it also be literature

or a linguistic artwork? Why not? There are predecessors for both text as collage and text as the result of collaboration.

The patchwork of text was advocated as early as 1920 when Dadaist Tristan Tzara, in his famous manifesto "How to Write a Dada Poem," proposed producing a poem by cutting out words from a newspaper and putting them together in random order.

> Take a newspaper.
> Take a pair of scissors. Choose an article as long as you are planning to
> make your poem.
> Cut out the article.
> Then cut out each of the words that make up this article and put them in
> a bag.
> Shake it gently.
> Then take out the scraps one after the other in the order in which they left
> the bag.
> Copy conscientiously.
> The poem will be like you.
> And here you are a writer, infinitely original and
> endowed with a sensibility that is charming
> though beyond the understanding of the vulgar.

With this proposition, Tzara only applied to literature the collage technique already used by visual artists, among them his Dada colleagues Kurt Schwitters, John Heartfield, and Hannah Höch. The result was a surprising juxtaposition of text segments, which of course did not resemble the author at all; nor did it really express her sensibility. Tzara's instruction to make a poem this way, however, did express the intention of Dada to reject bourgeois attitudes. Nonsense was considered the ultimate opposition, materializing, for example, in the sound poems and optophonetic poems by Hugo Ball, Kurt Schwitters, Richard Huelsenbeck, and Raoul Hausmann (Hausmann 1994).[1] What in Dada was part of a radical protest against the conventional understanding of art, and against bourgeois culture in general, came to new life and artistic reputation in the 1960s with William Burroughs's cut-up technique. Interestingly, again, the source for this example of experimental literature was visual art. The painter Brion Gysin introduced Burroughs to this technique, which Burroughs (2002) then extended to his fold-in method.[2] Since the 1960s, cut-ups became an alternative strategy for dealing with words, a writing aid. However, this strategy and aid was not used to produce nonsense, but to surpass the limits of the

author's creativity, to overcome his personal perspectives. The central aim of the poetics of chance art was the creation of unexpected but meaningful combinations.

Access to deeper levels of human consciousness was also the intention of collaborative writing experiments undertaken by the surrealists, such as *écriture automatique*. Here the limits of the author were exceeded by multiplying the author, as in *Cadavre exquis* ("exquisite corpse"), where several people write in turn on a sheet of paper, fold it to conceal part of the writing, and then pass it to the next person for further contributions. Since then, both the technique of collage and collaboration belong to the repertoire of experimental literature. The poetics of collage has been taken up in Marc Saporta's novel *Composition No. 1* (1962), which offers 150 unbound, unpaginated pages, or in Konrad Balder Schäuffelen's novel *deus ex skatola* (1964), which offers aphorisms on small paper rolls, and has later gained popularity as a fundamental technique of computer-aided hyperfiction. With the arrival of the World Wide Web, the poetics of collage found new life in the various forms of collaborative writing projects online.

In this light, we understand that the text collage can be traced back to visual art. However, we do not have difficulty understanding a collaboratively created text, such as the one imagined above, as a linguistic artwork rather than any other kind of art. One could call it the jabber of the Internet, captured by a computer program. Does this interpretation change with the way such text collage is presented?

Text as Sculpture, Music, Cinema

The text collage imagined above exists, not on paper but on screen, on 231 miniature text display screens. The installation is called *Listening Post* and was created by the statistician Mark Hansen and sound designer and multimedia artist Ben Rubin in 2000–2001 (Figure 22).[3] It has been exhibited, among other places, at the Whitney Museum in New York City (2003) and at Ars Electronica in Linz, Austria (2004), where it won the Golden Nicas at the Prix Ars Electronica competition.

The screens are organized on aluminum poles on a suspended curved grid of 11 rows and 21 columns with overall dimensions of 21 × 14 × 3 feet. Several computers analyze data from thousands of Internet chat rooms, bulletin boards, and other public forums. The culled text fragments are fed

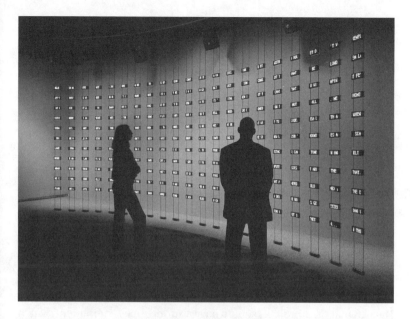

Figure 22. Mark Hansen and Ben Rubin, *Listening Post* (2000–2001). Photo by David Alison.

to a statistical analysis server, which selects certain phrases to be displayed across the grid of screens and read aloud by computer-generated voices.

The piece is organized into a repeating seventeen-minute sequence of separate compositions, each consisting of six movements with different data processing logics and arrangements of visual, aural, and musical elements. While in the first movement cycles of text wash in from right to left over the entire grid of 231 screens, rendering text as mere visual, illegible object, in the second movement the text snippets are presented in a readable way distributed to the 231 screens. The texts are organized by topic clusters; for example, phrases starting with "I am," "I like," or "I love." In the third movement the text scrolls within each screen at high speed, stopping from time to time, thus allowing the reading of a snippet of the captured conversation. The fourth movement begins with blank displays that eventually fill out completely with texts spoken by a voice synthesizer generating a cacophony of overlapping voice streams. Movement five is visual and silent, presenting sets of four screen names that appear on a single screen, scrolling bottom to top, from the edges to the center. Movement six presents four-character words scrolling downward and then fading upward. Rubin explains the intention behind *Listening Post*:

My starting place was simple curiosity: What do 100,000 people chatting on the Internet sound like? Once Mark and I started listening, at first to statistical representations of web sites, and then to actual language from chat rooms, a kind of music began to emerge. The messages started to form a giant cut-up poem, fragments of discourse juxtaposed to form a strange quilt of communication. It reminds me of the nights I spent as a kid listening to the CB radio, fascinated to hear these anonymous voices crackling up out of the static. Now the static is gone, and the words arrive as voiceless packets of data, and the scale is immense. And so my curiosity gave way to my desire to respond to this condition. (Hansen and Rubin 2001)

The cooperation between Rubin, the artist, and Hansen, the statistician, is described as one with almost no disciplinary divides: "Ben had as much input in data collection and modeling as I did on questions of design and aesthetics."[4] This interest in a partner's particular concerns and approach is an essential condition for a successful collaboration between art and technology. There was also a mutual understanding between Rubin and Hansen that their projects should have a strong social component, which is why they used data from online chats rather than from a Web site. As Rubin says in an interview, "Internet chat is a strange mirror to look at society. It reflects something about our society but I am not always sure what" (Abumrad 2002). Steve Johnson, in an interview with Studio 360, compares *Listening Post* with Google's zeitgeist portraits, which show the most prevalent search requests over the year and hence gives an idea of user search behavior and contemporary culture (Abumrad 2002). Jad Abumrad (2002), in his feature for Studio 360, sees *Listening Post* as mirroring "the mood of the web in that moment." Sex, the war on terror, the space shuttle—everything that is obsessing people on the Internet at that moment enters the room in a stream of text and sound. However, this installation is more than simply documentation, which already becomes clear from the fact that only some of the movements listed above allow actual reading of the texts. As Roberta Smith (2003) notes, *Listening Post* "operates in the gaps between art, entertainment and documentary." There are specific aesthetic qualities that overwrite this installation's function as mirror to the zeitgeist.

First of all, one may wonder whether the cut-up method, in which the text is assembled, and the collage form, in which it is presented, really provide an accurate reflection of ideas communicated on the Internet. Taking text snippets out of their context resembles rather a distorting mirror.

This aspect of the piece is underlined in the third movement, when only a very small part of the scrolling text becomes readable, which actually reenacts the underlying technique on the screen and underlines—as pars pro toto—the decontextualized status of the presented text.

Apart from the questionable documentary value of the text assemblage, the way the text appears distracts from its reading. The text is "flying by like blood racing through a vessel, accompanied by the chittering sound of a rainstorm," report Pop Fizz and Melanie McFarland (2002). Peter Eleey, in a 2003 review, speaks of the "particularly striking moments the text washes rapidly across the screens in patterns akin to the topologies created by the movement of wind across a wheat field." "At one point," Eleey continues, "what begins with one phrase builds into a cacophonic deluge of communication, suggesting a kind of *horror vacui* in the human psyche. During another act the text bursts across the screens like a flock of birds alighting, crawling in a Holzerian manner, like stock quotes."

In addition, the sonic and visual arrangement of the text contributes to the aesthetic thrill: the darkened gallery space features text pulses of soft blue light and accompanying waves of synthetic voices and sonorous Glassesque musical chords. There are eight computer voices emanating from different speakers around the room separately or in unison, in call-and-response or round robin. The computer voices make the messages taken from the Internet sound like messages from outer space, as if aliens, not human beings, were behind it. Such a connotation may not be in the interest of the artists for whom *Listening Post* is a "mirror to look at society" (Abumrad 2002), which is supposed to give "a real sense of what people are talking about" (Coukell 2004). Nevertheless, the alienation of the voices draws attention to itself rather than to the content of messages and creates a distance between senders and listeners in the gallery. It is as if aliens are staging human life; it sounds as if they mock the banality of it, even if the subject is the war in Iraq or Bush's presidency. The computerized voices evoke the Turing test: What if all those messages in *Listening Post* are created by computers, rather than human beings? The artists may not have had the intention of triggering such associations. However, they decided to implement the text-to-speech feature, taking the risk that the inevitable synthetic tone causes undesirable connotations. It may be difficult to resist the temptation of having the text read in real time by computer voices, if one is particularly interested in the medium of sound and searches, as Rubin does, for "new ways of hearing inaudible phenomena and of mapping the observable world into the sound domain."[5]

One wonders whether the result is worth this risk, and to what extent the state of the art simply gets in the way of the artist's purpose in this instance.

However, the sonification of the text is in line with the general aesthetics of the piece, namely its theatrical effect, which is reinforced by the location of benches in front of the "text curtain." The theatricalization makes the text part of a larger event—that is, dissolves it into the experience of the sonic and visual environment. This experience has been compared with "watching graffiti out of a window of a moving car" (Abumrad 2002), or looking at a modern painting whose canvas consists of a curtain of computer screens (Gibson 2003). Rubin himself compares the "giant cut-up poem" *Listening Post* with "a kind of music."[6]

This appearance and arrangement of text lets visitors experience the installation as "beguiling, sublime" (Schmader 2002); as "almost irresistible, like magic" (Smith 2003); as "meditative, sublime and elevating . . . hypnotic and captivating," making it easy "to be lulled into a trance-like state, forgetting the passage of time and the surroundings" (Huhtamo 2004a). One may conclude that, in the end, the set up of the installation overshadows the text it presents and actually (mis)uses words as ornament. It will become clear that this "misuse" is the actual artistic merit of Rubin's and Hansen's work.

Turning Linguistic into Visual Art

At the end of her review, Roberta Smith (2003) wonders whether *Listening Post* "is simply the latest twist in the familiar modernist tradition of making art from chance arrangements of everyday materials, and is more a result of technological progress than genuinely new thought." Smith's concern is a valid one because there are many examples of applied technology that have been labeled art, although they are missing a genuine idea or artistic statement beyond their actual application. As seen in chapter 5, this is especially true for mapping art. I argued that not everything mapped and transformed consequently transformed into art. As a rule of thumb, one may say that the more the transformation focuses on the accuracy of data presentation and the less it focuses on a symbolic description of the data presented, the smaller the likelihood that it will be perceived as art. What is the situation with regard to *Listening Post*?

As Christopher DeLaurenti (2002) notes, Rubin and Hansen "do what composers have done for centuries: transform ordinary, overlooked means of expression into art." *Listening Post* certainly participates in the project

of transformation and beautification of found everyday data that is significant for mapping art. However, the piece is not a naturalistic mirror of reality; it has a mesmerizing effect because of the way the data are presented. Does this represent a message beyond the pseudo function of documentation?

Rubin describes his position as an artist with respect to *Listening Post* as follows: "As an artist right now with the whole prospect of war it's a very difficult thing to know how to conceive of a response. And this piece has no political message per se but it is listening. It is at least an open space" (Abumrad 2002). Rubin's words—proposing like Whitelaw (2008) the idea of "open space"—explain and justify the withdrawal of the artist and the abdication of a personal message symptomatic of naturalism and applicable to the postmodern condition, as I discussed it with respect to the mimetic variety of mapping art in chapter 5. Listening—that is, collecting data from real life—is favored over voicing a political message. In this light, *Listening Post* seems to embody the same disorientation and lack of message that is characteristic for many of the mapping art examples. It seems to belong to the same type of Web mapping as Jonathan Harris's and Sepandar Kamvar's *We feel fine*, an "exploration of human emotion, in six movements" that, since 2005, searches a large number of Weblogs for sentences containing the phrases "I feel" and "I am feeling" and presents them as a collection of colored, animated, and clickable particles representing single feelings, posted by a single individual (Figure 23).[7] The growing database (increasing by 15,000 to 20,000 new feelings per day) is searchable according to a list of about 5,000 preidentified feelings, to gender, age, weather, location, and year.[8] The single utterances link to their origin on the Web. Although *We feel fine* is a sophisticated and interesting example of data mining and data representation, in light of the discussion of chapter 5, it is questionable whether it is also art, as its authors claim.[9] The difference becomes clear if one compares *We feel fine* with *Listening Post*, which not only listens—or transmits the data collected—but also speaks to its audience, providing a specific message through the way the data are presented, turning, to apply the distinction made in chapter 5, data into information. As mentioned above, one aspect of its specific manner of presentation is the (undesirable) connotation of the computer-generated voices. Another aspect is the trancelike experience, which overwhelms the overt message of the data presented. There are more metaphors to be taken into account.

Debra Singer, curator at the Whitney Museum, points out that participating in a chat room is, while ostensibly social, actually solitary and

Figure 23. Jonathan Harris and Sepandar Kamvar, *We feel fine* (2005).
Web site opening (*top*). Text of a specific item (*bottom*).

isolating—"just the lone person, you in front of your keyboard"—and holds
that *Listening Post* gives "a sense of that collective global buzz. It sort of
makes visceral the diversity and the scale of Internet conversations and
exchanges" (Balkin 2003). Singer is absolutely right in that *Listening Post*
indicates the magnitude of virtual communication. One could say that the
"lonely crowd," once withdrawn to the TV, groups together and becomes

visible again, thanks to the Internet as a bidirectional medium.[10] As Rita Raley notes, "'Listening Post' *is* the crowd, or least a representation of the crowd" (2009, 31). However, it is an artificial crowd created by Hansen and Rubin because *Listening Post* makes data public that are "private to a particular community," as Raley also notes (27), referring to the element of surveillance in this piece. The texts are taken from communities resembling salons rather than crowds on the street. The crowd presented in *Listening Post* is the result of the collage Hansen and Rubin generate. The crowd represents individual groups rather than a crowd unified by the same opinion and intention. Only the combination of all the more or less private communicative communities creates the sense of a crowd. The scale of Internet conversations, the sense of the "collective global buzz" that *Listening Post* provides, according to Singer, is the result of a collage of different communications making obvious their diversity rather than their unity.

Even though Hansen and Rubin consider the "creation of a kind of community from the informal gathering of thousands of visitors to a given Web site" to be a by-product of their Web traffic sonification (Hansen and Rubin 2001, 12), the correlation between the crowd and the individual, the social and solitary is perceived as the underlying subject of *Listening Post*. Although the piece funnels communication from thousands of chat rooms into the installation space, one wonders whether this space is another room: thousands plus one. How does the exhibition space connect to the online world? How does *Listening Post* talk about its own audience? There is anecdotal evidence for the relationship between both spaces: "Hansen recalls one showing that amused a silent audience when the installation's strange song began with a short solo that loudly asked, 'Are there any bisexuals in the room?'" (Fizz and McFarland 2002). At least after bringing to mind the given exhibition situation, the audience knows it is not the addressee for this question. Nevertheless, the ambiguity of its situation of communication points to the difference between both spaces. The audience of *Listening Post* is listening (it is assumed silently) to the presented collection of text snippets, while people out there are sending messages. The latter sit separately behind keyboards connecting to other people via the Internet; the former come together in a room, most likely not connecting to one another in person. *Listening Post* addresses two completely different situations of crowd or groups. The text from the Internet—and not only the quoted particular question—asks people in the gallery who they are and how they connect to each other. The answer may

be that they too connect via chat rooms to other people, which would only affirm the advantages of the virtual room over the real.

But there is more. The meaning of *Listening Post* also lies in the texts' dissolve into sound or background music. The decontextualization that *Listening Post* is undertaking—Rubin calls the piece "a big de-contextualization machine" (Coukell 2004)—makes it hardly reliable as documentary. This very fact, however, underscores its potential as an interactive story. Rubin explains that when everything is pulled out of its original context, he tends to project around the fragments he hears, to imagine the conversation the fragment came from (Coukell 2004). When people listen to messages such as "I am fifteen," "I am alive," "I am lonely and sad too," "I am cooking now for my son," "I am sexy but not mature," "I am getting tired of Muslims," "I am back," to quote only from the "I am" proclamations, they wonder what these messages mean, what their context may be, and to whom they are addressed, as well as what they are responding to and how they may have been answered. Thus, *Listening Post* actually has its audience doing more than listening. It prompts them to fill in the gaps. The listeners are provoked to use their imagination; they become coauthors in a kind of delayed collaboration with the unknown authors from the Internet.

This is true at least as long as the text is presented in a readable way, and as long as the audience stays with the text and moves through it as reader. The moment the listeners—or visitors—step away from the text is the point where the linguistic phenomenon eventually leaves the center of attention, giving space to the experience of sonic and visual effects no longer based on deciphering the text. Which brings us back to our initial question: Is *Listening Post* linguistic or visual art?

Eric Gibson, in his 2003 review in the *Wall Street Journal*, compares the experience of *Listening Post* with the experience of a painting: "The viewer relates to *Listening Post* much as he does [to] a traditional painting, that is, by alternating between the part and the whole. One may back up to take everything in, then move in to scrutinize a detail—in this case a message on the screen." Gibson's comparison of the installation to the traditional medium of painting may intend to furnish the former with the dignity of the latter, but it is nonetheless misleading. Although Gibson only sees a quantitative change between the part and the whole, there is a qualitative change between two completely different modes of perception. The alteration between the part and the whole is an alteration between reading

and watching. The audience redirects its attention from the text conveyed to the installation conveying it. The installation takes on its own life, which is more than the sum of its parts.

One may compare the transformation of the parts to a whole with Robert Silvers's *Christ II,* a photomosaic image of Christ composed of images of six hundred ancient Hebrew and Aramaic manuscripts of papyrus and leather known as the Dead Sea Scrolls shaping the image of Christ.[11] Paying attention to the parts, one deals with hymns, commentary, and apocalyptic writings. Paying attention to the whole, one sees Christ's face formed out of these various pieces of text. The literal transformation of text into image or of linguistic signs into visual ones is a strong metaphor and the actual point of this artifact: Christ consists of nothing else than what is passed on by text.

What would be the meaning of the transformation from reading to watching—or "taking everything in," as Gibson (2003) phrases it—in the case of *Listening Post?* Pop Fizz and Melanie McFarland (2002) describe this change of experience as follows: "Close to the screens, voices and content color the experience more than if you take it as a whole from farther away, a perspective that makes it look like a raging river." What has been text, with its particular linguistic meaning, becomes the image of a raging river when one steps away. This change from reading the single text to taking it (in) as a whole is not only a change between two modes of perception regarding the language of signification. It also changes the perceived mood. Reading the single text stimulates us to imagine its context. In this situation, the reader deciphers the text and connects with it like a detective or archeologist. The reader feels herself to be the agent of this undertaking. Stepping away from the texts, the letters become a "raging river," to which the visitor feels subjected and inclined to surrender. The sensation of having control gives way to the overwhelming, "hypnotic and captivating," "trance-like," "sublime" experience reported above.[12]

Listening Post lives a double life as a "document" of online communication—or rather a "giant cut-up-poem" (Hansen and Rubin 2001)—and as a sculpture or installation with its own aesthetic value. As a document or poem, the piece presents text in a readable way. As a sculpture—a gigantic curtain of screens with ever-changing compositions of dissociated messages—it uses text as visual and sonic icon to convey the magnitude and immediacy of virtual communication. Close to the screen, *Listening Post* therefore may be considered an example of experimental literature. Farther away, when letters turn illegible, it becomes visual and sonic art;

it exists outside the linguistic paradigm and has to be read like a sign in visual art or an action in a performance. This transmedial transition is the effect of walking. Perceiving *Listening Post* either way lies in the hands (or rather the feet) of the audience.

One may go one step further in understanding the symbolic power of *Listening Post*. Although it is debatable to what extent the work mirrors "the mood of the web in that moment" (Abumrad 2002), it can be argued that the work tells the story of its history: walking away from the curtain is walking in time. At its beginning, the Internet consisted only of words appearing as green letters on a black screen—pretty much the way text is presented in *Listening Post*. What Michel Joyce said about the hypertext as an essential feature of the computer—"the word's revenge on TV" (1995, 47)—was equally true for the Internet. However, with the arrival of the World Wide Web, people observed the "breakout of the visual" (Bolter 1996, 258) and recognized "the constant threat of hypermedia: to suck the substance out of a work of lettered art, reduce it to surface spectacle" (Coover 2001).

This development is reenacted in *Listening Post* by walking away from the curtain. The walk communicates the history of the Internet in two ways. First is that the scale of communication changes. Stepping back widens and deepens the perspective; the single-text screen comes into sight as part of a grid of 231 screens, demonstrating the organic growth of the Internet. Second is that the way of communication changes. Stepping back shifts the attention from the text as linguistic sign to the audiovisual environment demonstrating the development of the Internet from textual toward multimedial signs. In this perspective, *Listening Post* is not only about the content transmitted on the Internet, but also about the way content is transmitted online. It is a linguistic artwork that turns into a sculpture and allows the audience, in this transmedial transition, to experience time by experiencing space. Walking backward from the screen is going forward in the history of the Internet.[13]

It has become clear by now that *Listening Post* offers the data it gathers in a special way that differentiates this work from the aesthetics of naturalism demonstrated by other examples of mapping art. Rather than aiming at an accurate presentation of data, *Listening Post* generates an image—or sensation—that prompts reflections about these data. Having laid out some directions for this reflection, I want finally to compare *Listening Post* with a similar installation, whose differences with *Listening Post* may disclose even more aspects of this work.

Balkanization and Orchestration of Text

In chapter 1, I discussed various forms of "eating" the text through its presentation as an asemantic object. *Text Rain* (1999) by Camille Utterback and Romy Achituv and *RE:Positioning Fear* (1997) by Rafael Lozano-Hemmer both present text to the audience in such a way that is more or less deprived of its linguistic value. In both cases, the linguistic value of the text can be reestablished only through a separate step of perception dislocated from the installation venue: the audience must look up the poem used in *Text Rain* in a book or the discussion presented in *RE:Positioning Fear* on a Web site. In *Listening Post,* however, the text enjoys both its states simultaneously as linguistic and visual–sonic object at the installation venue. Its turning into an asemantic object depends on the audience's engagement with the piece; stepping away from the text "devours" it. It is a subtle example of text cannibalism, and because the installation consists of so much text taken from the Internet, one may miss the work's consumption of the text.[14]

This potential materializes itself much more obviously in another installation, which could be called the younger sister of *Listening Post,* although it is actually its older brother. Two years after *Listening Post,* Ars Electronica's Golden Nica 2006 in the category of interactive art was awarded to an installation that also takes its content from online conversation.[15] Paul DeMarinis's *The Messenger* (created in 1998; developed version through 2005) distributes e-mails that DeMarinis received to three systems of bizarre output devices, on which they are displayed letter by letter (Figure 24). There are twenty-six talking washbasins, each intoning a letter of the alphabet in Spanish; there is a chorus line of twenty-six dancing skeletons, each wearing a poncho with a letter, and there is a series of twenty-six electrolytic jars with metal electrodes in the form of the letters A to Z that oscillate and bubble when electricity is passed through them. Thus, the compiled text is presented to the bodily senses; the linguistic message has been transformed into sound, light, and performance.[16]

The Messenger pushes the transmedial transformation seen in *Listening Post* much further by turning text into unintelligible signs. As the description of the work provided on the Ars Electronica Web site states, "The installation is the end of the line for messages that had traveled around the world to meet their demise here."[17] The message of this end of all messages is, despite the fascinating, playful output of the installation, described in a rather pessimistic tone: "The installation thus becomes an allegory for

Figure 24. Paul DeMarinis, *The Messenger* (1998/2005). Photograph by Paul DeMarinis.

messages whose final destination is a total void—a phenomenon that has become a standard component of everyday life in the modern world."[18] Although the installation does give those messages an audience, it also enforces this void by depriving them of their linguistic meaning. The installation becomes an allegory of the annihilation of linguistic meaning, which has become a standard component of visual culture in modern society.

However, *The Messenger* is also a media archeological exploration in the history of electronic transmitted communication. In an essay about *The Messenger,* DeMarinis recalls the Catalan scientist Don Francisco Salvá i Campillo's proposal at the end of the eighteenth century of a system of rapid signaling across distances using static electricity. This system used a separate wire for each letter of the alphabet, a Leyden jar to transmit a spark across these wires, and twenty-six people connected to the wires to call out their corresponding letter upon receiving a sensible shock. "A twenty seventh person, presumably literate, was to write down the message so shockingly spelled out" (DeMarinis 1998). Salvá's proposal—an absurd performance of Stelarcian quality[19]—not only explains how DeMarinis got the idea for his output devices, but it also raises questions, as DeMarinis suggests, about the relationship of technology and democracy.

Erkki Huhtamo, in his symptomatic reading of DeMarinis's installation, interprets the collective human telegraphic receiver in Salvá's system as

the ultimate manifestation of a society based on slavery: "The identity of a slave/servant has been reduced to his/her voice uttering a letter, a mere phoneme, physically solicited by electricity. Reduced to enouncing [sic] a single letter, the human individual has been denied the right to meanings. Meanings emerge only as the result of the collective action of the dehumanized human telegraphic 'relays' (and ultimately, only become evident when traced on paper)" (2004b, 35). Huhtamo stresses that this scheme not only signifies the past, but is also reminiscent of the female telephone operators literally connected to the switchboard for hours on end, excluded from the meanings they transmitted.

In this light, DeMarinis's installation first of all underlines the waste of human resources in the process of communication and the exclusion of people from the meanings they transmit. It is obvious that the situation is different today. People are not literally connected to the wires or to the switchboard. On the contrary, as DeMarinis points out in his essay, with the Internet "as inherently democratic," people have become messengers themselves; freedom of speech is increasing; democracy and electricity "have mounted their horses and are once again coming to deliver us" (DeMarinis 1998). The mechanisms and metaphors of *The Messenger* nonetheless may serve to remind us, as DeMarinis concludes his essay, "that there is no inherent bi-directionality in electrical communication, that a body can be a telegraph as well as a recipient of a message, that who is transmitting what to whom is often lost in the speed and coded immateriality of electricity."

DeMarinis's words sound euphoric and anxious at the same time. They may also serve to remind us that the democratic access to communication media does not warrant democratic communication. It is debatable how inherently democratic the Internet really is. From the perspective of political science, concerns have been voiced about the fact that the substitution of place-based communities with interest-based communities, information personalization, and group polarization online do not promote the exposure to a diverse set of topics and opinions. As a result, it has been argued, rather than fostering a culture of discussion, the Internet allows for the exclusion of the other, thus undermining the foundation of democracy. Hence, despite (or rather because of) its bidirectionality, the Internet also poses a threat to democracy.[20]

The consideration of the Internet as threat to democracy is not new. From early on, the Internet has been considered not only a modern form

of agora but also the perfect panopticon.²¹ Because *The Messenger*—as well as *Listening Post*—pulls its material from Internet communication, it is not surprising that it is also discussed in terms of surveillance and privacy.²² Rubin himself lends weight to such an analysis, saying that with his work he wants to provoke "questions as to the shifting boundaries between our public and private lives."²³ Although in neither *The Messenger* nor in *Listening Post* are data used to profile a person, one is made aware of the fact that they easily could be used to this end.

The question of surveillance and privacy is highlighted whenever an art installation takes its content from real-life communication or uses in public art data that have been recorded in public spaces. Besides many mapping artworks, many interactive installations works—such as David Rokeby's *Seen* (2002), Simon Biggs's *Habeas Corpus* (2006–7), Rafael Lozano-Hemmer's *Under Scan* (2005), and even Scott Snibbe's *Deep Walls* (2003)—bring up the question of to what extent surveillance technology is whitewashed by art by making the audience accustomed to it. The answers vary depending on the underlying benefit from and expressed opposition to the technology of surveillance. However, the issue of surveillance should not make us overlook other equally important threats to democracy brought up by artworks like *The Messenger* and *Listening Post*.

One such threat is the downgrading—or cannibalization—of text, which has been associated with the World Wide Web and the general shift of digital media from textual to media of images, sound, and animation. The reference to the illiterate servants who once, in Salvá's proposal, transmitted a message without understanding it and without "the right to meanings," prompts the question of what access to and interest in meaning and reasoning the users of contemporary media enjoy. The problem begins with the portioning of text in small pieces. Thus, in his essay "The Cognitive Style of PowerPoint," Edward Tufte (2003) maintains that "slideware" often reduces the analytical quality of presentations and weakens reasoning. However, while text presented within the aesthetics of bulleted lists may result in simplistic thinking, depriving text of its linguistic dimension means to generally corrupt its value as a source for thought, dispute, and search for agreement or compromise and turn it into ornament or spectacle. The transformation of the text into a sensual object undermines the culture of discourse essential to a democratic society, as does the exclusion of parts of the population from this discourse, or as does the separation of discourses, the fragmentation of the communication market into the Daily Me of shared interests.

Listening Post speaks about both invalidation and separation through its presentation of different voices and their transformation into a visual–sonic object. This doubling of the threat to democracy eventually gives rise to the utopian image of a unified society. The crucial point is the audience's movement along the curtain of screens as well as away from it.

The curtain combines different voices from different places and juxtaposes different, often conflicting statements. The combination of diverse utterances—Raley reports the sequence "I like peach pie" and "I like to masturbate and torture small animals"—simultaneously invites identification and the refusal of identification. Raley concludes, "It is impossible to stabilize the mood, the sentiment, the affect of this piece, just as it is impossible to stabilize the mood of the Web. The pleasure of the quotidian, the amusement of the odd—these can quickly be superseded by mistrust and distaste as viewers gasp, laugh, and recoil from the articulations of self and desire" (2009, 30). To this extent, at least, Hansen's and Rubin's work mirrors the mood of the Web. Moreover, this is important for my point: it mirrors the mood of the world, of which the Web is a condensed extract. By bringing together different people, the curtain brings together diverse and separate threads of communication. It sheds light on atomization and difference, and it indicates the lack of dialogue and understanding among the individual speakers.

However, the differences are fused, the individuals are united once the various utterances are no longer recognizable. The "virtually unintelligible murmurs of the crowd" (Raley 2009, 31) are a symbol for unity—as Raley puts it, a "community without community" because it is not based on identity or consensus but heterogeneity and dissensus. The murmurs blend the multitude and diversity in the utopian image of an orchestra, where many different instruments are found together. This unity is comparable to the "data points" in *We feel fine* (Figure 23), whose "teeming multiplicities" display "what might be called uniform diversity" and "encode a kind of idealistic humanism of equality and diversity, harmonious multiplicity, and fundamental (emotional) commonality" (Whitelaw 2008). It may seem strange to understand the meaningless murmur—or the democratic presentation of diverse expressions—as a symbol for a desired unity between the individual and the diversity. Shouldn't one expect a happy ending in dialogue rather than in murmur? Is the interface of similar dots strong enough to serve as an image of idealistic humanism? With respect to the murmur in *Listening Post*, I consider it of philosophic significance, for it exceeds the mere representation of uniform diversity. If unintelligibility is

understood as the absence of information, as invalidation of the message, it is also the end of ideology, politics, religion, and ethics, none of which can operate without language. The murmur is a harmonious neutralization of every possible message. It is, to push Raley's reading even further, the melting pot that *Listening Post* evokes after it has called up all kinds of different utterances. The emphasis lies on "after" in two ways.

It is crucial that every possible message is heard (that is, public) before it is suspended by something that is above meaning and whose meaning is reconciliation. A society of tolerance and coexistence cannot be established by suppressing certain subject positions, but only by looking for the quality all humans share beyond their specificities. One principle of universalization is the principle of discourse, prominently advocated in Jürgen Habermas's discourse ethics according to which the unforced force of the better argument prevails. This concept represents the belief of modernity in reason, truth, and progress and may undermine its impartiality through its implicit demand for a reason informed by the standards of Western civilization (enlightenment, rationalism). Habermas's theory leads, as Gianni Vattimo puts it, to the "colonization of the lifeworld by a specific form of action, the scientific-descriptive, surreptitiously adopted model" and actually requires "a category of experts . . . who decide which communications are to be considered distorted" (1997, 33). An opposite approach, prominently advocated in Jean-François Lyotard's ethics of difference, gives up the idea of universal value and truth and requests to accept and live with dissent. This concept is informed by postmodern theory according to which universal values can only be established at the expense of devaluing and suppressing the diverse. From this perspective, there is agreement only beyond meaning. Following this position, the only universal language is the ability of all humans to feel pain and humiliation, as Richard Rorty concludes in his 1989 book *Contingency, Irony, and Solidarity*.[24] Put in different words with the same result, there is only agreement before content. We may also refer to Charles Taylor, who, in his discussion of the politics of recognition, considers the "universal human potential"—rather than "anything a person may have made of it"—"a capacity that all humans share" (1994, 41). In the case of the politics of difference, Taylor suggests, "a universal potential is at its basis, namely, the potential for forming and defining one's own identity, as an individual, and as a culture" (42). With respect to *Listening Post*, we may say that the only thing all people in this

compilation of messages have in common is to have a message. All of them search for answers to the same questions: Who am I? How shall I live?

The magnitude of communication that *Listening Post* represents can finally be seen as commensurate with life. We all are searching for meaning in life; this fact lies above all utterances. Because of our different cultural and personal backgrounds, we will find diverse, often conflicting answers. According to the theory of discourse ethics, these conflicts are solvable through reasoning, that is, listening and speaking. The aesthetics of *Listening Post*, with its juxtaposition of the diverse, rather incline to an ethics of dissent that suggests no happy ending on the cognitive level. *Listening Post*, with its shift of text into an unintelligible object, nonetheless does provide a happy ending on the sensual level, which points back to the discussion of meaning and the sensual in the introduction to this book.

The transformation of text in *Listening Post*—the shift from meaningful, diverse, and conflicting utterances to a magic, irresistible, elevating experience—corresponds to the shift from the culture of meaning to the culture of presence, or, vis-à-vis Susan Sontag (1966, 14), from hermeneutics to erotics. In its unintelligible form, when *Listening Post* does not confront us with specific meanings but symbolizes—a "raging river," as Fizz and McFarland (2002) put it—the magnitude of the Web, the concept of listening changes. One does not listen to the words while trying to understand their meaning and judging their message; one "listens"—taking "everything in," as Gibson (2003) says—to the generated visual–sonic event. It is a shift from interpretation to appreciation—appreciation of the sensation presented, of the presence marked by pure intensity. It is a shift that recalls the aesthetic positions of Sontag, Lyotard, and Gumbrecht. In the moment the audience of *Listening Post* only hears the murmur of the diverse utterances, it experiences the utopia of unity. Listening has shifted from a hermeneutic paradigm to an erotic one.

This shift may be the message *Listening Post* utters beyond the utterances from the Web it documents. When the messages from the Web become unintelligible, the message of the artwork becomes visible. The crucial point is that the murmur only becomes visible as the utopian image of a unified society after one has become aware of the diversity that the various utterances signify. One has to understand the murmur as an answer to the premurmur state. One has to be close to the screens and endure the distance of reading before walking away and giving in to the immersion. The very fact of the shift from listening to embracing becomes clear only as a result of interpretation. There is no erotics without hermeneutics.

Epilogue
CODE, INTERPRETATION, AVANT-GARDE

THE LAST SENTENCE OF THE LAST CHAPTER is not intended to promote a shift of focus from hermeneutics to erotics. The discussion of *Listening Post* has made clear that the erotics of the overall embrace of its different utterances can only be perceived once one has realized the differences those utterances signify. The erotics proposed does not replace hermeneutics but rather is based on it. This is different from the notion of erotics in the famous final line of Susan Sontag's 1964 essay "Against Interpretation": "In place of a hermeneutics we need an erotics of art" (1966, 14). It is also different from the embrace of presence that Hans Ulrich Gumbrecht proposes in his essay "A Farewell to Interpretation" (1994). Here, Gumbrecht welcomes Jacques Derrida's critique of logocentrism and expresses his disappointment that "although the logocentric exclusion of exteriority is extremely important in understanding the absence of the human body as a topic within the humanities, Derrida pays astonishingly little attention to it—and exteriority almost disappeared as an element of antilogocentrism from subsequent forms of deconstructive practice" (394). Although both Gumbrecht and Derrida reject any substantive truth-claims, they come to very different conclusions concerning their interest in meaning and body. For Gumbrecht and other proponents of the notion of presence, the focus on the materiality of communication entails a shift of interest from the meaning of signifiers to their physical qualities and to the human body, which eventually results in a farewell to interpretation. By contrast, deconstruction has been adopted as a modality of interpretation, which rejects the notion of a textual harmony and its final correct reading but nonetheless remains in the paradigm of hermeneutics, fostering a vigorous cognitive model of provocation and interpretative engagement. The question is not whether to subscribe to the culture of presence

or meaning, as Gumbrecht distinguishes, but how to address materiality through a thick interpretative field that is grounded in subjectivity (as position and inflection), and in a nonessentialized and highly associative reading. The task is to establish an erotic hermeneutics of art.

Criticism and Erotics

The farewell to the idea of one correct reading of the text or artifact at hand brings about a different understanding of the role of the reader. In his essay "Criticism and Truth," published at the same time as Sontag's "Against Interpretation," Roland Barthes notes, "Only reading loves the work, entertains with it a relationship of desire" (1987, 93). However, although to read is to desire the work and to "want to be the work," to go from reading to criticism changes the desire: "It is no longer to desire the work but to desire one's own language" (94). Thus, criticism redirects the reader to embrace herself rather than the work. The desire of one's own language is a form of narcissism or autoeroticism. It is the eroticism of a person who uses interpretation to find her own voice. Again and in a more general way: There is no erotics without hermeneutics. The essential element of this erotics is irony. Barthes says in the same essay, "Criticism is not a translation but a periphrase. It cannot claim to rediscover the 'essence' of the work, for this essence is the subject itself" (87). Given that all interpretation is deeply rooted in the subjectivity of the interpreter, irony "is perhaps the only serious form of discourse which remains available to criticism"—so that we, as Barthes concludes, do not ask the critic to "make me believe what you are saying" but rather to "make me believe in your decision to say it" (90). As Gianni Vattimo concludes with respect to Foucault, Rorty, and Nietzsche, interpretation needs to be "conceived less as a means to understanding than as an activity in which the subjectivity of the interpreter is implicated" (1997, 35).

This is not about "anything goes" or "nothing matters." The irony Barthes promotes is the consequence of a correspondent disbelief in single correct interpretations. The refusal of substantive truth-claims, the awareness and acceptance of polysemantic, multiple-perspective readings has been related to the specific demands of a multicultural world with different and divergent values and perspectives.[1] When discussing the paradigms of meaning and presence in the introduction, I questioned whether in a world of global multiculturalism "dancing" (that is, the body) would be a better solution than "talking" (that is, meaning). I concluded that the

desire for control, criticized in Sontag's "Against Interpretation," cannot be challenged by avoiding hermeneutics but only by destabilizing every attempt at making sense. To experience the relativity, uncertainty, and infinity of signification, one has to remain within the interpretive enterprise. The underlying assumption is that one is willing to question one's own reading rather than taking it as the end of the hermeneutic endeavor. Such willingness is the signal feature of the aesthetic experience.[2]

My discussions in this book have been exercising such questioning by going beyond my own reading and looking for still other possible perspectives on the artworks or theoretical issues at hand. Particularly in the case of *Listening Post* (2000–2001) I provided several readings of the same work, which seem as diverse as the Web-sourced messages that this installation utters. Usually different readings of the same work are provided by different critics all claiming to present the (only) correct one. Taking up different perspectives as a single person and presenting several, perhaps contradictory, readings rather than one implies the choice of diversity over "truth."[3] In his close reading of Paul DeMarinis's *The Messenger* (1998/2005), Erkki Huhtamo points out that this work is culturally and theoretically informed without being didactic or doing any "theoretical–political finger-pointing" and speaks of "the power of its delicately uncanny poetics" (2004b, 42). Part of this uncanny poetics is the potential to extend the media-archaeological discourse into one that is media-philosophical. I carried out just such extension in my analysis, discussing not only the issue of who has access to the content a medium provides, but also how the medium presents the content. It remains open whether or not DeMarinis anticipated such reading, as well as it remains open whether *Listening Post* was intended to be read the way I read it. Because we are dealing with contemporary art, the artists could be consulted and asked for confirmations or denials that might, in some sense, prove the critic wrong. Apart from the fact that this is not a common practice, and the fact that artists are mostly grateful for readings of their work, it would also be contentious to consider the artist a privileged source for the comprehension of her work. Given the fact that the creation of art is often a more or less spontaneous, emotional, intuitive, perhaps even subconscious process, one can even argue that the artist is the person least equipped to rationally comment on her own work.

The theoretical consequence of this notion is the assumption that the reader—and especially the critic—may understand a text better than the author does. Such assumption has been rejected by theorists claiming the meaning of a text is nothing other than the meaning intended by its

author, while others argue a text carries meaning beyond or independent of an author's intention.[4] However, the notion that the reader could find more in the text than the author intentionally put in there was established as early as 1828, when Friedrich Schleiermacher stressed in an article on the concept of hermeneutics that the goal of the hermeneutic undertaking is first to understand the utterance as well as the author, and then better than the author, and stated: "For because we have no immediate knowledge of what is in him, we must seek to bring much to consciousness that can remain unconscious to him, except to the extent to which he himself reflectively becomes his own reader. On the objective side he has even here no other data than we do" (1998, 23). The aphoristic formulation of such a notion of difference between the author's and the text's intent comes from Schleiermacher's contemporary, Georg Christoph Lichtenberg, namely, that the metaphor is wiser than its author. Since then, academics have developed various methods—poetologic, gnoseologic, or psychoanalytic—to reveal the "actual" meaning of a text and what is unconsciously suppressed in this text. Today critics not only seek to find out what the author really wanted to say, but also what she had no clear intention of saying, or in fact intended not to say.

Such an approach is appropriate for the present investigation because digital aesthetics mainly rely on undeveloped semiotic systems. Symbols and signs are not innocent; they have meaning. The artist may have to learn to interpret them much as her audience has to. It may be the critic who, because of her job, is most sensitive to those semiotic signals and more eager to examine them. As discussed in the introduction, the critic, in her eagerness, may fail to see that in some cases a sign has no intended meaning (as in the case of the fog), or is just a bug (as in the blackout of the images in Rafael Lozano-Hemmer's *Body Movies* [2001]), or simply the result of technical constraints and requirements (as in the characters of Grace and Trip in Michael Mateas and Andrew Stern's *Façade* [2005]). In other cases, lack of apparent meaning may itself be the meaning. Nonetheless, the critic must not just consume or describe a work of art in an unreflective way; she must engage in the hermeneutic endeavour of looking for deeper meaning, which should not be mistaken for finding *the* meaning. It is also part of her mission to convince her readers to do likewise. If critics offer diverse interpretations of the same object, it should not come as a surprise. The history of literary and art criticism includes a myriad of different readings of one and the same work. It is generally assumed that the possibility of being open to more than one interpretation

is part of what qualifies a work of art as such. Hence, different readings by different critics—over time but also within the same period—can validly coexist and serve to prove the aesthetic potential of works that encourage critics in such diversities of understanding. If the critic desires the wisdom and qualities of the artwork itself, she will do well to attempt to recover all these differing readings herself.

Authors and Audience

With respect to hypertext, the claim had been made that the reader turns into a coauthor. Although this claim is hardly appropriate in the case of hypertext, in other cases—collaborative writing projects, interactive installations such as *Deep Walls* (2003) or *Vectorial Elevation* (1999)—it is. The change of roles has consequences for the complex of relationships between author, artwork, and audience. If the reader becomes the author, who is left to occupy the reader's position? This question—discussed in chapter 3 with regard to collaborative writing projects—also applies to interactive installations, where the spectator must physically participate in the work and the audience is turned into an audience of interactors. As has been argued in chapter 4, the interactor eventually has to step back and become a spectator of her own actions; the newly recruited author has to become a reader again. After figuring out and playing with the grammar of interaction, one is obliged to reflect on these aspects of the work.

There is an irony in the way cultural products that are not considered interactive nonetheless trigger a participatory culture by turning readers into authors who negotiate meaning among each other and with the original authors, while results of interactive art, such as the installations discussed in this book, may only trigger an instantaneous and momentary interaction with no search for meaning, let alone collective negotiation of whatever meanings are discovered. A well-known example of readers turning into writers occurs in the genre of fan fiction, where readers take the freedom to literally rewrite, continue, and recombine the texts they read. Although fidelity to the plots and characters is an important issue in this enterprise, it lies in the eye of the beholder as to what constitutes infidelity or "character rape," and what is rather a bringing to the surface of inscription the unexploited implications and inherent deconstructive elements of the text. As Henry Jenkins notes in his essay on the rewriting of *Star Trek*, although "producers insist upon their right to regulate what their texts may mean and what kinds of pleasure they can produce," fan writers

suggest the need "to redefine the politics of reading, to view textual property not as the exclusive domain of textual producers but as open to repossession by textual consumers" (2006, 60). This state of affairs not only answers to the matter of hermeneutics beyond the author's intent, as raised above, but also portrays a version of participatory culture in which participation is not reduced to mechanical interaction but extends to interpretation.[5]

Interactive art rarely achieves this level of interpersonal control with reflexive corrections of interpretation. There are two reasons for this. Interactive art hardly ever creates finished works that can be meaningfully compared with one another or respond to one another. Any response only occurs during the experience of and the interaction with the work. In contrast to nonparticipatory works, such response does not materialize in a way that can be shared among the audience and interactors. The rule-proving exceptions may include examples such as *Deep Walls*, where interactors encounter and react to the recorded movements of prior interactors. Equally, *Vectorial Elevation* allows the comparison of different ways of choreographing the light show above the Plaza el Zócalo in Mexico City, although the generated light shows are not understood—and not organized—as a reaction to the interventions of prior interactors. With respect to interactive art, one can say that even if people leave their traces in the form of their own contribution to the piece at hand, it will not become clear exactly how they understand the piece; nor will it create a dialogue between interactors similar to fan fictions.[6]

The interactor—this is the second reason—may not even be able to answer the question about understanding for herself precisely because of the specific nature of interactive art. The invitation to interact with the work and to contribute to it foregrounds exploration and action at the expense of interpretation. Interpretation is often limited to the understanding of the grammar of interaction, not in terms of its meaning but in terms of its configuration. To interact with the work, one needs to understand its rules of operation. Hence, the audience reads the work at hand in order to become an author—that is, to contribute to the work without necessarily having to ponder its meaning. Finding out how it works becomes more important than finding out what it means. Markku Eskelinen's characterization of the difference is stated in terms of that between interpretation for the sake of configuration and configuration for the sake of interpretation.[7] What John Cayley asserts with respect to Eskelinen and computer games is also true of interactive installations: "For some practitioners the

playing—the playing-well—will be the goal of engagement with such objects. For these people the instrumental practice becomes more like a game. For others, the playing—the configuration—will be done for the sake of achieving an interpretable moment or series of moments. The play or configuration will resolve time-based performances to objects of critical interpretation."[8]

In contrast to fan fiction, in the case of interactive art, participation is possible and likely without dialogue. Or to put it another way, in interactive art, the dialogue between the audience and the artwork can occur on two levels, interpreting the rules of operation and interpreting the content. The latter encompasses the particular type of dialogue between the interactor and the work (on the first level) that is allowed by the specific rules of operation that the artist has set up. Although in traditional art engaging with a work basically meant to search for its deeper meaning, interactive art allows us to engage with the work without any attempt at interpretation. One could even say that the dialogue with the work as an interactor gets in the way of a dialogue with it as an interpreter because the initial interactive dialogue may give the interactor the impression that she has engaged thoroughly and sufficiently with the work.

The discussion of the role of the Cartesian paradigm within interactive art and the examples of close reading given in this book clearly advocate a dialogue with interactive art that is not limited to the physical level but includes an intellectual engagement. Such advocacy addresses the question, "How does it work?" as a ground from which to answer the question, "What does it mean?" from a new angle. How much does the interactor need to know in order to interpret? To what extent does the audience need to understand how exactly the author created—that is, programmed—her work?

The discussion about fog, bugs, and technical constraints and requirements made it clear that appropriate media competence is essential for any hermeneutic undertaking. The interpreter or critic should be able to decipher a feature as a bug and will be able to do so only with the necessary knowledge of programming. With respect to digital art—that is, coded art—it seems natural that the critic should be familiar with the code and be able to address it. If programming is such an important part of the work, how can one possibly ignore it? How can one do a close reading if one does not know the language in which the work under discussion has been programmed? As Noah Wardrip-Fruin (2009) rightly argues, computational

processes themselves express meaning through distinctive design, history, and intellectual kinship that may, as is the case with any art, not be visible to the entire audience. One could even consider the code an indispensable part of any biographical method of interpretation, given that the manner of coding can reveal additional information about the programmer. One might think in this context of *critique génétique*, which looks at the handwriting of authors in order to derive a better understanding of the meaning of the text from data literally inscribed within the physical process of writing. Where did the author stop and pause? Where did she cross out a word? However, the preface already addressed the overeager embrace of the code, with the consequence that the formalistic focus on technology underlying the interface neglects the actual experience of the audience and may actually impede access to the artwork's aesthetics. After having carried out a number of close readings, I want to take up this issue again and state that the requirement for the technologically savvy critic—and any spectator or interactor who wants to understand the work at hand—is based on presuppositions that need further discussion.

It is not always the case that knowledge concerning the coding of a work necessarily contributes to its better understanding. There is a difference between knowing that, in *Text Rain* (1999) for example, the letters stop moving down whenever they collide with the image of anything darker than a certain threshold, and knowing exactly how this is coded. It is surely important to understand that the artist wanted the letters to stop at that threshold. But is it also important to understand how this is executed? Is the program used really the language in which the artist is expressing herself, or is it rather a tool? One may consider it simply as the pencil used to communicate certain ideas. But it could also be the typewriter fundamentally affecting the way of writing. One can argue that only those who understand the typewriter understand what was written with it, and hence only those who know how one programs the behavior of falling letters on a screen can fully understand *Text Rain*. This argument is tantamount to saying that only if one knows how to paint or how to play the piano can one appreciate and discuss a painting by Caravaggio or a symphony by Beethoven. However, we know that there are great critiques of paintings and musical works produced by critics with no facility or rather poor skills in creating a painting or playing a piece of music. To render the issue of technology in an aesthetic utterance even more absurd: Can I understand a text written on a typewriter if I myself am only able to type with two fingers? On the other hand, how does my professional ten-finger

typing affect my understanding of a text written by a slow two-finger typist? In addition to this practical argument, there are also pragmatic concerns.

If familiarity with the art of programming were a precondition for the understanding of coded art, it would turn art into something only accessible by a small group of specialists. In a sense, this has always been the case. The accessibility of art has at all times been more or less accessible depending on the special knowledge and experience of its audience. For the most part, this specialist knowledge concerned the history of art, philosophy, iconology, and semiotics. A precondition of familiarity with the software applied in an artwork seems merely to exchange a coterie of artists and art connoisseurs for a coterie of programmers. One may consider this the final victory of the (software) engineer over the artist. It should not really come as a surprise that it is an engineer who would thus steal the public's attention from the artist because this continues the project of industrial revolution in the nineteenth century. Now programmers, software designers, and data architects have "stolen" the materials of art from the artist as well. One may even say: Why not, if it fosters the engineer's interest in aesthetic issues? However, an art and its reception based on the foundation of programming changes more than the members of its coterie. It also changes the message of art as such.

The implicit aim of art is to open up the coterie and to include as many members of the audience as possible in the appreciation of the artwork. Art wants people to see the world with different eyes. It does not want to be perceived and appreciated at a restricted level of understanding; it wants the audience to grow. If familiarity with programming becomes the sine qua non for a full experience of new media art, as the Software Studies Initiative at UC–San Diego and the Critical Code Studies seem to suggest, the agenda of art changes drastically. First, art would alter our way of seeing the world by turning us into programmers. However, seeing the world through the eyes of a programmer may undermine what many critics (among them such heterogeneous theoreticians as Gadamer, Adorno, and Derrida) have considered the driving principle of art: to present us (or rather confront us) with an unlimited number of possible interpretations without the prospect of eventually finding a right answer. The hermeneutic enterprise that art offers consists of the lack of any solution. The result of the aesthetic experience, the threat that art embodies, is the subversion of reason. This subversion is considered to be a valuable contribution that art makes to the nonart world because it puts this world in perspective; it makes us aware of ambiguity and multivocality in life and

society. Regardless of the specific content of a particular artwork, this subversion is, to echo Marshall McLuhan, the message of the medium (or social system) of art.

Seeing the world through the eyes of a programmer basically promotes a contrary paradigm in which—although there may be more than one way to code a certain effect—right and wrong may always be discerned. This paradigm endorses the notion of correctness and ultimate (re)solution. Whatever new media art offers (or confronts us with) on the screen or scene of installation, at the level of code, it is founded on concepts of precision, certainty, and truth. An artist using digital technology gives, as Frank Popper underlines, "preference to rational thought and mathematical calculation" (1995, 27).[9] As seen with respect to Flash aesthetics and playful interactive works, the foundation of these artifacts by code does not mean that the surfacing, semantic effect of code necessarily endorses rationality. However, requiring the audience to understand the code brings rationality and calculation on the forefront of the aesthetic experience and jeopardizes the traditional message of art—that is, epistemic subversion. Art, the way it has been understood in modern and postmodern theory, would end. Programmers may not regret such a change or appreciate its significance. They already promote the transformation with works that mirror the principle of truth and precision—so indispensable at the level of code—as is the case, for example, with many works of naturalistic mapping art. The question remaining for critics who are not invested in becoming technologically savvy is not how to improve their programming skills, but whether they want art to go down this path at all. The question is whether one should surrender art based on digital technology to a paradigm and perspective correlated with and intrinsic to technology or, as David Golumbia (2009) puts it culture critically, the logic and ideology of computationalism.[10]

To be sure, there is no advantage in not knowing the code. We do want to know how the "internal demon of the apparatus" works, to use Jacques Derrida's phrase concerning the word processor (2005, 23). It is important not to mistake something on the screen because of incorrect (or nonexistent) ideas about the code behind it. It matters that the delay with which the program presents the video clips corresponding to the immobilized body part in *Exchange Fields* was not intended. It matters that in the case of *Text Rain* the authors decided not to have the letters bouncing or making noise when hitting a dark object. It is important for interpretation to know whether a certain effect is the result of technical constraints or

deliberate decision. It is important to tell a bug from a feature. The question, however, remains how disadvantageous it is not to know the code, and how valid an interpretation may be when it is not based on a close reading of the code itself. The question brings us back to the answer given above about the critic who discusses a painting but who cannot paint. Although it is clear that skill in painting or programming can help to see more in a picture or work of digital art, one can also—as is clearly demonstrated in this book and many previous works of criticism—discuss the complexity of such artwork thoroughly without such special skills.

The way the question of code and interpretation is approached clearly depends on the critic's disciplinary background. Critics and scholars in the field of digital aesthetics coming from the humanities will be most likely to underline the importance of semiotics, philosophy, art history, literary, and cultural and media studies to understand a work of digital art. For those coming to the work from computer science, programming will take its place as a sine qua non for the comprehension and appreciation of such work. They will point out that coding is not exhaustively defined by rationality, efficacy, or even efficiency, but has style and art of its own. They will hold that code, "having meaning beyond its functionality since it is a form of symbolic expression and interaction" (Marino 2006), should be considered another variety of expressive cultural practice. Such differences in disciplinary background will eventually result in distinct methodological priorities.

Those who do not know coding are more likely to focus on a close reading in the manner of New Criticism, as has been undertaken, for the most part, in this book. In this case, the principle of "the text and only the text" not only excludes the social and biographical subtext, but also the code—not in terms of its materialization on the surface, but in its form as itself a distinct (alphanumeric, symbolic) text. Corresponding to the position of New Criticism is an immanent approach, focusing on the work as the audience experiences it, with no outside information. One might argue from such a position in relation to digital art that, in many cases, the code is inaccessible and hence should not be taken into account in the process of interpretation. The opposing position will counter that code is inevitably a part of the text, and even if it is not immediately accessible, one has to make an effort to gain access to it in order to explore its extrafunctional significance. Leaving open the question of whether a reading of digital artwork based on information that is not available on the surface level of

the work necessarily opposes the close-reading principles of New Criticism or continues to operate solely within the work, I want to emphasize that the close reading favored in this book does not refuse the inclusion of text-external information, such as the social and biographical subtext, per se. Because it eventually aims at critical reading, it occasionally also engaged with social or biographical data mining and discussed the interconnections between the single artifact and the broader cultural situation. Central to this book, however, was the notion of starting the reading close to the actual work before understanding it in light of a broader context.

It is likely that the next generation of critics and scholars will develop a reading competency that combines expertise in code and coding, as well as in the interpretations of the representations that are generated by code on the screen or at the site of installation. The development of such a new generation of critics and scholars is the impetus behind programs that bring together teachers from both the humanities and computer science.[11] Meanwhile, however, it is important to undertake close readings using both approaches. Critics coming from the humanities will have to discuss the symbolic significance that they see in a work and demonstrate the work's associations and connections with art history. Critics coming from computer science will need to determine and discuss whether a work adds anything to the culture of coding, whether its algorithmic content is, for example, beautiful or trivial (and how this would help or harm the work, rendering it pointless or fascinating in terms of its surface representation), and whether their answers to such questions affect the close reading by those critics taking a complementary humanities approach.

Perhaps this is the best way to proceed with the questions of code and interpretation. Instead of an abstract theoretical debate about the importance of code for the understanding of coded art, all critics should make their specific cases, showing how knowledge of art history or coding shapes their understanding of the work. A good way to start might be to take close readings produced by the other side and demonstrate how these readings inevitably change once a complementary expertise is brought to bear.

Avant-garde

A question that is raised frequently concerning digital arts is: Is it avant-garde? With respect to digital media, this claim is made using both Clement Greenberg's (1961) formalistic as well as Peter Bürger's (1984) political understanding of avant-garde. Within the perspective of formalism, it is easy

to point to digital art's concern with its own material and mediality. This is not limited to the politically charged art browser, such as Webstalker by I/O/D, which Brett Stalbaum (1997), for example, notes as avant-garde. Any technical effect for effect's sake is implicitly a formalistic investigation of the characteristic of the medium: the less an animation conveys content, the more it draws attention to its form; the less it represents meaning, the more it presents itself. The technical effect for effect's sake celebrates the code on which it is based. With reference to the pure visual in avant-garde painting and film, I have discussed this aspect in chapter 2 as pure code.

In the introduction to his collection of interviews with authors of Net art, Tilman Baumgärtel (2001) points out that the medium of Net art is the same one used for working, shopping, information gathering, and corresponding. Hence one experiences Net art in the same locus as one carries out actions not at all related to art; unlike visiting a museum or going to the theater, all that is required is a click. The material—or rather the technology—with which Net art is concerned is the material of daily life. This is why Baumgärtel eventually claims that Net art, as formalistic as it may be, can never become art for art's sake. Whenever Net art talks about its own materiality, it always involves issues ranging beyond just art itself: "Net art, on the one hand, can have so much to do with the technological attributes of the Internet, but on the other hand, and often enough, at the same time, it can also encompass the political, social and economic factors which are a part of a result of this technology" (Baumgärtel 2001, 28)

Baumgärtel's notion provokes Bürger's approach to the avant-garde as a revolt against the art system and dominant aesthetics. It is obvious that digital arts blur the lines between art and life, as it was constitutive for the classical avant-garde when it included oilcloth, clock parts, or tickets in collages; when it insinuated ready-made objects into museums; or when it proffered poems made up of words cut out of newspapers. The nature of digital media calls for the bridging of art and life because the Internet constantly links the most divergent sites (and systems) together, because search engines allow and encourage the collage of ready-made data, and because the binary code—the common denominator of all data distributed in digital media—facilitates the visualization and beautification of such data. As a result—and this can be seen in many publications on the digital arts—the borderline between applied technology, investigative journalism, or social studies on one hand and art on the other dissolves. Digital art not only blurs the lines between art and life, but also between

technology and art. The discussion on mapping art in chapter 5 has addressed the problems caused by the recognition and proclamation of such data gathering as art. Recalling similar concerns of contemporaries regarding the actions and creations of Dadaism, one may conclude that if it raises doubt about whether or not it is art, then it must be avant-garde.

However, the situation is more complicated at times when a homogenous society and art system have vanished. In a polyvalent and multipolar society, the avant-garde has difficulties identifying opponents. It cannot differentiate and define itself accordingly. This point has already been made by Richard Chase, who, in *The Fate of the Avant-Garde*, announced its death as early as 1957. The same conclusion was drawn in 1962 by Hans Magnus Enzensberger *(Die Aporien der Avantgarde)* as well as Renato Poggioli *(Teoria dell'arte d'avanguardia)*, who pointed out the impossibility of an avant-garde in the light of flexibility in the art system. Bürger then spoke of post-avant-garde (*Theorie der Avantgarde*, 1974), and Achille Bonito Oliva coined the term *trans-avant-garde* (*La transavanguardia italiana*, 1980). The overall belief was that because the undermining of what art means has long become mainstream in the art business, such undermining can hardly be considered avant-garde anymore.

Against this background, it seems difficult to argue that the avant-garde is still possible. Nonetheless, the avant-garde has been reclaimed for the digital age and digital media. With respect to collage, hypertextuality, ready-mades, political performance, and protosemantic poetry, scholars have pointed out that the conceptual and aesthetic roots of digital (or new media) art lie in the classical and neo-avant-garde.[12] Some activists of digital media announce themselves as avant-garde. Thus, the Critical Art Ensemble questions the so-called death of the avant-garde and suggests "electronic civil disobedience" in digital technology (such as hacking) as an elixir that can reanimate its corpse (2002, 17). Ironically, references within art history somehow undermine the claim: the fact that digital arts transform techniques and aesthetic methods established decades ago suggests its conserving and conservative, rather than avant-garde, disposition.

Lev Manovich addresses this issue in his 1999 essay "Avant-Garde as Software," holding that the actual claim of new media to avant-garde status is not the transformation of the classical avant-garde techniques into software but the introduction of an equally revolutionary set of communication techniques: "The new avant-garde is no longer concerned with seeing or representing the world in new ways but rather with accessing and using in new ways previously accumulated media. In this respect new

media is post-media or meta-media, as it uses old media as its primary material." Because Manovich dates the arrival of the metamedia society back to the 1960s, the question remains to what extent new media is avant-garde or just a transformation of avant-garde visions into computer software. Manovich must have realized this problem, for he finally declares rather than the new ways of accessing previously accumulated media, the "new computer-based techniques of media access, generation, manipulation and analysis" to be the crucial criterion. Hence, the notion of avant-garde boils down to the mere use of the new technology instead of a specific use of technology; avant-garde becomes a default, or, as Manovich concludes without critical connotation, "avant-garde becomes software," which implies that software is avant-garde.[13]

If Manovich's discussion of new media avant-garde is not compelling, nonetheless it surely convinces us of a desire to hold onto the concept of the avant-garde. One wonders why, given the fact that the avant-garde has become so fashionable. Simon Biggs (2007), who asked this question at the Electronic Poetry Festival in May 2007 in Paris, assumes that our motives are not pure and that authors of digital arts fancy themselves as avant-garde because they perceive the avant-garde as exciting and as something that made certain art forms—and their associated artists, theorists, and critics—famous, which they hope may also happen to them. Biggs holds that if something was truly avant-garde at this time, it could not afford to be shocking, because the shocking (Biggs names Emin, Hirst, and Cattelan) is now routine. This remark triggers the picture of an avant-garde that is in contrast to its historic predecessors, not scandalous because of its rebellious attitude but rather insubordinate out of indifference and obsession.

In "The Sublime and the Avant-Garde," Jean-François Lyotard famously states that "a work of art is avant-garde in direct proportion to the extent that it is stripped of meaning" and adds the question, "Is it not then like an event?" (1989a, 210). In pictorial arts, Lyotard noted with reference to nonfigurative painting, that the paint, the picture, is an occurrence or an event (the shock and enigma of the happening), unexpressible, stripped of meaning (199).[14] This notion can be linked to the phenomenon of pure code as well as pure information discussed before. In chapter 5, I argued that in the light of Alan Liu's *Laws of Cool* (2004), metaphoric, nonnaturalistic mapping could be seen as a command over information that actually is indifferent toward the meaning of information, and thus it is in

accordance with a law of cool that regards information in a nonutilitarian way. However, I eventually considered mimetic or naturalistic mapping even more entitled to the epithet *cool* because of its approach to information in an apathetic, emotionally inexpressive manner, which Liu also lists as an attribute of cool (234). Although the useless information in metaphoric mapping can easily be understood in terms of Lyotard's event stripped of meaning, it is important to emphasize the fact that the pure information of naturalistic mapping also embodies such events as a result of its lack of a personal perspective beyond the precise rendering of data. It offers information (or data) as such, stripped of any further information added by the artist; it presents an informative but inexpressive occurrence. Following Lyotard's notion of the sublime, such mapping may be considered (strange as it might seem) the model of a contemporary form of the avant-garde. It is the unshocking enigma of the happening, the enigma that life is happening, the mystery of presence.[15]

This avant-garde blurs the border between art and life as well as between art and technology. Although naturalistic mapping presents data in a rather meaningless way, it also represents absolute command over data, which materializes in various, elaborate visualizations. The other side of this indifference toward information is the obsession with technology, or, as Liu puts it, "the pure eroticism of *technique*" (2004, 236). In the case at hand, the obsession with technology is an obsession with programming, which has been discussed in chapter 2 as pure code and fascination with virtuosity finding its purpose in itself rather than in the expression of a particular message.[16] The border blurred most clearly by this projected contemporary avant-garde is the border between the artist and the engineer. This becomes especially clear when a representative of the classical avant-garde is referred to—or, rather, taken on and coded.

The interactive installation *Mondrian* (2004) by Zachary Booth Simpson and his collaborators allows the audience to generate Mondrian-like images by drawing lines on a screen with one's hand and coloring sections with one's finger (Figure 25). Simpson's company, Mine-Control, claims that they are "an artistic endeavor" and that they "create interactive installation artwork."[17] The list of exhibitions shows that their work is on display not only at science centers, museums for science and technology, and children's museums, but also art museums. It is important to note in their statement that they believe "that art can be both playful and thought-provoking." *Mondrian* is certainly playful. To what extent is it thought-provoking?

Figure 25. Zack Booth Simpson, *Mondrian* (2004). Art by Zack Booth Simpson.

The accompanying text on the Web site states that this work "permits participants to simply sketch out and edit compositions in the style of the great abstractionist Piet Mondrian. Create your own composition in 10 seconds!"[18] There are two interesting aspects to this statement: first, the homage to Mondrian as a great abstractionist, and second, and the promise to imitate him in ten seconds. As for the homage, it should be noted that Mondrian is revered as a great abstractionist, not as a great painter or artist. While this may be a random, insignificant detail, Mondrian's position as artist is certainly undermined and trivialized by the suggestion that the audience could do in ten seconds something that would have taken Mondrian considerably longer.

Although we do not know how long it took Mondrian to create his paintings, or compositions, as he called them, we know that it took him a while to overcome his naturalistic and impressionistic style and find his own voice. His style became an important milestone in the history of art, together with other movements in painting that signaled the shift from the mode of representation to pure abstraction. Mondrian's work contains—

in a similar manner to the way Duchamp carried more than just a ready-made into a museum—a complexity that belies its apparent simplicity. What makes Mondrian's, and even more so Duchamp's, work art is not something that meets the eye, but something that happens in the intellect. This art is not perceptual but conceptual. It can no longer be fully appreciated on the visual level—although spectators did and do visually appreciate Duchamp's urinal as well as Mondrian's compositions. Rather, it requires an understanding of its historical and conceptual references. Nonetheless—or, rather, for that reason—Mondrian's work was often parodied and even trivialized. The rock band Botch released a song entitled "Mondrian Was a Liar" that speaks of the hardship of life and work with your hands. Mondrian only appears in the title of the song. However, the lyrics evoke the notion that he was not a hard manual worker, in contrast, say, to the painters of the trompe l'oeil school, who aimed at such virtuosic craft that their paintings could fool the audience into taking them for reality. Does Simpson think Mondrian was a liar?

By allowing the audience to paint just like Mondrian with a few clicks and flicks of the hand and finger, Simpson's piece inevitably lends weight to the idea that Mondrian's work is so simple a child could do it. The fact that this installation effortlessly generates artifacts that "look just like it did in the museum," as participants may think, mocks the famous artist. But it goes further, because it is not a canvas on which people unchain the inner Mondrian in their soul. It is an interactive screen with highly sophisticated programming behind it. The programmer is Simpson and his team. Whereas the participants may change their conception of Mondrian's talents, they will appreciate the achievement of the creators of the *Mondrian* machine. This achievement is based on excellent coding. It is based on craftsmanship, which is what Mondrian was denied when he was parodied, mocked, or even called a liar. Simpson's work not only mocks Mondrian, but it also actually offers a better candidate for homage. It establishes the fame of the programmer at the expense of the painter in a certain way. It praises real painting (that is, virtuosity) over the intellectualized image (as in abstract, conceptual art such as Mondrian's compositions). Simpson's work turns out to be an example, deliberately or subconsciously, of deconstructing the avant-garde. He does not really honor Mondrian with *Mondrian*, but uses Mondrian's abstractionism to position himself against it. Only if Simpson compares himself to Mondrian can he maintain his superiority with respect to craftsmanship.

Simpson's *Mondrian* machine functions as a toy, which is fun to play with for a brief time. The discussion, however, reveals that it is more than simply a toy. It raises the question: Can it also be art? According to Arthur Danto (2000), for the evaluation of an artifact as art or nonart, neither craftsmanship nor visible quality is important, but "aboutness." He explains this aboutness with respect to Andy Warhol's *Brillo Boxes* (1964), an arrangement of the branded cardboard cartons containing scouring pads that are sold in supermarkets. In Warhol's installation, these boxes contain more than the scouring pads. They are not only about their content, but also about the boxes themselves, about their visual pleasure, about their possible status as art. Warhol's boxes comment on the original boxes and thus become art, as Danto (2000) states. Can we say the same about Simpson's *Mondrian*?

The answer may be yes and no. It is no, if we see this work only as an example of coding—that is, artistry and virtuosity. Coding, understood in terms of craftsmanship, would be a problematic foundation for art and could certainly not bear comparison with the conceptual complexity of Mondrian's work. However, the answer may be yes; Simpson's *Mondrian* machine is art, if we see it as a comment on Mondrian's lack of craftsmanship. Simpson's work could be understood as being about (and against) a concept of art that approaches art merely from an intellectual perspective rather than on the basis of technical virtuosity. This model of art is adequately described by Sol LeWitt, who, in his 1967 essay "Paragraphs on Conceptual Art," holds that in conceptual art "the idea becomes a machine that makes the art" (2000, 12). LeWitt, in his *Wall Drawings* since the late 1960s, consequently delegates the execution of the idea to a draftsperson.

The aboutness of Simpson's work may be a critique of this liberation of art from any skill of the artist as a craftsman. It is a critique of the "philosophical disenfranchisement of art," as Danto titled one of his books in 1986. It is the end of the expulsion of the technical. While Mondrian presents his intellectual sophistication by reducing painting to its utmost simplicity, Simpson, in a kind of counterstrike, however deliberate and intentional, presents his technical sophistication by creating a machine that imitates this simplicity: an objection to the intellectualization of art that is itself conceptual and intellectual. Of course, it is the simple shape of the grid in Mondrian's work that allows its imitation within the digital medium as matrices of discrete values. It is exactly this paradigm of the

grid that allows us to see Simpson's turn against Mondrian as continuation of what Mondrian represents.

As Rosalind Krauss points out, "The grid functions to declare the modernity of modern art" and announces "modern art's will to silence, its hostility to literature, to narrative, to discourse" (1986, 9). Similar to the database in Manovich's account (2001, 225), the grid is the enemy of the narrative and represents, as Krauss continues, "a naked and determined materialism" (1986, 10). However, the grid does not embody the culture of presence or the aesthetics of the performative or the sublime because it does not aim at materiality as an uncontrollable event. On the contrary, as Lutz Koepnick asserts, grids, with their conceptualization of the world as a predictable system of horizontal and vertical lines, "energize sensation of control, power, and omnipotence" and thus "arrange the perceptible world as something that more or less excludes the possibility of chance and surprise" (2006, 53). The grid "removes the messy, strange, and the mysterious and entertains the modern subject with sensations of unmitigated presence and wholeness" (54). Koepnick's words recall the notion of coding in digital media as control over the messiness of bodies and unruliness of the physical world. In fact, the grid is seen as having exactly the same effect as the code when Koepnick states, "To 'go digital' is to reconstruct the world within a grid of discrete values" (48).[19]

Insofar as the grid signifies control and represents one of the "most stunning" myths in modernity—as Koepnick (2006, 54) states, in line with Krauss—Simpson's *Mondrian* does not actually oppose Mondrian but reconfirms his practice. Simpson radicalizes the concept of Mondrian's grids by expanding it from the surface (of the canvas) to the level of code, thus applying the modus of "discrete values" even to the process of constructing the grids on the screen. In light of this doubling of the emblem of control, we may understand the code as first-degree relative of the grid and—because of its extrapolation of avant-garde visions by ways of software—consider *Mondrian* to be the inheritor of the avant-garde represented by Mondrian. The irony of this view is the return of craftsmanship (as software engineering) in art that had been fundamentally disregarded by the avant-garde. The question of to what extent this really qualifies the *Mondrian* machine and similar projects as an avant-garde of the early twenty-first century must be left for others to decide; the primary aim of this book is to engage in detailed and specific readings rather than to resolve such general theoretical issues. Nevertheless, we may use the *Mondrian* example to end this book with an indication of a bigger picture.

Happy (Bl)End

In his 1968 essay "Avant-Garde Attitudes," Greenberg complains that the boundaries between art and everything that is not art are being obliterated and that scientific technology is invading the visual arts. Of course, the marriage of art and technology has a long tradition (Strosberg 2001; Ede 2005). Painters and architects have always benefited from technical innovations. Even literary movements such as naturalism have drawn inspiration from scientific methodology. Sometimes this marriage has led to a change of profession, as in the cases of Samuel F. B. Morse and Loius-Jacques-Mandé Daguerre, who both started their careers as artists searching for new modes of expression and finally became famous for their technological inventions. History also provides examples where technology turned into art, as is the case with Jean Tinguely's kinetic sculptures and Arthur Ganson's gestural engineering, which both qualify as art precisely for the reason that they represent technology for technology's sake—pure technology, one might say, analogous with the avant-garde's pure painting or pure film. As far as digital media is concerned, the change of profession is the potential future and actual agenda. As is stated on the cover of Stephen Wilson's 2002 book *Information Arts: Intersections of Art and Technology,* the role of the artist "is not only to interpret and to spread scientific knowledge, but to be an active partner in determining the direction of research." Wilson documents over almost 1,000 pages the vast number of artists utilizing technology in their work. Other publications—such as Popper's *From Technological to Virtual Art* (2007)—confirm and update the notion that the outlook for art is determined by its engagement with technology. What does this prospect signify for the question of the avant-garde?

Despite the plausible declarations of its death and the noted lack of mainstream culture as a necessary opposition, one could still consider the digital arts to be avant-garde, and could do so using either Greenberg's or Bürger's criteria. With respect to Bürger's concept of the avant-garde, it is certainly the case that digital art undermines the established system of art by blurring the boundaries between art, technology, and science. The marriage between artist and engineer or scientist ends old resentments and bridges the cultures of human and natural sciences as described by C. P. Snow in his 1959 essay, "The Two Cultures and the Scientific Revolution." Snow holds that not only familiarity with Shakespeare should be considered part of our culture, but also familiarity with the second law of thermodynamics. Digital art seems to be the perfect place for the reconciliation of

these cultures. It combines the paradigm of arts—as a humanistic discipline intended to provide general knowledge and intellectual skills (rather than occupational or professional skills)—with the paradigm of engineering—as the discipline that applies scientific knowledge to practical problems.

As Popper (1995, 27) states, and as has been seen with respect to *Mondrian*, art based on digital technology gives preference to rational thought and mathematical calculation—that is, virtuosity—in the realm of programming. Whatever the aboutness of such art may be, it not only involves an idea but also requires knowledge of how to translate the idea into the world of coding.[20] The reclamation of craftsmanship does not associate with the avant-garde but a *derriére-garde,* which stresses technical competence, rather than complex or complicated intellectual concepts, and whose style of realism may be considered a conservative reaction to the results of modernism.[21] However, it is precisely this return of the *artes mechanicae* into art that, in light of Greenberg's formalistic approach, allows us to speak of code-based art as avant-garde. In the realm of code, the concern with its own materiality—according to Greenberg a characteristic of the avant-garde—requires proficiency rather than intellectual phantasmatic imagination. As we saw in chapter 2, Greenberg himself underlined that such concern with the nature of the medium, and hence with "technique" becomes an "artisanal" concern (1971, 46). It is the precise programmer (à la Simpson), not the ingenious visionary (à la Mondrian), who is needed when art is based on code. Digital art—and this may be the paradoxical conclusion—is avant-garde in particular because it is so much *derriére-garde.*

It should be noted finally that there is crucial gain for both cultural protagonists within the hybrid "scientist-*cum*-artist" (Popper 1995, 30). The scientist (programmer, software designer, researcher, experimenter, inventor) working with the artist starts to be concerned with aesthetic issues, which expands the influence and domain of art into the regions of technology and science. As regards the artist working with technology, the required collaboration yields "a happy blend of solitude and collective creation," as Popper phrases it—a blend of solitude needed for conception and discussion time with other creators (32). The departure of the artist from her realm of solitude to meet and marry the scientist is likely (and proven) to result in the production of less melancholic, severe, heavy, but rather playful, pleasant, fascinating artifacts and make the happy blend to a truly happy end. It is a happy end, which Hegel, when he predicted

the end of art, did not foresee: its transformation into science—or simply into technology.

This conversion may be problematic when the result is that code becomes everything, vision is replaced by data, and information is mistaken for ideas, as in the case of naturalistic mapping. However, for many people, such examples may be cool precisely because they are not trying too hard to be art. The happy end lies in the eyes of the beholder. With digital art, it is exactly as with other art forms: There is convincing and less convincing work, and there are people who consider this same work to be powerful or weak. In the end, it is the same old discussion about taste and judgment; in the end, it will not be important, if possible at all, to explain whether and why a work is avant-garde, but it will simply be preferable to express what one sees in it and why one likes or dislikes it. This book has argued that the act of articulating one's ideas is an essential part of the aesthetic experience and has presented some examples of such an undertaking. If it has inspired its readers to come up with their own words in front of other or even these same examples, it has achieved its goal.

NOTES

Preface

1. For the notion of computer programs as "literature in a highly elaborate syntax of multiple, mutually interdependent layers of code," see Cramer and Gabriel (2001). For a vigorous critic, see Trevor Batten's remarks at http://www.tebatt.net/SAT/RESOURCES/SOCIAL/Cramer_SoftwareArt.html. For an account of the arguments on body and control, see Munster (2006).

2. Rather than the term *user*, which implies that someone makes use of something, I use, in accordance with Rokeby (1996), the term *interactor*, which was coined in 1992 by Kristi Allik and Robert Mulder with respect to interactive theater (Gianetti 2004).

3. For such accounts, see the discussion of Ascott (2003) and Bourriaud (2002) in chapter 4.

4. Jane Gallop fears, for example, that literary historians are not more than "armchair historians" and recommends that we leave the arena of cultural history to "our colleagues in history departments." She goes so far as to consider such reaching beyond the discipline as "disciplinary suicide": "If we persist in becoming second-rate historians, we lose any rationale for the continued existence of literary studies" (2007, 183, 184).

Introduction

1. For an introduction to digital literacy, see most recently Lankshear and Knobel (2008) and Rivoltella (2008); for digital humanities, see Schreibman, Siemens, and Unsworth (2008) and O'Gorman (2007); for the concept of electracy, see Ulmer (2006) and Rice and O'Gorman (2008).

2. For such a media-specific analysis, see, for example, Hayles (2002, 2008) and Ricardo (2009), which present many contributions of the U.S.–German conference *Reading Digital Literature* I organized at Brown University in October 2007. The focus on specific readings in this book does not neglect the need to continue a general discussion and to refine terminology and typology. The quoted definition of digital art, for example, is much too vague concerning its essential element: the use of

digital technology. With the definition provided, every poem typed on a word processor or photograph displayed on a Web site would qualify to be called digital poetry or digital image, which actually would declare any art represented within digital media digital art and thus deprive the definition of its heuristic power. The indispensable aspect of the definition of digital art is the need of digital technology not only for distribution but for an aesthetic reason: for a specific way of expression, which cannot be realized without digital technology. Although the terminological debate is not the overall objective of this book, we will come back to it in chapter 1 when discussing the question what constitutes digital literature.

3. The objection against the distinction of the educated critic over the "stupid" Joe can also be seen in Roy Ascott's rejection of the "skilled decoder or interpreter" quoted in the preface (2003, 234) above.

4. Such features are the remix, visualization, and animation of data and the prevalence of the spectacular, corporeal, and playful over the contemplative and meaningful. Janez Strehovec (2009) therefore locates digital poetry in the context of club and mainstream culture rather than the elite culture of poetry.

5. For surveys on digital art, see Wilson (2002), Paul (2003), Greene (2004), Rush (2005), Tribe and Jana (2006), and Wands (2006).

6. Forensic materiality concerns the physical properties of the hardware, including the effect of voltage differences on the way the device reads patterns of bit. Formal materiality consists of the "procedural friction or perceived difference—the torque—as a user shifts from one set of software logics to another" (Kirschenbaum 2008, 13).

7. For a systematic discussion and illustration of classical rhetoric terms with respect to digital literature (i.e., kinetic allegory, kinaesthetic rhymes) as well as various forms of the poetic link, see Saemmer (2009). For a discussion of the dramatic irony of an almost isolated node as well as the visual trope of a mise-en-abyme by reopening the same frame in the right-hand side of the frame (and further in the right-hand side of the frame embedded in the frame, ad infinitum), see the discussion of Caitlin Fisher's hypertext fiction *These Waves of Girls* (2001) in Koskimaa (2009b); for a close reading of this hyperfiction and the discussion of the nature of a link as utterance of the author or the author's characters, see Simanowski (2002, chap. 3).

8. There are, of course, more or less easy ways to access the code source. However, it is normally not a factor of the experience of the artifact itself and often not accessible at all.

9. For an extended discussion of code as a sublinguistic structure and the five ways to write code, see Cayley (2006). Cayley's approach implicitly reacts to Florian Cramer's (2004) understanding of code as text.

10. Rafael Lozano-Hemmer reports of a brief blackout of the images as slides change in his piece *Body Movies* (2001). Although at first he did not want this, he is now pleased with the "silence" this rupture introduces and considers this technological limitation "a fundamental feature of the piece" (Lozano-Hemmer 2002, 154).

11. Mateas and Stern (2007, 197). "FightOverFixingDrinks" is one of the twenty-seven beats (basic plot elements) in *Façade*. A beat consists of a canonical sequence of narrative goals (beat goals).

12. Ibid. Mix-ins are "beat-specific reactions used to respond to player actions and connect the interaction back to the canonical sequence" (192).

13. Since the late 1960s, the term *performative turn* had been used by anthropologists and sociologists such as Victor Turner, Erving Goffman, and Clifford Geertz to stress the performative elements inherent in everyday life and the social dramas off the stage.

14. More recently, Jones (2006) condemned the reduction of the senses in art experience to only the rational. Although this is not the place to engage in a methodical discussion of the mind–body dichotomy (debating, for example, to what extent mental processes are the result of sensory organs or are physical experiences resulting from mental properties), for this book, especially with respect to interactive installations, it is useful to differentiate between the perception, or rather experience, of an artifact on the grounds of bodily immersion and the cognitive reflection (interpretation) of this experience.

15. Other predecessors of such condemnation in the context of German scholarship are the critique of Friedrich Schleiermacher's hermeneutics as colonizing and liquidating the Other in Hörisch (1988) and the critique of a hermeneutic aesthetic in Bubner (1973).

16. Critics have considered Gumbrecht's aesthetics of a refashioning of existentialist ideas by traditional thought to be religious (Martinez 2006). Gumbrecht himself admitted his fascination with theology (2004, 145) and titles one of his chapters "To Be Quiet for a Moment: About Redemption." See also Seel (2005), which proposes a more sensual sensitivity in our relationship to the world, and Mersch (2002a, 2002b), which promotes, in the sense of Lyotard, the aura of the event *(Ereignis)* against hermeneutics, semiotics, and structuralism.

17. "Something reveals itself in atmospheric appearing when it becomes intuitable in its existential significance to the perceivers." Seel thus explains the *atmospheric* appearing with the example of an abandoned ball in a garden as a reminder of the traces of children who are long gone (2005, 92). In contrast, in its *mere* appearing, this ball would simply be perceived in its phenomenal presence meaning or reference.

18. In the modus of *artistic* appearance, one would see the (visibly deflated) ball as if it were a sculpture by Oldenburg (Seel 2005, 90).

19. In fact, Gumbrecht's position is influenced by the discussion of performativity by Fischer-Lichte and colleagues, to which he was exposed in various workshops. A specific contribution to this philosophy of a new aesthetic sensibility is the focus on atmosphere as an affective power of feeling in Gernot Böhme's aesthetics, which also criticizes the dominance of semiotics and "intellectualism" (1995, 30) in favor of the attentiveness to the presences, atmosphere, and aura of things.

20. The absence of meaning itself can be interpreted insofar as no artifact can exist without meaning. However, the difference between this kind of meaning (the symbolic rejection of meaning) and the author's deliberate production of meaning by a specific structure and composition of the artwork should be obvious. In the cases at hand, *P-Soup* implicitly carries a reference to the history of (abstract) painting,

which unavoidably attaches deeper meaning to the play with color and sound. The fact that the painting in *P-Soup* consists solely of code and is produced by the visitor is the main contribution of Napier's work to the discourse of abstract painting and relates it to other examples of interactive art such as Camille Utterback's *Untitled 5* (2004).

21. Appolinaire (1913) described the nonfigurative paintings of Cubism as "pure painting." Greenberg spoke of "pure poetry" (and "art for art's sake") regarding poetry in which "subject matter or content becomes something to be avoided like a plague" (1961, 5).

22. For an account of the arguments, see Munster (2006).

23. Within the culture of presence, Gumbrecht states, people want to connect to the universe the way it is, in contrast to the Cartesian paradigm of thinking (including about alternatives) that always aims at the alteration (improvement) of the world (2004, 82, 106; see also 142ff.). The affirmative character of Lyotard's aesthetics is already expressed in the title of a German collection of his writings: *Essays zu einer affirmativen Ästhetik* (1982), which also contains a translation of his essay "La peinture comme dispositif libidinal." Although the terms *culture* and *aesthetics* carry different meanings, Gumbrecht and Lyotard use both terms to discuss basically the same idea.

24. Thus Lyotard explains his concept of the energetic theater with reference to the event aesthetic of Cage's chance art.

25. Although chance art is the rejection of a decision that would require the suppression of alternatives, interactive art is the rejection of the dominance of the author over the audience.

26. See also Vattimo's later remark on "the guiding thread of nihilism (the reduction of violence, the weakening of strong and aggressive identities, the acceptance of the other, to the point of charity)" (1997, 73). It is of course debatable to what extent Vattimo's claim is appropriate, and it has been argued that such nihilistic approach to meaning and truth is undermining or even poisoning democracy; the most recent example is Stiegler (2010). However, my belief is that it will better serve the need of increasingly multicultural societies to accept the Other if dissent is understood as the result not of incorrect but rather conflicting interpretations.

27. As Martin Seel reports, Menke originally planned to title his book *Nach der Hermeneutik* (After Hermeneutics) (Seel 2007, 27). The attribute *after* must—and this is also true for *beyond* in the case of Vattimo—not be understood as a farewell to interpretation or hermeneutics but as the overcoming of a particular form of interpretation or hermeneutics based on the illusion to find *the* truth or meaning of a text or artifact.

28. One experiences, for example, a theme in the Planet Hollywood restaurant or the Rainforest Café, described as "eatertainment."

29. The statement implicitly (and anticipatingly) aims at Arthur Danto's definition of art as *aboutness,* although "not only" indicates that in Sontag's perspective, art is nevertheless about something.

30. See also Munster's (2006) account of the reconfiguration of the bodily experience in digital culture.

1. Digital Literature

1. http://eliterature.org/about.

2. See Hayles (2008, 5–30). Hayles distinguishes between "hypertext fiction, network fiction, interactive fiction, locative narratives, installation pieces, 'codework,' generative art, and the Flash poem" (30).

3. This distinction also allows us to answer questions as to what nondigital might mean in contrast to digital literature: literature that does not employ digital technology to exceed semiotic digitality. See in this context Hans H. Hiebel's differentiation between primary digitality (discrete–distinctive signs) and secondary digitality (digitalization of signs as consequence of the computer) (1997, 8). Digital literature can be related to secondary digitality. It has been pointed out that digital media, strictly speaking, should be called binary media (Pflüger 2005), so that the term *digitality* relating to the computer proves to be questionable. This objection is certainly valid. However, because the term *digital media* has generally been accepted—and has to be chosen over the even more imprecise *new media*—it would be unserviceable to speak of *binary* instead of *digital* literature.

4. The work of Young-Hae Chang Heavy Industries consists of text presented in big letters on the screen as chunks of phrases or single words accompanied by jazz music that impels the text fragments at considerable velocity in most cases. An example of Knoebel's animated poetry is *A Fine View,* a poem about a roofer fallen from a roof, the lines of which move with accelerating speed toward the reader, giving the impression of falling.

5. http://www.youtube.com/watch?v=ZGWkdNWFZiI. The specifics of the technical production of this clip, camera work, and so on are described in detail by Reither (2004).

6. http://www.jeffrey-shaw.net/html_main/show_work.php3?record_id=83.

7. Saskia Reither (2004) stresses, however, that this textualization also leads to a de-stereotyped perspective since the architectural highlights of the city (e.g., MoMA, Guggenheim, Chrysler Building) do not appear in their generally known form but as texts that are put alongside the other buildings. It is not surprising that the work also sparked the interest of an ad agency: Bardou-Jacquet was asked to use the same technique for a Vodafone commercial in which a man slumbers away his travel plans and, called by his girlfriend on his cell phone, rushes to the airport. The commercial finally connects a reference to its own technique with the common Vodafone slogan presenting the line "In a world full of words, the word is . . . ," followed by the Vodafone logo. An interesting detail is the softening of the sound while the cab drives through a tunnel. This makes the sound diegetic, although the narrative does not provide any source for it—except the cell phone itself. The video hence seems to advertise more than it says: the sound is also Vodafone. Today, cell phones also send images and video clips (http://www.youtube.com/watch?v=4IYxULb6dWs).

8. http://www.camilleutterback.com/textrain.html.

9. Utterback at the opening of the *Text Rain* exhibition at Brown University on October 19, 2005.

10. Students also identified a contradiction between the poem's line "limbs' loosening of syntax" and the restriction of interaction with the letters, which does not allow the user to move letters horizontally and to rearrange them into new words. This raised the question of whether there is a conceptual reason for such constraint, whether it is due to the limits of implementation, or whether the installation unconsciously undercuts its own promises. It was suggested that the simplicity of *Text Rain*—which also forgoes the use of color and sound or gimmick effects such as letters bouncing after hitting the user's body—signals an aesthetic preference for minimalism and allows the interactor to concentrate on playing with the letters, possibly including other viewers' actions. In line with this aesthetics is that in contrast to raindrops, the letters do not accelerate toward the ground, which puts the focus more on the metaphor of rain rather than on a realistic imitation.

11. In this distinction, the concept of art does not mean art in opposition to nonart but fine or visual arts in contrast with literature, which itself is included in the realm of arts, as can be seen in Hegel's *Aesthetics* or Adorno's *Aesthetic Theory* (1984). One may also speak of linguistic versus visual arts.

12. On the basis of his description of words as "units each of which already has a meaning" (in contrast to phonemes and letters but also to the elements of the pictoral system), Barthes describes the paintings by Guiseppe Arcimboldo as painting with words because they decompose "into forms which are *already* namable objects—in other words—words, as chicken carcass, a drumstick, a fishtail"; as Barthes further explains, "These objects [or 'words'] in their turn decompose into forms which in themselves signify nothing" (1991, 134).

13. The consecutiveness of reception first as literature and then as visual art (or vice versa) follows the principle of alternating reception that we also experience in concrete poetry. Thus, in Eugen Gomringer's *Schweigen* (1954) where the word *schweigen*, "silence," in five horizontal and three vertical lines surrounds an empty, silent space, one first has to read the word and understand its meaning before one can meaningfully refer it to the gap between the fourteen utterances of the word.

14. This conclusion may sound judgmental, especially because of the wording borrowed from the poem. Rather, it is intended to be self-ironic, insinuating that the speculations of my interpretation may have failed to realize that the appropriate appropriation of the poem is not to transform it into an installation (and thus turn it to something beyond the play) but to use it—and then drop it when required by new circumstances. The reason to drop it was first of all a practical or commercial one, as Utterback explained in an April 22, 2008, e-mail to me. To sell *Text Rain* to the Phaeno Museum, Utterback and Achituv had to make a new piece because the original edition of *Text Rain* had been sold out. On the basis of conversations with the collectors and various people in the art world, the artists decided that by greatly changing the words, they were not infringing on the initial edition. However, in other cases (a Hebrew and Portuguese edition of the piece), the artists decided to translate the poem, with Evan Zimroth working with the translator to approve it.

15. http://www.youtube.com/watch?v=WOwF5KD5BV4.

16. In *Phaidros,* King Thamus rejects the script offered by the Egyptian god Theuth with the explanation that the chance to store knowledge as script will ruin memory.

17. The proceedings of the IRC sessions, plus submitted notes, quotes, and other texts, can be found at http://rhizome.org/artbase/2398/fear/repository.html.

18. Lozano-Hemmer (1997) provides the following details: "To read the building, a participant standing in front of it must wear a small wireless sensor and walk around the courtyard. As he or she walks, two pigi 7kW Xenon light sources track his position and project his shadow onto the facade of the Zeughaus. By using robotic lighting control, the shadows were focused dynamically so that regardless of the participant's proximity to the lamps the shadows were always crisp and well defined. The final effect was a 'dynamic stencil' whereby the shadow of the participant was an active architectural element which 'revealed' the IRC texts that appeared to be within the building, as though the shadow was a cutout or an x-ray of the building." Other than the portraits in Lozano-Hemmer's piece *Body Movies* that were only visible within the shadow of the interactor, in *RE:Positioning Fear,* the text is only projected within the shadow.

19. http://www.lozano-hemmer.com/video/repositioning.html.

20. In addition, the sound of the installation created directly by the interactions of the shadows and the building may also draw attention away from the reading to a different mode of perception.

21. http://www.brunonadeau.com/stillstanding. *Still Standing* tries to match as best as possible the silhouette of the person. As long as the person touches the floor, the silhouette is detected and sliced into a number of horizontal layers that guide the position of the text. If someone stands on one leg, for example, the shape of the text will be thinner at the bottom. If people hold their elbows far from their body with their hands on their hips, the text will be thicker at the height of the torso.

22. Ibid.

23. This would be similar to Utterback's 2000 *Composition,* which transforms the visitor's image on the screen into text in a live recording (http://www.camilleutterback.com/composition.html). While *Still Standing* offers a readable text, *Composition,* which could easily have presented text taken (in real time) from news magazine or other Web sites, thus revealing the media as source of the composition, provides 0 and 1 signs as a symbol of not only text, but of all information available in digital media.

24. I borrow the term *cannibalism* from Chris Funkhouser's lecture at the Electronic Poetry Festival in Paris, May 21, 2007, entitled "Creative Cannibalism and Digital Poetry." Digital poetry devours other texts by appropriating, transforming, and reconfiguring them. There are many general accounts of the annihilation of text in new media, including Sanders (1994) and Mihai (1997). The diminishing role of text in digital art seems to have been rarely pointed out because art critics tend to be thrilled by experiments with text rather than inclined to insist on its linguistic or symbolic effects, while literary critics usually do not discuss the role of text in digital art. An exception is Stefans (2003), which engages with language on the cusp of symbolic meaning in digital media.

25. For the exploration of the consumption of text in digital media in terms of cultural anthropophagy, see Simanowski (2010). For the rivalry between media, see Fischer-Lichte, Hasselmann, and Kittner (2011).

26. There are more examples of such intermedial takeover, such as Michael Snow's text-film *So Is This* (1982), which presents a text unfolding, word after word, on the screen. An example born in digital media are the animated texts by Young-hae Chang Heavy Industries.

27. A specific form of "narcotizing"—apart from alcohol or drugs as the usual stimulants—is the diversion of the author in the process of writing by simultaneously reading texts to him, as in the experiments by Gertrude Stein and Leon Mendez Salomon in 1896.

28. Compare the *cadavre exquis* invented by the Surrealists as the most popular form of collective automatism: players write words consecutively, without knowing the previous word.

29. http://www.ekac.org/geninfo2.html.

30. http://www.ekac.org/translated.html.

2. Kinetic Concrete Poetry

1. http://www.davidsmall.com/portfolio/illuminated-manuscript.

2. http://www.davidsmall.com.

3. For a reconstruction of the historical context, see Johanna Drucker (1994). Although Drucker cannot show that Saussure's lectures on language (published posthumously by two of his students as *Cours de linguistique générale* in 1916) were absorbed by Dadaists, she claims that his approach to the structure of language clearly influenced his contemporaries.

4. Eugen Gomringer and the Noigandas poets of São Paulo agreed on this term to describe the new poetry in 1956, unaware that Öyvind Fahlström had already written his "manifest for konkret poesie" in 1953.

5. The irony of the piece resides in the overkill: fewer horizontal lines would have been sufficient to build the empty space in the middle.

6. Whereas the system of reading consists of discrete elements that possess meaning as such—words (lexemes) one can look up in a dictionary—the system of visual perception consists of nondiscrete elements that structure only against the background of a projected meaning to signs. Thus, the gap in Gomringer's *Schweigen* signifies silence only in the context of its surrounding words, "schweigen." On visual signs consisting of discrete elements, see Roland Barthes's notions about Giuseppe Arcimboldo's "painting with words," which I discuss in note 12 in chapter 1.

7. Another example of visual poetry is *lettrism*, founded by Isidore Isou in 1945 as a continuation of developments in futurism and Dadaism. Collages such as Carlo Carrà's *Manifestazione interventista* (1914) or Kurt Schwitter's *Merzbilder* (1919ff.) are examples of the "lingualization" of painting at the beginning of the twentieth century. An earlier example of lingualization is Arcimboldo's allegorical portraits in the baroque period; a later one is the technology of photomosaics, which builds

images out of small pictures, thus giving the image a narrative feature (http://www.photomosaic.com), and Chris Jordan's *Running the Numbers: An American Self-Portrait* (2006–9), creating images from discrete objects in a statistically symbolic number (http://www.chrisjordan.com/gallery/rtn). There are various other experiments at the intersection of linguistic and visual signs that cannot be discussed here but have been explored in detail elsewhere. Apart from Drucker's reconstruction of the typographical experiments in the early twentieth century, I will mention only Mitchell (1994) and Harrison (2001).

8. http://vispo.com/bp.
9. http://www.uol.com.br/augustodecampos/poemas.htm.
10. http://amuribe.tripod.com.
11. http://auer.netzliteratur.net/worm/applepie.htm.
12. http://home.ptd.net/~clkpoet/fineview/fineview.html.
13. Other examples of this art are Brian Kim Stefans's *the dreamlife of letters* (2000) and Robert Kendall's *Soft Poems* (1990–91). A piece of kinetic concrete poetry that also works without requiring reader action but that could not exist on film or video because of its real-time processing is *Overboard* (2004), by John Cayley, in which a poem about a man falling overboard during a storm continually drifts in (rising) and out (sinking) of legibility. This reenactment of the text's content is performed by a program of carefully designed algorithms that allow letters to be replaced by other letters, thus undermining the words' lexical relationship until the original letters are restored and the text has surfaced again.
14. http://www.arte-tv.com/them@/dtext/literatur/lesereise/lesereise_fs.html. For a detailed review in German, see *dichtung-digital* 14 (http://www.dichtung-digital.de/2000/Simanowski/19-Okt).
15. The piece is accessible at http://http://www.zeitgenossen.com/outerspaceip/index1.html.
16. For a description of the piece and its contextualization within (kinetic) concrete poetry, see Cayley (2006).
17. The moving and "stepping through" in the Cave version of *Lens* is simulated by using the controls of a pointing device known as a wand. This incorporates a track-ball that allows the interactor's point of view to move through the graphical world of the piece, from the dark-on-light world through to the light-on-dark world and on, into the abyss. The text presented on the white background is as follows: "the letter is a threshold, a threshold at which both writer and reader leave some inkling of the glory they have seen within the other." The text presented on the white background is as follows: "the writer reaches beyond this threshold and brings back an emphasis, the mingling of the readers' gaze with literal flesh."
18. An example of mise-en-abyme as text is the story of the brigands who sit around the fire on a dark and stormy night. When the chief says to Antonio, "Tell us a tale!," he spits out his false teeth and begins: "It was a dark and stormy night, and around the campfire sat the brigands. . . . " An example as film is the sequence in Michael Snow's *Corpus Collasum* (2002) where the eye (of the camera) moves into the lens of a surveillance camera located at the upper corner of the room, then through it,

to arrive again at the same room, including the surveillance camera in the upper corner, into which the camera eye moves again.

19. http://www.theremediproject.com/projects/issue11/andrewsarteroids/arteroids .htm. An extensive review and an interview with Andrews can be found at *dichtung-digital* 21 (http://www.dichtung-digital.org/2002/01-10-Simanowski.htm; http://www.dichtung-digital.org/2002/01-29-Andrews.htm).

20. Enzensberger proposed a "political alphabetisization of Germany" and questioned the political potential of experimental texts (1968, 189). More recently, such a claim has been made by Jost Hermand (2004) accusing the formalistic experiments of the 1950s and 1960s of being antiprogressive, populist, and even consumeristic.

21. In Bremer's work, the line "immer schön in der reihe bleiben" repeatedly appears until the page is covered and it is difficult to read the content. It provokes "not to keep in line but, on the contrary, to get out of line [and thereby setting] the reader free in the realm of his own possibilities, the realm in which we are brothers" (Williams 1967, entry for Bremer).

22. Although scholars such as Erwin Panofsky and Gustav René Hocke differentiate between mannerism and the baroque insofar as the latter is a return to the Renaissance principles of clarity and simplicity and revitalizes the policy of *docere* after the domination of *delectare*, the reference to the baroque in contemporary scholarship often neglects such distinctions and ascribes the attributes of obsession with formal effects, exaggeration, and entertainment to the baroque. In contrast to the baroque, mannerism is a term applied not only to works in the seventeenth century but also in other epochs including Hellenism, the late Middle Ages, romanticism, and art nouveau.

23. See, for example, Calabrese (1992) and Wollen (1993).

24. Robert Coover's essay "Literary Hypertext: The Passing of the Golden Age"—originally delivered as the keynote address at the Digital Arts and Culture Conference in Atlanta, Georgia, in October 1999—appeared in 2000 in the online journal *Feedmag*, which no longer exists. The text can be found online at http://nickm.com/vox/golden_age.html.

25. For a harsh and simplicistic reckoning with postmodernism from a radical left position in Germany, see Kurz (1999). For a much more nuanced and sophisticated account from a left-wing perspective in the United States, see the works of Frederic Jameson and Hal Foster.

26. For a description of postmodernism as dissolving commitment into irony, see Grossberg (1989).

27. A more recent example in German literature, which explicitly dismisses the "grand narratives" of the revolutionary movements of the 1960s and 1970s, is pop literature obsessed with questions of design, lifestyle, and consumption rather than with politics or social issues.

28. See also Vattimo (1997, 73): "The inessentialness that has overtaken certain manifestations of contemporary art . . . may well be explained by the fact that secularization began and has been lived as the abandonment of any lingering illusion over the capacity and the duty of art to serve as a 'new mythology,' a rational religion, in

short, as a place in which society or determinate social groups recognize themselves and their shared convictions."

29. Peter Wollen (1993) sees in the rejection of modernism through postmodernism the reiteration of the Renaissance's rejection by the baroque. Christine Buci-Glucksmann (1994) describes the baroque instability of forms as a postmodern conception of reality.

30. Manovich's essay provided the theoretical context for the presentation of Flash animations by 122 software artists at Whitneybiennial.com, organized by Miltos Manetas and Peter Lunenfeld in early 2002. The original Web page of the exhibition can be found at http://www.manetas.com/eo/wb/w/index.htm.

31. A perfect example for the poetics of the Generation Flash and its eroticism of *technique* is the work of Joel Fox, playful and discharged of any message other than playfulness and virtuous programming (http://www.manetas.com/eo/wb/w/artists/FOX/index.htm). The absence of meaning itself can be interpreted insofar as no artifact can exist without meaning. The distinction to be made here is one between the meaning resulting from the rejection of uttering a specific message, and the deliberate production of meaning by the author.

32. Liu admits that the analogy to the concept of the "technology of the uselessness" is inadequate, "for it is the uselessness of useful information upon which cool rings the chance" (2004, 186), while "pure technology" provides objects or features useless in the first place. Liu does not judge the adequacy of the Critical Art Ensemble's discussion on pure technology. It should at least be noted, that while the option to program a VCR for a month in advance may indeed be "an homage to the useless," because "most programming information is not available a month in advance"—and the same may be true of an electric potato peeler—the question to what extent the magnetic resonance imaging device is useless or the missile system is a "monument to uselessness" (rather than proving its usefulness exactly by the fact that it has not been used) is more complex than the Critical Art Ensemble suggests (Liu 1996, 77–78, 86–87).

33. Nick Montfort (2008, 193, 194, 197) describes this phenomenon as "obfuscated code," which can be traced back to the "one-line BASIC programs" in the early 1980s and to the first "International Obfuscated C Code Contest" in 1984, and which has led to the phenomenon of double coding—that is, code readable as text by humans (who are familiar with the applied programming language) as well as executable by the computer. This is the case, for instance, in *Perl Poetry*—that is, poetry that uses the dynamic programming language Perl.

34. For a definition of kitsch as the loss of distance, see Giesz (1960).

35. For the correlations between contemporary entertainment industry and the early cinema of attraction, see Gunning (1990) and Moran (1994).

36. http://www.theremediproject.com/projects/issue7/squidsoupuntitled/index.html.

37. Squid Soup explains in a private e-mail the generation of the text: "1. take a random book off of a random shelf and open at a random page; 2. read a random passage; 3. repeat steps 1 and 2 a few times; 4. take recorded passages and cut them into small

pieces (samples); 5. change the speed and direction of some of the samples; 6. stick them back together in a different order. What you are left with is the essence of speech" (e-mail, September 3, 2001).

38. http://www.vispo.com/animisms/enigman.

39. http://www.vispo.com//animisms/enigman2/index.htm.

40. Desemantization has been conceptualized as musicalization by Guillaume Appolinaire who in his 1913 essay "Les Peintres Cubistes" calls the nonfigurative, antinarrative cubistic painting "pure painting" and an art "which will be to painting, as hitherto understood, what music is to literature. It will be pure painting, as music is pure literature" (Appolinaire 2004, 12). The metaphor has been reused by Martin Seel, who has called action movies "music for the eyes" (*Musik fürs Auge*) (2004, 136).

41. On March 17, 2003, Bush called the next day's decision of the U.N. Security Council about the ultimatum to disarm to Saddam Hussein "a moment of truth for the world," adding, "Many nations have voiced a commitment to peace and security. And now they must demonstrate that commitment to peace and security in the only effective way, by supporting the immediate and unconditional disarmament of Saddam Hussein."

42. On February 3, 2003, Manfred Kock, chair of the Evangelien Church in Germany, accused Bush of using the same terminology and claiming the same divine sense of mission as the Islamic fundamentalists. CDU politician Heiner Geisler criticized Bush's rhetoric about "religious truth," holding that politics is always only about the last but one truth ("vorletzte Wahrheiten") and that those who deny this act like a "Christian Ayatollah." On February 3, 2003, Cardinal Karl Lehmann, chair of the Catholic German Bishop Conference, declared that even war intended to overthrow tyranny is ethically impermissible. As for the role the Western world plays with respect to the Islamic terrorism, Benjamin Barber (1995), for instance, calls, long before 9/11, jihad the nervous comment of modernity to itself. After the 9/11 terrorist attacks, politicians called for a worldwide social policy and a sufficient development policy as the better safety policy.

43. Interestingly, Lyotard defines the lack of criteria as a sign (shall we say criterion?) of modernity, which he conceptualizes, as Foucault does for Enlightenment, not as a time period but as a constellation that can also occur in the time of Aristotle, Augustine, or Pascal (Lyotard and Thébaud 1985, 15).

3. Text Machines

1. The text is quoted in Shaw (2004, 72). McGraw (1995) describes the procedure of Minstrel as follows: "For example, at one point MINSTREL is asked to tell a story about a knight who commits suicide. Being unable to recall any such stories from its memory, MINSTREL applies the TRAMs, Intention-Switch and Similar-Outcomes-Partial-Change, to its recall parameters: 'knight who purposefully kills self.' Other models of creativity . . . allow 'kills' to become 'injures,' and 'purposely' to become 'accidentally.' These tweaks allow MINSTREL to recall a story about a knight who accidentally injures himself while killing a troll. Once this story has been recalled, it is subjected to 'backwards' adjustments that undo the changes made to the recall

parameters. This results in a scenario in which a knight purposefully kills himself by losing a fight with a troll—a newly-invented story-fragment."

2. To the connection between text machines and structuralism, see Klein et al. (1973); Rumelhart (1975); Johnson and Mandler (1980); and Lang (1997).

3. In 2002, OMCS contained over 400,000 English sentences gathered through a Web community of collaborators (Liu and Singh 2002).

4. For a description of RACTER and its discussion from a literary critic's point of view, see Ernst (1992).

5. See Georg Philipp Harsdörffer's two-line poem "Wechselsatz," in *Poetischer Trichter* (1648–53), and Quirinus Kuhlmann's four-line poem "XLI. Libes-Kuß" (1671).

6. Of course, part of the history of combinatory writing also includes William S. Burroughs's cutup technique; Marc Saporta's novel of 150 unbound sheets of text, *Composition No. 1* (1962); Julio Cortázar's novel *Rayuela* (1974), which offers alternative ways of navigation; and the so-called dictionary novels, such as Milorad Pavić's *Dictionary of the Khazars* (1984) (Hayles 1997). For a systematic reconstruction of the history of text generation using the computer, see Funkhouser (2007).

7. The example is quoted in Döhl (2000); I am using the translation provided in Funkhouser (2007, 37).

8. The interactive version of RACTER published by Mindscape in 1984 revealed that in contrast to Chamberlain's claim in the book's introduction, the output of the program must have been essentially modified by a human author. See Berger (1993).

9. The title of this book (in English, "The Journey: Within Eighty Poems Around the World") obviously plays with the title of Jules Verne's 1873 book, *Around the World in 80 Days*. Schmatz and Czernin disclosed the real authorship in their 1987 production report *Die Reise. In achtzig flachen Hunden in die ganze tiefe Grube* (in English "The Journey. Within Eighty Flat Dogs into the Entire Deep Cavern") with a smaller publishing house (Edition Neue Texte).

10. Katherine Hayles, paper presented at the Reading Digital Literature conference, October 4–7, 2007, Brown University, Providence, Rhode Island.

11. For the sake of the anecdote of finding a poem written by an unknown person on the shore, Knapp and Michaels (1982) use the waves as authors. They later make clear that what is really at stake is asking whether the computer can be intentional agents.

12. For this position, see Schmidt (1988) and Scheffer (1992).

13. For Lyotard's discussion of the sublime and Barnett Newman, see the introduction; for a discussion of pure code, see the introduction and chapter 2; for John Cage, chance art, and Buddhism with respect to mapping art, see chapter 5.

14. Aarseth (1997) speaks of preprocessing as the phase in which the machine is programmed, configured, and loaded by the human.

15. In addition to the author's agency as postprocessor, Lebowitz also stresses—without providing further explanation—the role as preprocessor: "Although the stories themselves would be generated by computer, the knowledge bases from which they worked—information about people, places, and plot devices—would presumably be built by human writers" (1990, 392).

16. Szilas (1999) promotes, in contrast to the traditional drama where the notion of conflict is often fuzzy and ambiguous, a model with a very clear concept of conflict: "The situation where an overstepping task is negatively evaluated according to a character's values."

17. Lebowitz explained to Noah Wardrip-Fruin in November 2007 that his text generator *Universe* (1985) was inspired by the soap opera *Days of Our Lives* and that he was imagining a database "reading the soap plot summaries on say TVGuide.com and automatically process[ing] them into fragments that could be reused (and real soaps certainly do reuse plot lines all the time)" (http://grandtextauto.org/2007/11/19/michael-lebowitz-on-universe). Selmer Bringsjord and David Ferrucci write about the future of Brutus, a program that generates short stories (of about 500 words) about treachery: "If *Brutus n*, some refined descendant of *Brutus 1*, is to soon find employment at the expense of a human writer, in all likelihood it will be as an author of formulaic romance and mystery" (1999, xxii).

18. It is not surprising that Szilas (1999), who promotes the reduction of ambiguity, refers to Vladimir Propp's *Morphology of the Folktale* (1927) as the theoretical background of his work. Another, much more influential genre requiring simplification and a clear good-or-evil schema is computer games, where the ambiguity or complexity of situations would hinder the game's pace.

19. Mix-ins are "beat-specific reactions used to respond to player actions and connect the interaction back to the canonical sequence"; a beat consists of a canonical sequence of narrative goals (Mateas and Stern 2007, 191).

20. In this case, the player has chosen the name Will. The passage is taken from the file that archives the dialogue and can be saved at the end of play.

21. Rilke's poem "Archaischer Torso Apollos" is itself a multilayered text about the relationship between author, work, and audience in which the claim of the sculpture results from its intensive perception by the spectator, who completes and brings alive the sculpture in her own imagination. One may argue that Rilke's poem about a sculpture lacking its head is actually also a poem about an artwork lacking its author and may hold that in both cases, the artifact receives its value to the audience by the audience. However, the important difference is that the spectator of the sculpture can assume that the sculpture at one point did possess a head (and the poem makes the point that the head's eyes are still present in the torso), while the reader of a computer-generated text is, to stick to the analogy, not confronted with the remnants of the sculpture of a person but with the sculpture of a truncated body.

22. A much more recent, much shorter, much more effective, and more controversial wall than the Chinese one clarifies what walls are supposed to do. The Berlin Wall—and its counterpart, the border between East and West Germany—was an attempt to seal off people in order to erect a Tower of Babel, which in this secularized version aimed to provide access to truth by excluding difference, suppressing polyvocality, and imposing certain data and algorithms on people.

23. For Derrida's position, see also my discussion in chapter 2.

24. For a detailed review in German, see Simanowski (2002, 27–34); for an interview

with the project leader, see *dichtung-digital* 24 (http://www.dichtung-digital.de/
Interviews/Klinger-3-Mai-00).

25. http://www.melody.de/emanze; http://www.maennerseiten.de.

26. http://www.dreiundzwanzigvierzig.de. For a detailed review in German, see Siman-
owski (2002, 39–46).

27. Grigat undermines the exciting running-out-of-space feature of the project by
posting in phase 2 as many contributions in a certain time spot as arrive.

28. http://www.assoziations-blaster.de. For a detailed review, see Simanowski (2002,
46–53); for an interview with the authors, see *dichtung-digital* 14 (http://www
.dichtung-digital.org/Interviews/Espenschied-Freude-6-Nov-00).

4. Interactive Installations

1. This may change if the shift from the paradigm of hermeneutics to the cult(ure) of
presence promoted by Gumbrecht and others proceeds.

2. See, for example, Alan Kaprow's *18 Happenings in Six Parts* in 1959, and the *Living
Theater*, which in the 1960s, as a kind of antitheater, sought immediate interaction
with the audience.

3. http://homepage.mac.com/davidrokeby/vns.html.

4. Utterback does not directly reflect the interactor's movement but creates a com-
plex system in which prior interactors "respond" to later interactors: "As a person
moves through the space, a colored line maps his or her trajectory across the pro-
jection. When a person leaves the installation, their trajectory line is transformed
by an overlay of tiny organic marks. These marks can now be pushed from their
location by other people's movement in the space. Displaced trajectory marks
attempt to return to their original location, creating smears and streaks of color as
they move. The resulting swaths of color occur at the intersections between cur-
rent and previous motion in the space, elegantly connecting different moments of
time" (http://www.camilleutterback.com/untitled5.html).

5. For an account of disciplining or controling of the body during the appreciation of
art (the silencing of reading, the immobilization of the audience), see Schön (1987).

6. For cyberspace, see Barlow's (1996) proclamation that it "is not where bodies live."
For the position of the neo-Cartesians, see Munster (2006).

7. Hansen makes this connection right at the beginning of *Bodies in Code* (2006, 5),
which of course does not prevent him from discussing the "inconsistencies in
Merleau-Ponty's conception of reversibility" of the seeing and the visible, the touch-
ing and the touched (71). While Ridgway and Stern refer to *electronic digitality*,
Hansen applies the term *virtual reality*.

8. An example is Gibbs and Angel (2008), whose central argument is that the world
can only be grasped in action and not by reflection. Such a statement, resulting
from a search for a "new materialism of the corporeal body" in online environ-
ments, opposes rather than acknowledges the dualism of body and mind.

9. The term *implicit body* evokes the concept of the *explicit body*, which was coined
by Rebecca Schneider to address the ways feminist performance art "aims to expli-
cate bodies in social relations" (1997, 2). In contrast, one could say, interactive

installations aim at explicating the body in its personal relationship with the wearer.

10. Rokeby refers to Sakane (1989).

11. To list only a few representative examples: Iser (1976) claims famously that the reader's contact with text and the author is not a one-way street, but rather the reader negotiates meaning in this dialogue; de Certeau (1980) holds that people appropriate cultural texts in a kind of semiotic guerilla tactic; Hall (1973), in his encoding/decoding model, underlines the openness of the signifier for transformation of meaning; Schmidt (1987) states that the subject constructs reality according to personal cognitive patterns to which incoming data are assimilated.

12. "The dominant feature of art of the past was the wish to transmit a clearly defined message to the spectator as a more or less passive receptor, from the artist as a unique and highly individualized source. This deterministic aesthetic was centred upon the structuring, or 'composition,' of *facts,* of concepts of the *essence* of things, encapsulated in a factually correct field. Modern Art, by contrast, is concerned to initiative *events* and with the forming of concepts of *existence*" (Ascott 2003, 110).

13. Here again we find similar notions in performance studies. Fischer-Lichte claims for the performative turn in the 1960s a turn from the artwork to the event, which involves not only the artists "but also the observers, listeners, and spectators." Fischer-Lichte concludes: "Thus the relationship between the material and the semiotic status of objects in performance and their use in it has changed. The material status does not merge with the signifier status; rather, the former severs itself from the latter to claim a life on its own. In effect, objects and actions are no longer dependent on the meaning attributed to them" (2008, 22).

14. Paul (2006) reports this surprise.

15. The same self-absorbance with one's own shadow rather than interest in the object that one is supposed to disclose with the shadow has been seen in the case of *RE:Positioning Fear,* discussed in chapter 1. Figure 3 demonstrates an interaction similar to the one between the gigantic shadow woman and tiny shadow man mentioned above. In his later work, *Under Scan* (2005), Lozano-Hemmer learns from earlier surprises and forces the audience to really engage with the other (which is also expressed in the detail that the other turns away once the interactor turns away).

16. Two examples independent of digital media for a restrictive and a more open grammar of interaction are Bruce Nauman's 1970 *Live-Taped Video Corridor* (which requires its audience to walk closer to or away from the monitors at the end of the corridor) and John Cage's 1952 *4'33"* (which expects its audience to generate noise, no matter what kind of noise it may be).

17. http://projects.visualstudies.duke.edu/billseaman/workSpcExchange01.php.

18. http://www.kenfeingold.com/artworks90s.html.

19. http://www.medienkunstnetz.de/works/der-zerseher.

20. Scheffer (1992) discusses reading as an autobiographical act.

21. http://www.medienkunstnetz.de/works/der-zerseher.

22. Fleischmann and Strauss, in a description of *Rigid Waves,* at http://netzspannung.org/database/rigid-waves/en.

23. Derrick de Kerckhove (1993) considers the eyes in *Der Zerseher* as an extension of the hand, referring to Thomas Aquinas's declaration of the eye as a subtle version of the sense of touch. The understanding of the gaze as touch is surely interesting and helps to integrate *Der Zerseher* in de Kerckhove's thesis about the shift from vision to touch in interactive art. However, because such touch is not a real bodily experience but the result of a cognitive undertaking, one wonders whether it really supports de Kerckhove's point of the return to the (language of the) body (142).

24. http://www.snibbe.com/projects/interactive/deepwalls.

25. This was the case with the exhibition of *Deep Walls* I curated in the lobby of Brown University's CIT building in March 2006.

26. Although the artist himself speaks of shadows, one may more accurately call it silhouettes because a shadow cannot exist without the presence of its owner. The reverse is true in Adelbert von Chamisso's novella "Peter Schlemihls wundersame Geschichte" (1813), the main character of which sells his shadow to the devil and hence, as a person without shadow, loses his social reputation.

27. The exhibition's location fundamentally influences the way people interact with the work. In contrast to a busy lobby, a quiet gallery space where the interactor can generate a movie without being watched by others helps to overcome self-consciousness when interacting with the work.

28. For Barthes, therefore, "the relation between signifieds and signifiers is not one of 'transformation' but of 'registration'"; the true relation between signifier and signified or their identity respectively is the literal message of a photograph (the "message without a code") (1991, 33, 32).

29. See the KQED Spark feature about Scott Snibe from September 15, 2005, at http://www.kqed.org/arts/people/spark/profile.jsp?id=4844.

30. The fact that everybody can walk up to the screen to be displayed evokes Andy Warhol's famous notion about the fifteen minutes of fame.

31. http://www.snibbe.com/projects/interactive/deepwalls. In an earlier Web site to this work, Snibbe added: "By collecting the viewers' own shadows, the piece reveals how individual objects gain in symbolic meaning, while losing literal meaning, through organization, repetition and display" (http://snibbe.com/scott/mosaics/deep%20walls/deep_walls.html; this Web site no longer exists).

32. http://et-arts.com/blog/exhibits/recollections-45.

33. This impression is affirmed by the videos provided on *Deep Walls* and *Recollection 4.5*—silent on the one hand, elaborate and captivating in terms of sound and visuals on the other.

34. With respect to the theory of mirror neurons mentioned above, it could be stated that *Deep Walls* inspires an emphatic response to the images presented by the collection of interactors' (re)actions to such responses, while *Recollections 4.5* fosters an emphatic response through the applied time delay and coloration of the interactor's performance.

35. Documentaion and video at http://www.alzado.net/eintro.html.

36. Each design was sent to the control center in Mexico City, numbered, and entered into a queue. Every six seconds, the next item was presented and filmed by three

Webcams in order to transmit it live. An archival Web page was created for each participant including his or her name, place of residence, commentaries, and the date and time on which his or her design was displayed. The URL was sent automatically to the appropriate participant.

37. See Huhtamo (2000, 109). One may conclude that while the hypnotic immersion of spectators into the light sculptures—for example, in the Third Reich, but also in democratic societies—is based on their distance from its creation, their immersion in its making generates distance insofar as technological and aesthetic concerns replace amazement and awe. In the same spirit, Coulter-Smith celebrates *Vectorial Elevation* as an artwork in which "the public are placed in control of the means of production of spectacle. If, as Guy Debord and Jean Baudrillard argue, spectacle is one of the principal methods whereby the capitalist system ensures its hegemony then *Vectorial Elevation* can be said to possess an emancipatory dimension" (2006, 270). This euphoric and uncritical assessment will be questioned by asking, who is the "public," and who is "in control"?

38. María Fernández states that *Vectorial Elevation* made evident the resilience of nationalism in the popular imaginary: Many comments on the *Vectorial Elevation* Web site expressed great pride in the technological achievements of the Mexican nation, and many participants congratulated the artist for strengthening Mexico's presence internationally (2000, 153). As far as *Vectorial Elevation* goes, it does indeed represent cutting-edge, sophisticated technology in terms of data generation and processing.

39. See also the concept notes at http://www.alzado.net/reading.html.

40. Ibid.

41. Ibid.

42. http://spencertunick.com. Photographs of the Zócalo project can be found at Artnet (http://www.artnet.com/usernet/awc/awc_thumbnail.asp?aid=425378777&gid=425378777&works_of_art=1&cid=129836).

43. http://www.cbc.ca/arts/artdesign/story/2007/05/07/tunick-mexico-record.html.

44. See Hansen (2001) and de Kerckhove's discussion of the theoretical approach to the world as based on the sense of sight (1993, 159).

45. It can, moreover, also be argued that the decision not to get involved in the interaction is itself a bodily experience when understood as the result of self-consciousness, which makes one prefer to observe the moves of others.

46. Benayoun (1997) describes the structure and meaning of his work as follows: "Armed with cameras, we are making our way through a three-dimensional space. The landscape before our eyes is scarred by war-demolished buildings, armed men, tanks and artillery, piles of rubble, the wounded and the maimed. This arrangement of photographs and news pictures from different zones and theaters of war depicts a universe filled with mute violence. The audio reproduces the sound of a world in which to breathe is to suffer. Special effects? Hardly. We, the visitors, feel as though our presence could disturb this chaotic equilibrium, but it is precisely our intervention that stirs up the pain. We are taking pictures; and here, photography is a weapon of erasure. . . . Each photographed fragment disappears from the

screen and is replaced by a black silhouette. With each click of the shutter, a part of the world is extinguished."

47. Visitors of *TGarden* are "invited to put on specially designed clothes, made from plastic or metal. These costumes carry velocity sensors, which measure the speed of gestures, the turn of the body, the movement of the legs etc. Through a wireless transmission system, these data are distributed into a computer network, which is situated outside the scenario. There, the data triggers the generation of sounds in real-time" (Salter 2004). For details on *TGarden*, see http://framework.v2.nl/archive/ archive/node/event/minimal.xslt/nodenr-125538.

48. Concerning the role of shadow in his work, Lozano-Hemmer refers to the shadow as metaphor for being in Plato, for the birth of representation and painting in the Dibutade myth, for the mysterious expression of the self in shadograms, and as expression of a hidden monstrosity or otherness in an engraving by Van Hoogstraten. Concerning the searchlight in *Vectorial Elevation,* Lozano-Hemmer refers to air surveillance and light shows by authoritarian regimes. Concerning his concept of relational architecture, he eventually relates to Edward Said's critique of the idea of local separation of Israel and Palestine and his stress on the coexistence of different identities in the same space, and notes, "Locality, like identity, is a performance" (2002, 155, 158).

49. A revealing example not for overwhelming praise but for the favorable attention such combinations of cutting-edge technology and participation normally receives is Frank Popper's short remark: "By ensuring that participants were an integral part of the artwork, *Vectorial Elevation* attempted to establish new creative relationships between control technologies, ominous urban landscapes, and a local and remote public. It was intended to interface the postgeographic space of the Internet with the specific urban reality of the world's most populous city" (2007, 211).

5. Mapping Art

1. Manovich (2002a) refers to the Jewish Museum in Berlin, where architect Daniel Libeskind mapped into the structure of the building the addresses of Jews living nearby before World War II. In this case, one may wonder to what extent the architecture is really the result of the mapping, because other addresses are neglected and because Libeskind has developed similar architectural structures before without such mapping (see the Felix-Nussbaum-Building in Osnabrück). As for fashion, see the wearable design project *soundSleeves,* which synthesizes sounds within the sleeves of clothing and outputs it through miniature flat speakers according to the way users flex or cross their arms (http://www.uttermatter.com/sleeev). See also *Sonic City,* which senses bodily and environmental factors and maps them to the real-time processing of concrete sounds (http://www.tii.se/reform/projects/pps/soniccity).

2. For an extensive discussion of various examples of information visualization both online and outside the Internet, see Wilson (2002). For mapping in dance, see the dance companies Palindrome (http://www.palindrome.de) and Troika Ranch (http://www.troikaranch.org). An example of mapping as sculpture is *The Source* (2004) by Greyworld, a cube of 729 spherical balls on 162 strings that stretch 32 meters up to

the top of the main atrium of the London Stock Exchange, controlled by a computer and repositioned depending on the data stream from the stock market (http://www.greyworld.org/artwork/source). For the use of mapping in painting, see *Untitled 5* (2004) by Camille Utterback, where video tracking and drawing software output a changing wall projection in response to the user's activities in the exhibit space. For mapping and music, see *Ping* (2001) by Chris Chafe and Greg Niemeyer, which turns the ping data of Internet traffic into sound (http://crossfade.walkerart.org/ping), and *Shape of Song* (2001) by Martin Wattenberg, which draws musical patterns in the form of translucent arches (http://www.turbulence.org/Works/song).

3. For data mapping in a nonartistic way, see Ware (2000). Interesting facets of mapping are of course its reflection on maps itself as well as the extension of cartography into the Internet (see Dodge and Kitchin 2000). However, in the context of this book, the focus of my discussion is on the artistic rather than the scientific, geopolitical, or sociological aspects of mapping, which are discussed widely as a result of the spatial or topographical turn in cultural and social studies (Warf and Arias 2008).

4. http://www.mat.ucsb.edu/~g.legrady/glWeb/Projects/spl/spl.html.

5. http://www.potatoland.org.

6. http://www.stelarc.va.com.au/pingbody.

7. For a subdivision of mapping according to its subject matter rather than aesthetic, see Frieling (2005).

8. "The body is obsolete," Stelarc declares. "It is time to question whether a bipedal, breathing, beating body with binocular vision and a 1400cc brain is now an adequate biological form. . . . The body is neither a very efficient nor a very durable structure. It malfunctions often and fatigues quickly, its performance is determined by its age and sex. It is susceptible to disease and is doomed to a certain and early death" (2000, 561).

9. http://www.mat.ucsb.edu/~g.legrady/glWeb/Projects/pfom/Pfom.html.

10. Ready-mades are undisguised but sometimes modified found objects transformed into art by the designation placed upon it by the artist. A famous example is Marcel Duchamp's *Fountain*, a urinal that he signed with the pseudonym R. Mutt and submitted to the Society of Independent Art exhibition in 1917. An important attribute of ready-mades is the lack of singleness and the aesthetic indifference of its selection by the artist.

11. The Web-based conceptual art piece *Every Icon* (http://www.numeral.com/applet software/eicon.html) explores, one after another, every combination of black and white squares that could occur within a grid of 32 by 32 squares. Although it does this with a speed of several icons every second, it will take several hundred trillion years to see all 2,256 possible icons.

12. "We get examples of the mathematically sublime of nature in mere intuition in all those instances where our imagination is afforded, not so much a greater numerical concept as a large unit as measure (for shortening the numerical series). A tree judged by the height of man gives, at all events, a standard for a mountain; and, supposing this is, say, a mile high, it can serve as unit for the number expressing

the earth's diameter, so as to make it intuitable; similarly the earth's diameter for the known planetary system; this again for the system of the Milky Way; and the immeasurable host of such systems, which go by the name of nebulae, and most likely in turn themselves form such a system, holds out no prospect of a limit" (Kant 1914, §26).

13. Jevbratt reads the dialectic of pain and pleasure Kant localizes in the experience of the sublime as an empowering call to actions: "He [Kant] claims that in experiencing the sublime, by facing large amounts of information, huge distances and ungraspable quantities, our senses and our organizing abilities are mobilized. Contrary to what might be believed, we feel empowered, able to make decisions, and capable to act" (2004, 6).

14. For the discussion of the technological sublime, see Nye (1994). An investigation of the technological sublime in light of new technology and digital art was undertaken by the exhibition and symposium Techno-Sublime at the University of Colorado at Boulder, February 4–March 18, 2005.

15. See Paul (2003, 178): "Databases in themselves are essentially a fairly dull affair."

16. For Roland Barthes's concept of photography as turning *here-now* into *there-then*, see chapter 4. An exception is *They Rule*, which is based on data collected in early 2004.

17. Shapiro reminds us that "since all forms are expressive and the content of a work is the meaning of the forms both as representations and expressive structures, therefore content and form are one. In a representation every shape and color is a constituting element of the content and not just a reinforcement" (1994, 41).

18. http://www.theyrule.net.

19. Johanna Drucker uses this term to describe pictorially shaped poems such as Guillaume Appolinaire's *Il Pleut* (1916), whose visual form—the letters are presented on the page in tilted lines like raindrops—is essentially mimetic, and considers this imitative naturalism "most limiting" (1998, 113).

20. One advocate of such aesthetics is Bölsche (1887).

21. Such complete coverage was the declared goal of naturalism with its so-called Sekundenstil: a style of description covering every detail or second. Nonetheless, the position of the artist—in Arno Holz's famous formula "Art = Natur – X" represented by X—can never be zero in writing.

22. Legrady (2005) explains the change also as a result of the discussion—or negotiations—with his collaborators: "Each of the participants makes decisions at every step of the development, which transforms the outcome to varying degrees. These decisions are shaped by individuals' world views, aesthetic approaches, and logical problem-solving solutions that inadvertently pull and push the process so that the outcome may need to be readjusted if the conceptual and aesthetic goals of the project diverge from the initial artistic concept." Working together with programmers and screen designers, the artist may simply have been outnumbered by the problem-solving solutions his colleagues provided from a data design rather than from an artistic point of view. Legrady changes his position in his new works, such as *Kinetic Flow* (2005) and *Dynamic Modulation* (2006). *Kinetic Flow* visualizes in

abstract form the kinetic experience of the downward movement on the escalator and staircase of a subway station in Los Angeles (http://www.mat.ucsb.edu/~g .legrady/glWeb/Projects/k/k.html); *Dynamic Modulation* is a large multiscreen display in the waiting area of the OU–Tulsa campus clinic, which features dynamically generated visualizations based on the movement of fish inside three tanks (http://www.georgelegrady.com). Legrady's shift to abstraction, however, does not, in this constellation, offer a deeper meaning or personal artist's perspective, in contrast to Napier's abstraction *Black and White*.

23. Interestingly, Whitelaw, knowing the lecture version of my discussion of mapping art from 2005 and basically sharing its distinction between naturalistic and metaphoric mapping, does not pick up the allusion to naturalism and operates with the distinction of indexical and poetic data art. This different formulation of similar content is certainly due to specific personal perspectives resulting from different cultural and educational backgrounds.

24. Camus speaks misleadingly of realism, though what he describes is in fact what is known as naturalism. Although realism, which started in Germany in the mid-nineteenth century, was also attacked as a daguerreotypic idolatry of brute matter that betrays the purpose of literature and turns poets into craftsmen, it never gave up the autonomy of poetry and reserved to itself the right to indulge in imagination not generated by real events and to furnish the banal event with his own fantasy. While (poetic) realism reveals a utopian perspective (see, for example, Downing 2000), naturalism lacks any attempt in such direction. It should also be noted that naturalism is conceptualized quite differently by Zola, who defines art as nature seen through a temperament, and Holz, who defines art as nature minus x, with x representing the subjective factor that should be as small as possible.

25. For Adorno's criticism on Sartre, see "Commitment" in *Notes to Literature* (1993).

26. Although *The Source* maps the data of the stock market, it does not render the information in any readable way.

27. Carnivore was written in 2001 by Alex Gallowey and the Radical Software Group, inspired by the software DCS 1000 (nickname Carnivore), which is used by the FBI to perform electronic wiretaps and to search for suspicious keywords. The Carnivore Open Source Project (http://r-s-g.org/carnivore) makes the software available to anyone interested in spying on a specific local area network.

28. All police codes refer to possible threats of domestic U.S. terrorism, such as "10–79" for a bomb threat or "1,000" for a plane crash.

29. http://www.coin-operated.com/projects/policestate.

30. "Conspiracy theorists would've had a field day. But, *They Rule* manages to completely avoid that, focusing instead on the facts and allowing the user to investigate them at their own pace" (Barr-Watson 2002).

31. Because the visual aspect of *Black and White* encourages visitors to search for a deeper meaning, this piece may not be the best example for the second subgenre of mapping listed above, marked as formalistic and as beautification of data. It rather belongs to the third subgenre, marked as sensualization of an idea. A better example of purely formalistic mapping—and of the aesthetics of the cool—is *The*

Source, which offers neither precise information about its subject matter nor a deeper meaning in a symbolic way, beyond the moving spheres as a metaphor for the stock market's volatility.

32. It should be mentioned that even in cartography and geography, maps are not necessarily naturalistic but often biased and manipulative, as Denis Wood (1992) illustrates.

33. http://www.turbulence.org/Works/nums.

34. The same can be said about Christian Nold's emotional mapping, which reveals the "secret life" of public places. In this community mapping project, people go for a walk wearing a biomapping device that measures their galvanic skin response as an indicator of emotional arousal in conjunction with their geographical location. The resulting maps visualize where people feel stressed and excited and hence present reality depending on how it is perceived. As in *The Secret Lives of Numbers*, the artistic aspect of Nold's biomapping is not so much to reveal the exact data about the places mapped, but rather to teach a new way of looking at these places and their relation to our intimate body states (http://biomapping.net).

35. *Lungs* was created for the exhibition "Making Things Public" (March–October 2005) at ZKM (Center for Art and Media, Karlsruhe), whose main exhibition hall is a former munitions factory.

36. http://www.mongrel.org.uk/?q=lungszkm.

37. Ibid.

38. http://www.mongrel.org.uk/?q=netmonstercontext.

39. The killings that are counted can come from any source. The program simply looks for the keyword *killed*. As for the accuracy of the scans: For each headline that it finds, the program takes the number that the text-parsing algorithm provides and looks in the database for a number within that range being reported in the last twenty-four hours. If it finds other reports with this number, it does a simple text comparison to determine how similar the headlines are. If they are sufficiently distinct (based on a similarity threshold), it includes the new report. If not, then it rejects it.

40. http://calebbarsen.com/projects/monument/index.html.

41. Manovich's (2001, 219) notion of an unordered database is questionable because it reduces the complex database forms into simple collections of items and ignores the fact that any database must be planned and programmed. For a critique of Manovich's approach to databases, see LeMay (2005).

42. It should be emphasized again that this does not mean that formalist work per se is deprived of meaning. This would be wrong with respect to the formal aspect in Kafka's prose and the abstract paintings of Klee or Kandinsky. It would, as I argue, also be untrue for a mapping artwork such as *Black and White*. The experiment with form can be meaningful, and according to Adorno, content locates in the form. However, one has to distinguish between the formalism Adorno has in mind and the focus on formal aspects and effects that Darley points out. The latter does indeed care little for meaning or message.

43. Other advocates of chance art, such as George Brecht, Robert Filliou, and Merce Cunningham, have a similar interest in Buddhism.

44. The affinity of Lyotard's aesthetics of affirmation to Cage's aesthetics of chance art manifests in Lyotard's many references to Cage. For Lyotard's and Gumbrecht's position of affirmation, see the introduction, note 24.

45. It should be pointed out that such rescue of the nonaesthetic world, as Siegfried Kracauer once identified the message of the medium film, nonetheless does not undergo without beautification and aestheticization. Besides the beautification through the transfer of "invisible and 'messy' phenomena . . . into ordered and harmonious geometric figures" (Manovich 2002b), data are aestheticized through the special attention they receive as a result of their visualization (which is similar to the aestheticization of ready-mades and in photography).

46. See Yuli Ziv's (2006) rather critical notion: "One effect produced by Macromedia's new release was the blurring of boundaries between artists and programmers, which significantly increased the numbers of 'digital artists.'"

47. The Conversation Map system is a Usenet newsgroup browser that analyzes the content and the relationships between messages and outputs a graphical interface, which shows the social (who is talking to whom) and semantic (what are they talking about) relationships that have emerged over the course of the discussion.

6. Real-Time Web Sculpture

1. German predecessors to the Dada nonsense poems are Christian Morgenstern's *Das große Lalula* (1905) and Paul Scheerbarts's *Kikakoku Ekoralaps* (1897).

2. The "fold-in method" means to fold a page of text down the middle, place it on another page, and then read the composite text (Burroughs 2002, 305).

3. http://www.earstudio.com/projects/listeningpost.html.

4. http://www.earstudio.com/projects/listeningpost.html?middle=listening_state ment.html.

5. Statement by Mark Hansen and Ben Rubin on the Web site of the Brooklyn Academy of Music at http://web.archive.org/web/20030901145300/cm.bell-labs.com/cm/ms/departments/sia/ear/index.html.

6. *Listening Post* provides further possibilities for the discussion of the concept (or, rather, various concepts) of theatricality. The texts' unwittingly (that is, with respect to their authors) being taken out of their quotidian context and dramatized as part of a mesmerizing text collage evoke the passersby in Josette Féral's third scenario of theatricality who do not know that the spectators in the street café are inscribing theatricality onto them and their surrounding space. Whereas in this case "it is the simple exercise of watching that reassigns gestures to theatrical space" (2002, 97), in *Listening Post* it is Rubin and Hansen who inscribe theatricality onto those texts by looking at them—or rather designing them—in a particular way.

7. http://www.wefeelfine.org.

8. Because blogs are structured in largely standard ways, along with the sentence can be saved the age, gender, and geographical location of the author as well as the local weather conditions (broken down to sunny, cloudy, rainy, or snowy) at the time the sentence was written.

9. "At its core, We Feel Fine is an artwork authored by everyone. It will grow and

change as we grow and change, reflecting what's on our blogs, what's in our hearts, what's in our minds. We hope it makes the world seem a little smaller, and we hope it helps people see beauty in the everyday ups and downs of life" (http://www .wefeelfine.org/mission.html).

10. See Riesman et al. (1950). Günther Anders (1956), in his remarks on electronic media, speaks of mass hermits (*Massen-Eremiten*).

11. The texts in *Christ II* cannot really be read. However, for the sake of the argument, such possibility may be imagined to illustrate the shift from one mode of perception to another. For details on Robert Silvers and his photomosaics, see http:// www.photomosaic.com

12. If one wants to pursue the discourse of the sublime, it is worth noticing that in the case of *Listening Post*, the work is perceived as the immeasurable, overwhelming sublime (or "raging river") if perceived from afar rather than from up close, when spectators are able to engage with the messages on the screens. In contrast, Barnett Newman, on whose writings and paintings Lyotard based his aesthetics of the sublime, always required that his gigantic paintings be hung in such a way that spectators could not look at them from a distance and thus could not gain any visual control over their spatial dimension. The different material of the installation and the paintings cause a reversion of when it causes the feeling of the "inadequacy of our greatest faculty of sense," as Kant (1914, §27) describes the result of the sublime.

13. Ironically, this going-forward contains a going-backward concerning the means of communication in a person's growing up. While the shift from a child to an adult is characterized by a shift from image to text—an example is the continual reduction of the portion of images in books—the growing of the Internet as a new technology of communication somewhat undoes this process.

14. In those movements or moments of movements that render the text illegible independent from the audience, the text has only an asemantic life without even the option to gain a legible one. For further examples and a discussion of text cannibalism, see also Simanowski (2010).

15. It should be mentioned that it is problematic to award *Listening Post* the Golden Nica in the category of interactive art because the ontology of its experience is not one of interactivity but rather similar to the perception of a traditional installation—or, as the statements above have shown, to sculpture, music, or cinema. *Listening Post* only presents "system interactivity," which is, as Erkki Huhtamo (2004a) points out, "the *opposite* of user interaction." The same is true for DeMarinis's *The Messenger*, which does not offer any occasion for active user intervention.

16. For a video documentation of *The Messenger*, see http://www.stanford.edu/ ~demarini/messengerweb.mov.

17. http://www.aec.at/en/archives/prix_archive/prix_projekt.asp?iProjectID=13755.

18. Ibid.

19. See Stelarc's experiments with voltage shocks in *Ping Body*.

20. Cass Sunstein, for example, in *Republic.com*, speaks of "cybercascades" and a "fragmented speech market" rather than of an online "agora" (2001, 53, 199), and in the book's 2007 second edition, he charges Weblogs with the same effect of segregation.

David Bell concludes that dealing with differences online is partly a matter of boundary drawing and speaks of "compartmentalizing the heterogeneity of cyberspace into 'neighbourhoods' of shared interest" (2001, 110).

21. See, for instance, Provenzo (1992). Even regardless of the Internet, digital media has, for the efficient monitoring in computer-aided management, been discussed in terms of a "panopticon society" (Bowers 1988).

22. See Huhtamo's discussion of *The Messenger* with respect to surveillance and panopticon (2004b, 40). See Eleey (2003): "In a perfectly timed Foucaultian twist *Listening Post* brought to the people a version of the knowledge the government collects on a sublime scale—along with its attendant power, fear and pleasure."

23. Rubin here talks about *Ear to the Ground*, a predecessor of *Listening Post*, that also displays in real time the conversations taking place in tens of thousands of different sites on the Internet. The Web site providing the quote (http://web.archive.org/web/20030901145300/cm.bell-labs.com/cm/ms/departments/sia/ear/index.html) is no longer active.

24. According to Rorty, solidarity is thought of as "the ability to see more and more traditional differences (of tribe, religion, race, customs, and the like) as unimportant when compared with similarities with respect to pain and humiliation—the ability to think of people wildly different from ourselves as included in the range of 'us'" (1989, 192).

Epilogue

1. Christoph Menke (1992) and Günter Seubold (2005), to name only two representatives from the aesthetic discourse in Germany, assert the same moral, antifundamentalist effects of putting any claim of truth or "correct" interpretation into the perspective of the context from which it arises, as noted for Gianni Vattimo in the introduction. The "Nihilistic Vocation of Hermeneutics"—as Vattimo titles one of the chapters of *Beyond Interpretation*—is the "ethics of hermeneutics" (1997, 39).

2. It should also be referred to other contemporary aestheticitions, such as Menke (1999), who indicates that the essential role of art is to undermine any automatism and certainty in the process of signification. Hence, Menke aptly titles one of his chapters "The Aesthetic Experience of Crisis," and consequently, with regard to Lyotard, opposes the cult of materiality, as has been seen in the introduction.

3. To be sure, what I understand as an exercise of what Vattimo called the "nihilistic vocation of hermeneutics" (1997), others, with a rather undisturbed relationship to truth and interpretation, may dismiss as a "breezy compilation" of unreconciled readings. However, this would point to principal intellectual disagreements that cannot be discussed in the context of this book.

4. A strong advocate of the first position is Eric Donald Hirsch (1967, 1976), who plays the author's meaning against the reader's meaning, calling the reconstruction of the author's meaning (or intention) the proper object of interpretation. The second, opposite position is represented by deconstruction as well as constructivism.

5. Jenkins's (2006) approach is informed by Michel de Certeau's concept of the rebellious audience in his book *The Practice of Everyday Life* (1984; French 1980). The

subtitle of Jenkins's essay—"Fan Writing as Textual Poaching"—is a clear reference to de Certeau's notion that people appropriate cultural texts as a kind of semiotic guerilla tactic.

6. Such dialogue is more likely to happen with respect to computer games where we find a similar *fandom* (from "fan" and "dom," as in "kingdom") as described by Jenkins (2006). It is worth noting that an interactive installation may leave the members of its audience much more on their own than a book or film, which may be consumed alone but then experienced collectively within the realm of fandom.

7. See Eskelinen (2001): "In art we might have to configure in order to be able to interpret whereas in games we have to interpret in order to be able to configure, and proceed from the beginning to the winning or some other situation." Eskelinen develops Espen Aarseth's (1997, 64) notion that in cybertext in addition to the interpretative function of the user there is the explorative (i.e., navigational) and configurative function.

8. John Cayley in a response to Stuart Moulthrop's essay "From Work to Play," on May 21, 2005, at http://www.electronicbookreview.com/thread/firstperson/manovichian.

9. See in this context the claim that because they are coded, digital spaces represent a strong desire for control over the messiness of bodies and unruliness of the physical world (Munster 2006).

10. Part of such shift to the logic of programming is that Critical Code Studies, "rather than creating a language separate from the work of programmers . . . will build on pre-existing terminology and analysis used within the programming community" (Marino 2006). It should be stated that I do not at all oppose a critical reading of code and software within its broader social and ideological contexts. I absolutely endorse code studies that examine how code is constructed and constructing or explore—similar to Friedrich Kittler's exploration of technology, including digital technology (Kittler 1992)—code as an agent in social history. For the characteristics of software and its interconnections with culture and society, see Fuller (2008); for the claim for greater software literacy, see Wardrip-Fruin (2009). A good example for the approach to code with respect to its semiotic effects situating them within culture and art history is Raley (2006).

11. For an analysis of programs teaching new media literacy in different countries and academic environments, see section 2 in Simanowski, Schäfer, and Gendolla (2009).

12. See Manovich (1999), Paul (2003, 11), and Tribe and Jana (2006). For a discussion of Net art as avant-garde with respect to Greenberg, Peter Bürger, and Renato Poggioli, see Stringer (2001); for the discussion of electronic literature as literary and artistic avant-garde movement, see Rettberg (2008).

13. Manovich (1999) continues: "On the one hand, software codifies and naturalizes the techniques of the old avant-garde. On the other hand, software's new techniques of working with media represents the new avant-garde of the meta-media society." See also Raine Koskimaa (2009a), who considers digital artworks to be technological avant-garde because of the crucial role technology plays in it.

14. See Lyotard's definition of the sublime as the "enigma of the 'Is it happening?'":

"Shock is, *par excellence,* the evidence of (something) happening, rather than nothing, suspended privation" (1989a, 210, 205).

15. Though the concept of cool is principally different from the concept of avantgarde, it shares with it the aloof and slightly subversive air and the fact that wherever it goes—beatnik or hippy music, punk or hip-hop—mainstream culture follows a step or two behind. According to Lyotard's own understanding, mapping art would not qualify as sublime because of the attitude to control that it represents. As Lyotard remarks with respect to digital technologies and its modus of *téchnē,* such control prevents us from experiencing powerlessness and awe (1989b, 337, 339). One may argue with Kant against Lyotard that the sublime lies in the eye of the beholder and that what is a matter of rule-based, rational coding to programmers exceeds the capacity of imagination for others.

16. On the relationship between the pleasure in the mastery of technique, self-referentiality, and desemantization, see Virno (2004, 52).

17. http://www.mine-control.com.

18. http://www.mine-control.com/mondrian.html.

19. Koepnick (2006, 60–63) further discusses the relationship between grids and digitality.

20. David Z. Saltz misses this point when he agrees with Christine Tamblyn and Timothy Binkley that interactive computer art can be considered a form of conceptual art because "interactive computer artists do seem to work largely in the realm of ideas, creating logical structures in the medium of software." He adds, "Interactive computer art, however, can never exist *only* as software. The work must reach out into the world in some way to capture the human interactor's input" (2003, 396). Although Saltz's objection is correct, it is not the only one to be made. Software art is also not only conceptual for the reason that it has to be carefully programmed and requires craftsmanship that classic conceptual art had abandoned. See Tamblyn (1990) and Binkley (1990).

21. The request of the *derriére-garde* that artists should be able to draw beyond a third-grade level and the popular comment, "My six-year-old could do that," is supported by James Elkins's remark that many representatives of modern art (he lists Bonnard, Duchamp, Delaunay, Picabia, Rothko, Magritte, and Masson) lacked essential skills in painting (2003, 135–45).

BIBLIOGRAPHY

Aarseth, Espen. 1997. *Cybertext: Perspectives on Ergodic Literature.* Baltimore: Johns Hopkins University Press.

Abumrad, Jad. 2002. "Feature for Studio 360." Sound file. http://www.studio360.org/show012602.html.

Adorno, Theodor W. 1984. *Aesthetic Theory.* Translated by C. Lenhardt. London: Routledge & Kegan Paul.

———. 1992. "Commitment." In *Notes to Literature,* 2: 76–94. New York: Columbia University Press.

Anders, Günther. 1956. *Die Antiquiertheit des Menschen.* Munich: C. H. Beck

Andrews, Jim. 2002. "The Battle of Poetry against Itself and the Forces of Dullness." http://www.vispo.com/arteroids/onarteroids.htm.

Appolinaire, Guillaume. 2004. *The Cubist Painters.* Berkeley: University of California Press.

Ascott, Roy. 2003. *Telematic Embrace: Visionary Theories of Art, Technology, and Consciousness.* Edited by Edward A. Shanken. Berkeley: University of California Press.

Baake, Dieter. 1995. "Spiele jenseits der Grenze. Zur Phänomenologie und Theorie des Nonsense." In *Deutsche Unsinnspoesie,* edited by Klaus Peter Dencker, 355–77. Stuttgart: Reclam.

Balkin, Adam. 2003. "Exhibit Brings the Internet to Life." *NY1 News,* January 22. http://www.ny1.com/ny1/content/index.jsp?stid=101&aid=27376.

Balpe, Jean-Pierre. 1997. "Trois mythologies et un poète aveugle." http://hypermedia.univ-paris8.fr/Jean-Pierre/articles/Creation.html.

Barber, Benjamin. 1995. *Jihad vs. McWorld: How the Planet Is Both Falling Apart and Coming Together and What This Means for Democracy.* New York: Times Books.

Barlow, John Perry. 1996. "Declaration of the Independence of Cyberspace." http://homes.eff.org/~barlow/Declaration-Final.html.

Barr-Watson, Pete. 2002. "Inspired, Educated and Entertained." http://www.aec.at/en/archives/prix_archive/prixjuryStatement.asp?iProjectID=11718.

Bateson, Gregory. 1973. *Steps to an Ecology of Mind.* St. Albans: Paladin.

Barger, Jorn. 1993. "'The Policeman's Beard' Was Largely Prefab!" *Journal of Computer Game Design* 6.

Barthes, Roland. 1977. "The Death of the Author." In *Image-Music-Text*, edited by Stephen Heath, 142–48. New York: Noonday Press.

———. 1984. *Camera Lucida*. London: Flamingo.

———. 1987. *Criticism and Truth*. 1966. Translated by Katrine Pilcher Keuneman. Minneapolis: University of Minnesota Press.

———. 1991. *The Responsibility of Forms: Critical Essays on Music, Art, and Representation*. Berkeley: University of California Press.

Baumgärtel, Tilman. 2000: "Heute ist morgen." *Telepolis*, June 3. http://www.heise.de/tp/r4/artikel/3/3532/1.html.

———. 2001. *Net-Art 2.0. New Materials towards Net Art*. Nürnberg: Verlag für moderne Kunst.

Bell, David. 2001. *An Introduction to Cyberspace*. London: Routledge.

Bell, David J., Brian Loader, Nicholas Pleace, and Douglas Schuler. 2004. *Cyberculture: The Key Concepts*. London: Routledge.

Benayoun, Maurice. 1997. "World Skin." http://www.benayoun.com/Worskieng.htm.

Bense, Max, and Reinhard Döhl. 1964. "Zur Lage." http://www.reinhard-doehl.de/zurlage.htm.

Bezzel, Chris. 1978. "Dichtung und revolution." In *Text & Kritik* 25 (March): 35–36.

Biggs, Simon. 1996. *Great Wall of China*. http://hosted.simonbiggs.easynet.co.uk/wall/greatwall1.htm.

———. 2007. "Multimedia, Multiculturalism, Language and the Avantgarde: Notes and Observations from ePoetry 2007." In *Networked_performance: A Research Blog about Network-Enabled Performance*. http://www.turbulence.org/blog/archives/004315.html.

Binkley, Timothy. 1990. "The Quickening of Galatea: Virtual Creation without Tools or Media." *Art Journal* 49 (3): 233–40.

Blais, Joline, and Jon Ippolito. 2001. "Looking for Art in All the Wrong Places." In *Takeover: Who's Doing the Art of Tomorrow*, edited by ARS Electronica, 28–40. New York: Springer.

———. 2006. *At the Edge of Art*. London: Thames & Hudson.

Böhme, Gernot. 1995. *Atmosphäre: Essays zur neuen Ästhetik*. Frankfurt am Main: Suhrkamp.

Bölsche, Wilhelm. 1887. *Die naturwissenschaftlichen Grundlagen der Poesie: Prolegomena einer realistischen Ästhetik*. Leipzig: Carl Reissner.

Bolter, Jay David. 1991. *Writing Space. The Computer, Hypertext, and the History of Writing*. Hillsdale, N.J.: Lawrence Erlbaum.

———. 1992. "Literature in the Electronic Writing Space." In *Literacy Online: The Promise (and Peril) of Reading and Writing with Computers*, edited by Myron C. Tuman, 19–42. Pittsburgh, Pa.: University of Pittsburgh Press.

———. 1996. "Ekphrasis, Virtual Reality, and the Future of Writing." In *The Future of the Book*, edited by Geoffrey Nunberg, 253–72. Berkeley: University of California Press.

———. 1997. "Die neue visuelle Kultur: Vom Hypertext zum Hyperfilm." *Telepolis* 2: 84–91.

Bolter, Jay David, and Richard Grusin. 1999. *Remediation: Understanding New Media*. Cambridge, Mass.: MIT Press.

Bolz, Norbert. 2002. *Das konsumistische Manifest*. Munich: Wilhelm Fink.

Bourdieu, Pierre. 1987. *Distinction: A Social Critique of the Judgement of Taste*. Translated by Richard Nice. New Haven, Conn.: Harvard University Press.

Bourriaud, Nicolas. 2002. *Relational Aesthetics*. Dijon: Les presses du réel.

Bowers, C. A. 1988. *The Cultural Dimension of Educational Computing: Understanding the Non-Neutrality of Technology*. New York: Teachers College Press.

Bringsjord, Selmer, and David Ferrucci. 1999. "Artificial Intelligence and Literary Creativity: Inside the Mind of Brutus, a Storytelling Machine." http://www.cogsci.rpi .edu/brutus/brutus.preface.pdf.

Brus, Günter. 1999. *Leuchtstoffpoesie und Zeichenchirurgie*. Ostfildern: DuMont.

Bubner, Rüdiger. 1973. "Über einige Bedingungen gegenwärtiger Ästhetik." *Neue Hefte für Philosophie* 5: 38–73.

Buci-Glucksmann, Christine. 1994. *Baroque Reason: The Aesthetics of Modernity*. Translated by Patrick Camiller. London: Sage.

Bülow, Ralf. 2007. "Sinn ist fern: Wie die Computer dichten lernten." In *Ex Machina: Frühe Computergrafik bis 1979*, edited by Wulf Herzogenrath and Barbara Nierhoff-Wielke, 134–81. Berlin: Deutscher Kunstverlag.

Bürger, Peter. 1979. "Naturalismus—Ästhetizismus und das Problem der Subjektivität." In *Naturalismus/Ästhetizismus*, edited by Christa Bürger, Peter Bürger, and Jochen Schulte-Sasse, 18–55. Frankfurt am Main: Suhrkamp.

———. 1984. *Theory of the Avant-garde*. Minneapolis: University of Minnesota Press.

Burroughs, William. 2002. "The Future of the Novel." In *Multimedia: From Wagner to Virtual Reality*, edited by Randall Packer and Ken Jordan, 303–6. New York: Norton.

Cage, John. 1966. *Silence: Lectures and Writings*. Cambridge, Mass.: MIT Press.

———. 2002. "Diary: Audience 1966. A Year from Monday." In *Multimedia: From Wagner to Virtual Reality*, edited by Randall Packer and Ken Jordan, 91–94. New York: Norton.

Calabrese, Omar. 1992. *Neo-Baroque—A Sign of the Times*. Princeton, N.J.: Princeton University Press.

Calvino, Italo. 1987. *The Uses of Literature: Essays*. San Diego, Calif.: Harcourt.

Camus, Albert. 1956. *The Rebel: An Essay on Man in Revolt*. New York: Vintage.

Carlson, Marvin. 1996. *Performance: A Critical Introduction*. London: Routledge.

Cayley, John. 2004. "The Code Is Not the Text (Unless It Is the Text)." In *p0es1s: Ästhetik digitaler Poesie/The Aesthetics of Digital Poetry*, edited by Friedrich W. Block, Christiane Heibach, and Karin Wenz, 287–306. Ostfildern-Ruit: Hatje Cantz.

———. 2006a. "Lens: The Practice and Poetics of Writing in Immersive VR (A Case Study with Maquette)." *Leonardo Electronic Almanac* 14, no. 5. http://leoalmanac.org/ journal/vol_14/lea_v14_n05-06/jcayley.asp.

———. 2006b. "Time Code Language: New Media Poetics and Programmed Signification." In *New Media Poetics: Contexts, Technotexts, and Theories*, edited by Adelaide Morris and Thomas Swiss, 307–33. Cambridge, Mass.: MIT Press.

Certeau, Michel de. 1980. *Invention Du Quotidien: Arts de Faire*. Paris: Gallimard.

Coover, Robert. 2001. "Literary Hypertext: The Passing of the Golden Age." Translated by Roberto Simanowski. *Text & Kritik* 152: 22–30.

Coukell, Allan. 2004. "Report for Here and Now." *Boston's NPR News Station,* February 12. Sound file. http://www.here-now.org/shows/2004/02/20040212_17.asp.

Coulter-Smith, Graham. 2006. *Deconstructing Installation Art.* Madrid: Brumaria.

Coyle, Rebecca. 1990. "Holography—Art in the Space of Technology: Margaret Benyon, Paula Dawson and the Development of Holographic Arts Practice." In *Culture, Technology and Creativity,* edited by Philip Hayward, 65–88. London: John Libbey.

Cramer, Florian. 2004. "Digital Code and Literary Text." In *p0es1s, Ästhetik digitaler Poesie / The Aesthetics of Digital Poetry,* edited by Friedrich W. Block, Christiane Heibach, and Karin Wenz, 263–76. Ostfildern-Ruit: Hatje-Cantz.

Cramer, Florian, and Ulrike Gabriel. 2001. "Software Art and Writing." In *DIY Media— Kunst und digitale Medien: Software, Partizipation, Distribution (transmediale.01),* edited by Andreas Broeckmann and Susanne Jaschko, 29–30. Berlin: Trabnsmediale.

Critical Art Ensemble. 1996. *Electronic Civil Disobedience.* New York: Autonomedia. http://www.critical-art.net/books.html.

———. 2002. *Digital Resistance: Explorations in Tactical Media.* New York: Autonomedia.

Cubitt, Sean. 1998. *Digital Aesthetics.* London: Sage.

Dahl, Roald. 1948. "The Great Automatic Grammatizator." In *Someone Like You,* 190–209. Harmondsworth: Penguin Books.

Danto, Arthur C. 1997. *After the End of Art: Contemporary Art and the Place of History.* Princeton, N.J.: Princeton University Press.

———. 2000. "Art and Meaning." In *Theories of Art Today,* edited by Noël Carroll, 130–40. Madison: University of Wisconsin Press.

Darley, Andrew. 2000. *Visual Digital Culture: Surface Play and Spectacle in New Media Genres.* London: Routledge.

Davis, Erik. 2000. "Millennial Light." In Lozano-Hemmer, *Vectorial Elevation,* 241–51.

De Campos, Augusto. 1999. "Do Tipo ao Videograma." In *Poesia Visual Vídeo Poesia,* edited by Ricardo Araújo, 167–70. São Paulo: Perspectiva.

De Kerckhove, Derrick. 1993. "Touch Versus Vision: Ästhetik neuer Technoligien." In *Die Aktualität des Ästhetischen,* edited by Wolfgang Welsch, 137–68. Munich: Fink.

DeLaurenti, Christopher. 2002. "Classical and Jazz: Two Sound Installations." *Stranger,* November 21–27. http://www.earstudio.com/projects/pdf/StrangerSuggests.pdf.

DeMarinis, Paul. 1998. "The Messenger." http://www.well.com/~demarini/messenger .html.

Derrida, Jacques. 1994. *Force de loi: Le "Fondement mystique de l'autorité."* Paris: Galilée.

———. 2004. "Semiology and Grammatology: Interview with Julia Kristeva." In *Positions,* translated by Alan Bass, 15–34. New York: Continuum.

———. 2005. "The Word Processor." In *Paper Machine,* 19–32. Standford, Calif.: Stanford University Press.

Didi-Huberman, Georges. 2005. *Confronting Images: Questioning the Ends of a Certain History of Art.* Translated by John Goodman. University Park, Pa.: Penn State University Press.

Dischner, Gisela. 1978. "Konkrete Kunst und Gesellschaft." *Text & Kritik* 25: 37–41.

Dodge, Martin, and Rob Kitchin. 2000. *Mapping Cyberspace.* London: Routledge.

Döhl, Reinhard. 2000. "Vom Computertext zur Netzkunst. Vom Bleisatz zum Hypertext." http://www.netzliteratur.net/computertext_netzkunst.htm.

Downing, Douglas, Michael Covington, and Melody Mauldin Covington. 2000. *Dictionary of Computer and Internet Terms.* New York: Barrons.

Downing, Eric. 2000. *Double Exposures: Repetition and Realism in Nineteenth-century German Fiction.* Stanford, Calif.: Stanford University Press.

Drucker, Johanna. 1994. *The Visible Word: Experimental Typography and Modern Art, 1909–1923.* Chicago: University of Chicago Press.

———. 1998. "Experimental/Visual/Concrete." In *Figuring the World: Essays on Books, Writing, and Visual Poetics,* 110–36. New York: Granary Books.

Eco, Umberto. 1994. "Post Script to *The Name of the Rose.*" In *The Name of the Rose: Including the Author's Postscript,* 530–36. New York: Harvest Books.

Ede, Sian. 2005. *Art and Science.* London: I. B. Tauris.

Eleey, Peter. 2003. "Mark Hansen and Ben Rubin." *Frieze,* May 2003. http://www.frieze.com/issue/review/mark_hansen_and_ben_rubin/.

Elkins, James. 2003. *What Happened to Art Criticism?* Chicago: Prickly Paradigm Press.

Enzensberger, Hans Magnus. 1968. "Gemeinplätze, die Neueste Literatur betreffend." *Kursbuch* 15: 187–97.

Ernst, Josef. 1992. "Computer Poetry: An Act of Disinterested Communication." *New Literary History* 23: 451–65.

Eskelinen, Markku. 2001. "The Gaming Situation." *Game Studies* 1 (July). http://www.gamestudies.org/0101/eskelinen.

Féral, Josette. 2002. "Theatricality: The Specificity of Theatrical Language." In *SubStance* 31, no. 2/3: 94–108.

———. 2003. "Performance and Theatricality: The Subject Demystified." In *Performance: Critical Concepts in Literary and Cultural Studies,* edited by Philip Auslander, 206–17. New York: Taylor & Francis.

Fernández, María. 2000. "Postcoloniality in the Spotlight." In Lozano-Hemmer, *Vectorial Elevation,* 133–62.

Fischer-Lichte, Erika. 2008. *The Transformative Power of Performance: Re-enchanting the World.* London: Routledge.

Fischer-Lichte, Erika, Kristiane Hasselmann, and Alma-Elisa Kittner. 2011. *Kampf der Künste! Kultur im Zeichen von Medienkonkurrenz und Eventstrategien.* Bielefeld: Transcript.

Fizz, Pop, and Melanie McFarland. 2002. "Exhibit Brings the Internet to Life." *Seattle Times,* November 18. http://seattletimes.nwsource.com/cgi-bin/PrintStory.pl?document_id=134577668&zsection_id=268448483&slug=fizz18&date=20021118.

Fleischmann, Monika, and Wolfgang Strauss. 1995. "The Body as Interface and Representation." *Tight Rope* 3. http://www.phil.uni-sb.de/projekte/HBKS/TightRope/issue.3/text/liquid.html.

Foster, Hal. 2002. *Design and Crime.* London: Verso.

———. 2006. "Chat Rooms." In *Participation: Documents of Contemporary Art,* edited by Claire Bishop, 190–95. Cambridge, Mass.: MIT Press.

Foucault, Michel. 1987. "What Is Enlightenment?" In *Interpretive Social Science: A Second*

Look, edited by Paul Rabinow and William Sullivan, 157–74. Berkeley: University of California Press.

Freedberg, David, and Vittorio Gallese. 2008. "Motion, Emotion and Empathy in Esthetic Experience." *Trends in Cognitive Sciences* 11, no. 5: 197–203.

Frieling, Rudolf. 2005. "Das Archiv, die Medien die Karte und der Text." In *Media Art Net 2: Key Topics*, edited by Rudolf Frieling and Dieter Daniels Wien, 216–53. New York: Springer 2005. http://www.medienkunstnetz.de/themen/mapping_und_text/archiv_karte/.

Fujihata, Masaki. 2001. "On Interactivity." In *Takeover: Who's Doing the Art of Tomorrow*, edited by ARS Electronica, 316–19. New York: Springer.

Fuller, Matthew, ed. 2008. *Software Studies: A Lexicon*. Cambridge, Mass.: MIT Press.

Funkhouser, Christopher Thompson. 2007. *Prehistoric Digital Poetry: An Archaeology of Forms, 1959–1995*. Tuscaloosa: University of Alabama Press.

———. 2008. "The Scope for a Reader." *dichtung-digital* 38. http://www.dichtung-digital.org/2008/1-Funkhouser.htm.

Gallop, Jane. 2007. "The Historicization of Literary Studies and the Fate of Close Reading." *Profession* 2007: 181–86.

Gendolla, Peter. 2000. "'Was hat man dir du armes Kind, getan' Über Literatur aus dem Rechner." *dichtung-digital* 8. http://www.dichtung-digital.de/2000/Gendolla/21-Jan.

Gianetti, Claudia. 2004. *Ästhetik des Digitalen: Ein intermediärer Beitrag zu Wissenschaft, Medien- und Kunstsystem*. Vienna: Springer.

Gibbs, Anna, and Maria Angel. 2008. "Memory and Motion: The Body in Electronic Writing." Presented at Beyond the Screen: Transformations of Literary Structures, Interfaces and Genres, University of Siegen, Siegen, Germany, November 20. http://www.litnet.uni-siegen.de/veranstaltungen/beyond-the-screen-2008/memory-and-motion-the-body-in-electronic-writing.html?lang=de. (See also "Memory and Motion: The Body in Electronic Writing." In Schäfer and Gendolla, *Interfaces and Genre*, 123–35.)

Gibson, Eric. 2003. "Poised between Old and New." *Wall Street Journal*, February 14. http://www.earstudio.com/projects/pdf/WallStreetJournal.jpg.

Giesz, Ludwig. 1960. *Phänomenologie des Kitsches*. Heidelberg: Rothe.

Glazier, Loss Pequeño. 2002. *Digital Poetics: The Making of E-Poetries*. Tuscaloosa: University of Alabama Press.

Golumbia, David. 2009. *The Cultural Logic of Computation*. Cambridge, Mass.: Harvard University Press.

Grau, Oliver. 2003. *Virtual Art: From Illusion to Immersion*. Cambridge, Mass.: MIT Press.

Greenberg, Clement. 1961. "Avant-Garde and Kitsch." In *Art and Culture: Critical Essays*, 3–21. Boston: Beacon Press.

———. 1971. "Necessity of 'Formalism.'" In *Late Writings*, 45–49. Minneapolis: University of Minnesota Press.

Greene, Rachel. 2004. *Internet Art*. London: Thames & Hudson.

Grossberg, Lawrence. 1989. *It's a Sin: Essays on Postmodernism, Politics, and Culture*. Sydney: Power Institute of Fine Arts.

Gumbrecht, Hans Ulrich. 1994. "A Farewell to Interpretation." In *Materialities of Communication*, edited by Hans Ulrich Gumbrecht and K. Ludwig Pfeiffer, 389–402. Stanford, Calif.: Stanford University Press.

———. 2004. *Production of Presence: What Meaning Cannot Convey.* Stanford, Calif.: Stanford University Press.

———. 2005. "Sanfte Wende: Erika Fischer-Lichte findet eine Ästhetik für unsere Gegenwart." *Frankfurter Allgemeine Zeitung,* January 22, p. 18.

Gunning, Tom. 1990. "The Cinema of Attractions: Early Film, Its Spectator and the Avant-Garde." In *Early Cinema: Space, Frame, Narrative,* edited by Thomas Elsaesser, 56–62. London: British Film Institute.

Hall, Stuart. 1973. *Encoding and Decoding in the Television Discourse.* Birmingham: Centre for Contemporary Cultural Studies.

Hansen, Mark B. N. 2001. "Seeing with the Body: The Digital Image in Postphotography." *Diacritics* 31, no. 4: 54–84.

———. 2006. *Bodies in Code: Interface with Digital Media.* London: Routledge.

Hansen, Mark, and Ben Rubin. 2001. "Babble Online: Applying Statistics and Design to Sonify the Internet." In *Proceedings of the 2001 International Conference on Auditory Display, Espoo, Finland, July 20–August 1, 2001,* 10–15. http://www.acoustics.hut.fi/icad2001/proceedings/papers/hansen.pdf.

Harger, Brenda Bakker. 2006. "Behind *Façade:* An Interview with Andrew Stern and Michael Mateas." http://www.uiowa.edu/~iareview/mainpages/new/july06/stern_mateas.html.

Harrison, Charles. 2001. *Essays on Art and Language.* Cambridge, Mass.: MIT Press.

Hart, Julius. 1889. "Phantasie und Wirklichkeit." *Kritisches Jahrbuch* 1, no. 1: 73–82.

———. 1890. "Der Kampf um die Form in der zeitgenössischen Dichtung." *Kritisches Jahrbuch* 1, no. 2: 58–76.

Hausmann, Raoul. 1994. "Pamphlet gegen die Weimarische Lebensauffassung." In *DADA total: Manifeste, Aktionen, Texte, Bilder,* edited by Karl Riha and Jörgen Schäfer, 101–4. Stuttgart: Reclam.

Hayles, N. Katherine. 1997. "Corporeal Anxiety in *Dictionary of the Khazars:* What Books Talk about in the Late Age of Print When They Talk about Losing Their Bodies." *Modern Fiction Studies* 43, no. 3: 800–820.

———. 2002. *Writing Machines.* Cambridge, Mass.: MIT Press.

———. 2006. "The Time of Digital Poetry: From Object to Event." In *New Media Poetics: Contexts, Technotexts, and Theories,* edited by Adelaide Morris and Thomas Swiss, 181–209. Cambridge, Mass.: MIT Press.

———. 2008. *Electronic Literature: New Horizons for the Literary.* Notre Dame, Ind.: University of Notre Dame Press.

Heibach, Christiane. 1999. "'Creamus, ergo sumus' Ansätze zu einer Netz-Ästhetik." In *Hyperfiction: Hyperliterarisches Lesebuch: Internet und Literatur,* edited by Beat Suter and Michael Böhler, 101–12. Frankfurt am Main: Stroemfeld.

Hermand, Jost. 2004. *Nach der Postmoderne. Ästhetik heute.* Cologne: Böhlau.

Hiebel, Hans. 1997. *Kleine Medienchronik: Von den ersten Schriftzeichen zum Mikrochip.* Munich: Beck.

Hirsch, Eric Donald. 1976a. *The Aims of Interpretation.* Chicago: University of Chicago Press.

———. 1976b. *Validity in Interpretation.* New Haven, Conn.: Yale University Press.

Hörisch, Jochen. 1988. *Wut des Verstehens*. Frankfurt am Main: Suhrkamp.

Howes, David. 2005a. "Introduction." In *Empire of the Senses: The Sensual Culture Reader*, edited by David Howes, 1–17. Oxford: Berg.

———. 2005b. "Hyperaesthesia, or, The Sensual Logic of Late Capitalism." In *Empire of the Senses: The Sensual Culture Reader*, edited by David Howes, 281–303. Oxford: Berg.

Huhtamo, Erkki. 1996. "Surreal-time Interaction, or How to Talk to a Dummy in a Magnetic Mirror?" *Artintact* 3: 45–55.

———. 1999. "From Cybernation to Interaction: A Contribution toward the Archaeology of Interactivity." In *The Digital Dialectic: New Essay on New Media*, edited by Peter Lunefeld, 96–110. Cambridge, Mass.: MIT Press.

———. 2000. "Re:Positioning Vectorial Elevation: Media Archaeological Considerations." In Lozano-Hemmer, *Vectorial Elevation*, 99–113.

———. 2004a. "Trouble at the Interface, or The Identity Crisis of Interactive Art." *Framework: The Finnish Art Review* 2. http://www.mediaarthistory.org/Programmatic%20key%20texts/pdfs/Huhtamo.pdf.

———. 2004b. "An Archaeology of Networked Art: A Symptomatic Reading of *The Messenger* by Paul DeMarinis." In *Networked Narrative Environments*, edited by Andrea Zapp, 32–44. Manchester: Manchester Metropolitan University Press.

Huyssen, Andreas. 2007. "Geographies of Modernism in a Globalizing World." *New German Critique* 100: 189–201.

Iser, Wolfgang. 1976. *Der Akt des Lesens. Theorie ästhetischer Wirkung*. Munich: Fink.

Jameson, Frederic. 1984. Foreword to *The Postmodern Condition: A Report on Knowledge*, by Jean-François Lyotard, vii–xxii. Minneapolis: University of Minnesota Press.

———. 1998. "'End of Art' or 'End of History'?" In *The Cultural Turn: Selected Writings on the Postmodern, 1983–1998*, 73–92. London: Verso.

Jean Paul. 1974. *Jean Paul Sämtliche Werke*. Section 2, Vol. 1. Edited by Norbert Miller. Munich: Carl Hanser.

Jenkins, Henry. 2006. "*Star Trek* Rerun, Reread, Rewritten: Fan Writing as Textual Poaching." In *Fans, Bloggers and Gamers: Exploring Participatory Culture*, 37–60. New York: New York University Press.

Jevbratt, Lisa. 2004. "A Prospect of the Sublime in Data Visualizations." *YLEM* 24, no. 8: 4–8. http://www.ylem.org/Journal/.

Johnson, Nancy S., and Jean M. Mandler. 1980. "A Tale of Two Structures: Underlying and Surface Forms in Stories." *Poetics* 9: 51–86.

Jones, Caroline A. 2006. *Eyesight Alone: Clement Greenberg's Modernism and the Bureaucratization of the Senses*. Chicago: University of Chicago Press.

Joyce, Michael. 1995. "Siren Shapes: Exploratory and Constructive Hypertext." In *Of Two Minds: Hypertext Pedagogy and Poetics*, 39–59. Ann Arbor: University of Michigan Press.

———. 2000. "MOO or Mistakenness." In *Othermindedness: The Emergence of Network Culture*, 35–48. Ann Arbor: University of Michigan Press.

Kac, Eduardo. 2003. "Biopoetry." In *Cybertext Yearbook 2002–03*, edited by Markku Eskelinen and Raine Koskimaa, 184–85. Jyväskylä: Research Center for Contemporary Culture.

Kant, Immanuel. 1914. *Critique of Judgement.* Translated and introduction by J. H. Bernard. London: Macmillan.

Kaye, Nick. 1994. *Postmodernism and Performance.* New York: St. Martin's Press.

Kilb, Andreas. 2002. "Peter Greenaway oder Der Bauch des Kalligraphen." Interview. In *Die Postmoderne im Kino: Ein Reader,* edited by Jürgen Felix, 230–38. Schüren: Marburg.

Kirschenbaum, Matthew G. 1999. "The Other End of Print: David Carson, Graphic Design, and the Aesthetics of Media." *MIT Communications Forum.* http://web.mit.edu/comm-forum/papers/kirsch.html.

———. 2008. *Mechanisms: New Media and the Forensic Imagination.* Cambridge, Mass.: MIT Press.

Kittler, Friedrich. 1992. "There Is No Software." *Stanford Literature Review* 9, no. 1 (Spring 1992): 81–90.

Klee, Paul. 1949. *Über die moderne Kunst.* Bern: Benteli.

Klein, Sheldon, et al. 1973. *Automatic Novel Writing: A Status Report.* University of Wisconsin.

Knapp, Steven, and Walter Benn Michaels. 1982. "Against Theory." In *Against Theory: Literary Studies and the New Pragmatism,* edited by W. J. T. Mitchel, 11–30. Chicago: University of Chicago Press.

Koepnick, Lutz. 2006. "[Grid <> Matrix]: Take II." In *[Grid <> Matrix],* edited by Sabine Eckmann and Lutz Koepnick, 47–75. Saint Louis, Mo.: Mildred Lane Kemper Art Museum, Washington University.

Koskimaa, Raine. 2009a. *Approaches to Digital Literature: Temporal Dynamics and Cyborg Authors.* In Simanowski, Schäfer, and Gendolla, *Reading Moving Letters,* 129–44.

———. 2009b. *Teaching Digital Literature through Multi-layered Analysis.* In Simanowski, Schäfer, and Gendolla, *Reading Moving Letters,* 299–310.

Krauss, Rosalind E. 1986. *The Originality of the Avant-garde and Other Modernist Myths.* Cambridge, Mass.: MIT Press.

Krueger, Myron. 2002. "Responsive Environments." In *Multimedia: From Wagner to Virtual Reality,* edited by Randall Packer and Ken Jordan, 104–20. New York: Norton.

Kurz, Robert. 1999. *Die Welt als Wille und Design. Postmoderne, Lifestyle-Linke und die Ästhetisierung der Krise.*

Kuspit, Donald. 2004. *The End of Art.* Cambridge: Cambridge University Press.

Landow, George P. 1997. *Hypertext: The Convergence of Contemporary Critical Theory and Technology.* Baltimore: Johns Hopkins University Press.

———. 2000. "Hypertext as Collage Writing." In *The Digital Dialectic: New Essays on New Media,* edited by Peter Lunefeld, 150–70. Cambridge, Mass.: MIT Press.

Lang, R. Raymond. 1997. "A Formal Model for Simple Narratives." Dissertation, Tulane University.

Lankshear, Colin, and Michele Knobel, eds. 2008. *Digital Literacies: Concepts, Policies and Practices.* New York: Peter Lang.

Latour, Bruno, and Peter Weibel, eds. 2005. *Making Things Public: Atmospheres of Democracy.* Cambridge, Mass: MIT Press.

Lebowitz, Michael. 1990. "The Age of Intelligent Machines: All Work and No Play Makes

HAL a Dull Program." In *The Age of Intelligent Machines*, edited by Raymond Kurzweil, 390–93. Cambridge, Mass.: MIT Press.

Legrady, George. 2005. "Interview with Roberto Simanowski." *dichtung-digital* 35. http://www.dichtung-digital.org/2005/2-Legrady.htm.

Lem, Stanisław. 1983. "Die Moderne oder der Zufall." In *Philosophie des Zufalls: Zu einer empirischen Theorie der Literatur,* 1:255–97. Frankfurt am Main: Insel.

LeMay, Matthew. 2005. "Reconsidering Database Form: Input, Structure, Mapping." In *dichtung-digital* 35. http://www.dichtung-digtial.org /2005/2/Lemay/index.htm.

LeWitt, Sol. 2000. "Paragraphs on Conceptual Art." In *Conceptual Art: A Critical Anthology,* edited by Alexander Alberro and Blake Stimson, 12–17. Cambridge, Mass.: MIT Press.

Liu, Alan. 2004. *The Laws of Cool: Knowledge Work and the Culture of Information.* Chicago: University of Chicago Press.

Liu, Hugo, and Push Singh. 2002. "Makebelieve: Using Commonsense Knowledge to Generate Stories." In *Proceedings of the 20th National Conference on Artificial Intelligence* (AAAI-02), Student Abstracts, Seattle, Wash., 957–58. http://web.media.mit.edu/~hugo/publications/papers/AAAI2002-makebelieve.pdf.

Loos, Adolf. 1970. "Ornament and Crime." 1910. In *Programs and Manifestos on 20th-century Architecture,* edited by Ulrich Conrads, 19–24. Cambridge, Mass.: MIT Press.

Looy, Jan van, and Jan Baetens, eds. 2003. *Close Reading New Media: Analyzing Electronic Literature.* Leuven: Leuven University Press.

Lozano-Hemmer, Rafael. 1997. *RE:Positioning Fear.* http://rhizome.org/artbase/2398/fear.

———. 2000a. "Introduction." In Lozano-Hemmer, *Vectorial Elevation,* 28–47.

———. 2000b. "Interview (with Geert Lovink)." In Lozano-Hemmer, *Vectorial Elevation,* 48–67.

———, ed. 2000c. *Vectorial Elevation: Relational Architecture No. 4.* Mexico City: Conaculta and Ediciones San Jorge.

———. 2001. "Metaphors of Participation: Interview with Heimo Ranzenbacher." In *Takeover: Who's Doing the Art of Tomorrow,* edited by ARS Electronica, 240–47. New York: Springer.

———. 2002. "Alien Relationships with Public Space: A Winding Dialog with Rafael Lozano-Hemmer by Alex Adriaansens and Joke Brouwer." In *TransUrbanism,* edited by Joke Brouwer and Arjen Mulder, 138–59. Rotterdam: V2_Publishing/Netherlands Architecture Institute. http://www.lozano-hemmer.com/texts/transurbanism.doc.

Lyotard, Jean-François. 1973. "La peinture comme dispositif libidinal." In *Des Dispositifs pulsionnels,* 237–80. Paris: Union générale d'éditions.

———. 1982. *Essays zu einer affirmativen Ästhetik.* Berlin: Merve.

———. 1984. *The Postmodern Condition: A Report on Knowledge.* Minneapolis: University of Minnesota Press.

———. 1989a. "The Sublime and the Avant-Garde." In *The Lyotard Reader,* edited by Andrew E. Benjamin, 196–211. Malden, Mass.: Blackwell.

———. 1989b. "Das Undarstellbare—wider das Vergessen. Ein Gespräch zwischen Jean-François Lyotard und Christiane Pries." In *Das Erhabene—Zwischen Grenzerfahrung und Größenwahn,* edited by Christiane Pries, 319–47. Weinheim: Acta Humaniora.

————. 2003. "The Tooth, the Palm." In *Performance: Critical Concepts in Literary and Cultural Studies*, edited by Philip Auslander, 2:25–31. London: Routledge.

Lyotard, Jean-François, and Jean-Loup Thébaud. 1985. *Just Gaming*. Minneapolis: University of Minnesota Press.

Manovich, Lev. 1999. "Avant-Garde as Software." http://www.manovich.net/docs/avant garde_as_software.doc.

————. 2001. *The Language of New Media*. Cambridge, Mass.: MIT Press.

————. 2002a. "Generation Flash." http://www.fdcw.unimaas.nl/is/generation_flash.doc.

————. 2002b. "The Anti-Sublime Ideal in Data Art." http://www.manovich.net/DOCS/data_art.doc.

Marino, Mark C. 2006. "Critical Code Studies" *Electronic Book Review*, March 2006. http://www.electronicbookreview.com/thread/electropoetics/codology/.

Martin, Randy. 1990. *Performance as Political Act: The Embodied Self*. New York: Bergin and Garvey.

Martinez, Roberto Sanchino. 2006. "'Die Produktion von Präsenz': Einige Überlegungen zur Reichweite des Konzepts der 'ästhetischen Erfahrung' bei Hans Ulrich Gumbrecht." In *Ästhetische Erfahrung: Gegenstände, Konzepte, Geschichtlichkeit*, edited by Sonderforschungsbereich 626. Berlin. http://www.sfb626.de/veroeffentlichungen/online/aesth_erfahrung.

Massumi, Brian, 2002. *Parables for the Virtual: Movement, Affect, Sensation*. Durham, N.C.: Duke University Press.

Mateas, Micheal, and Andrew Stern. 2007. "Writing Facade: A Case Study in Procedural Authorship." In *Second Person: Role Playing and Story in Games and Playable Media*, edited by Pat Harrigan and Noah Wardrip-Fruin, 183–207. Cambridge, Mass.: MIT Press.

Matussek, Peter. 1998. "Hypomnemata und Hypermedia. Erinnerung im Medienwechsel: Die platonische Dialogtechnik und ihre digitalen Amplifikationen." *DVjS* 72: 264–78.

Mayer, Mónica. 2000. "The Zócalo, Ephemeral Interventions." In Lozano-Hemmer, *Vectorial Elevation*, 223–38.

McGraw, Jack Barley. 1995. "Creativity and Artificial Intelligence." http://www.cogsci.indiana.edu/farg/mcgrawg/thesis/chapter3.ps.gz.

McLuhan, Marshall. 1964. *Understanding Media: The Extensions of Man*. New York: McGraw-Hill.

Meehan, James. 1981. "Tale-Spin." In *Inside Computer Understanding: Five Programs Plus Miniatures*, edited by R. C. Schank and C. J. Riesbeck, 197–226. Hillsdale, N.J.: Erlbaum.

Menke, Christoph. 1992. "Unbequeme Kunst der Freiheit. Chancen und Risiken einer Ästhetik jenseits von Gut und Böse." *Frankfurter Rundschau*, May 5.

————. 1999. *The Sovereignty of Art: Aesthetic Negativity in Adorno and Derrida*. Cambridge, Mass.: MIT Press.

Merleau-Ponty, Maurice. 2002. *Phenomenology of Perception: An Introduction*. London: Routledge.

Mersch, Dieter. 2002a. *Was sich zeigt. Materialität, Präsenz, Ereignis*. Munich: Fink Verlag.

————. 2002b. *Ereignis und Aura: Untersuchungen zu einer Ästhetik der Performativen*. Frankfurt am Main: Suhrkamp.

———. 2002c. *Was sich zeigt. Materialität, Präsenz, Ereignis.* Munich: Fink Verlag.

Meyer, Urs, Roberto Simanowski, and Christoph Zeller, eds. 2006. *Transmedialität. Zur Ästhetik paraliterarischer Verfahren.* Göttingen: Wallstein.

Mihai, Nadin. 1997. *The Civilization of Illiteracy.* Dresden: Dresden University Press.

Mitchell, W. J. T. 1992. "The Pictorial Turn." *Artforum* 30, no. 7: 89–94.

Mon, Franz. 1994. "Zur Poesie der Fläche." In *Gesammelte Texte 1: Essays,* 77–80. Berlin: Janus Press.

Montfort, Nick. 2008. "Obfuscated Code." In *Software Studies: A Lexicon,* edited by Matthew Fuller, 193–99. Cambridge, Mass.: MIT Press.

Moran, James. 1994. "Reading and Riding the Cinema of Attractions at Universal Studios." *Spectator* 14, no. 1: 78–91.

Munster, Anna. 2006. *Materializing New Media: Embodiment in Information Aesthetics.* Hanover, N.H.: University Press of New England.

Nancy, Jean-Luc. 1992. *Corpus.* Paris: Métailié.

———. 1993. *The Birth to Presence.* Stanford: Stanford University Press.

Ndalianis, Angela. 2004. *Neo-Baroque Aesthetics and Contemporary Entertainment.* Cambridge, Mass.: MIT Press.

Nye, David E. 1994. *American Technological Sublime.* Cambridge, Mass.: MIT Press.

O'Gorman, Marcel. 2007. *E-Crit: Digital Media, Critical Theory, and the Humanities.* Toronto: University of Toronto Press.

Oliva, Achille Bonito. 1980. *La transavanguardia italiana.* Milan: Politi.

Paul, Christiane. 2003. *Digital Art.* London: Thames & Hudson.

———. 2006. "Marie Sester's *Access* and Rafael Lozano-Hemmer's *Body Movies*: Digital Art as Public Art and Performance Art." Presented at Brown University, April 4, within the Wayland Faculty Seminar "Reading Digital Literature and Art."

Pegrum, Mark A. 2000. *Challenging Modernity: Dada between Modern and Postmodern.* New York: Berghahn Books.

Pflüger, Jörg. 2005. "Wo die Quantität in Qualität umschlägt—Notizen zum Verhältnis von Analogem und Digitalem." In *HyperKult II,* edited by Martin Warnke, Wolfgang Coy, and Georg Christoph Tholen, 19–87. Bielefeld: Transcript.

Popper, Frank. 1995. "The Artist and Advanced Technology." *Leonardo* 28, no. 1: 27–33.

———. 2007. *From Technological to Virtual Art.* Cambridge, Mass.: MIT Press.

Provenzo, Eugene F. 1992. "The Electronic Panopticon: Censorship, Control, and Indoctrination in a Post-Typographic Culture." In *Literacy Online: The Promise (and Peril) of Reading and Writing with Computers,* edited by Myron C. Truman, 167–88. Pittsburgh, Pa.: University of Pittsburgh Press.

Raley, Rita. 2006. "Code.surface ‖ Code.depth." *dichtung-digital* 36. http://www.dichtung-digital.org/2006/1-Raley.htm.

———. 2009. "List(en)ing Post." In Francisco Ricardo, *Literary Art in Digital Performance,* 22–34.

Reither, Saskia. 2004. "46 Cuts in 3 Minuten: Rhythmisierte Typografie im Musikvideo 'The Child.'" In *Geteilte Zeit: Zur Kritik des Rhythmus in den Künsten,* edited by Patrick Primavesi and Simone Mahrenholz, 126–37. Schliengen: Edition Argus.

Rettberg, Scott. 2008. "Dada Redux: Elements of Dadaist Practice in Contemporary

Electronic Literature." *Fibreculture* 11. http://journal.fibreculture.org/issue11/issue11_rettberg.html.

Ricardo, Francisco, ed. 2009. *Literary Art in Digital Performance: Case Studies and Critical Positions.* London: Continuum.

Rice, Jeff, and Marcel O'Gorman, eds. 2008. *New Media/New Methods: The Academic Turn from Literacy to Electracy.* Anderson, SC: Parlor Press.

Ridgeway, Nicole, and Nathaniel Stern. 2008. "The Implicit Body." In *Cyberculture and New Media,* edited by Francisco J. Ricardo, 117–55. New York: Rodopi Press.

Riesman, David, Nathan Glazer, and Reuel Denne. 1950. *The Lonely Crowd: A Study of the Changing American Character.* New Haven, Conn.: Yale University Press.

Rivoltella, Pier Cesare, ed. 2008. *Digital Literacy: Tools and Methodologies for Information Society.* London: IGI.

Rokeby, David. 1996. "Transforming Mirrors." http://homepage.mac.com/davidrokeby/mirrorsconclusion.html.

———. 1997. "The Construction of Experience: Interface as Content." In *Digital Illusion: Entertaining the Future with High Technology,* edited by Clark Dodsworth, 27–48. New York: Addison-Wesley.

———. 2003. "Very Nervous System and the Benefit of Inexact Control. Interview with Roberto Simanowski." *dichtung-digital* 21. http://www.dichtung-digital.org/2003/1-rokeby.htm.

Rorty, Richard. 1989. *Contingency, Irony, and Solidarity.* Cambridge: Cambridge University Press.

Rumelhart, David E. 1975. "Notes on a Schema for Stories." In *Representation and Understanding: Studies in Cognitive Science,* edited by Daniel G. Bobrow and Allan M. Collins, 211–36. New York: Academic Press.

Rush, Michael. 2005. *New Media in Art.* London: Thames & Hudson.

Ryan, Marie-Laure. 2000. "Narrative as Puzzle!?—Interview with Roberto Simanowski." *dichtung-digital* 10. http://www.dichtung-digital.de/Interviews/Ryan-29-Maerz-00/index2.htm.

Sack, Warren. 2004. "Aesthetics of Information Visualization." Presented at the 4S-EASST Conference. http://hybrid.ucsc.edu/SocialComputingLab/Publications/wsack-infoaesthetics-illustrated.doc.

Saemmer, Alexandra. 2009. *Digital Literature: A Question of Style.* In Simanowski, Schäfer, and Gendolla, *Reading Moving Letters,* 163–82.

Sakane, Itsuo. 1989. *Introduction to Interactive Art, Catalogue: Wonderland of Science-Art.* Kanagawa, Japan: Committee for Kanagawa International Art & Science Exhibition.

Salter, Chris. 2004. "Multimedia Art between Artaud and Brecht: Chris Salter in Conversation with Sabine Breitsameter." http://www.audiohyperspace.de/en/2004/02/multimedia-art-between-artaud-and-brecht.

Saltz, David Z. 2003. "The Art of Interaction: Interactivity, Performativity, and Computers." In *Performance: Critical Concepts in Literary and Cultural Studies,* edited by Philip Auslander, 3:395–410. London: Routledge.

Sanders, Barry. 1994. *A Is for Ox: The Collapse of Literacy and the Rise of Violence in the Electronic Age.* New York: Vintage.

Sauter, Joachim. 2001. "Interview with Susanne Schuricht." *Chinese Art and Collection Magazine*. http://www.sushu.de/sauter_sushu_01_en.pdf.

Schäfer, Jörgen, and Peter Gendolla, eds. 2009. *Beyond the Screen: Transformations of Literary Structures, Interfaces and Genre*. Bielefeld: Transcript.

Scheffer, Bernd. 1992. *Interpretation und Lebensromen. Zu einer konstruktivistischen Literaturtheorie*. Frankfurt am Main: Suhrkamp.

Schleiermacher, Friedrich. 1998. *Hermeneutics and Criticism and Other Writing*. Edited by Andrew Bowie. Cambridge: Cambridge University Press.

Schmader, David. 2002. "The Listening Post." In *The Stranger: The Stranger Suggest*, November 24. http://www.earstudio.com/projects/pdf/StrangerSuggests.pdf.

Schmidt, Siegfried J. 1987. *Der Diskurs des radikalen Konstruktivismus*. Frankfurt am Main: Suhrkamp.

———. 1988. "Diskurs und Literatursystem. Konstruktivistische Alternativen zu diskurstheoretischen Alternativen." In *Diskurstheorien und Literaturwissenschaft*, edited by Jürgen Fohrmann and Harro Müller, 134–58. Frankfurt am Main: Suhrkamp.

Schneider, Rebecca. 1997. *The Explicit Body in Performance*. London: Routledge.

Schön, Erich. 1987. *Der Verlust der Sinnlichkeit oder Die Verwandlungen des Lesers: Mentalitätswandel um 1800*. Stuttgart: Klett.

Schreibman, Susan, Ray Siemens, and John Unsworth, eds. 2008. *A Companion to Digital Humanities*. Malden, Mass.: Blackwell.

Seel, Martin. 2004. "Adornos Apologie des Kinos." In *Wieviel Spaß verträgt die Kultur: Adornos Begriff der Kulturindustrie und die gegenwärtige Spaßkultur*, edited by Günter Seubold and Patrick Baum, 127–44. Bonn: Denkmal.

———. 2005. *Aesthetics of Appearing*. Translated by John Farrell. Stanford, Calif.: Stanford University Press.

———. 2007. "Ästhetik und Hermeneutik: Gegen eine voreilige Verabschiedung." In *Die Macht des Erscheinens: Texte zur Ästhetik*, 27–38. Frankfurt am Main: Suhrkamp.

Serres, Michel. 1985. *Les cinq sens. Philosophie des corpes mêlés*. Paris: Grasset.

Seubold, Günter. 2005. *Das Ende der Kunst und der Paradigmenwechsel in der Ästhetik*. Bonn: DenkMal.

Shapiro, Meyer. 1994. "On Perfection, Coherence, and Unity of Form and Content." In *Theory and Philosophy of Art: Style, Artist, and Society*, 33–49. New York: George Braziller.

Shaw, David. 2004. "Aspects of Interactive Storytelling Systems." Thesis, University of Melbourne. http://users.rsise.anu.edu.au/~davids/docs/Shaw_Masters.pdf.

Simanowski, Roberto. 2002. *Interfictions: Vom Schreiben im Netz*. Frankfurt am Main: Suhrkamp.

———. 2010. "Digital Anthropophagy: Refashioning Words as Image, Sound and Action." *Leonardo* 2: 159–63.

Simanowski, Roberto, Jörgen Schäfer, and Peter Gendolla, eds. 2009. *Reading Moving Letters: Digital Literature in Research and Teaching: A Handbook*. Bielefeld: Transcript.

Smith, Roberta. 2003. "Mark Hansen and Ben Rubin, 'Listening Post.'" *New York Times*, February 21. http://www.nytimes.com/2003/02/21/arts/design/21GALL.html.

Sontag, Susan. 1966. *Against Interpretation and Other Essays*. New York: Noonday Press.

Stalbaum, Brett. 1997. "Conjuring Post-worthlessness: Contemporary Web Art and the

Postmodern Context." *Switch* 3, no 2. http://switch.sjsu.edu/web/art.online2/brett .links/conjuring.html.

Stefans, Brian Kim. 2003. *Fashionable Noise: On Digital Poetics*. Berkeley, Calif.: Atelos.

Steiner, George. 1986. *Real Presence*. Cambridge: Cambridge University Press.

Stelarc. 2000. "From Psycho Body to Cyber-System: Images as Post-Human Entities." In *The Cybercultures Reader*, edited by David Bell and Barbara M. Kennedy, 560–76. London: Routledge.

Stiegler, Bernhard. 2010. *Taking Care of Youth and the Generations*. Stanford, Calif.: Stanford University Press.

Strachey, Christopher. 1954. "The 'Thinking' Machine." *Encounter* 3, no. 4: 25–31.

Strehovec, Janez. 2009. *Alphabet on the Move: Digital Poetry and the Realm of Language*. In Simanowski, Schäfer, and Gendolla, *Reading Moving Letters*, 207–27.

Stringer, Daniel. 2001. "How Does the Tradition of the Avant-garde Continue on the Internet in Net.art?" http://sparror.cubecinema.com/dan/diss.html.

Strosberg, Eliane. 2001. *Art and Science*. New York.

Sunstein, Cass. 2001. *Republic.com*. Princeton, N.J.: Princeton University Press.

Szilas, Nicolas. 1999. "Interactive Drama on Computer: Beyond Linear Narrative." http://nicolas.szilas.free.fr/research/Papers/Szilas_aaai99.pdf.

Tamblyn, Christine. 1990. "Computer Art as Conceptual Art." *Art Journal* 49: 253–56.

Taylor, Charles. 1994. "The Politics of Recognition." In *Multiculturalism: Examining the Politics of Recognition*, edited by Amy Gutman, 25–73. Princeton, N.J.: Princeton University Press.

Tomasula, Steve. 2003. "Gene(sis)." In *Data Made Flesh: Embodying Information*, edited by Phillip Thurtle and Robert Mitchell, 249–57. London: Routledge.

Tribe, Mark, and Reena Jana. 2006. *New Media Art*. Cologne: Taschen.

Tufte, Edward. 1997. *Visual Explanations*. Cheshire, Conn.: Graphics Press.

———. 2003. *The Cognitive Style of PowerPoint*. Cheshire, Conn.: Graphics Press.

Turner, Scott. 1992. *Minstrel: A Model of Story-telling and Creativity*. Tech. Note UCLA-AI-17-92. Los Angeles: University of California, AI Laboratory.

Ulmer, Gregory L. 2006. *Internet Invention: From Literacy to Electracy*. New York: Longman.

Vattimo, Gianni. 1981. *Al di là del soggetto: Nietzsche, Heidegger e l'ermeneutica*. Milan: Fetrinelli

———. 1988. *The End of Modernity: Nihilism and Hermeneutics in Post-modern Culture*. Translated by John R. Snyder. Baltimore: Johns Hopkins University Press.

———. 1997. *Beyond Interpretation: The Meaning of Hermeneutics for Philosophy*. Translated by David Webb. Stanford, Calif.: Stanford University Press.

Virno, Paolo. 2004. *A Grammar of the Multitude: For an Analysis of Contemporary Forms of Life*. Los Angeles: Semiotext(e).

Wands, Bruce. 2006. *Art of the Digital Age*. London: Thames & Hudson.

Wardrip-Fruin, Noah. 2004. "Digital Literature. Interview with Roberto Simanowski." *dichtung-digital* 32. http://www.dichtung-digital.org/2004/2-Wardrip-Fruin.htm.

———. 2007. "Playable Media and Textual Instruments." In *The Aesthetics of Net Literature: Writing, Reading and Playing in Programmable Media*, edited by Peter Gendolla and Jörgen Schäfer, 211–53. Bielefeld: Transcript.

———. 2009. *Expressive Processing: Digital Fictions, Computer Games, and Software Studies*. Cambridge, Mass.: MIT Press.

Ware, Colin. 2000. *Information Visualisation: Perception for Design*. San Francisco: Morgan Kaufman.

Warf, Barney, and Santa Arias, eds. 2008. *The Spatial Turn: Interdisciplinary Perspectives*. New York: Routledge.

Whitelaw, Mitchell. 2008: "Art against Information." *Fibreculture* 11. http://journal.fibre culture.org/issue11/issue11_whitelaw.html.

Williams, Emmett, ed. 1967. *An Anthology of Concrete Poetry*. New York: Something Else Press.

Wilson, Stephen. 2002. *Information Arts: Intersections of Art and Technology*. Cambridge, Mass.: MIT Press.

Wollen, Peter. 1993. "Baroque and Neo-Baroque in the Age of Spectacle." *Point of Contact* 3 (April): 9–21.

Wood, Denis. 1992. *The Power of Maps*. New York: Guilford Press.

Wright, Richard. 2008. "Data Visualization." In *Software Studies*, edited by Matthew Fuller, 78–87. Cambridge, Mass.: MIT Press.

Wyman, Jessica. 2003. "On Eduardo Kac's Genesis." In *YYZ Artists' Outlet*. http://www .ekac.org/jessica.yyz.html.

Ziegfeld, Richard. 1989. "Interactive Fiction: A New Literary Genre?" *New Literary History: A Journal of Theory and Interpretation* 20, no. 2: 341–72.

Zimroth, Evan. 1993. *Dead, Dinner, or Naked*. Chicago: TriQuarterly Books/Northwestern University Press.

Ziv, Yuli. 2006. "Parallels between Suprematism and the Abstract, Vector-Based Motion Graphics of Flash." *Intelligent Agent* 6, no. 1. http://www.intelligentagent.com.

Zola, Émile. 1885. "Aussprüche über die bildende Kunst." *Die Gesellschaft* 1, no. 3: 55–56.

INDEX

Roberto Simanowski is professor of media theory and aesthetics at the University of Basel.